VENICE
FROM CANALETTO AND TURNER TO MONET

FROM CANALETTO AND TURNER TO MONET

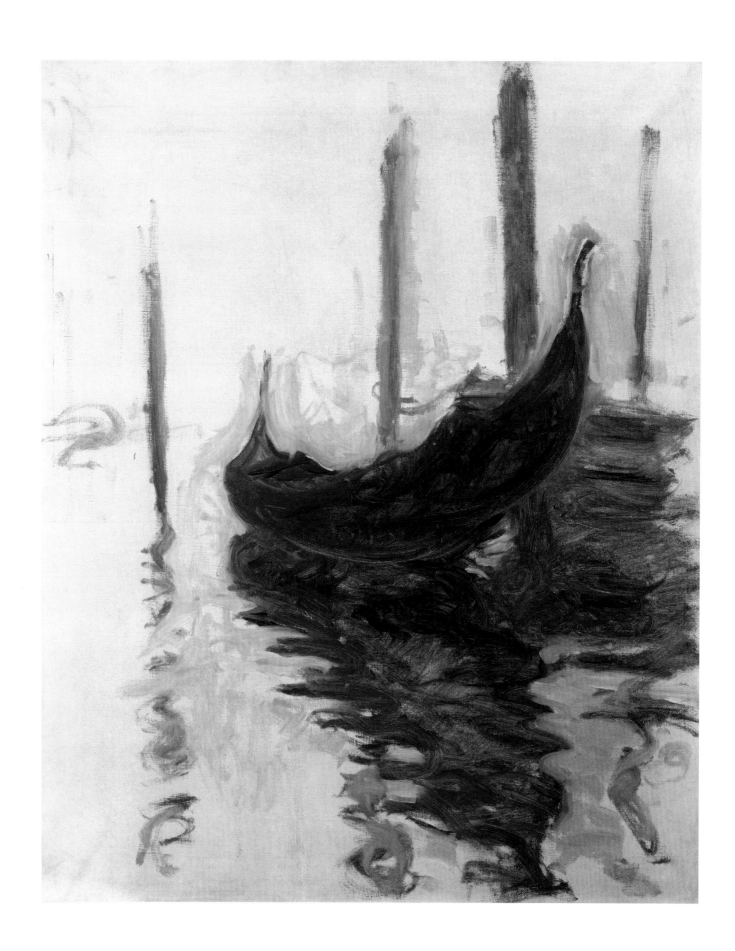

VENICE

FROM CANALETTO AND TURNER TO MONET

Edited by Martin Schwander
on behalf of the Fondation Beyeler

HATJE CANTZ

*The exhibition and catalogue
are dedicated to Hildy Beyeler
(1922–2008)*

CONTENTS

LENDERS

The Fondation Beyeler would like to thank all the lenders who generously contributed to the success of the exhibition:

Addison Gallery of American Art, Phillips Academy, Andover, Massachusetts, Brian T. Allen

Adelson Galleries, New York, Warren Adelson and Elizabeth Oustinoff

Albertina, Vienna, Klaus Albrecht Schröder

Paul G. Allen Family Collection

Amgueddfa Cymru—National Museum Wales, Cardiff, Michael Houlihan and Oliver Fairclough

Batliner Collection, Herbert Batliner

Bayerische Staatsgemäldesammlungen, Alte Pinakothek, Munich, Reinhold Baumstark and Cornelia Syre

Bayerische Staatsgemäldesammlungen, Neue Pinakothek, Munich, Reinhold Baumstark and Joachim Kaak

Brooklyn Museum of Art, Arnold L. Lehman and Charles Desmarais

Centre Georges Pompidou, Musée national d'art moderne, Paris, Alfred Pacquement

Chrysler Museum of Art, Norfolk, Virginia, William J. Hennessey

Sterling and Francine Clark Art Institute, Williamstown, Massachusetts, Michael Conforti and Kathleen Morris

Colección Carmen Thyssen-Bornemisza, Madrid

Collection Juan Abelló, Madrid

Collection Albright-Knox Art Gallery, Buffalo, Louis Grachos

Collection of The Honorable and Mrs. Joseph P. Carroll

Collection of The Dixon Gallery and Gardens, Memphis, Tennessee, Kevin Sharp

Collection Dr. Gert-Rudolf Flick, London

Collection Fondation Pierre Gianadda, Martigny, Switzerland, Léonard and Annette Gianadda

Collection Galerie Larock-Granoff

Collection of the Lauren Rogers Museum of Art, Laurel, Mississippi, George Bassi and Jill R. Chancey

Collection Westmoreland Museum of American Art, Greensburg, Pennsylvania, Judith H. O'Toole

Dickinson, London, James Roundell, Emma Ward and Cornelia Pallavicini

Edelman Arts, Inc., Asher B. Edelman

The Fine Art Society, London, Gordon Cooke

Foundation E.G. Bührle Collection, Zurich, Hortense Anda-Bührle and Lukas Gloor

Galleria Internazionale d'Arte Moderna di Ca' Pesaro, Venice, Giandomenico Romanelli and Silvio Fuso

Gemäldegalerie der Akademie der bildenden Künste Wien, Vienna, Renate Trnek

Solomon R. Guggenheim Museum, New York, Thomas Krens and Marc Steglitz

Calouste Gulbenkian Museum, Lisbon, João Castel-Branco Pereira, Maria Luísa Sampaio, and Manuela Fidalgo

Hahnloser/Jaeggli Stiftung, Villa Flora, Winterthur, Verena and Robert Steiner

Marie and Hugh Halff

Hamburger Kunsthalle, Kupferstichkabinett, Hubertus Gaßner and Andreas Stolzenburg

Mrs. Henry J. Heinz II

Herzog Collection, Basel, Ruth and Peter Herzog

Hirshhorn Museum and Sculpture Garden, Smithsonian Institution, Washington, D.C., Kerry Brougher

Hull Museums, Ferens Art Gallery, United Kingdom

Hunterian Museum & Art Gallery, University of Glasgow, Ewen D. Smith and Pamela Robertson

HVB Group, Christiane Lange

Indianapolis Museum of Art, Maxwell Anderson and Ellen W. Lee

Kunsthaus Zürich, Stiftung Betty und David M. Koetser, Christoph Becker and Christian Klemm

Kunstmuseum St. Gallen, Roland Wäspe and Nadia Veronese

Dr. John E. and Colles B. Larkin

The Metropolitan Museum of Art, Philippe de Montebello and Peter M. Kenny

Musée des Beaux-Arts et d'Archéologie, Besançon, Emmanuel Guigon

Musée des Beaux-Arts de Bordeaux, Olivier Le Bihan

Musée des Beaux-Arts de Nantes, Blandine Chavanne and Jean-Marc Ayrault

Musée Granet, Aix-en-Provence, Bruno Ely and Guy Cogeval

Museo Thyssen-Bornemisza, Madrid, Guillermo Solana

Museum of Fine Arts, Boston, Malcolm Rogers and George T.M. Shackelford

Museum Langmatt, Stiftung Langmatt Sidney und Jenny Brown, Baden, Switzerland, Rudolf Velhagen

Nahmad Collection, Switzerland

National Gallery of Art, Washington, D.C., Earl A. Powell III

New Britain Museum of American Art, Connecticut, Douglas Hyland

Niedersächsisches Landesmuseum Hannover, Heide Grape-Albers and Annette Weisner

Petit Palais, Musée des Beaux-Arts de la Ville de Paris, Gilles Chazal

Philadelphia Museum of Art, Anne d'Harnoncourt (†) and Joseph J. Rishel

Pinacoteca Giovanni e Marella Agnelli, Turin, Ginevra Elkann Agnelli and Marcella Pralormo

Pola Museum of Art, Pola Art Foundation, Japan, Hiroshi Ueki and Yoko Iwasaki

Royal Academy of Arts, London, Charles Saumarez Smith and MaryAnne Stevens

Saint Louis Art Museum, Brent R. Benjamin

Shelburne Museum, Shelburne, Vermont, Stephan F. F. Jost

The Syndics of the Fitzwilliam Museum, Cambridge, Timothy Potts and David Scrase

Tate, Nicholas Serota, Caroline Collier, David Blayney Brown, Stephen Deuchar and Ian Warrell

Toledo Museum of Art, Don Bacigalupi

The Whitworth Art Gallery, The University of Manchester, Maria Balshaw

Zornsamlingarna, Mora, Sweden, Johan Cederlund

and all those who wish to remain anonymous.

ACKNOWLEDGMENTS

In addition, we would like to thank the following for their help and assistance:

Konrad O. Bernheimer; Hans Ulrich Bodenmann; Constance R. Caplan; Christie's: Dirk Boll, Amy Cappellazzo, Cyanne T. Chutkow, John Lumley; David Claerbout; Catherine Couturier; Michael Darling; Eric Decelle; Dolores Delgado; Eric Denker; Catherine Dreyfus-Soguel; Filmpodium der Stadt Zürich: Corinne Siegrist-Oboussier; Gagosian Gallery: Rebecca Sternthal, Putri Tan, Robin Vousden; Galerie Beyeler: Claudia Neugebauer, Karin Sutter; Galerie Gmurzynska; Galerie Taménaga; Lee Glazer; Matthias Haldemann; Hayashida Hideki; Gregor Hoffmann; Lowell Libson Ltd.; Vera Lutter; Robert E. Meyerhoff; Yusuke Minami; Isabela Mora; Maja Oeri; Richard Ormond; Osborne Samuel Ltd.; Ingrid Pfeiffer; Philippe Piguet; Joachim Pissarro; Lauren Proctor; Angela Rosengart; Norman Rosenthal; Julia V. Shea; Robert Simon Fine Art; Sotheby's: Virginia Chang, Emmanuel Di Donna, Caroline Lang, Charles S. Moffett, David Norman, Claudia Steinfels; Anne Spink; Hugh Stevenson; Timothy Taylor Gallery; Mathieu Ticolat; Gary Tinterow; Paul Hayes Tucker; Tse-Ling Uh; Tom Venditti; Christoph Vitali; John Zarobell; Miguel Zugaza Miranda

PARTNERS

For their continued support, the Fondation Beyeler would like to thank:

Bank Sarasin & Cie AG
Basler Kantonalbank
Basler Zeitung Medien
Bayer
Fondation BNP Paribas
Gemeinde Riehen
ISS
Kuhn & Bülow
Kultur Basel-Stadt
kulturelles.bl
Manor
UBS

PREFACE

Ernst Beyeler, Sam Keller, and Martin Schwander

Since its inauguration more than ten years ago, the Fondation Beyeler has focused on modern and contemporary art in its presentations of the permanent collection and temporary exhibitions. The collection amassed by Ernst and Hildy Beyeler represents a unique record of highlights from the beginnings of Modernism in French Impressionism to selected examples of postwar European and American art. The Fondation Beyeler's exhibitions offer an opportunity for a profound study and appreciation of the modern artists represented in the collection. Yet—as we were aware from the beginning—modern art did not just appear out of the blue, and in view of this, the art of Modernism was placed in its historical context in our 2001 exhibition *Ornament and Abstraction.* A further example was *Francis Bacon and the Tradition of Art,* organized in collaboration with the Kunsthistorisches Museum Vienna, which was devoted to the involvement of a prototypical modern artist with the history of Western painting. Paintings by Bacon were hung on purple walls and for the first time juxtaposed with works by Old Masters such as Titian, Diego Velázquez, and Rembrandt.

Venice: From Canaletto and Turner to Monet confronts artists of diverse epochs with increased intensity. Beginning with the views painted by Canaletto and Francesco Guardi in the eighteenth century, the exhibition traces a grand arc to the series of canvases Claude Monet executed in Venice in 1908. Our review, focusing on twelve European and American artists, amounts to an impressive panorama of visual representations of Venice, indicating that it was indeed a highly fertile source of artistic motifs. In the course of more than one hundred years, key figures of early Modernism such as William Turner, Edouard Manet, James McNeill Whistler, and John Singer Sargent sought out the city and represented it in painting.

During the three years preparing for the exhibition, we were able to rely on the aid and advice of many friends and colleagues. Our thanks go first to the numerous institutions and private lenders in Europe, the United States, and Japan. With a commitment beyond the ordinary, they have agreed to make a great number of significant loans available to us, without which the exhibition could never have been staged in such a comprehensive form.

We also wish to thank the authors, Gottfried Boehm, Alan Chong, Anne Distel, Dario Gamboni, Elaine Kilmurray, Bożena Anna Kowalczyk, Margaret F. MacDonald, Christopher Riopelle, Giandomenico Romanelli, Ian Warrell, and Juliet Wilson-Bareau, whose essays enrich the catalogue with new findings from their research work. Catalogue editing lay in the experienced hands of Delia Ciuha and Raphaël Bouvier, and Christopher Wynne was responsible for coordinating the copyediting. The subtle elegance of the catalogue design reflects the skills of Heinz Hiltbrunner. The publication proper, finally, lay in the competent hands of Annette Kulenkampff of Hatje Cantz.

Our heartfelt thanks go once again to the entire staff of the Fondation Beyeler and to the curatorial assistant, Michiko Kono, who devoted themselves with great commitment to the project and made it a reality.

We are extraordinarily grateful to the Hansjoerg Wyss Foundation for their continued generous support of our exhibition activities.

INTRODUCTION

Martin Schwander

"No One Enters Venice as a Stranger."
English travel guide, 1842

Venice is a city that has fascinated people for centuries. The uniqueness of the Serenissima was first extolled in written and visual records of the Renaissance. From then on, visitors and natives alike recorded the beauties and glories of a city that had developed into the political, economic, and military center of a great European power. In the eighteenth century, Venice advanced to become Europe's "festival venue," attracting droves of visitors from northern Europe. When Napoleon's troops marched into Italy in spring 1797, Venice's rich social and cultural life came to an abrupt end. For many historians and art historians, the fall of the millennial maritime republic represented Venice's entry into something akin to a posthistorical period. From this point of view, the nineteenth-century history of the city consists of lackluster narratives about an economically and culturally impoverished provincial town that was controlled by foreign powers for six decades.

The present exhibition and this publication provide an unprecedented review of the astonishing range of visual depictions created by precursors and representatives of modern art in the nineteenth and early twentieth century. It is a concise art-historical panorama in which only few Venetian artists appear. Canaletto and Francesco Guardi were the last great painters of views, whose joyous and festive works, some of the finest examples of which are here on view, lastingly shaped the image of Venice in the minds of northern Europeans long after the city's demise.

The most important pictures of Venice of the nineteenth and early twentieth centuries were painted by artists from various European countries and the United States. Already probably the most frequently depicted city in Canaletto and Guardi's times, Venice took on a veritably cult status in the nineteenth century, a place that fueled the imagination of great painters and photographers, writers and poets, musicians and philosophers. The images created by artists and intellectuals are one key reason why Venice, more than any other city, became a conventionally received experience. In the nineteenth century, the image of Venice developed increasingly into a palimpsest on which diverse, and generally ambivalent, pictures were superimposed: pictures of power and demise, love and death, beauty and transitoriness, *joie de vivre* and melancholy.

The foundations for this new image of Venice were laid in the early years of the century by Lord Byron in his poems and dramas. Byron's sentimental devotion to Venice as an allegory of decline and fall was shared by the English painter J.M.W. Turner. As the superb loans from the Tate show, the artist's transcendent visualizations by no means fall short of the poet's evocative imagery.

In 1874, the first representative of early modern art, Edouard Manet, came to Venice to paint. This might seem surprising when you consider that Manet and his fellow Impressionists, advocates of a self-reflective, pure painting, tended to avoid genres and subjects that were freighted with sentimental and literary meaning. This sort of thing was the domain of artists who exhibited regularly at the official Paris and London salons. Even more progressive artists were not immune to the uniqueness and beauty of Venice: for Manet and James McNeill Whistler, Odilon Redon and Paul Signac, depicting Venice implied finding new approaches to challenge run-of-the-mill visual stereotypes. In so doing, each of the artists

exhibited here developed his own strategy on the basis of his previous oeuvre.

The exhibition brings together major representatives of the French and Anglo-American avant-garde who were active in Venice in the late nineteenth and early twentieth century. Many of them, such as John Singer Sargent and Claude Monet, Pierre-Auguste Renoir and James McNeill Whistler, had enjoyed friendly ties from early on.

In Venice, the Swedish artist Anders Zorn—at the time an internationally acclaimed painter and printmaker—was associated with John Singer Sargent and the Palazzo Barbaro circle. In our exhibition and in this publication, Zorn represents the attraction exerted by cosmopolitan Venice on a continually growing number of moderately progressive artists. Its magnetic appeal to artists of the *juste milieu* was further increased by the *Esposizione internazionale d'arte della Città di Venezia,* the Venice Biennale, which first opened its doors in 1895. This new forum also had a stimulating effect on local art production, as reflected here, for instance, by Pietro Fragiacomo's painting *Piazza San Marco.*

A new chapter in the media dissemination of the city on the lagoon, which would effect contemporary painting as well, had already begun with the rise of photography in Venice around 1850. An increasing numbers of tourists stimulated the demand for photographs of the city's main landmarks and popular Venetian life, especially around 1900, when tourism became the city's prime *raison d'être.* We are pleased to be able to include a representative selection of early Venice photographs from the Herzog Collection in our exhibition.

For Claude Monet, the trivialization of Venice in painting was long a reason to avoid going there. When he finally traveled to Venice with his wife, Alice, for the first—and last—time in 1908, he was sixty-eight years old. After hesitant beginnings, even Monet succumbed to the mysterious fascination of the *ville nénuphare,* or "water-lily city," as Paul Morand called it. Monet spent two months at various locations laying out paintings which he finished during the following years in his Giverny studio. In spring 1912, he exhibited the series at the Galerie Bernheim-Jeune in Paris. One hundred years after their emergence, we decided to bring together significant works in Monet's Venice series, which has never been seen in its entirety since its first Paris showing. In hindsight, Monet's elegiac compositions have the effect of a farewell to the image of the city held by an epoch that came irrevocably to an end a few years later, with the outbreak of the First World War.

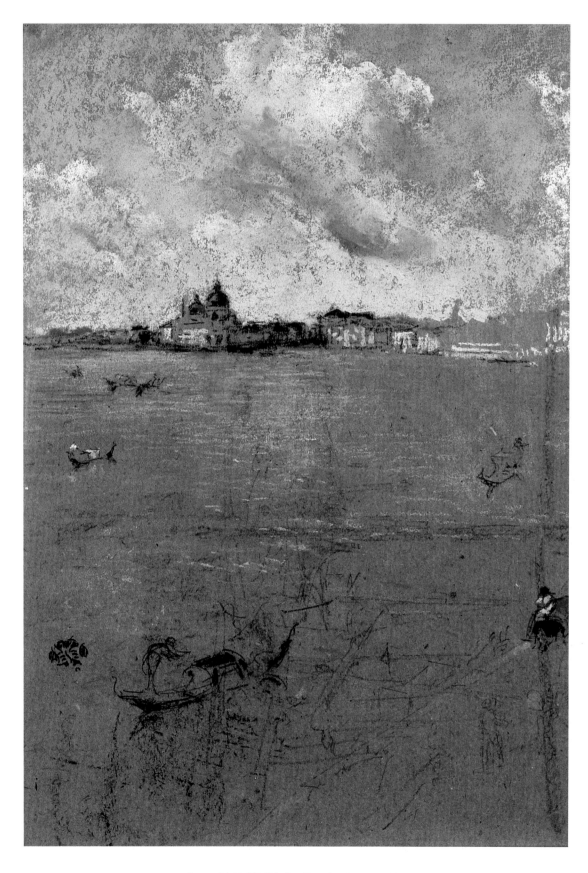

James McNeill Whistler, *Venetian Scene, c.* 1880
New Britain Museum of American Art, Connecticut, Harriet Russell Stanley Fund

IMAGES OF VENICE
HISTORY AND MYTHS OF A CITY

Martin Schwander

The pictures of Venice painted by artists from the eighteenth century onward, and especially in the period from 1870 until the outbreak of the First World War in 1914, form the subject of this publication and exhibition. Why did this city become such an important subject over such a long time for so many artists, many of whom were key figures in the history of European painting? The following essay traces the unusual and complex history of the city, which provided the background and matrix for the diverse and repeatedly overlapping "images of Venice."

The Basilica di San Marco and the Palazzo Ducale are the magnificent architectural embodiments of a state that stood at the apex of its military, economic, and cultural importance in the early modern era.[1]

At the height of their power in the fourteenth and fifteenth century, large parts of Istria and Dalmatia, Corfu, groups of the Aegean islands, Crete, and Cyprus belonged to regions that were subjects of the Venetian Republic. The Venetian fleet controlled the eastern Mediterranean (from present-day Turkey across the Levant and Egypt to North Africa). It continually faced strong competition, fighting four wars with Genoa alone in the thirteenth and fourteenth century. However, the hostile powers were never a serious challenge to Venice's dominant trade position with the Orient.

In the early modern era, "la Serenissima Repubblica di San Marco" was the most important commercial and cultural hub between the Orient and the Occident, with the Bacino di San Marco as the distribution harbor for countless products and luxury goods from the East (silk, brocades, gems, ivory, spices, dyes, and perfumes)[2] that were in demand throughout Europe. In turn, trade with western and northern Europe (silver, amber, wool, lumber, tin,

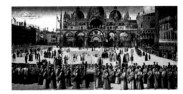

Fig. 1 Gentile Bellini,
The Procession on the Piazza San Marco,
1496, oil on canvas, 323 × 430cm,
Gallerie dell'Accademia, Venice

iron, but also cut jewels, glassware, and medicines) was conducted through Venice.

Despite Venice's dominance in long-distance and intermediate trade, shipbuilding in the Arsenale was flourishing and was by far the largest employer. This was followed by the manufacture of textiles, silk, and glass. Also of great significance was the monopolized trade in salt, pepper, and grain, which contributed as much to the patricians' wealth as all the other fields of commerce combined.

Seen against this background, it comes as no surprise that Venice—this miracle of urbanity, beauty, wealth, and scholarship—saw itself predestined from early on to become the "New Rome." As far as its statesmen were concerned, this New Rome was superior to ancient Rome, because thanks to a constitution that guaranteed political stability and economic prosperity, it was effected neither by the social unrest of the Roman republic nor the despotic excesses of the imperial period. The New Rome was to introduce an *Aurea aetas,* a golden age, in which the political philosophers of Italy saw the Platonic-Christian ideal state realized for the first time. Donato Giannotti of Florence, for instance, in his treatise *Libro dela Republica de' Vinitiani* of 1540, already spoke in admiration of "the myth of the Venetian constitution."[3] The *splendor civitatis Venetiae* also impressed countless foreign guests. As the French ambassador Philippe de Commynes noted in October 1494: "It is the most triumphant of all cities I have ever set eyes upon; it extends its respect to both ambassadors and foreigners, governs wisely, and where service to God is paid most solemnly."[4]

The splendor of Venice included the new palaces on the Canal Grande, which were erected in a new style—the Renaissance—and a new material—marble. New churches and

chapels went up on many sites, their decorations donated both by private individuals and corporations. This was the Golden Age of Venetian painting, which began with Gentile and Giovanni Bellini, Vittore Carpaccio, and Giorgione, and would find its temporary end nearly one hundred years later, with Tintoretto and Titian. The outstanding architect of the epoch was Andrea Palladio, who with his San Giorgio Maggiore created a landmark that would fascinate countless painters, from Canaletto and Francesco Guardi to Claude Monet.

The first signs of a serious threat to Venice's predominance in trade with the Orient had become evident several decades previously. In 1453, the Ottoman armies had conquered Constantinople, and the Venetian fleet had been unable to mount sufficient resistance to the fall of Byzantium, the eastern Christian empire. In 1470, the first great sea battle between Venetian and Ottoman naval forces occurred. After their defeat, the Venetians were forced to accept the takeover of Euboea by the Turks. This debacle shook the republic to its foundations. It marked the onset of conflicts with the Ottoman Empire that would tie up Venice's economic and demographic resources for three hundred years.

In the course of the sixteenth and seventeenth century, the Republic of Venice became involved in a hopeless war of attrition with the Ottoman Empire. During the same period, Spain, Portugal, England, and the Netherlands opened up new maritime trade routes that generated immeasurable wealth. From the sixteenth century onward, many of the raw materials and trade goods in demand in Europe passed through the harbors of Lisbon, Amsterdam, and London.

By the end of the seventeenth century, Venice had declined politically and militarily to a mere regional power of second-rate economic importance. Still, la Serenissima could pride herself on having maintained her territorial integrity. From the sixteenth century, she had managed to keep her possessions on the mainland out of the periodical conflicts over dominion in Upper Italy between Spain, France, the Habsburg Empire, and the Papal State. That its *Domini di Terraferma* was never seriously challenged was due principally to the legendary negotiating skills of Venetian diplomats, who managed to turn the antagonisms among the great European powers to their own ends.

Nevertheless, at the beginning of the eighteenth century the Republic of Venice was "still the most significant city in Italy, in terms of economic power as well."[5] It continued to hold large territories, extending from the hills of Lombardy to Friaul, from the coasts of Dalmatia and Albania to the Ionian islands. At the start of the eighteenth century, however, the Venetian Republic increasingly began to take on the traits of an agricultural society, whose conservatism northern European observers found difficult to understand. Less courageous and innovative than before, the patrician class was unable to decide between protectionism, their own fiscal interests, and free trade. On the whole, no broad economic decline occurred, yet the Venetians fell behind the rapidly expanding mercantile powers. The economy of the regional power of Venice in the eighteenth century rested primarily on the manufacture of luxury merchandise and agrarian production on the mainland.[6]

In his *Remarks on Several Parts of Italy*—a widely disseminated publication that first appeared in 1705 and went to ten editions by 1773—Joseph Addison gave a lucid analysis of Venice's economic stagnation:

*... their Trade is far from being in a flourishing Condition for many Reasons. The Duties are great that are laid on Merchandises. Their Nobles think it below their Quality to engage in Traffic. Their Merchants who are grown rich, and able to manage great Dealings, buy their Nobility, and generally give over Trade. Their Manufactures of Cloth, Glass, and Silk, formerly the best in Eu*rope, *are now excell'd by those of other Countries. They are tenacious of old Laws and customs to their great Prejudice, whereas a Trading Nation must be still for new Changes and Expedients, as different Junctures and Emergencies arise.... This Republic has been much more powerful than it is at the present, as it is still likelier to sink than to increase its Dominions.*[7]

Economic stagnation and political and military erosion had little effect on the prestige and attractiveness of Venice.[8] On the contrary, the start of the eighteenth century brought its first (and profitable) wave of popularity as a destination for prosperous travelers from the north. More and more young, well-to-do English, French, German, and Dutch tourists added their note to the traditionally colorful and cosmopolitan scene. For British aristocrats on their Grand Tour—their educational and pleasurable jaunt through central Europe and Italy—Venice, Rome, and Naples were absolute musts.[9] Venice promised experiences offered by no other European city. Joseph Addison summed up the external traits of this Venetian singularity, stating that:

*Venice has several Particulars, which are not to be found in other Cities, and is therefore very entertaining to a Traveler. It looks, at a distance, like a great Town half floated by a Deluge. There are Canals everywhere crossing it, so that one may go to most Houses either by Land or Water. This is a very great Convenience to the inhabitants; for a Gondola with two oars at Venice, is as magnifi*cent as a Coach and six horses with a large Equipage in another country;*[10]

By the middle of the century, Venice had established itself as "Europe's festival site."[11] The republic's grand finale had begun. Anyone who could afford it went there for the Carnival, heard concerts at the conservatories, attended the opera, and frequented the various cafés and casinos. Locals and tourists enjoyed the *Commedia dell'arte* and prayed for luck at the great casino, the Ridotto. The promise of sexual adventure only heightened the attraction of Venice as a destination.[12]

The cultural offers in the *settecento* were high-level: Carlo Goldoni's and Carlo Gozzi's comedies were heralded as great successes; the opera houses run by patrician families hosted the great (and costly) voices of the time; Antonio Vivaldi and Baldassare Galuppi performed their compositions at the *ospedali* and conservatories; the artist Rosalba Carriera portrayed celebrities from all over Europe; printing houses published books in many languages. Also renowned were the salons of cultivated ladies, such as Caterina Dolfin Tron and Contarina Barbarigo.

From the middle of the century, major Venetian artists and writers sought their luck abroad as well. Man of letters and art connoisseur Francesco Algarotti, who enriched the Dresden collection with Italian, not least Venetian, painting, was a long-time dinner companion of Frederick the Great; Baldassare Galuppi performed his operas in London and Vienna; in 1762, Carlo Goldoni accepted an appointment at the Comédie Italienne in Paris; the poet Lorenzo Da Ponte wrote the librettos to Mozart's major operas in Vienna; the author-adventurer Giacomo Casanova, Chevalier de Seingalt, after stopovers in Paris and St. Petersburg, spent his dotage as a librarian in Dux;

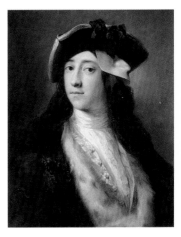

Fig. 2 Rosalba Carriera, *Portrait of Gustavus Hamilton, 2nd Viscount Boyne,* c. 1730, pastel, 59.7 × 47.6 cm, courtesy of Christie's, London

Giambattista Tiepolo painted the last convincing apotheoses of power for royal and ecclesiastical patrons in Würzburg and Madrid.

In the 1720s, Giovanni Antonio Canal, known as Canaletto (1697–1768), became the shooting star of the Venice art scene. As early as 1725, the Veronese painter Alessandro Marchesini advised the collector Stefano Conti of Lucca against acquiring the *vedute,* or views, of Luca Carlevarijs (1663–1730).[13] Instead, he recommended "Sigr. Antonio Canale, who astounds everyone who sees his works in this city—it is like that of Carlevarijs, but you can see the sun shining in it."[14] In 1730, Canaletto entered a business agreement with Joseph Smith, an Englishman who had settled in Venice at the start of the century. The banker, merchant, and later Consul Smith, who played an important part in Canaletto's commercial success, actively contributed to recruiting English collectors such as Samuel Hill, the Earl of Essex, the Duke of Leeds, and the Duke of Bedford. As early as 1739, the Frenchman Charles de Brosses remarked:

[Canaletto] surpasses everything I have ever seen. His style is clear, light-hearted, vivacious; his perspectives and eye for detail wonderful. But by offering him more than three times the price he is asking for his paintings, the English have spoilt the artist so much that it is not longer possible to barter with him.[15]

The enthusiasm for Canaletto's views among English art lovers was for a time so great that when they actually went to Venice they experienced a sort of *déjà-vu.* The British diarist and author Hester Lynch Piozzi, for instance, found in 1785 that Venice

revived all the ideas inspired by Canaletti [sic], whose views of this town are most scrupulously exact; those especially which one sees at the Queen of England's house in St. James's Park; to such a degree indeed, that we knew all the famous towers, steeples, etc. before we reached them.[16]

Piozzi's remarks bear early witness to an experience that has greater validity than ever in the age of omnipresent media imagery:

[Venice] has come to us mediated through the words of writers from Shakespeare to Byron, Ruskin, George Sand, Henry James, Marcel Proust, and Ezra Pound, and through the images of painters from Canaletto, Guardi and popular vedutisti to Turner, Whistler, Sargent and Monet. She is, perhaps more than any other city, a "received" experience, difficult to reinvent or see afresh. A guidebook from 1842 noted that "No One Enters Venice as a Stranger."[17]

One of the prime tasks of these painters of views was to record the unique magnificence unfolded by the Venetian state. Especially successful in the field was Francesco Guardi (1712–93), the last and most inventive of the great Venetian *vedutisti.*[18] He repeatedly depicted the major state festival, the *Festa della Sensa* (pp. 52–53), the annual symbolic wedding of the chief magistrate—the doge—with the sea, which attracted thousands from around Europe who watched the doge embark the *bucintoro,* the gilded ship of state.

The glory of la Serenissima celebrated in the views tended to gloss over the symptoms of crisis that—as mentioned—had increased to a disturbing extent during the course of the century. Less easy to grasp, yet with equally grave mid-term sociopolitical consequences, were the unwilligness and inability of the powerful patrician families to undertake the institutional reform so urgently needed in the Age of Enlightenment. In Venice, power became concentrated among an ever decreasing circle of senatorial families, while the number of impoverished nobles (*barnabotti*) continually grew. In the subject regions, wealthy landown-

ers and citizens were denied a political voice. Viewed from the mainland, Venice was the parasitic capital that refused to countenance improvements and was concerned with maintaining its prerogatives and privileges.

With this in mind, it is not surprising that the Republic of Venice was incapable of mounting resistance to the Napoleonic troops who advanced into the Po Valley in spring 1797. Doge Lodovico Manin abdicated on May 12, to avert death and destruction to the city. With the doge, the entire patriciate withdrew from all government responsibility. Spring 1797 marked the downfall of a city-state that had managed to defend its independence for more than a millennium. The Republic of Venice was never to recover its independence.[19] As early as October 1797, Napoleon ceded Venice to Austria in the Treaty of Campo Formio. After the Battle of Austerlitz, the city was ceded to France in the Treaty of Pressburg in 1805 and was subsumed into Napoleon's "Royaume d'Italie." In April 1814, the Austrian occupying forces returned, and one year later, after the Congress of Vienna, Venice became part of the Habsburg Kingdom of Lombardy-Venetia. Venetian revolts under the leadership of Daniele Manin in the European revolutionary year of 1848–49 drove the Austrians out of the city for a few months, but Habsburg rule would not end until early November 1866. Venice became part of the young Italian nation-state; on November 7, the municipality and people of Venice received King Vittorio Emanuele II on Piazza San Marco.

In the wake of the spring 1797 invasion, Napoleon's troops humbled and plundered the city. They removed great numbers of works of art and libraries to Paris. Nor did they spare the city's renowned emblems—the horses of San Marco and the winged lion atop the column in the Piazzetta. They torched the doge's ship of state and devastated the Arsenale, the symbol of Venice's erstwhile military superiority. A great number of churches and monasteries were abolished and the demolition of church properties ordered. The Venetians, already suffering under a war-ruined economy and the Napoleonic embargo policy, were subjected to high taxation. The city's economic and political demise resulted in massive demographic losses. Countless artisans, skilled workers, and laborers emigrated, while sections of the nobility ensconced themselves in their estates on the mainland.[20]

Napoleon visited Venice in December 1807. A few weeks later, the French occupation authorities presented a plan that would open a new chapter in the city's urban development. Like Paris before it, Venice was to be fundamentally modernized. Among other things, the development plan foresaw the creation of green areas and sightlines, spacious squares and broad avenues. In spite of financial difficulties, a few progressive projects were undertaken, for instance, the Via Eugenia (today's Via Giuseppe Garibaldi), the Giardini Pubblici in the thickly settled Sestiere di Castello, and the central cemetery on the island of San Cristoforo. The unified appearance of the Piazza San Marco goes back to the construction of the Ala Napoleonica. Many Napoleonic construction projects entailed the razing of valuable existing buildings. These incursions into the dense and closely woven urban structure provoked the first debate between advocates of the preservation of the historic heritage (and the *singolarità* of Venice) and advocates of a city adapted to contemporary needs and requirements—a debate that profoundly affected the history of Venice in the nineteenth and twentieth century.

During the Napoleonic Wars, tourism in Europe largely came to a standstill. After the Congress of Vienna in 1815, the English were among the first to resume travel to Italy. They arrived in Venice to find a strange city. Habsburg Venice had little in common with the image of the Serenissima popularized by Canaletto's paintings. This becomes clear from the observations of the Irish writer Lady Sydney Morgan (c. 1783–1859), from her 1821 study of Italy:

Every pre-conceived idea of Venice, as a city or a society, belongs purely to the imagination. One is apt to consider it as the seat of some giddy authority, whose councils are debated amidst the orgies of "midnight mirth and jollity," where time consumes itself in endless revels, and love is the religion, and pleasure the law of the land! Where the nights are all moonlight, the days all sunshine; and where life passes in perpetual carnival, under the fantastic guise of a domino and mask.... That moment is now over; and such images of desolation and ruin are encountered, in every detail of the moral and exterior aspect of the city, as dissipate all visionary anticipations, and sadden down the spirit to that pitch, which best harmonizes with the misery of this once superb mistress of the waves.[21]

For the Francophile lady there was no doubt that the Austrian occupation was responsible for this desolate situation:

... the Austrian Cabinet, from its first possession of the Venetian territory, has directed all its energies to the destruction of a city whose proximity may one day become dangerous to its other possessions.... While commercial restrictions throw every impediment in the way of making money, an heavy and oppressive taxation has gradually drained the Venetian territory of its currency.... The Venetians, thus plundered of their last sequin, are rendered incapable of conducting the great public works which are absolutely necessary for the preservation of the city. The lagunes are gradually filling up, and the houses falling into the canals, from the impossibility of renewing the piles on which they stand.... Should the present political influence continue, [Venice's] fate as a city would soon be decided: it would vanish from the view of its oppressors. Of this monument of a thousand years of glory not a wreck would remain; the waves of the Adriatic would close over the palaces of the Foscari and the Priuli; and the works of Sansovino and Palladio would sink into the lagunes, where they now already moulder in premature decay.[22]

Though the perception of Venice as a decaying city destined to sink into the waves was not what Lady Morgan had expected, it did provide a new and fascinating aesthetic experience:

Yet if the character of interest with which Venice was once visited is changed, its intensity is rather increased than lessened; and in a picturesque point of view, it never perhaps was more beautiful, or more striking, than at the present moment.[23]

Her enthusiasm about the city's mysterious and morbid beauty shows Lady Morgan to have been an adherent of the new image of Venice that was propagated a short time before by Lord Byron (1788–1824) in the fourth canto of *Childe Harold's Pilgrimage*, 1818. This fourth canto was

the most famous and influential writing on Venice in modern times ... Byron ... relished its physical decay and used vivid images to press home the nature of the fall: palaces were sinking to their waterlines, what was left of the Bucintoro was rotting and the golden horses were bridled. All these one-time marvels of the Venetian empire were now redolent of "fallen states and buried greatness".... The city's demise was, again, as much moral as physical. Venice was a perfect allegory

of decline, which could be sustained as a personal as well as a national admonition: "in the fall of Venice think of thine."[24]

Admirers of Lord Byron included the artist William Turner (1775–1851)[25] and the writer and art theoretician John Ruskin (1819–1900). In 1843, Ruskin published the first volume of *Modern Painters,*[26] in which he expressed his admiration of Turner.[27] In September 1845, Ruskin continued his studies for the second volume of *Modern Painters* during five weeks in Venice, which attracted him thanks to his interest in Turner.[28] In the letters he wrote to his father in England, he also reported on the inner state of the pre-revolutionary city sufferung under Austrian rule. Only two-and-one-half years later the events of March 1848, mentioned above, were to occur. After a fifteen-month siege (and some intense shelling) by Austrian troops under Field Marshal Radetzky, Venice was racked by cholera, famine, and war losses. After their victory the Austrians fitted

the outer forts with the heaviest artillery and set up a heavy battery opposite San Marco. They held the historic center of the Serenissima hostage and threatened to reduce the city to sea level at the slightest sign of unrest.[29]

In November 1849, Ruskin and his wife, Effie, were among the first to visit the war-torn city. The couple stayed at the Hotel Danieli while Ruskin worked tirelessly during the next four months on the first volume of *The Stones of Venice.* After the book was published, he and his wife returned to Venice for an eight-month stay from September 1851 to July 1852. The second and third volumes of *The Stones of Venice* were published in 1853.[30]

The years of preparation for Ruskin's epochal work must have demanded the *restless and skilful employment of all abilities and means, including, by the way, photography ... a*

Sisyphean labor in view of the transitoriness of the object and the attempt to draw and survey all of the Byzantine and Gothic buildings on the five square miles of the city on the lagoon: "stone by stone, to eat it all up into my mind, touch by touch."[31]

Ruskin was now unwilling to accord a function to the transfiguring activity of the imagination which he had admired in Byron's poetry as a young man. The Venice of the modern novel and drama literature belonged to yesterday, was a flower of decay, a stage dream that was dissipated in the first light of day. Thus the book that resulted from Ruskin's work in the city with its prosaic title *The Stones of Venice* provided no magnificent historical picture or architectural fantasy. The first volume covered the Venetian architectural language in purposely dry prose, the city itself not coming into full view until near the end, in a several-page approach like a camera pan beginning in Padua, in which Venice is described like an English industrial city, its landmark the campanile of a church, now a steam mill, converted into its chimney.[32]

This magical compendium advanced to become a cult book among many English artists, writers, and culturally interested readers. *The Stones of Venice* provided one of the theoretical and practical bases for the Gothic Revival and the Arts and Crafts Movement in the latter half of the century. The enthusiasm it sparked for Venice and the concomitant aesthetic revaluation of Venetian Gothic (accompanied by condemnation of the Renaissance and Palladio as one of its leading representatives) had, for Ruskin, moral and religious reasons:

Now Venice, as she was once the most religious, was in her fall the most corrupt, of European states; and as she was in her strength the centre of the pure currents of Christian architecture, so

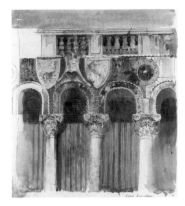

Fig. 3 John Ruskin, *Study of the Façade of Ca' Loredan,* 1845, pencil, ink, watercolor, and tempera, 32.4 × 26.7 cm, Ashmolean Museum, University of Oxford

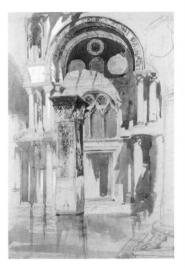

Fig. 4 John Ruskin, *Study of the Basilica of San Marco from the South,* 1846, pencil and watercolor, 42 × 28.6 cm, Ashmolean Museum, University of Oxford

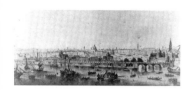

Fig. 5 Giuseppe Bertoja
and Gaspare Biondetti-Crovato,
*Project for the Railroad to the Giudecca
and San Giorgio Maggiore*, 1836,
lithograph, Biblioteca Marciana,
Venice

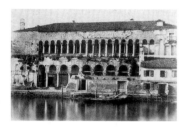

Fig. 6 Jakob August Lorent,
Fondaco dei Turchi, 1853,
albumen photograph, 36.7 × 47 cm,
state before the restoration,
Kunstakademiets Bibliotek,
Copenhagen

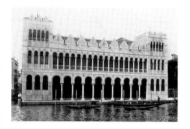

Fig. 7 Fondaco dei Turchi,
after the restoration, photograph

she is in her decline the source of the Renaissance… It is in Venice, therefore, and in Venice only, that effectual blows can be struck at this pestilent art of the Renaissance. Destroy its claims to administration there, and it can assert them nowhere else.[33]

The Stones of Venice remained Ruskin's most successful and influential work. Published in 1877 in an abridged version, the "Travellers' Edition," the book accompanied the continually growing number of tourists, artists, writers, and scholars from Europe and abroad on their trip to Venice. Thanks to Ruskin's influence, for many artists and writers "Byzantine" Venice was

more than an actual, lived place; it becomes a city in the mind and memory; indeed a city of the mind. This sense of Venice as a site of the imagination reaches its height in Proust, who was obsessed by the city, making it a central theme and motif in A la recherche du temps perdu *(1925). Though he did not see Venice for himself until 1900, Proust had experienced it in the writings of Ruskin, whom he revered and whose work he had translated…. For Proust, Venice was a crucible of beauty, sensuality, rapture, and, ultimately, disappointment, but she was chiefly experienced in anticipation and memory as part of his personal quest to reclaim lost time.*[34]

During his first sojourns, Ruskin was already a witness to the modernization processes that would have lasting effects on the historical, organic structure of the city. One of the most important infrastructural measures begun by the Austrian administration after decades of stagnation was the filling of canals, the repair of existing bridges, and the building of new ones at strategic points. In 1840, the first gas lanterns illuminated key *fondamente* and squares. On the Piazza San Marco there was a lantern under every arcade, which, to Ruskin's cha-

grin, destroyed the nocturnal charm of the square.

The most consequential city-planning incursion came in 1846 with the opening of the railway bridge connecting Venice with the mainland. For the city, the railway bridge entailed abandoning one of the key traits of its identity—its more than thousand years of splendid isolation. For the building of the first railway terminal in 1860 on the northwestern periphery, old building substance—including the Corpus Domini monastery and Santa Lucia church—had to be razed. The suggestion of some promoters to continue the rail line to the city center was rejected. Equally impractible was the project of a Zattere—Giudecca—Isola di San Giorgio Maggiore "panorama route" (with a terminal next to the Palladian church).

For Ruskin, however, the campaign to save ancient buildings that was growing concurrently was a source of vexation. He was extremely concerned that the restoration work was being conducted without theoretical foundation and historical knowledge. Ruskin was also alarmed by the fact that the restorers' lists included some of the city's most significant monuments: the Doge's Palace, the north façade of San Marco, and the Ca' d'Oro on the Canal Grande.

Now, although there is no pleasure in being in Venice, I must stay a week more than I intended, to get a few of the more precious details before they are lost forever,

he wrote to his father in September 1845.[35]

You cannot imagine what an unhappy day I spent yesterday before the Casa d'Oro, vainly attempting to draw it while the workmen were hammering it down before my face.[36]

One of Ruskin's most important allies in Venice was Alvise Zorzi, who in 1877 published

the essay *Osservazioni intorno ai ristauri interni ed esterni della Basilica di San Marco.*[37] Zorzi, who dedicated his groundbreaking essay to Ruskin (who had financed it), advocated a respectful and careful treatment (*conservare*) of the historical architectural heritage. He opposed a preservation of monuments (*ristorare*) which attempted to restore buildings to an imaginary original state and therefore risked the destruction of valuable building substance. For Zorzi and Ruskin, the "restoration" of the Fondaco dei Turchi, completed in about 1869, represented a prototypical example of an irresponsible and destructive treatment of existing historical buildings. When Zorzi's essay appeared, the same fate threatened the west façade of San Marco. For the first time, this sparked debates over the restoration of a Venetian monument that had international repercussions, which for a short time would overcloud Italian-British relations. The English Society for the Protection of Ancient Buildings was the first to address the subject in 1879. William Morris, one of the founders of the Arts and Crafts Movement, launched a press campaign and issued a petition that was signed by personalities like John Ruskin, Benjamin Disraeli, William Gladstone, and Robert Browning. Reactions from Italy were not long in coming: restorers and architects in Venice and the Ministry of Education in Rome accused the "sentimental" British of interfering in their internal affairs. Yet under the unabating local and international pressure, the Venetian authorities felt themselves compelled to postpone the restoration project.

The diverse and sometimes contradictory attempts to turn Venice into an "open-air museum" that annually attracted increasing numbers of tourists, should not blind us to the profound, irreversible, and accelerating trans-

formation process to which the city was subject from its incorporation into the Kingdom of Italy. In 1880, the new Stazione Marittima was inaugurated not far from the main station. At long last Venice had a harbor for large ships at its disposal, from which both tourism and the growing economy profited. During the same period, the large vacant areas on the western and northern periphery of the city were occupied by more and more factories and industrial plants. An industrial area emerged at the west end of the Giudecca in the space of only a few years. In 1896, at the extreme end of the Giudecca, the Molino Stucky was inaugurated, the largest and most modern grain mill in Italy, whose prominent location lastingly altered the city's skyline. With the burgeoning of the tourist industry, the traditional crafts—glassmaking in Murano and lacemaking in Burano—experienced a new heyday.

The first priority of urban planning measures during those years was to improve the flow of pedestrians and goods. For the first time since the Napoleonic period, broad swaths were cut through the historical building substance to make way for arrow-straight "pedestrian highways" (Lista di Spagna, Strada Nova, Calle Larga XXII Marzo). In 1881, with the *vaporetti* on the Grand Canal, Venice obtained its first public transportation. In 1905, the electrification of the city got underway. One important aim of the municipality was to correct the negative image of Venice—poor, dilapidated, neglected, foul smelling, dubious hygenic and sanitary conditions—by means of conspicuous urban planning measures. By razing slum buildings and blocks the authorities hoped to bring more sun and air into the lanes and squares, and a central hospital facility was built in Santi Giovanni e Paolo to ensure better health care for the public, including its poorer citizens.

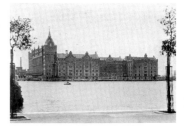

Fig. 8 Molino Stucky on the Giudecca, after 1900, photograph

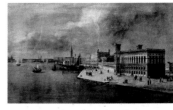

Fig. 9 Luigi Querena, *Project for a hotel by the architect Ludovico Cadorin for the Riva degli Schiavoni*, 1852, pencil, pen, and watercolor, Museo Correr, Venice

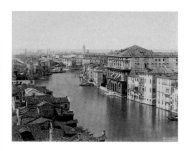

Fig. 10 Carlo Naya, *The Grand Canal,* *c.* 1875, albumen photograph, 18.7 × 24 cm, Herzog Collection, Basel

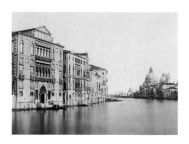

Fig. 11 Domenico Bresolin, *The Grand Canal with Santa Maria della Salute, c.* 1860, albumen photograph, 20 × 28 cm, Herzog Collection, Basel

The renaissance of Venice as a travel destination for a more demanding cosmopolitan clientele went hand in hand with improvements in the touristic infrastructure. Groups of investors and architects advocated the construction of new hotel complexes at prominent sites. Public and municipal opposition to these gigantic projects forced the tourism promoters to look for alternatives. One option with developmental potential was the thinly populated Lido. In 1857, Giovanni Busetto-Fisola opened a *stabilimento balneare,* a bathing establishment that would become the nucleus of one of the most significant changes in Venice in the late nineteenth century. The development of the Lido for tourism reached its first culmination around 1900, with the building of two luxury hotels. In July 1900, The Grand Hôtel des Bains celebrated its opening, followed by the Excelsior Palace Hotel in July 1908. This palace in the "Moorish-Venetian" style was enormous for the day (400 rooms) and furnished with prodigal opulence. The two grand hotels made the Lido one of the most fashionable bathing resorts in Italy. Venice was both: a mythical city of culture and an exclusive bathing resort. The Austrian writer Hermann Bahr summed up the situation by noting that, for him, sun, sand, and water were more important than "the dead city" of Venice, this "museum for ... instructors of art history."[38]

Three years after the opening of the Excelsior Palace, a crisis occurred that seriously threatened the city's reputation and, with it, the investments of hotel proprietors and financers. On May 23, 1911, the first victim of a cholera epidemic died. By the end of the year, 247 had contracted the disease, 88 of whom succumbed.[39] To counteract this negative publicity, the city and leading hoteliers started a Europe-wide "information campaign," which was financed with approximately 100,000 lire from a special fund. The relief was great when tourists began to flock back to Venice again in summer 1912. With the appearance in autumn 1912 of Thomas Mann's *Death in Venice,* the cholera epidemic found its way into world literature.[40]

In addition to the bourgeois vacation clientele, a further group of guests became important—writers and artists, art lovers and collectors from Paris, London, New York, and Boston, who formed the nucleus of a true "scene" of great attraction. These guests preferred residing in Venetian palazzos to hotels. Noble families rented or sold their palazzos at prices far below those for stately residences in the buyers' home countries. By acquiring one of these buildings, preferably on the Grand Canal, the new owners contributed to the maintenance of important architectural monuments. When Daniel and Ariana Curtis of Boston purchased the Palazzo Barbaro in 1881, Giambattista Tiepolo's famous ceiling painting for the dining room of the *piano nobile, La Gloria della famiglia Barbaro (Valore, Fama, Prudenza e Nobiltà)* (The Glorification of the Barbaro Family), *c.* 1750,[41] had been sold at auction in Paris seven years previously. Also unimaginable from today's point of view is the fact that Ca' Rezzonico, designed by Baldassare Longhena (now the seat of the Museo del Settecento Veneziano), one of the largest and most significant Baroque palaces on the Canal Grande, was used by several artists as a studio building around 1880. These included John Singer Sargent, who occupied a studio there during his Venice sojourn in 1880–81. In 1888, the artist Pen Browning acquired the palace and moved into the mezzanine with his wife, Fannie Coddington. The following year, the artist's father,

the renowned Victorian poet Robert Browning, died in the Ca' Rezzonico.

The prominent members of the Anglo-American community in Venice,[42] apart from the Curtises from Boston, included Katharine and Arthur Bronson of Newport, who acquired the Casa Alvisi near Santa Maria della Salute in 1876. In 1885, their circle was expanded when Henry and Enid Layard took up retirement residence in the Ca' Cappello on the Canal Grande, which they had bought back in 1874. Henry Layard, English diplomat, politician, author, and archaeologist, was known as the discoverer of Nimrod and Ninive. His significant collection of Italian Renaissance paintings, which from 1875 was accessible to art lovers in the Ca' Capello, passed in 1916 to the National Gallery in London.

The soirées at the Curtis, Bronson, and Layard residences belonged for more than two decades to the fixed points in the social and cultural life of the city. Artists and writers, musicians and dancers, critics and scholars from Europe and abroad rubbed shoulders with the international *haute volée*, exiled monarchs and princes, and the Venetian and Italian high nobility. Regular guests of these soirées were the artists John Singer Sargent and James McNeill Whistler, art writer John Ruskin, poet Robert Browning, American novelist and essayist Henry James, Italian theater diva Eleonora Duse (who rented the top floor of the Palazzo Barbaro-Wolkoff from 1894 to 1897), and the Venetian musician and composer Pier Adolfo Tirindelli. The hostesses "carefully balanced their dinners, and structured their evenings around reading, performances, studio exercises, and small-scale exhibitions."[43]

The Communauté Française in Venice gathered at the Palazzo Dario and Palazzo Contarini-Polignac, both on the lower third of the Canal Grande. The Palazzo Dario with its polychrome Early Renaissance façade was a family pension at the time it was acquired by the Comtesse Isabelle de la Baume-Pluvinel and her friend Augustine Bulteau. The Académicien Henri de Régnier (1864–1936), who stayed in Venice nine times between 1899 and 1924, was among the *habitués* in the Palazzo Dario.[44]

In 1894, the Palazzo Contarini dal Zaffo (then Palazzo Manzoni-Angaran) passed into the possession of Prince and Princess Edmond de Polignac. The prince, scion of one of the oldest French aristocratic lines, had married Winnaretta Singer, daughter of the wealthy American sewing machine factory owner, in 1893. Her patronage for the music of the period (from Gabriel Fauré, Emmanuel Chabrier, and Reynaldo Hahn, down to Erik Satie and Maurice Ravel) would prove propitious.[45] In 1903, Marcel Proust honored her exquisite taste in art by reporting, in his chronicle "Le Salon de la Princesse Edmond de Polignac" in *Le Figaro*, on "the loveliest Claude Monet I know: a field of tulips near Haarlem."[46] Five years later, Monet would depict the Palazzo Contarini-Polignac. It lay within sight of the Palazzo Barbaro-Curtis, where Monet spent the first days in Venice during his sojurn with his wife, Alice, in autumn 1908. At the same time, with his views of the Palazzo Dario, Monet immortalized the second culmination of French culture in Venice in the early twentieth century. The two motifs can be understood as Monet's homage to his French friends and patrons.

In view of this situation, it was no coincidence that not only Monet but almost all of the artists represented in this publication and exhibition visited Venice between 1880 and 1914. In 1874, Edouard Manet (once again) embodied the vanguard. In the early phase of the "Venice boom," Whistler lived there from

Fig. 12 Carlo Naya, *The Grand Canal*, *c.* 1870, albumen photograph, 26.7 × 35.2 cm, Herzog Collection, Basel

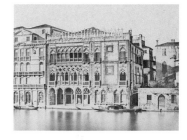

Fig. 13 Eugène Constant, *Ca' d'Oro*, *c.* 1855, calotype photograph, 16 × 21.5 cm, Herzog Collection, Basel

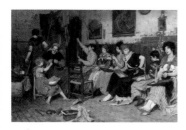

Fig. 14 Cecil van Haanen,
The Venetian Bead Stringers, 1876,
oil on panel, 64.8 × 94.5 cm,
courtesy of Christie's, London

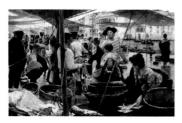

Fig. 15 Ettore Tito, *The Old Fishmarket*,
1893, oil on canvas, 131 × 200 cm,
Galleria Nazionale d'Arte Moderna,
Rome

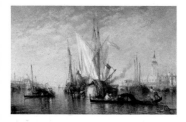

Fig. 16 Félix Ziem, *Venice: The Bacino
di San Marco with Fishing Boats,
c.* 1865, oil on canvas, 99.5 × 150.6 cm,
Trustees of the Wallace Collection,
London

September 1879 to November 1880; Pierre-Auguste Renoir stopped over in Venice in 1881 during his Grand Tour. Anders Zorn spent a month in autumn 1894 in the city on the lagoon, followed in the early twentieth century by Odilon Redon (1900 and 1908) and Paul Signac (1904 and 1908). The series of visitors was rounded off in autumn 1908 by Claude Monet. The only artist in this publication and exhibition for whom Venice became a kind of second home was John Singer Sargent, who, after a visit in 1880–81 and 1882, spent almost every summer there from 1898 to 1913.

In the late nineteenth century, Venice offered foreign artists

a way of life that was congenial, convivial, and relatively inexpensive; and it is apparent that a part of her appeal was an international artistic camaraderie. The American artist and illustrator Francis Hopkinson Smith (1838–1915) noted that the artists "all had a corner at Florian's. No matter what their nationality or speciality, they speak the common language of the brush."[47]

A favorite subject of this cosmopolitan group was everyday Venetian life, artfully arranged scenes from the lives of ordinary people, the *popolani*—young Friuli water girls, poor *gondolieri*, fishermen on the lagoon, street vendors, and beggar women—some in an academic, naturalistic style, others in an academic, Impressionist one. The artists working in Venice showed their paintings at all the important exhibitions in Europe and overseas. The Austrian Cecil van Haanen (1844–1914), for instance, was represented at the 1876 Paris Salon with the painting *Venetian Bead Stringers.* The success of van Haanen's genre picture contributed a great deal to popularizing this subject among both painters and photographers, and John Singer Sargent took it up only a few years later (p. 130 bottom).

The enthusiasm of the international art world for popular scenes from "picturesque" and "exotic" Venice led—after decades of stagnation—to a revival of local art as well. Painters such as Giacomo Favretto (1849–1887), Luigi Nono (1850–1918), and Ettore Tito (1859–1941) were among the leading Venetian "painters of modern life," who found their (often sentimental) subjects among the "Venezia povera e proletaria."

For the first time since the *settecento,* collectors and art lovers began to show an active interest in topographical views of the city and the lagoon:

The imagery of the city, distilled through the work of the Romantics and their successors, was a source of irresistible fascination to a wide public, as it always had been. If the city was less idealized and more domesticated by this later generation of artists, it was not made stale by familiarity. Views of the city continued to be highly marketable. Because Venice had inspired such a wealth of books and pictures, it was deeply embedded in the cultural consciousness of Europe and carried the weight of association and memory.[48]

Already by the turn of the century, this "wealth of books and pictures" had resulted in a trivialization of the image of the city that, for an artist like Monet, provided a reason to avoid Venice for a long time. As his friend Octave Mirbeau wrote in 1912:

I remember Claude Monet saying "Venice . . . no . . . I'm not going to Venice. . . ." It was understood that Claude Monet did not want to visit Venice, the city that is a city no more, but mere decoration or a motif. Claude Monet didn't dare. He felt he was strong enough to paint country scenes and townscapes. But to take on Venice, that would mean having to measure oneself against all human foolishness, which goes towards making up the image we have of Venice.[49]

The number of artists who made a name for themselves as painters of views in the late nineteenth century was considerable. There were Venetian painters such as Guglielmo Ciardi (1842–1917) and Alessandro Milesi (1856–1945), and there were foreign artists, some of whom settled in Venice, and then the many others who returned to Venice for a few weeks every year to hunt for original subjects. Yet most contemporaries of Whistler, Renoir, and Monet agreed that the French artist Félix Ziem (1821–1911), the "old magical painter of the East,"[50] was the master of Venetian *veduta* painting. Edmond and Jules de Goncourt also praised Ziem's views of Venice with their "waters tinted with pink, blue, and a tender green," and their "teeming mass of palaces, forests of domes, bell-towers, and countless turrets enveloped in haze."[51]

Even Gustave Geffroy, a close friend and biographer of Monet, could not avoid seeing a link between Monet's Venice pictures and the views of Canaletto, Guardi, and Ziem. In a review of Monet's 1912 show at the Galerie Bernheim-Jeune in Paris, Geffroy wrote:

Then [Monet] went to Venice and his works gained a new expression, as can be clearly seen, with a splendor so marvelous, a precision so pretty and so picturesque, even in his paintings of Venice itself, as ever seen in works by Carpaccio right up to Canaletto and Guardi, and sometimes by Ziem, filled with a flaming inspiration.[52]

A new chapter in the media-conveyed image of the city on the lagoon and its inhabitants was opened by the triumph of photography, which made itself felt from around 1850 in Venice. In the early days of this mass medium,

travel photographers, particularly from France, England, and Germany, visited the city ... The photographers usually oriented themselves to those vantage points and motifs they knew from views in paintings and prints. A few of them, such as Domenico Bresolin, Giuseppe Coen, Michele Kier, and Antonio Sorgato, were themselves active as painters or lithographers before they turned to photography.[53]

From the 1870s and '80s, the production and international dissemination of views of Venice was a profitable business. The "star photographers" of the younger generation, including Carlo Ponti (1820–93) and Carlo Naya (1816–82), offered their considerable photographic production in specialized shops at the best tourist locations (Piazza San Marco, Riva degli Schiavoni), in individual prints, and impressive *Souvenir de Venise* albums. The successes of their painter-colleagues with Venetian genre scenes at London and Paris exhibitions encouraged photographers' attempts to capture the everyday life of the *popolani*. Pictures of popular life were in great demand, resulting in innumerable records of the living and working conditions in the suburban quarters inhabited by the poorer groups of the population.

[The photographers] grouped types of people together and took considerable interest in the popolani. *These studies also gave an opportunity for figure-in-landscape compositions, such as Carlo Naya's fishermen from the islands of Pellestrina, Chioggia and Burano. Naya began his records with the poor people of Naples before making a systematic album of Venetian types entitled* L'Italie pittoresque: scènes et costumes pris d'après nature.[54]

As a remark by the photographer and art book dealer Ferdinando Ongania (1842–1911) indicates, he was quite aware of the limitations of "realism" in photographing Venetian everyday life. Ongania suggests:

that he too was alert to the perils of cliché and pastiche in representing a place about which so much

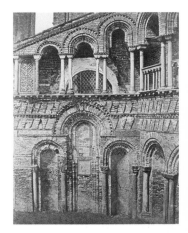

Fig. 17 Domenico Bresolin, *Basilica Santa Maria e Donato, Murano*, detail, *c.* 1851/54, calotype photograph, 34.9 × 27.4 cm, Herzog Collection, Basel

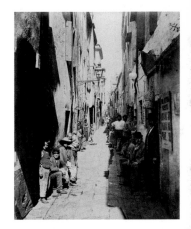

Fig. 18 Paolo Salviati, *Calle dell'Olio in San Francesco, c.* 1885, albumen photograph, 25 × 19.4 cm, Herzog Collection, Basel

has been written and of which so many images had been made: "Thus, paintings, poems, romances, and alas! many histories have combined to create a purely conventional Venice."[55]

With the opening of the first Biennale d'Arte[56] in the Giardini Pubblici in early summer 1895, Venice was enriched by a glamorous, image-enhancing facet. The ancient city with its superabundance of culture could now pride itself on providing a platform for contemporary art:

Given the historical weight it increasingly bore, and the increasing number of voices attuned to the defence of the old Venice, it may have appeared an unlikely venue for modern art. Yet the ambitions of Venice as a city of art were confirmed in the creation of the Biennale d'Arte… The international emphasis was deliberate and productive, reflecting the ambition to make the exhibition an international event. In this way it diverged significantly from previous national expositions, although Italian and Venetian art were well represented. Mayor Riccardo Selvatico was the first president: from the beginning the conjunction of roles involved the city and its government at the highest level, which has contributed to the Biennale's survival.[57]

The first Biennale was already a great success. The more than 220,000 visitors to the international review of contemporary art (516 works by 285 artists) saw, among others, paintings by the English Pre-Raphaelites Edward Burne-Jones, John Everett Millais, and Holman Hunt, and by the French Symbolists Puvis de Chavannes and Odilon Redon. America was represented by Whistler, Germany by Franz von Stuck and Franz von Lenbach. A total of twelve prizes were awarded, the Prize of the City of Venice going to Ettore Tito for his painting *Autunno*. The Biennale "did much to boost Venetian art and artists, and to

prompt foreign artists to take up Venetian subjects."[58]

For decades the Venice Biennale would be a showcase for artists of the international *"juste milieu* (moderately progressive rather than avant-garde)."[59] The patronage committee list of the second Biennale of 1897 reads like a "Who's Who" of established and successful contemporary artists: from America, Sargent and Whistler; from Germany, Begas, Klinger, Lenbach, Liebermann, and Uhde; from England, Alma-Tadema, Burne-Jones, and Millais; from France, Carolus-Duran, Henner, Moreau, and Puvis de Chavannes; from Austria-Hungary, Munkácsy, Passini, and van Haanen; from Russia, Repin; from Sweden, Zorn; from Switzerland, Böcklin; from Spain, Pradilla and Sorolla.

In addition to the "official" artists invited to the Biennales, from early on there were others who, uninvited, exploited the social and media attention they found in Venice for their own ends. These included the Futurists, who staged their first "performance" in Venice on the afternoon of July 8, 1910. From the Torre dell'Orologio on St. Mark's Square their theoretician and spokesman, the poet Filippo Tommaso Marinetti (1876–1944), regaled passersby with hundreds of flyers containing the manifesto *Contro Venezia passatista*.[60] Marinetti recited the manifesto as well—with the aid of a megaphone and accompanied by a trumpeter. As far as the Futurists were concerned, the recent history of Venice was an error that must be corrected. Venice had become a kitschy open-air museum for the amusement of tourists from around the world; its inhabitants mere shopkeepers out to fleece the foreigners. This backward-looking Venice (*Venezia passatista*) no longer had a *raison d'être*, declared the Futurists. Venice would do well to return to

the values that had made the republic unique and invincible: enterprise and military superiority. To accomplish this, Venice would have to undergo a fundamental economic, social, and urban renewal. In their manifesto and, in particular, at an event at La Fenice, the Futurists projected a vision of a modern Venice, on whose filled canals automobiles and tramways would run, whose waterways would be spanned by numerous steel bridges, and where great parts of the populace would find work in factories.

A favorite target of Futurist attacks in Venice were the protagonists of Symbolist *fin-de-siècle* aesthetics, who with great journalistic success had recently succeeded in propagating a late Romantic, morbid image of Venice. For these *littérateurs* and artists, Venice could not be dying or deteriorating enough. From the 1890s onward, they had made Venice (alongside Bruges and Toledo)[61] one of their preferred places of pilgrimage. Richard Wagner, who in 1858 had composed the second act of *Tristan and Isolde* in Venice and died twenty-five years later, on February 13, 1883, at Palazzo Vendramin-Calergi, was one of their idols, whose genius shone like a fixed star over these dandies in search of redemption. For them, the painter of Venice was Guardi, whose spirit they acutely rediscovered at the turn of the century in artists like Whistler and Monet. In the eyes of the late-Romantic *décadents,* Guardi's late views, with their tendency to monochromy and melancholy mood, were elegiac and prophetic allegories of ruin and decay.[62]

The literary representatives of decadence in Venice most hated by the Futurists were Gabriele D'Annunzio (1863–1938) and Maurice Barrès (1862–1923). Barrès had published *Amori et dolori sacrum. La Mort de Venise* in Paris in 1903.[63] Three years previously, D'Annunzio had published the scandalous novel *Il Fuoco.*[64]

Venice figured there as the site of an (erotic) love story in which contemporaries had no trouble recognizing a literary version of the author's love for Eleonora Duse. For the Futurists, D'Annunzio and Barrès were bards of putrefaction whose descriptions of lonely and enchanted spots on the lagoon were "diseased literature and all that romantic embroidery draped over them by poets poisoned with the Venetian fever."[65]

With their Venice manifesto, the Futurists succeeded in consolidating their image of "ruthless" modernists. On one essential point, however, they were fighting a sham battle: the salvation-hungry *fin-de-siècle* aesthetic had outlived itself by 1910. Four years before the outbreak of the First World War, its former heralds, Barrès and D'Annunzio, belonged to the apologists of a "nationalist cult of the soil and death."[66] Barrès's "new Venice" was the Lorraine, his homeland, occupied by imperial Germany.[67] D'Annunzio, a much-decorated war hero, reinvented himself after the war as a Venetian *condottiere,* occupied parts of the Dalmatian coast with partisans, and declared the Republic of Fiume with himself as commandante. For D'Annunzio, the Republic of Fiume was the point of departure for a restoration of the empire over which the Serenissima had ruled. The Futurists' nationalistic and militaristic rhetoric fell on fertile soil with D'Annunzio—as it did at the same period with his comrade and later rival, Benito Mussolini.

However, a further Futurist prophecy was not fulfilled in the way they had hoped: twentieth-century industrialization did not drive the tourists out of Venice. On the contrary, for several decades now both burgeoning mass tourism and the industrial zone that has continually expanded along the lagoon in Marghera and Mestre since the 1920s, gravely

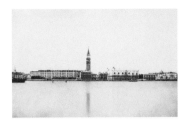

Fig. 19 Léon Gérard, *The Moorings Seen from the Giudecca,* 1854, calotype photograph, 22.5 × 35.4 cm, Herzog Collection, Basel

Fig. 20 Anon., *Isola San Giovanni, c.* 1870, albumen photograph, 19.1 × 25.7 cm, Herzog Collection, Basel

Fig. 21 Elsa Gold-Lutz, *Gondola, c.* 1920, colored carbon print, 18.5 × 28 cm, Herzog Collection, Basel

threaten the equilibrium of a city that, in the eyes of some urban and culture sociologists, has degenerated into a sort of historical Disneyland.[68]

For most representatives of the twentieth-century European and American avant-gardes, Venice had ceased to be a serious subject for art. This is best evinced by paintings done in Venice by some of the renowned representatives of (moderate) modernism: Giorgio de Chirico, Raoul Dufy, Oskar Kokoschka, Albert Marquet, and others. They contributed little to the history of the image of Venice. Seen in this light, the elegiac paintings of Venice exhibited by Monet in 1912 at the Galerie Bernheim-Jeune in Paris represented the last, late culmination of a unique history which began with Canaletto and Guardi.

[1] On the history and cultural history of Venice, see *Venezia! Kunst aus venezianischen Palästen: Sammlungsgeschichte Venedigs vom 13. bis 19. Jahrhundert,* exh. cat. Kunst- und Ausstellungshalle der Bundesrepublik Deutschland (Bonn, 2002); Alessandro Bettagno, ed., *Venezia da Stato a mito,* exh. cat. Fondazione Giorgio Cini (Venice, 1997); Manfred Hellmann, *Gründzüge der Geschichte Venedigs* (Darmstadt, 1976); Deborah Howard, *The Architectural History of Venice* (New Haven/ London, 2002); Frederic C. Lane, *Venice: A Maritime Republic* (Baltimore/London, 1973); John Julius Norwich, *A History of Venice* (London, 1982); Gerhard Rösch, *Venedig: Geschichte einer Seerepublik* (Stuttgart, 2000); Giandomenico Romanelli, ed., *Venedig: Kunst & Architektur,* 2 vols. (Cologne, 1997); Vittore Branca, ed., *Storia della civiltà veneziana,* 3 vols. (Florence, 1979); Girolamo Arnaldi and Manlio Pastore Stocchi, eds., *Storia della cultura veneta,* 10 vols. (Vicenza, 1976–86); *Storia di Venezia dalle origini alla caduta della Serenissima,* I–VIII (Rome, 1991–98); Alvise Zorzi, *La Repubblica del Leone: Storia di Venezia* (Milan, 1979).

[2] See *Venise et l'Orient /Venice and the Islamic World, 828–1797,* exh. cat. Institut du Monde Arabe, Paris; Metropolitan Museum of Art, New York; Palazzo Ducale, Venice (2006–07).

[3] Donato Giannotti, *Libro dela Republica de' Vinitiani* (Rome, 1540); see also Eduard Hüttinger, "Venezia come mito," in Bettagno 1997 (see note 1), p. 14.

[4] Philippe de Commynes, *Mémoires,* vol. III, Joseph Calmette, ed. (Paris, 1925), p. 110.

[5] Ekkehard Eickhoff, *Venedig: Spätes Feuerwerk. Glanz und Untergang der Republik 1700–1797* (Stuttgart, 2006), p. 55.

[6] *Storia della civiltà veneziana* (see note 1); Paola Lanaro, ed., *At the Centre of the Old World: Trade and Manufacturing in Venice and on the Venetian Mainland, 1400–1800* (Toronto, 2006).

[7] Joseph Addison, *Remarks on Several Parts of Italy, &c. in the Years, 1701, 1702, 1703,* (London, 1753), pp. 58–59, 62.

[8] On the history and cultural history of Venice in the eighteenth century (supplementing note 1); see *The Glory of Venice: Art in the Eighteenth Century,* exh. cat. Royal Academy of Arts (London, 1994); National Gallery of Art (Washington, 1995); Eickhoff 2006 (see note 5).

[9] *Grand Tour: The Lure of Italy in the Eighteenth Century,* exh. cat. Tate Gallery (London, 1996); Jeremy Black, *The British Abroad: The Grand Tour in the Eighteenth Century* (Stroud, 1992); John Eglin, *Venice Transfigured: The Myth of Venice in British Culture, 1660–1797* (New York, 2001); Bruce Redford, *Venice and the Grand Tour* (New Haven/London, 1996).

[10] Addison 1753 (see note 7), p. 59.

[11] Eickhoff 2006 (see note 5), p. 19.

[12] Giovanni Scarabello, *Meretrices: Storia della prostituzione a Venezia tra il XIII e il XVIII secolo* (Venice, 2006).

[13] On view painting in Venice in the eighteenth century, see Filippo Pedrocco, *Il Settecento a Venezia: I Vedutisti* (Milan, 2001).

[14] Alessandro Marchesini (1725), quoted in Francis Haskell, *Patrons and Painters: A Study in the Relations between Italian Art and Society in the Age of Baroque* (New Haven/London, 1980), pp. 227–28.

[15] Charles de Brosses, letter to M. de Blancey, November 24, 1739, in Charles de Brosses, *L'Italie il y a cent ans ou lettres écrites d'Italie à quelques amis en 1739 et 1740,* R. Colomb, ed., vol. I, letter XXX (Paris, 1836), p. 380.

[16] Hester Lynch Piozzi (1785), quoted in exh. cat. *Canaletto Paintings & Drawings,* The Queen's Gallery (London, 1981), pp. 23–24.

[17] Elaine Kilmurray and Elizabeth Oustinoff, "A Topographical Love Affair," in Warren Adelson, ed., *Sargent's Venice* (New Haven/London, 2006), p. 16.

[18] See Cornelia Friedrichs, *Francesco Guardi: Venezianische Feste und Zeremonien. Die Inszenierung der Republik in Festen und Bildern* (Berlin, 2006).

[19] On the history and cultural history of Venice from 1797, see e.g. Donatella Calabi, ed., *Dopo la Serenissima: Società, amministrazione e cultura nell'Ottocento veneto* (Venice, 2001); Giuseppina Dal Canton, "Pittori stranieri a Venezia nell'Ottocento: dalla veduta alla visione, dall 'impressionismo al simbolo," in *Venezia arti,* 15/16 (2005), pp. 113–30; Giovanni Distefano and Giannantonio Paladini, *Storia di Venezia, 1797–1997,* 3 vols. (Venice, 1996–97); John Julius Norwich, *Paradise of Cities: Venice in the 19th Century* (New York, 2004); Margaret Plant, *Venice: Fragile City, 1797–1997* (New Haven/London, 2002); Giandomenico Romanelli, *Venezia Ottocento: L'architettura. L'urbanistica* (Venice, 1998); Alvise Zorzi, *Venezia scomparsa,* 2 vols. (Milan, 1972).

[20] In 1790, Venice had a population of 140,000; by 1820 it had shrunk to 100,000. Today Venice has approx. 60,000 inhabitants and receives approx. 14 million tourists annually.

[21] Lady Sydney Morgan, *Italy* (London, 1821), vol. II, pp. 473–76.

[22] Ibid. On Venice under Austrian rule, see David Laven, *Venice and Venetia under the Habsburgs, 1815–1835* (Oxford, 2002); Alvise Zorzi, *Venezia austriaca* (Bari, 1985).

[23] Morgan 1821 (see note 21), pp. 451–52.

[24] Plant 2002 (see note 19), pp. 89–90.

[25] On Turner and Byron, see the essay by Ian Warrell in the present catalogue.

[26] [John Ruskin], *Modern Painters: their Superiority in the art of landscape painting to all the ancient masters proved by examples of the true, the beautiful, and the intellectual, from the works of modern artists, especially from those of J. M. W. Turner, Esq. R.A.* (London, 1843). The work was published anonymously (as was the third edition of 1846), the author being given as "a graduate of Oxford."

[27] On Ruskin and Turner, see *Ruskin, Turner and the Pre-Raphaelites,* exh. cat. Tate Britain (London, 2000). Ruskin's admiration for Turner in *Modern Painters* goes hand in hand with devastating verdicts on earlier artists, such as Canaletto: "The mannerism of Canaletto is the most degrading that I know in the whole range of art. Professing the most servile and mindless imitation, it imitates nothing but the blackness of the shadows...Canaletto possesses no virtue except

that of dexterous imitation of commonplace light and shade...."
([John Ruskin], *Modern Painters*, third revised and updated edition
(London, 1846), p. 109 f. In the first edition, published in 1843, these
comments do not appear. Ruskin's verdict of Canaletto is much
milder).

28 On Ruskin and Venice, see Jeanne Clegg, *Ruskin and Venice* (London, 1981); Wolfgang Kemp, *John Ruskin 1819–1900: Leben und Werk* (Munich, 1983); Sergio Perosa, ed., *Ruskin e Venezia: La bellezza in declino* (Florence, 2001).

29 Wolfgang Kemp, "Epilogue," in John und Effie Ruskin: *Briefe aus Venedig* (Stuttgart, 1995), p. 110.

30 John Ruskin, *The Stones of Venice*, 3 vols. (London, 1851–53).

31 Kemp 1995 (see note 29), p. 111; Ruskin in a letter to his father of June 2, 1852.

32 Kemp 1995 (see note 29), pp. 112–13.

33 John Ruskin, *The Stones of Venice* (Orpington, 1886), (4th ed.), vol. 1, pp. 24–25.

34 Kilmurray and Oustinoff 2006 (see note 17), pp. 17–18.

35 John Ruskin in a letter to his father of September 11, 1845, in Harold I. Shapiro, ed., *Ruskin in Italy: Letters to His Parents 1845* (Oxford, 1972), p. 200.

36 Shapiro (see note 35), p. 209; Ruskin in a letter to his father of September 23, 1845.

37 Alvise Zorzi, *Osservazioni intorno ai restauri interni ed esterni della Basilica di San Marco* (Venice, 1877).

38 Hermann Bahr, "Lido," *Neue Freie Presse* (Vienna), August 19, 1909; quoted in Reinhard Pabst, *Thomas Mann in Venedig: Eine Spurensuche* (Frankfurt am Main/Leipzig, 2004), p. 89.

39 See Thomas Rütten, "Die Cholera und Thomas Manns *Der Tod in Venedig*," in Thomas Sprecher, ed., *Liebe und Tod in Venedig und anderswo. Die Davoser Literaturtage 2004*, Thomas-Mann-Studien, vol. XXXIII (Frankfurt am Main, 2005), pp. 143, 163.

40 Thomas Mann, *Der Tod in Venedig*, Munich, 1912. Mann, who felt "more or less at home in the seductively death-allied city, the romantic city par excellence" [Thomas Mann, in his speech "Lübeck als geistige Lebensform," held on June 5, 1926 and published in Thomas Mann, *Über mich selbst. Autobiographische Schriften*, edited by Peter de Mendelssohn (Frankfurt, 1983), p. 44], had come precariously close to the epidemic when he resided with his wife, Katia, and brother, Heinrich, at the Grand Hôtel des Bains from May 24 to June 2, 1911. On the dating of this stay, see Rütten 2005 (note 39), pp. 130–35.

41 Tiepolo's ceiling fresco is now in The Metropolitan Museum of Art, New York.

42 On the Anglo-American community in Venice in the late nineteenth century, see Elizabeth Anne McCauley, Alan Chong, Rosella Mamoli Zorzi, and Richard Lingner, eds., *Gondola Days: Isabella Stewart Gardner and the Palazzo Barbaro Circle,* exh. cat. Isabella Stewart Gardner Museum (Boston, 2004); Adelson 2006 (see note 17); Norwich 2004 (see note 19).

43 Alan Chong, introduction "Romance and Art and History," exh. cat. (Boston, 2004), p. XIII–XIV.

44 In 1928, de Régnier published a volume of memoirs under the title *L'Altana ou la vie vénitienne, 1889–1924,* containing insouciant and detailed descriptions of everyday Venetian life; see the reprint, Henri de Régnier, *La vie vénitienne* (Paris, 1986).

45 See Michael de Cossart, *The Food of Love: Princesse Edmond de Polignac (1865–1943) and her Salon* (London, 1978).

46 Marcel Proust, "Le Salon de la Princesse Edmond de Polignac," *Le Figaro,* September 6, 1903; repr. in Proust, *Contre Sainte-Beuve, précédé de Pastiches et mélanges et suivi de Essais et articles* (Paris,

1971), p. 468. Monet's painting *Un champ de tulipes près de Haarlem,* 1886, is now in the collection of the Musée d'Orsay, Paris.

47 Kilmurray and Oustinoff 2006 (see note 17), p. 23. On Caffè Florian as meeting place of foreign artists, see also de Régnier 1986 (see note 44), p. 98 ff.

48 Richard Ormond and Elaine Kilmurray, *John Singer Sargent: Figures and Landscapes 1874–1882, Complete Paintings,* vol. IV (New Haven/London), 2006, p. 315.

49 Octave Mirbeau, "Préface," in *Claude Monet: "Venise,"* exh. cat. Galerie Bernheim-Jeune (Paris, 1912), n.p., repr. in Philippe Piguet, *Monet et Venise* (Paris, 1986), p. 112.

50 Maurice Barrès, *Du sang, de la volupté et de la mort,* in Barrès, *Romans et voyages* [vol. 1], Vital Rambaud, ed. (Paris, 1994), p. 474 (quoted in one of the notes that Barrès added to the text of the first edition, published in Paris in 1894, as a result of subsequent new editions). On Ziem, see Gérard Fabre, *Félix Ziem: De la Méditerranée à l'Orient. Le reflet d'une passion* (Marseilles, 2004).

51 Edmond and Jules de Goncourt, *Etudes d'art. Le salon de 1852. La peinture à l'exposition de 1855* (Paris [1893]), p. 35.

52 Gustave Geffroy (1912), quoted in Piguet 1986 (see note 49), p. 115.

53 Dorothea Ritter, *Venedig in historischen Photographien 1841–1920* (Munich, 1994), p. 27. On Domenico Bresolin, see Dorothea Ritter, *Venedig in frühen Photographien von Domenico Bresolin "Pittore Fotografo",* Sammlung Siegert (Heidelberg, 1996).

54 Plant 2002 (see note 19), p. 181.

55 Kilmurray and Oustinoff 2006 (see note 17), p. 23.

56 On the history of the Biennale d'Arte, see Enzo Di Martino, *Storia della Biennale di Venezia, 1895–2003* (Venice, 2003).

57 Plant 2002 (see note 19), pp. 215–17.

58 Ibid., p. 219.

59 Kilmurray and Oustinoff 2006 (see note 17), p. 25.

60 *Contro Venezia passatista,* repr. in Maria Drudi Gambillo and Teresa Fiori, *Archivi del Futurismo,* vol. 1, (Rome, 1958), pp. 19–20.

61 On Bruges as a cult city of *fin-de-siècle* writers and artists, see Dominique Marechal, "'Verging nicht diese Stadt?'—Brügge als Treffpunkt europäischer Symbolisten," in *Der Kuss der Sphinx: Symbolismus in Belgien,* exh. cat. BA-CA Kunstforum (Vienna, 2007–08), pp. 31–43. The culmination of the Toledo cult is described in Maurice Barrès, *Greco ou le secret de Tolède,* that was published between Oct. 30 and Nov. 27, 1909, in the *Revue bleue*.

62 The *décadents*' view of Guardi still forms the "subtext" of art-historical interpretations today; see e.g. Hüttinger 1997 (see note 3), p. 15, and Plant 2002 (see note 19), p. 15.

63 Maurice Barrès, *Amori et dolori sacrum. La mort de Venise* (Paris, [1903]).

64 Gabriele D'Annunzio, *Il Fuoco* (Milan, 1900). On D'Annunzio, see Annamaria Andreoli, ed., *D'Annunzio (1863–1938),* exh. cat. Musée d'Orsay (Paris, 2001).

65 Gambillo and Fiori 1958 (see note 60), pp. 22.

66 Vital Rambaud, "Introduction [to *Amori et dolori sacrum*]," in Maurice Barrès, *Romans et voyages,* Vital Rambaud, ed. (Paris, 1994), vol. II, p. 9.

67 Maurice Barrès, in *Amori et dolori sacrum* (see note 66, p. 103): "More than anything else in the world I thought I liked the Musée de Trocadéro, the marshes at Aigues-Mortes, Ravenna, and Venice, the countryside around Toledo and Sparta, but above all these famous, desolate places I now prefer the modest cemetery in Lorraine, where I can let my mind, in all is profundity, stretch out before me."

68 See e.g. Robert C. Davis and Garry R. Marvin, *Venice: The Tourist Maze. A Cultural Critique of the World's Most Touristed City* (Berkeley, 2004); Thomas Krämer-Badoni, *Vivere a Venezia* (Treviso, 2005).

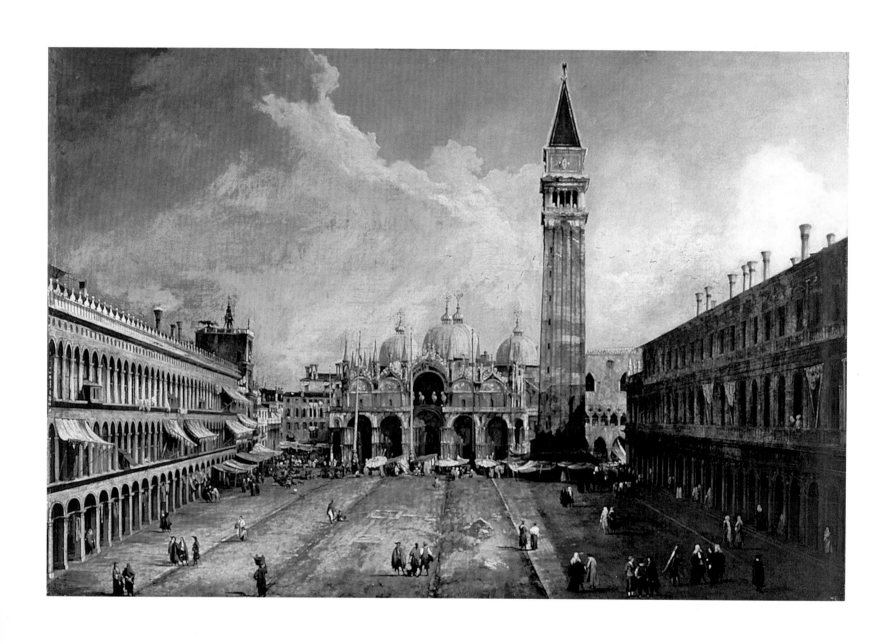

Canaletto, *Piazza San Marco*, 1723/24
Museo Thyssen-Bornemisza, Madrid

THE VENETIAN VEDUTA
CANALETTO AND GUARDI

Bożena Anna Kowalczyk

As for Canaletto, his craft is to paint scenes of Venice; in this genre, he surpasses everything I have ever seen. His style is clear, light-hearted, vivacious; his perspectives and eye for detail wonderful.

This is how the French writer Charles de Brosses aptly summed up the contemporary painting of Giovanni Antonio Canal, generally known as Canaletto (1697–1768), in a letter written on November 24, 1739.[1] The fascinating style adopted by the artist from around 1730 onward that suggests the most attractive aspects of a city like no other—the exquisiteness of the architecture, the spectacle of state festivals, the peculiar elements of everyday Venetian life, and an ideal, serene luminosity—was the stuff of dreams for those who had left Venice or those who had not yet seen it.

It is now a fortnight since I have had the pleasure of hearing from your ladyship, but I have (in imagination) attended you to the Doge's Palace in Venice, the front of which I am acquainted and charmed with, from a large picture that Sir Hugh Smithson has of it, painted by Canaletti. . . .[2]

writes Lady Frances Hertford to Lady Henrietta Louisa Pomfret on June 31, 1741 from her country house in Buckinghamshire. Similarly, the writer and art critic William Beckford of Fonthill Splendens, Wiltshire, was familiar with the same "marvelously detailed" manner before, in 1780, he embarked on a trip to the Continent at the age of twenty, as were the other British tourists at the end of the century and in successive decades, who constructed their image of the city from *vedute* of Venice by (or thought to be by) Canaletto, and which were a fundamental part of the myth of Venice in the eighteenth century:

I have no terms to describe the variety of pillars, of pediments, of moldings, and cornices, some Grecian, some Saracenic, that adorn these edifices, as the pencil of Canaletti conveys so perfect

an idea as to render all verbal description superfluous.[3]

It is not known which paintings the eccentric writer was referring to, but two *vedute* by Canaletto, perhaps executed contemporaneously with De Brosses's trip to Venice, were in his collection.[4] Later, in 1795, Beckford would have the good fortune to acquire a masterpiece, *The Riva degli Schiavoni, looking West*, of 1735, which in 1807 passed into the collection of the architect to whom he had entrusted the construction of his picture gallery, Sir John Soane[5] (fig. 1). Of all the Venetian *vedute* known in English collections, it was the Canaletto most familiar to Turner. He saw it at Fonthill two decades before his journey to Venice in 1819, and then at Soane's house-cum-museum in Lincoln's Inn Fields in London.

The greatest English landscape artist could not fail to admire the superb quality and naturalness of light in the Beckford/Soane painting, the transparent luminosity on the shore, the shadows (dark or *sfumato*) reflected in the limpid water of the Bacino di San Marco that enveloped the Punta della Dogana, the island of San Giorgio, and the sailing ships in the foreground. Here, Canaletto exhibits his best interpretative skills, the delicacy in the minute portrayal of the architecture (which he contrasts with the broad, rough, descriptive brushstrokes of the unfurled sails) and the rendering of the atmosphere into a monumental composition. In the eyes of Turner, the painting was the most fascinating representation of the past splendor of Venice, which the poet Lord Byron evoked in his works. The Venetian landscape artist was Turner's benchmark when later, from 1833 onward, he composed a series of paintings that were imbued with the same sense of grandeur as well as with a Romantic notion of history and atmosphere.[6]

Fig. 1 Canaletto, *The Riva degli Schiavoni, looking West, c.* 1735, oil on canvas, 126.2 × 204.6 cm, Sir John Soane's Museum, London

Canaletto's expansive, modern, and attractive work was principally an iconographical storehouse. In Venice, for later local painters, from Giuseppe Bison to Francesco Zanin—with the exception of Ippolito Caffi, the most innovative—it was a repertoire to be perpetuated. For Turner, as for other English landscape artists, *vedutisti*, and watercolorists of the first decades of the nineteenth century, Canaletto was the lens through which they saw Venice, and his compositions, also known from the prints of Antonio Visentini and Giambattista Brustolon, were an indispensable starting point. Jules-Romain Joyant became the "French Canaletto," known for his familiarity with British culture and his encounter with the English Romantic landscape painter Richard Parkes Bonington.[7] The Romantic myth of decadent Venice—with its air of sadness over everything—was nourished in France by Chateaubriand, and preparing for a trip to Venice—"an indispensable experience for all artists"—meant looking at pictures by Canaletto, Bonington, Joyant, and William Wyld, as Théophile Gautier commented in *Voyage en Italie*.[8]

As an admirer of Turner, the art critic John Ruskin saw Canaletto's paintings not for their qualities but for the characteristics that differentiated them from the vision of the inspired English artist. For Canaletto, Venice was the city he had in front of his eyes. For Turner, as for Byron, it was a dream suspended in time. The hatchet job was inevitable.[9] Ruskin was the first to discover but not welcome the fact that Canaletto's realism did not correspond to reality, inasmuch as he was "less to be trusted for renderings of details, than the rudest and most ignorant painter of the thirteenth century."[10] However, like Turner, and with him generations of artists, writers, and collectors,

he was unable to distinguish Canaletto from his followers and imitators, and his insistence on pointing out the "vulgar exaggeration of shadow" indicates that by 1843, the date of the first volume of *Modern Painters*, he had seen more paintings by Bernardo Bellotto and Michele Marieschi than by Canaletto.[11] The fact that he remembered "but one or two where there is any variation from [the] method of treatment of the water," leaves us not a little puzzled, given that the rendering of the watery surface, even more than that of the sky, records every slight stylistic variation in the autographed paintings of the maestro, and is indicative of the personal character of other *vedutisti*.[12]

The criticism of topographical accuracy was directed at *The Stonemason's Yard* of 1725, acquired for the National Gallery in London in 1828, but Turner (and later John Singer Sargent), saw mainly the pictorial qualities in this work of Canaletto's youth.[13] In general, the Canaletto of the *prima maniera* (early style) remained unknown to artists and writers at least until the first decades of the twentieth century, and his early works, comparable in their force and experimental boldness with Turner's visions and Claude Monet's quests for light and atmosphere, were for the most part attributed to Francesco Guardi (1712–93), in the opinion that Canaletto's rationalism precluded the expression of any such imaginativeness and painterly potential. Few people knew the etchings of the *Vedute altre prese da i luoghi altre ideate* series, invested with Canaletto's notion of the *capriccio* and picturesque.

Canaletto emerged as a painter of *vedute* in the early 1720s, in complete contrast to the style of Luca Carlevarijs (1663–1730). The Udine-born painter Carlevarijs, who "did not have a definite teacher but studied here and

there,"[14] offered his own synthesis of the two principle components of *veduta* painting at the beginning of the century: the Dutch topographical aspect, known from the works of Gaspar van Wittel (1653–1736), and on the other hand the representational aspect, such as pictures of historic scenes or festivities, a genre introduced in Venice by Augsburg painter Joseph Heintz the Younger (*c*. 1600–78). Carlevarijs's solid Baroque stock-in-trade—he "comes... from decorative perspective painting"[15]—and the rational qualities of *Mathematicae cultor egregius*[16] were an important basis for the definition of the principal *vedute* of the city.[17] They were, however, also a considerable handicap to the evolution of his paintings, which had an admirable richness of detail in their figures drawn from life, but were combined with a compact heaviness in the perspective structure of the architecture which was portrayed as a monumental backdrop.[18]

Canaletto took over Carlevarijs's repertoire as a *veduta* painter, but invested it with a new verve derived from his familiarity with the world of the theater and music, therewith manifesting a singular painterly talent. The metamorphosis of the image of Venice in the early paintings of Canaletto is astonishing: Canaletto shifts the focus of attention from the on-stage action to the scenery, nonchalantly outdoing his own excellent perspective preparation in order to impose a pattern of dramatic and musical effects, formed by the contrast of shadows and light, on the architectural wings of the Piazza San Marco or the palaces facing the Grand Canal. For the first time, in Canaletto, Venice itself becomes the protagonist.

San Marco, Carlevarijs's prime location, was the first to undergo this transformation. The *Piazza San Marco* in the Museo Thyssen-Bornemisza in Madrid, one of four large paintings by Canaletto formerly in the Liechtenstein Collection in Vienna, together with ten others in a smaller format, is considered the first of the views of the Piazza from the vicinity of San Geminiano (p. 28).[19] Studied closely in the context of the whole series for its chronology and date of commissioning, it represents a precise historical moment when work on renewing the paving was still under way as part of architect Andrea Tirali's scheme, which envisaged relaying it in a new design in Istrian stone. Work started in February 1723, definitely indicating a later date of 1723 or 1724 for this painting.[20]

Attributed by Wilhelm von Bode to Guardi, and then to the School of Guardi, but now attributed to Canaletto, another *veduta* of the Piazza San Marco has been at the Flagler Museum, Palm Beach, Florida since 1964. With the old bricks still present, it certainly precedes the painting in Madrid (fig. 2).[21] The composition is taken from a print by Carlevarijs, but the light is reversed and, in a view from above, the two wings of the Procuratie sweep towards the delicate silhouette of the basilica. On the right, the dark shadow of the irregular profile extends across the piazza to the foot of the campanile.[22]

The catalogues of the Liechtenstein Collection document the presence of a *Piazza San Marco* of the same dimensions in the Canaletto group, sold, like other paintings by the artist, in 1953.[23] It is evident that this involves the "model" of the Madrid *veduta*, developed and "corrected" in the position of the domes of the basilica, the perspective treatment of the Procuratie Vecchie and other compositional elements, but followed faithfully in the handling of the lighting effects and the spatial relationships. The study of light and technique suitable for putting across his dramatic and

Fig. 2 Attributed to Canaletto,
Piazza San Marco, 1722,
oil on canvas, 56 × 74 cm,
The Flagler Museum, Palm Beach

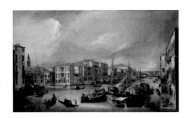

Fig. 3 Canaletto, *The Grand Canal from the Palazzo Corner Spinelli to the Rialto Bridge,* 1724, oil on canvas, 146 × 234 cm, Staatliche Kunstsammlungen, Dresden, Gemäldegalerie Alte Meister

atmosphere-filled vision of the stones of Venice can be taken to have been central to Canaletto's interests. The effect of the light reflected on the arches of the Procuratie Vecchie and the overlapping of blacks and grays in various *sfumature* on the façade of the Procuratie Nuove, with thin silver brushstrokes to suggest marble reliefs—disconcerting in the modernity of conception—express the painterly quality of the *prima maniera*.

The fact that the two phases of development of the same *veduta*, the "model" and the final work, were preserved in the same Liechtenstein Collection indicates that the client, a member of the family, followed the commission with special attention, getting the project sent from Venice. It could have been none other than Prince Joseph Wenzel (1696–1772), who expanded the collection of paintings put together by his forebears with great taste and kept his favorite purchases in the private apartments of the palace in Rossau in Vienna.[24]

Between 1724 and 1726, Canaletto repeated the compositions of the large Liechtenstein canvases—with the exception of the unusual *Rio dei Mendicanti*[25]—for Count Giambattista Colloredo-Waldsee, Imperial Ambassador to Venice,[26] and also for his first "agent," Owen McSwiney, a bankrupt theater manager of Irish origin.[27] *The Grand Canal from the Palazzo Balbi to the Rialto Bridge* (p. 38), which repeats the subject of the canvas now in Madrid, was commissioned by McSwiney and sold to Edward Southwell, Canaletto's first Grand Tour client to pass through Venice in 1725–26.[28] The artist found it particularly interesting to return to the same scheme later on, with new ideas of composition, light, and figures, and try out the effects of them. Certainly he had a stock of drawings, but added to it with every canvas ("... he always goes up to the place and does

everything from life...").[29] In the more limited space of water and the sky, Canaletto concentrated on defining the succession of palaces along the Grand Canal with a soft, alternating and contrasting use of shadow and light, in which the details of the architecture look "eaten away" by the atmosphere. It was a dramatic, monumental vision of Venice, despite the reduced dimensions. The painting was sold at auction in 1833, together with its *pendant*, and subsequently attributed to Francesco Guardi, a label still accepted by Antonio Morassi even in 1960.[30]

The *veduta* of *The Grand Canal from the Palazzo Corner Spinelli to the Rialto Bridge*, of 1724, acquired along with the Colloredo Collection between 1733 and 1754 for the Royal Gallery of Dresden, where it is still preserved[31] (fig. 3), and its possible *pendant*, *The Bacino di San Marco from the Giudecca, with the Reception of Ambassador Colloredo* of 1726, now in Upton House, Warwickshire,[32] are among the most innovative compositions in the *prima maniera*. The first shows the turbulent phase where "the sun is seen shining from within,"[33] with whorls of light in the sky reflected in the ripples on the water and a jumble of barges in the foreground, which would have delighted Turner; the second, with the boldness of a wide-angle *veduta* of the *bacino* and the attention to the lighting effects already takes us on to the next phase—one of transition from stage effects to landscape painting. In June 1726, Canaletto finished the *Campo Santi Giovanni e Paolo* and *The Grand Canal from Santa Maria della Carità, towards the Bacino di San Marco* (pp. 40–41), the second pair of a series of four commissioned by Stefano Conti, an aristocratic collector from Lucca.[34] The *veduta* of the Grand Canal, mentioned at the latest in the receipt for payment, is the most "modern" of

the series, even if it recycles a composition of 1722.[35] The bold prominence of the precisely outlined shadow on the façade of the church in the full glare of light, with the bricks carefully treated one by one—as in the almost contemporaneous *Stonemason's Yard*[36]—and the delicate handling of the shadows on the *palazzo* fronts along the canal with their details clearly visible, indicate a new quest in progress, moving from stage-like scenery and illumination to realistic light and topography. This idea of the Venetian *veduta*, developed by the artist in the thirties—as in the two beautiful paintings from the Abelló collection in Madrid, *The Molo from the Bacino di San Marco* and *The Grand Canal from the Campo di San Vio, towards the Bacino di San Marco* (pp. 42, 43), assured the success of Canaletto among British collectors on their Grand Tour, who between 1746 and 1755 would ask him to paint scenes of London and their country houses.[37]

Among the four paintings commissioned in 1758 from Canaletto by Sigismund Streit, a Berlin merchant resident in Venice, two are night scenes depicting the Santa Marta and San Pietro di Castello festivals. Replicas of all of them are known (p. 39).[38] Canaletto tackled the study of moonlight and its effects with care and an authentic scientific interest. From that moment, the tonality of his paintings became darker and the brushstrokes more and more edgy between contrasting areas of light and the differentiation of the skies.

Guardi maintained the tradition of *veduta* painting and collecting almost until the fall of the Republic. A little after the artist's death, the Italian art critic Luigi Lanzi wrote:

[Guardi] considered himself another Canaletto in those final years; and his vedute *of Venice aroused admiration in Italy and elsewhere; but only among such people as are content with that vivacity, that taste, that fine effect he always looked for; because he cannot match the master in the exactness of proportions and in terms of art.*[39]

The benchmark for Guardi was Canaletto's oeuvre of paintings, drawings, and prints, but his *vedute*, undertaken after thirty years of activity as a painter of figures and historical scenes, immediately lead to a transformation of the maestro's rules of perspective and lighting effects, not in opposition to them but as a new development. In the first decade of activity as a *vedutista,* or a little after, Guardi's paintings, composed from drawings executed on the spot and with the use of the *camera obscura,* depict Venice like those of Canaletto. Adherence to topography was one of the main requirements stipulated by English collectors, documented from the first and encouraged by the patronage of British consul Joseph Smith and John Strange, a British resident in Venice from 1774 to 1786.[40] The light conditions and atmosphere, and the skies and colors varying from one painting to another are characteristic of Guardi and his personal exploration—sometimes of reality, sometimes of pure abstraction.

In an original composition of 1757/58, *The Giudecca Canal with the Zattere* (p. 44), Guardi described with delicacy and precision, with the tip of the brush, the houses on the Zattere and the Giudecca with the Euganei Hills in the distance, observing—as the first of the painters of Venice—the rosy sky on the horizon, the reflections on the greenish water, and the façades of the houses, seen in the evening in the setting sun. A curious feature is the generous use of red for the clothes of the figures, very different from the usual rare red spots in Canaletto, scattered about to guide the eye within the space of the *veduta*.[41] Guardi signed his first works to clearly distinguish them from

Canaletto, his supposed and probable teacher in the second half of the 1750s.[42] Like Canaletto, he carried out various versions of the same *veduta*, explicitly for commercial purposes.

Various versions are known of the *veduta* of *The Grand Canal with the Rialto Bridge and the Palazzo dei Camerlenghi* now in the Alte Pinakothek in Munich (p. 47). They are of sundry dimensions, from the Duke of Buccleuch's painting of 1758–60 and the later one at The Metropolitan Museum, New York, to the large canvas belonging to Paul Channon (pre-1768), all of them of different chromatic range and luminosity, reinforcing the idea that Guardi's development as a *veduta* painter in the 1760s was not as rapid as was thought.[43] The Munich painting and its *pendant* showing *The Grand Canal with the Entrance to Cannaregio and the Church of San Geremia* (p. 46), based on previous compositions by Canaletto, are closer to the Buccleuch picture in the choice of perspective, the little figures, the dry, crisp brushstroke, the opaque coloring, and the light breaking up on surfaces with dramatic effect, beneath skies packed with clouds. But the handling of the light and execution are more assured, indicating a later dating, probably 1764–65.[44]

It is evident that *The Piazzetta with the Libreria* (p. 49), with its *pendant, The Torre dell'Orologio in Piazza San Marco*—the same subject as on the certainly later Munich painting, but different in detail (p. 48)—manifest a subsequent phase, in which Canaletto's works continued to be the model, but in which the artist, who was at the same time also working on his *capriccios*, always attributed less importance to topographical correctness and architectural details, adding staggered perspectives to the buildings and unusual shapes to the figures. The atmospheric quality of the color and light

develop into a play of fantasy or variations on a theme, rather than observations from real life. *The Veduta through an Arch,* (p. 50), with its similar *impasto* softness, is reminiscent of a moment in the second half of the 1770s.[45]

It was paradoxically the drawings of the twelve *Ducal Ceremonies and Festivals,* Canaletto's last masterpiece of 1766, that prompted Guardi to make a major change in his manner of painting Venice[46] (fig. 4). When Giambattista Brustolon accomplished his etchings of the whole series in 1773–77, Guardi was commissioned to paint the same compositions.[47] The artist found immense inspiration in the dogal ceremonial scenes and festivals, which took place in the familiar localities of San Marco and the *bacino,* and the rooms of the Doge's Palace, in the presence of a lively, festive throng. He caught their intensity of description, the fluid, stylized lines, and fluctuating *chiaroscuro* that conferred a sense of festiveness and dynamism on the scenes represented. He would make the formal elegance his own in the most exquisite rococo style, developing it immeasurably, with an ever more assured, bold, and rapid use of the brush. The way his interpretation follows Canaletto's style clearly indicates his direct knowledge of the drawings. Ten sheets were in Venice until shortly before February 11, 1789, when they were sold to an English collector, Sir Richard Colt Hoare.[48] In 1793, Guardi's paintings were acquired by the Musée Central des Arts, later the Musée Napoléon (Louvre), and attributed to Canaletto. Guardi's name was similarly neglected in respect to other works present in French collections.[49] Turner, who knew the drawings, must have meditated in front of the paintings. It was a Venice that also delighted Jean-Baptiste-Camille Corot and Edouard Manet in its fascinatingly unsettled light.

The *veduta* of *The Molo with the Doge's Palace,* along with its *pendant, Ascension Day on the Piazza San Marco,* were already imbued with that varying sparkle of light that is a feature of the mature Guardi, whereas *The Bucintoro Preparing to Leave the Molo on Ascension Day* (pp. 52–53) appears to precede the great change, and could have been painted in the first half of the 1770s.[50] The brilliance of light and the colors in *The Bacino di San Marco with the Bucintoro* (p. 55), which suggests a sunny spring day, is from the subsequent and last phase, in which the spaces are always deceptive and the luminosity sometimes silvery, sometimes warmer.[51] Beside the variations on Canaletto's themes, new compositions appeared, pictures that often have the character of a snapshot due to the way they catch the light. Examples of them include *The Giudecca with the Church of the Zitelle* (p. 54) and *The Grand Canal with the Churches of Santa Lucia and the Scalzi* (p. 45), but also compositions that had already been executed in different versions a number of times, such as *Piazza San Marco* (p. 51), appear transformed by a new luminosity and the magical lightness of the brushstrokes.[52]

The absence of critical opinions on Guardi or simple comments and references—Ruskin, for example, does not even mention his name—is disconcerting. The works of the prolific artist began to appear at the sales of the great European collections in the last quarter of the nineteenth century, and it became clear that he had conquered not only Canaletto's traditional English clientele but also French collectors' taste for the picturesque. His style of visual sensation was compared with that of the Impressionists, the gray and silver scales of the colors fascinated Sargent and Whistler, while his visions of Venice were, like a dream, a major portent for Félix Ziem. That was when the early works of Canaletto came to be attributed to Guardi.

In 1904, the first monograph on Francesco Guardi, by George A. Simonson, was published in London.

As a painter of Venice Guardi may be said to head the long list of Masters who idealised Venice. From Guardi to Turner and from Turner to Ziem, there has been a plentiful crop of artists, who instead of depicting the real Venice, which Canale has represented, have aimed at picturesque or fanciful effects rather than at truth in their portrayal of it.[53]

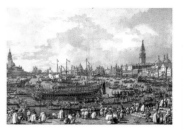

Fig. 4 Canaletto, *Ducal Ceremonies and Festivals: The Doge Leaving for the Lido in the Bucintoro on Ascension Day,* 1766, pencil, ink, and watercolor, 39 × 55 cm, The British Museum, London

1 Charles de Brosses, letter to M. de Blancey, November 24, 1739, in Charles de Brosses, *L'Italie il y a cent ans ou lettres écrites d'Italie à quelques amis en 1739 et 1740*, R. Colomb, ed., vol. I, letter XXX (Paris, 1836), p. 380.

2 William Bingley, ed., *Correspondence between Frances, Countess of Hertford (afterwards Duchess of Somerset) and Henrietta Louisa, Countess of Pomfret, between the years 1738 and 1741* (London, 1805), vol. III, p. 343.

3 William Beckford, *Italy; with Sketches of Spain and Portugal* (London, 1834), vol. I, p. 101; see also Ian Warrell, "Catalogo," in *Turner and Venice*, exh. cat. Museo Correr, Venice (Milan, 2004), p. 51.

4 William G. Constable, *Canaletto: Giovanni Antonio Canal, 1697–1768*, 2nd ed. revised by Joseph G. Links, 2 vols. (Oxford, 1989), nos. 280, 328

5 Ibid., 122; Joseph G. Links, *The Soane Canalettos* (London, 1998).

6 Warrell 2004 (see note 3), p. 55. The comment that it was Guardi's style of painting that appealed to Turner is correct (see Warrell, p. 56), but so was Michele Marieschi's: the white, changing light, the smooth matter, the artist's distinctive handling of architectural details, the unpredictable use of yellow, and the vibrant reflections in the water, are characteristics you find in some masterpieces considered of Canaletto, such as the *Bacino di San Marco towards the North*, familiar to Turner. See also Bożena Anna Kowalczyk, *Canaletto:Il trionfo della veduta*, exh. cat. Palazzo Giustiniani, Rome (Milan, 2005), pp. 144–47, no. 31.

7 Olivier Meslay, *Sur la route de Venise. Jules-Romain Joyant, 1803–1854. Les voyages en Italie du "Canaletto français"*, exh. cat. Musée d'Art et d'Histoire Louis-Senlecq, Ville de L'Isle-Adam (Paris, 2003), pp. 67–73.

8 François René de Chateaubriand, *Mémoires d'outre-tombe*, with comments by Maurice Levaillant, IV, book 7 (Paris, 1948), pp. 333–407; Théophile Gautier, *Italia. Voyage en Italie*, Marie-Hélène Girard, ed. (Paris, 1997), p. 22.

9 Edward T. Cook and Alexander D.O. Wedderburn, eds., *The Works of John Ruskin*, 39 vols. (London, 1903–12); see also Edward T. Cook, *A Popular Handbook to the National Gallery Including by Special Permission Notes Collected from the Works of Mr. Ruskin*, revised edition (New York, 1901), p. 163–65. Only in one of his last visits to the National Gallery did Ruskin admit to admiring Canaletto.

10 John Ruskin, *The Stones of Venice*, 2nd ed. (London, 1867), vol. III, p. 288, under the heading "Carità, Church of." Ruskin was certainly referring to *The Stonemasons' Yard* in the National Gallery, London, saying: "The effect of its ancient façade may partly be guessed at from the pictures of Canaletto, but only guessed at."

11 *The Works of John Ruskin...*, *Modern Painters*, vol. I, pp. 216, 337; see also J.G. Links, *Canaletto's Venice*, in *Modern Painters*, 7, no. 3 (Fall 1994), pp. 68–71.

12 Ibid., p. 513.

13 Constable and Links 1989 (see note 4), no. 199; Michael Levey, *National Gallery Catalogues: The Seventeenth and Eighteenth Century Italian Schools* (London, 1971), pp. 18–22; Warrell 2004 (see note 3), p. 55. In Sargent's case, familiarity with the Canaletto painting is evident in Venetian works such as *Campo Sant'Agnese* or *Sortie de l'Eglise*, *Campo San Canciano* (p. 129 top), in his brushwork and chromatic relationships.

14 Vincenzo Da Canal, *Vita di Gregorio Lazzarini*, Giovanni Antonio Moschini, ed. (Venice, 1809), p. 29.

15 Hermann G.Voss, "Studien zur venezianischen Vedutenmalerei des 18. Jahrhunderts," in *Repertorium für Kunstwissenschaft* (Berlin/Leipzig, 1926), p. 6.

16 Michael Levey, *Painting in Eighteenth-Century Venice*, 3rd ed. (New Haven/London, 1994), p. 98.

17 *Le Fabriche, e Vedute di Venetia disegnate, poste in prospettiva, et intagliate da Luca Carlevariis con privilegii* (Venice, 1703).

18 For an up-to-date bibliography of Carlevarijs, see Charles Beddington, *Luca Carlevarijs. Views of Venice*, exh. cat. Timken Museum of Art (San Diego, CA, 2001); William L. Barcham, "Luca Carlevarijs e la creazione della veduta veneziana del XVIII secolo," in Fabbio Benzi, Laura Laureati et al., eds., *Gaspare Vanvitelli e le origini del vedutismo*, exh. cat. Chiostro del Bramante, Rome/Museo Correr, Venice (Rome, 2002), pp. 57–67.

19 Constable and Links 1989 (see note 4), no. 1.

20 Alessandro Bettagno, *Canaletto. Disegni-dipinti-incisioni*, exh. cat. Fondazione Giorgio Cini, Venice (Vicenza, 1982), pp. 56–58, no. 79; Lionello Puppi, "La gondola del procuratore. Committenza e peripezie di collezione di quattro dipinti del Canaletto," in *Bollettino dei Civici Musei Veneziani*, 28, nos. 1–4 (1983–84), pp. 5–20; Bożena Anna Kowalczyk, *Canaletto prima maniera*, exh. cat. Fondazione Giorgio Cini, Venice (Milan, 2001), p. 110, no. 49.

21 Johann Dallinger, *Description des Tableaux, et des pièces de sculpture, que renferme la Galerie de son Altesse François Joseph Chef et Prince Régnant de la Maison de Liechtenstein, Vienne*, 1780, p. 74; Adolf Kronfeld, *Führer durch die Fürstlich Liechtensteinsche Gemäldegalerie in Wien* (Vienna, 1925) (later editions, 1927, 1931, 1943), no. 198*; Constable and Links 1989 (see note 4), no. 11 (c). The present writer would like to thank Derek Johns for kindly drawing to her attention this painting.

22 See note 17, no. 43.

23 Constable and Links 1989 (see note 4), no. 1.

24 Bettagno 1982 (see note 20), pp. 56–57.

25 Constable and Links 1989 (see note 4), no. 290.

26 Kowalczyk 2001 (see note 20), pp. 126–27.

27 For McSwiney, see Barbara Mazza, "La vicenda dei 'Tombeaux des Princes': matrici, storia e fortuna della serie Swiney tra Bologna e Venezia," in *Saggi e Memorie della Storia dell'Arte*, 10, 1976, pp. 81–102.

28 Constable and Links 1989 (see note 4), no. 214; Kowalczyk 2005 (see note 6), p. 56, no. 6, and pp. 60–67, nos. 7, 8.

29 Francis Haskell, "Stefano Conti, Patron of Canaletto and Others," in *The Burlington Magazine*, XCVIII, no. 642 (September 1956), p. 298.

30 Kowalczyk 2005 (see note 6), p. 56, no. 6. In the Christie's catalogue, the two paintings are described as "A view on the Great Canal at Venice" and "A Ditto, with the Rialto in the distance" (lots 61 and 62).

31 Constable and Links 1989 (see note 4), no. 208.

32 Ibid., no. 144; Kowalczyk 2001 (see note 20), pp. 128–30, nos. 56–57.

33 Haskell 1956 (see note 29), p. 297.

34 Constable and Links 1989 (see note 4), nos. 304 and 194, the other two paintings, nos. 234 and 230; William G. Constable, "Some Unpublished Canalettos," in *The Burlington Magazine*, XLII, 243 (June 1923), pp. 278–88.

35 Constable and Links 1989 (see note 4), no. 196*.

36 See notes 10 and 13.

37 Constable and Links, 1989 (see note 4), nos. 105, 189. On Canaletto in England, see Charles Beddington, *Canaletto in England. A Venetian Artist Abroad, 1746–1755*, exh. cat. Yale Center for British Art, New Haven (CT)/Dulwich Picture Gallery, London (New Haven, 2006).

38 Constable and Links 1989 (see note 4), nos. 242, 282, 359, 360. It is thought that Turner used the motifs of the latter (*Festival on the Eve of St.Martha*), which he knew from the etching of Giambattista Brustolon, for *Returning from the Ball (St Martha)*, (p. 71 in this catalogue); Warrell 2004 (see note 3), p. 254.

39 Luigi Lanzi, *Storia pittorica della Italia, dal Risorgimento delle Belle Arti fin presso al fine del XVIII secolo* (Florence, 1970), vol. II, p. 180.

40 Francis Russell, in "Guardi and the English Tourist," in *The Burlington Magazine*, CXXXVIII, no. 1114 (January 1996), pp. 4–11; Francis Haskell, *Patrons and Painters*, 2nd ed. (New Haven/London, 1980),

pp. 374–75; see also, Haskell, "Francesco Guardi as *vedutista* and some of his patrons," in *Journal of the Warburg and Courtauld Institutes*, XXIII, no. 3/4 (July-December 1960), pp. 256–76.

[41] Antonio Morassi, *Guardi*, 2 vols. (Venice, 1973), no. 622, fig. 590; Russell (see note 40), pp. 4–9. The present writer is convinced that the inspiration for Guardi's lagoon *vedute* can be traced back to drawings by Canaletto preserved in the Smith Collection, where the broad expanses of water are punctuated by little boats.

[42] James Byam Shaw, *The Drawings of Francesco Guardi* (London, 1951), pp. 16–24.

[43] Morassi 1973 (see note 41), no. 551, fig. 525; no. 549, fig. 523; no. 554, fig. 530; no. 555, fig. 529; Russell 1996 (see note 40), pp. 9–10.

[44] Morassi 1973 (see note 41), no. 573, fig. 550.

[45] Morassi 1973 (see note 41), no. 387, fig. 407; no. 355, fig. 383; no. 812, fig. 737.

[46] Constable and Links 1989 (see note 4), pp. 525–34, nos. 630–41.

[47] Morassi 1973 (see note 41), nos. 243–54, figs. 268–84; Byam Shaw 1951 (see note 42), p. 37. Some of the canvases were done in 1780, to judge by the ultra-fashionable hairstyle of the ladies; Dario Succi, *Francesco Guardi. Itinerario dell'avventura artistica* (Milan, 1993), pp. 83–90 (1776–78).

[48] Constable and Links 1989 (see note 4), vol. II, p. 527.

[49] See Pierre Rosenberg, *Venise au dix-huitième siècle. Peintures, dessins et gravures des collections françaises,* exh. cat. Orangerie des Tuileries (Paris, 1971), pp. 72–75, nos. 70, 71, 73.

[50] Morassi 1973 (see note 41), no. 400; fig. 419; no. 278, fig. 305; no. 403, fig. 427.

[51] Morassi 1973 (see note 41), no. 288, fig. 320.

[52] Morassi 1973 (see note 41), no. 633, fig. 598; no. 584, fig. 557; no. 332, fig. 361.

[53] George A. Simonson, *Francesco Guardi, 1712–1793* (London, 1904), p. 70.

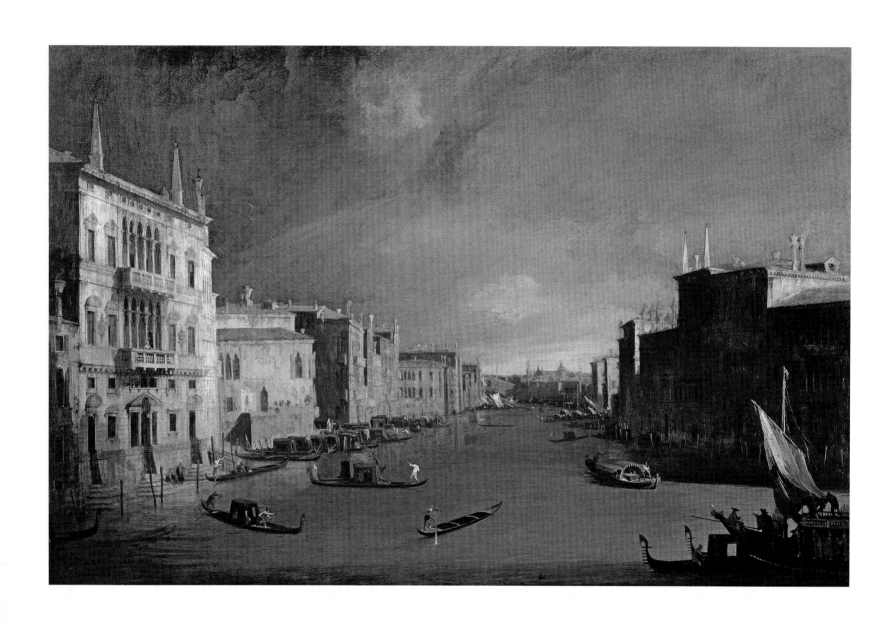

Canaletto, *The Grand Canal from the Palazzo Balbi to the Rialto Bridge*, 1724/25
Hull Museums, Ferens Art Gallery, United Kingdom

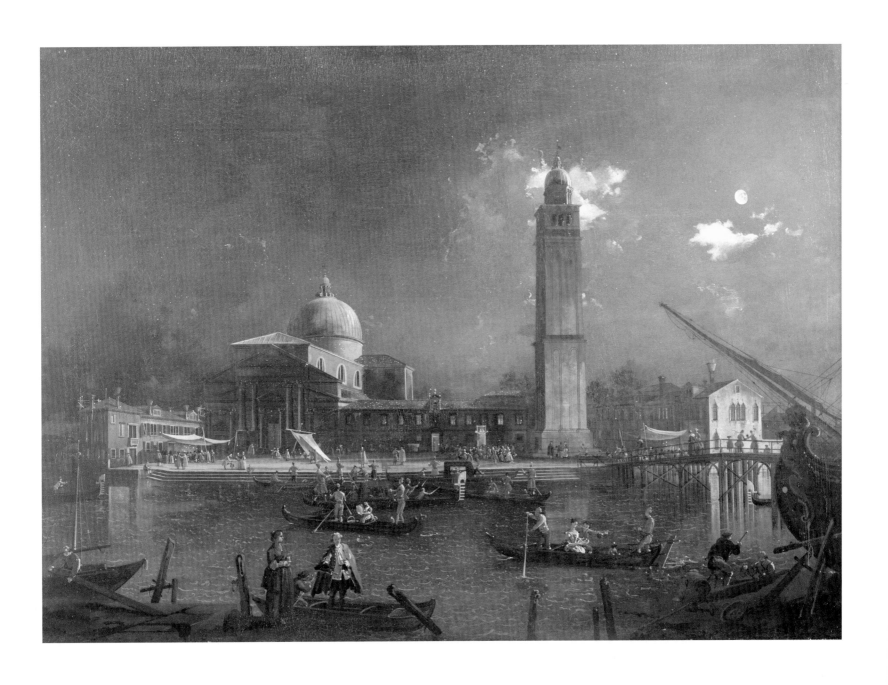

Canaletto, *Night Festival at San Pietro di Castello*, 1758/63
Collection Dr. Gert-Rudolf Flick, London

Pages 40–41:
Canaletto, *The Grand Canal from Santa Maria della Carità, towards the Bacino di San Marco*, 1726
Pinacoteca Giovanni e Marella Agnelli, Turin

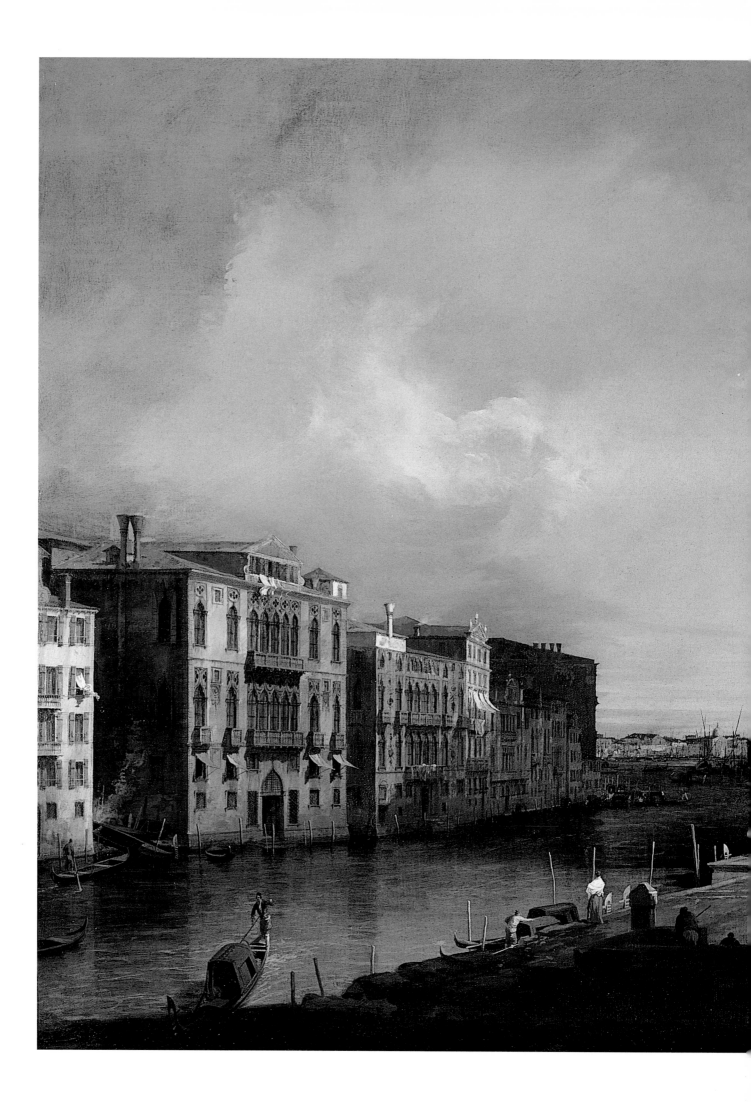

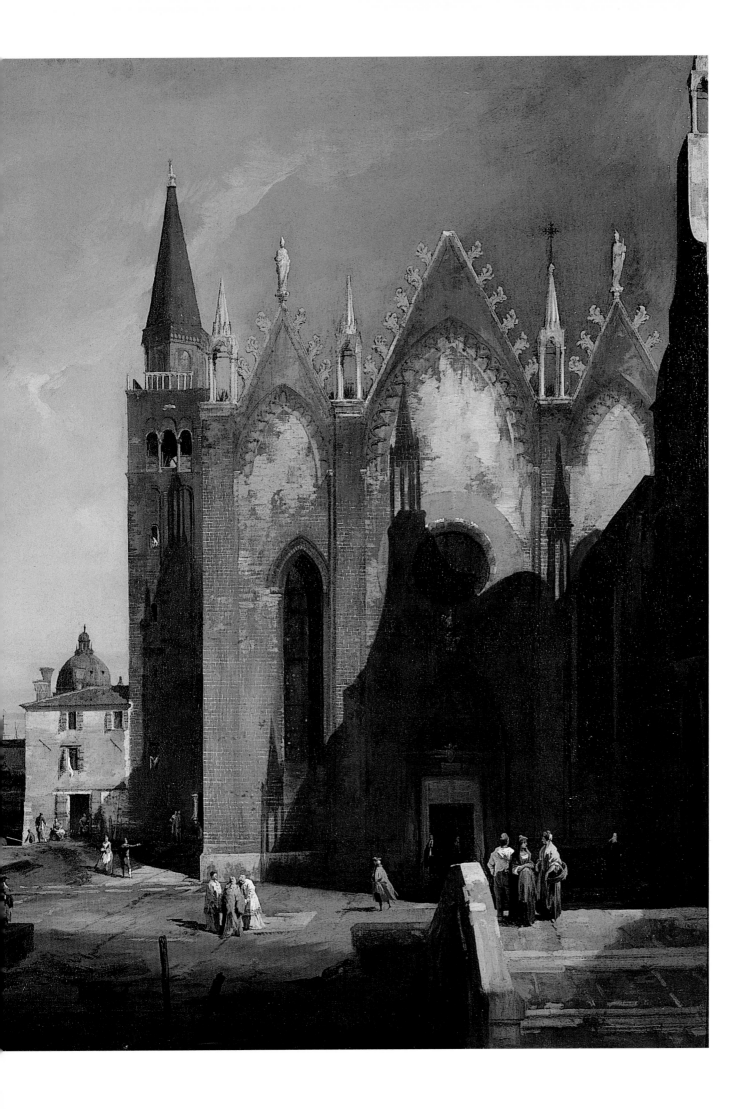

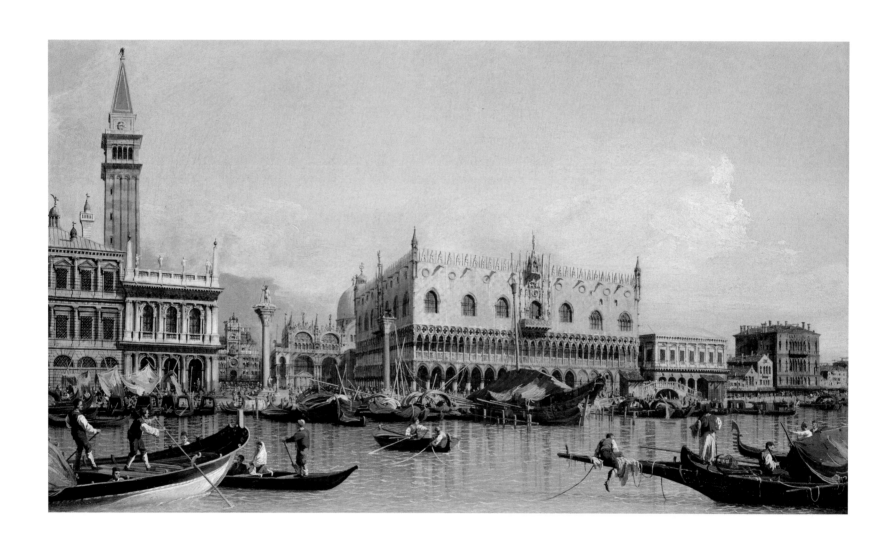

Canaletto, *The Molo from the Bacino di San Marco*, 1733/34
Collection Juan Abelló, Madrid

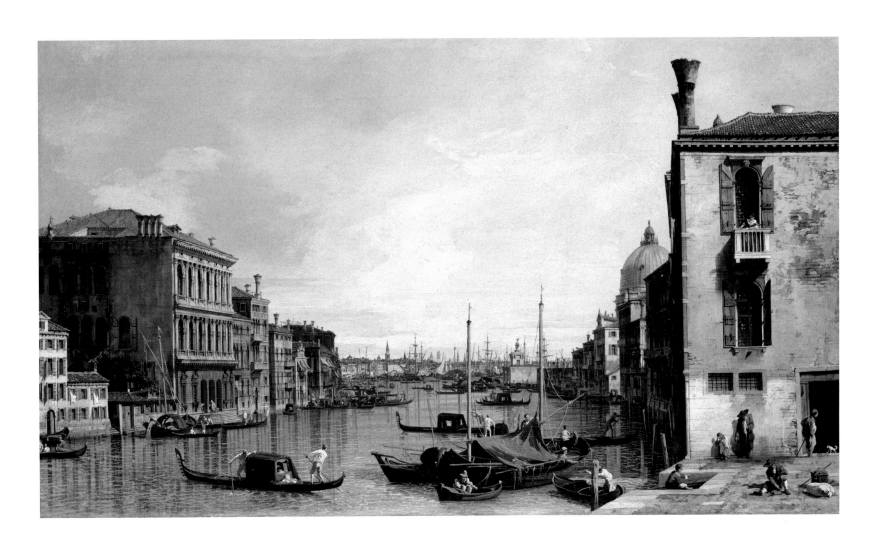

Canaletto, *The Grand Canal from the Campo di San Vio, towards the Bacino di San Marco,* 1733/34
Collection Juan Abelló, Madrid

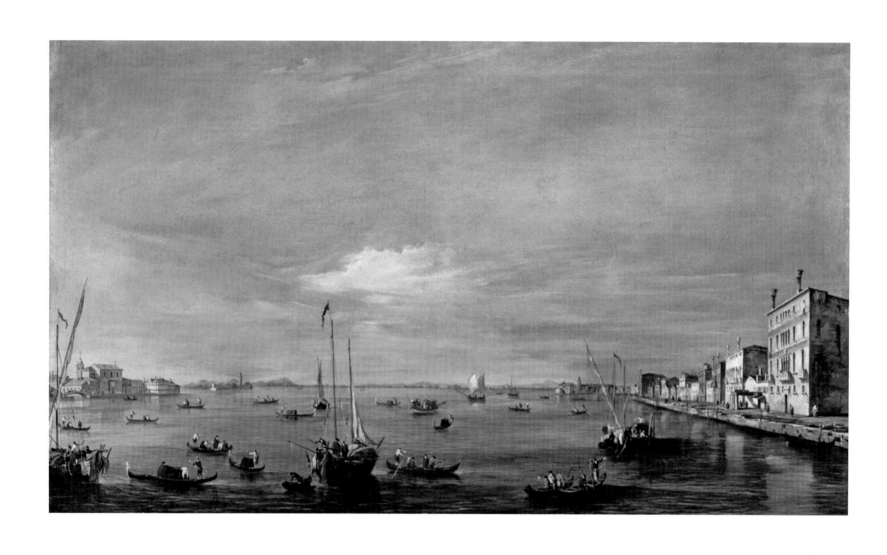

Francesco Guardi, *The Giudecca Canal with the Zattere*, 1757/58
Colección Carmen Thyssen-Bornemisza on loan to the Museo Thyssen-Bornemisza, Madrid

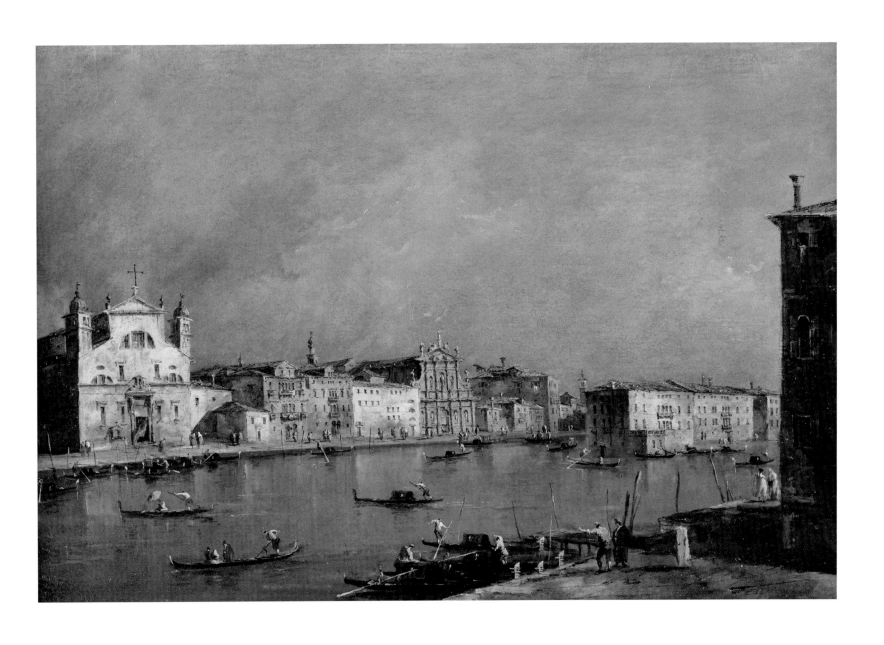

Francesco Guardi, *The Grand Canal with the Churches of Santa Lucia and the Scalzi, c.* 1780
Gemäldegalerie der Akademie der bildenden Künste Wien, Vienna

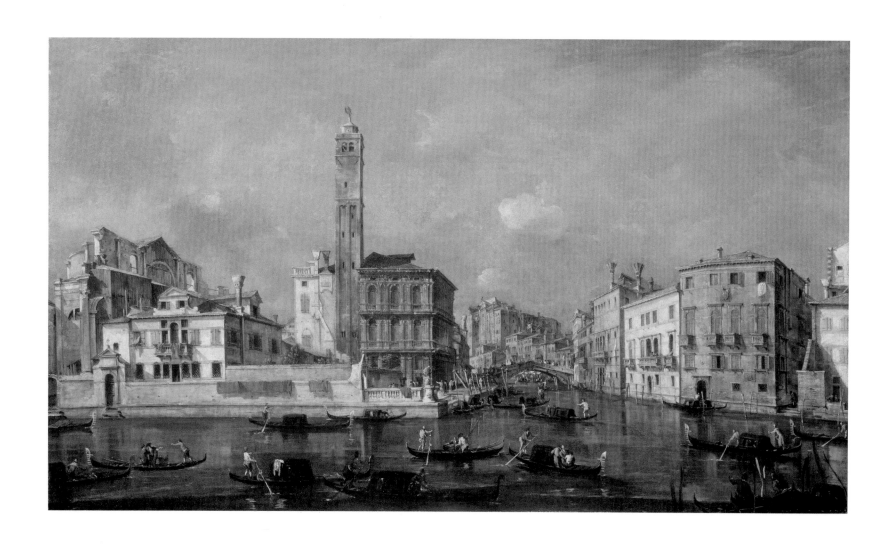

Francesco Guardi, *The Grand Canal with the Entrance to Cannaregio and the Church of San Geremia*, 1764/65
Bayerische Staatsgemäldesammlungen, Alte Pinakothek, Munich, on loan from the HVB Group

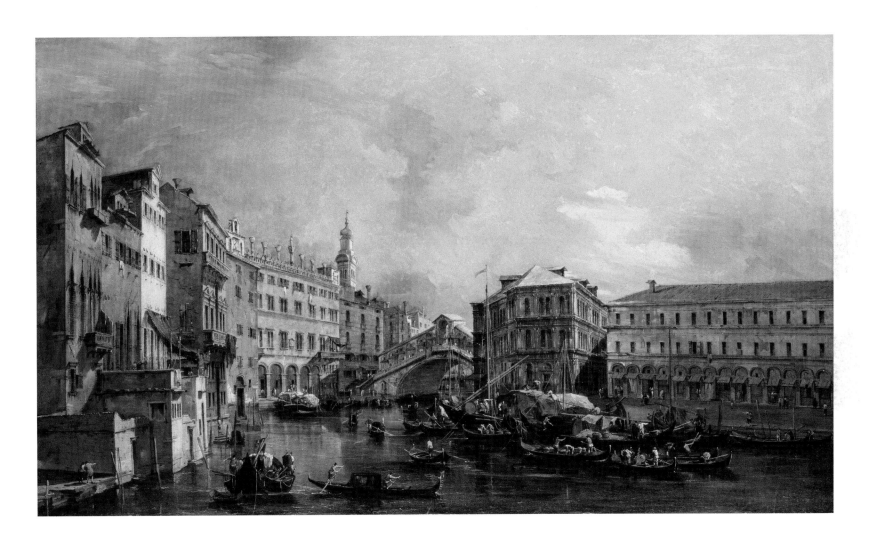

Francesco Guardi, *The Grand Canal with the Rialto Bridge and the Palazzo dei Camerlenghi*, 1764/65
Bayerische Staatsgemäldesammlungen, Alte Pinakothek, Munich, on loan from the HVB Group

47

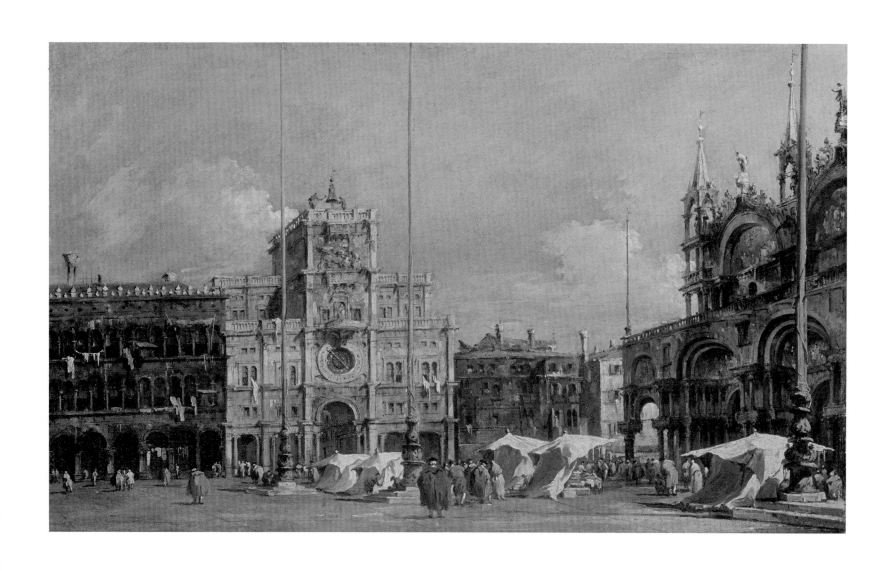

Francesco Guardi, *The Torre dell'Orologio in Piazza San Marco, c.* 1775
Bayerische Staatsgemäldesammlungen, Alte Pinakothek, Munich, on loan from the HVB Group

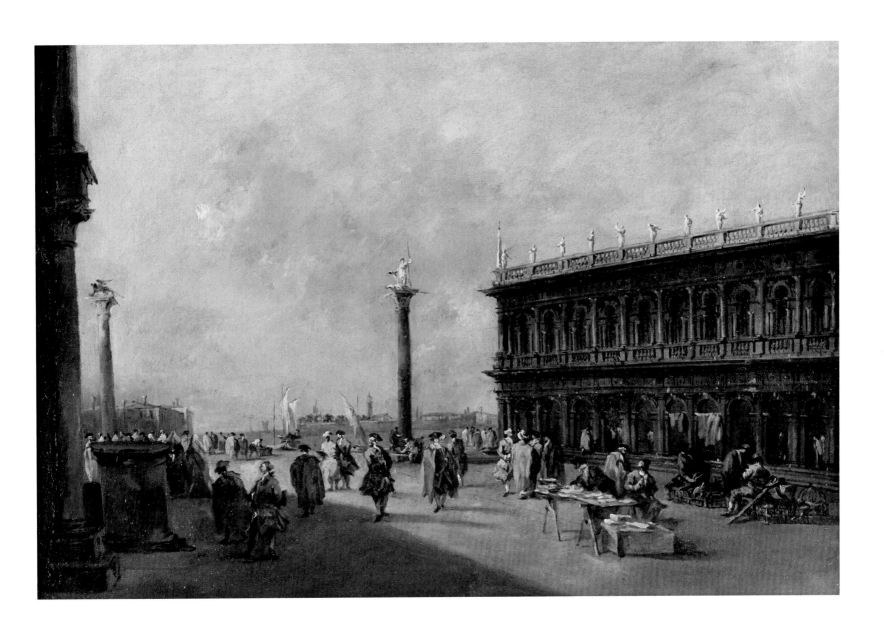

Francesco Guardi, *The Piazzetta with the Libreria*, 1770/75
Gemäldegalerie der Akademie der bildenden Künste Wien, Vienna

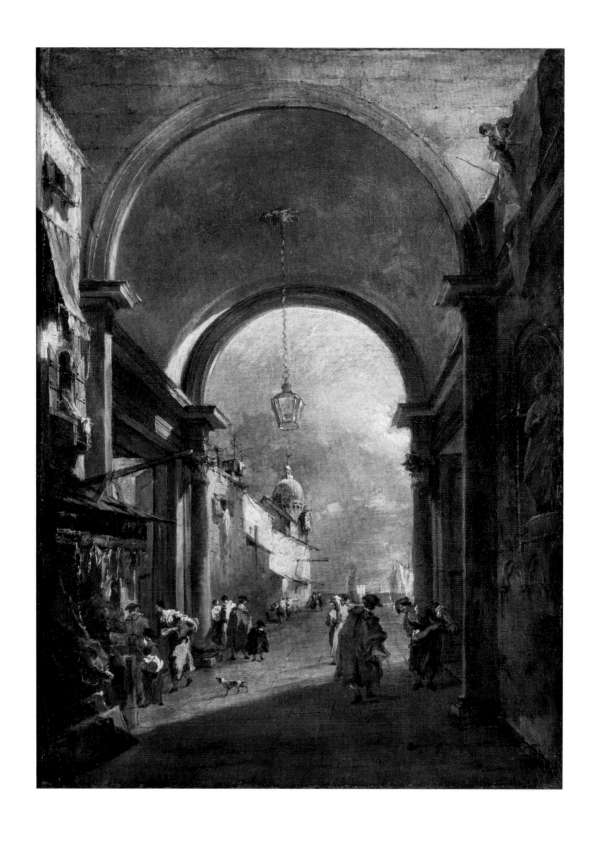

Francesco Guardi, *The Veduta through an Arch*, 1775/80
Bayerische Staatsgemäldesammlungen, Alte Pinakothek, Munich, on loan from HVB Group

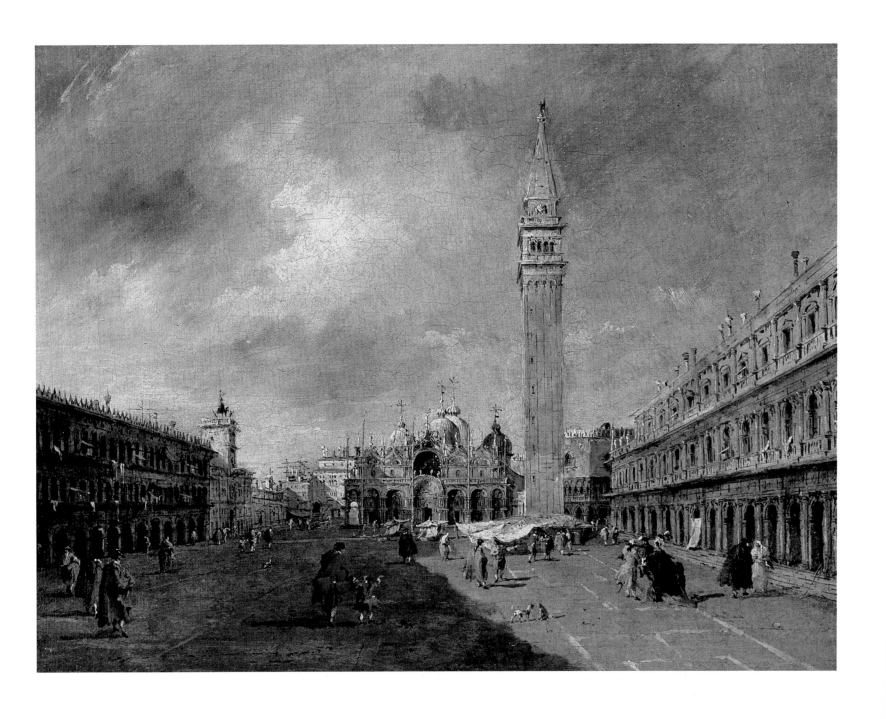

Francesco Guardi, *Piazza San Marco*, c. 1785
Musée Granet, Aix-en-Provence, anonymous donation, 2000

Pages 52–53:
Francesco Guardi, *The Bucintoro Preparing to Leave the Molo on Ascension Day*, 1770/75
Calouste Gulbenkian Museum, Lisbon

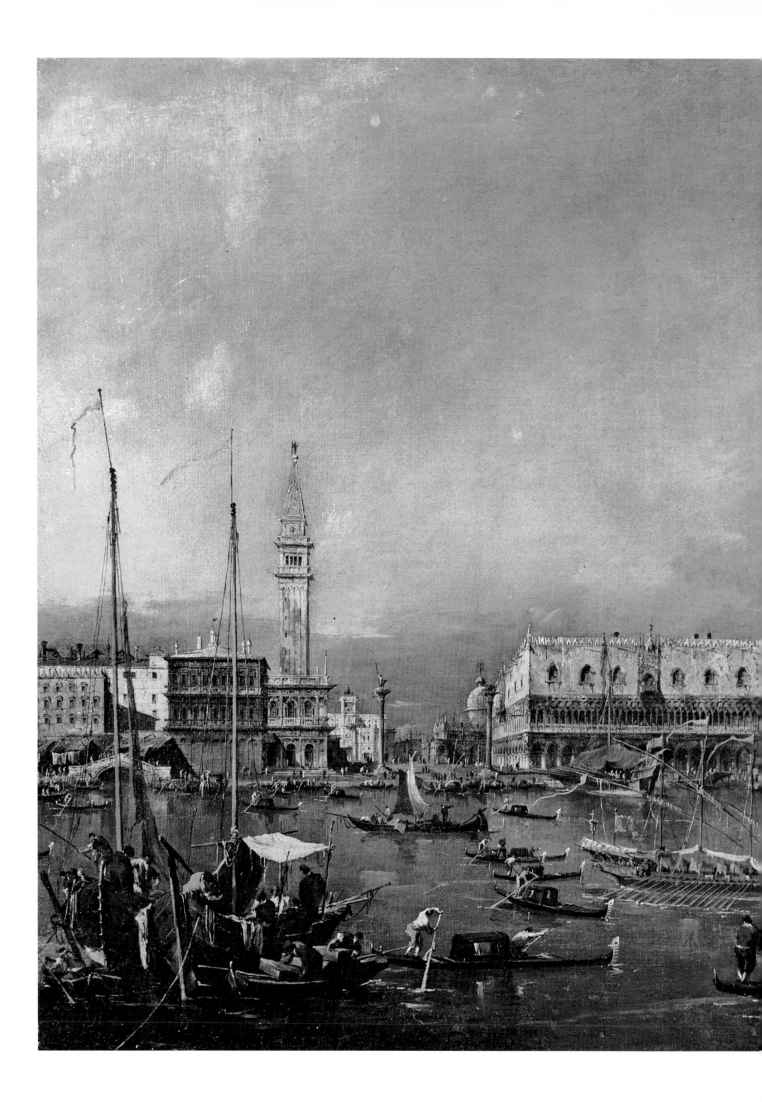

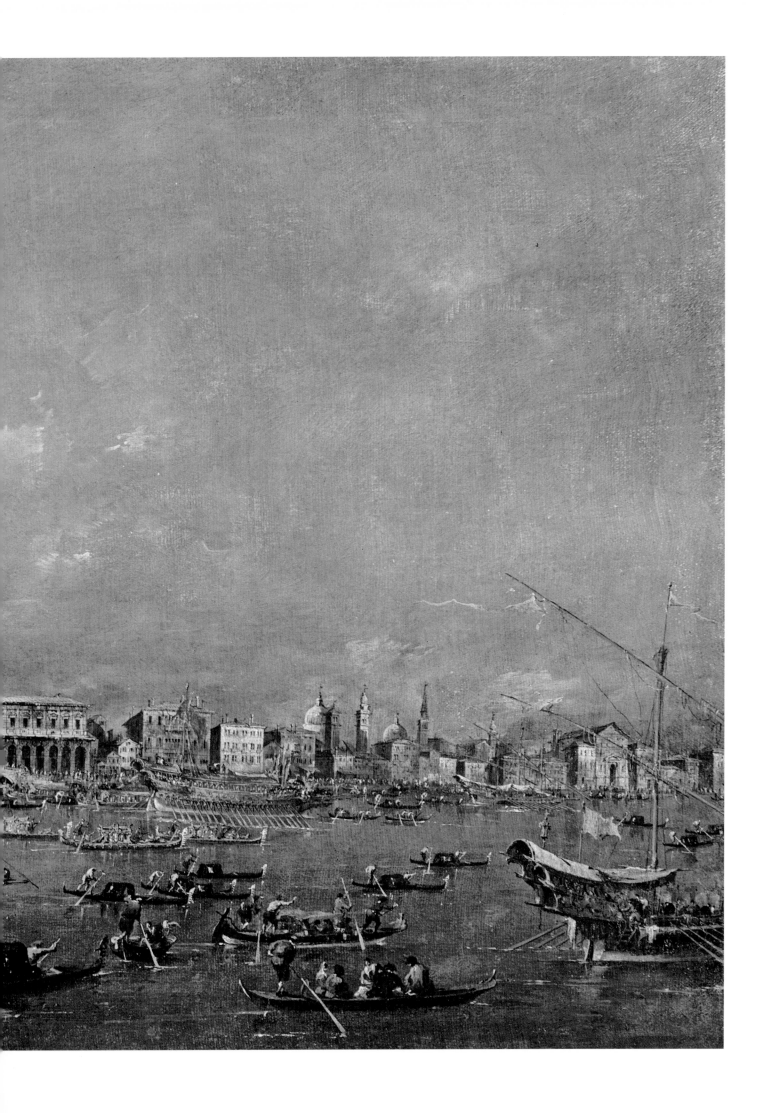

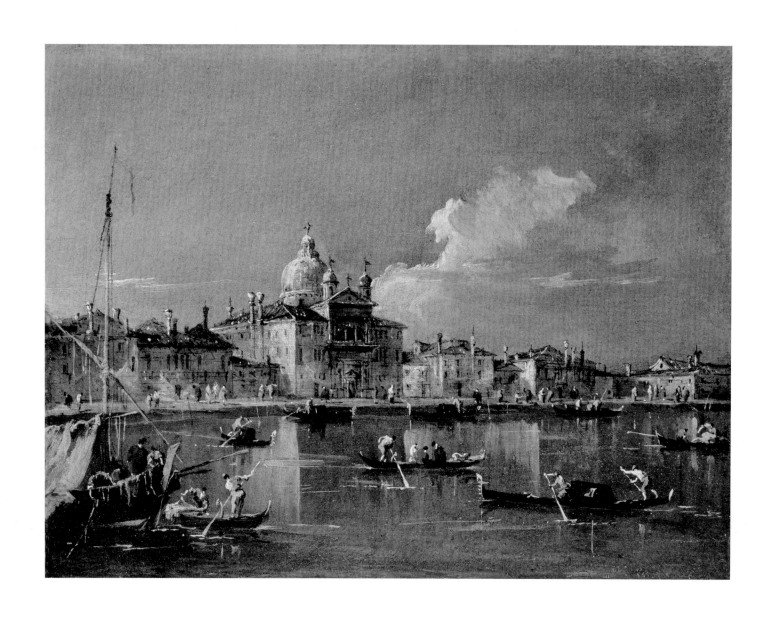

Francesco Guardi, *The Giudecca with the Church of the Zitelle*, 1780/85
Kunsthaus Zürich, Stiftung Betty und David M. Koetser, Zurich, 1986

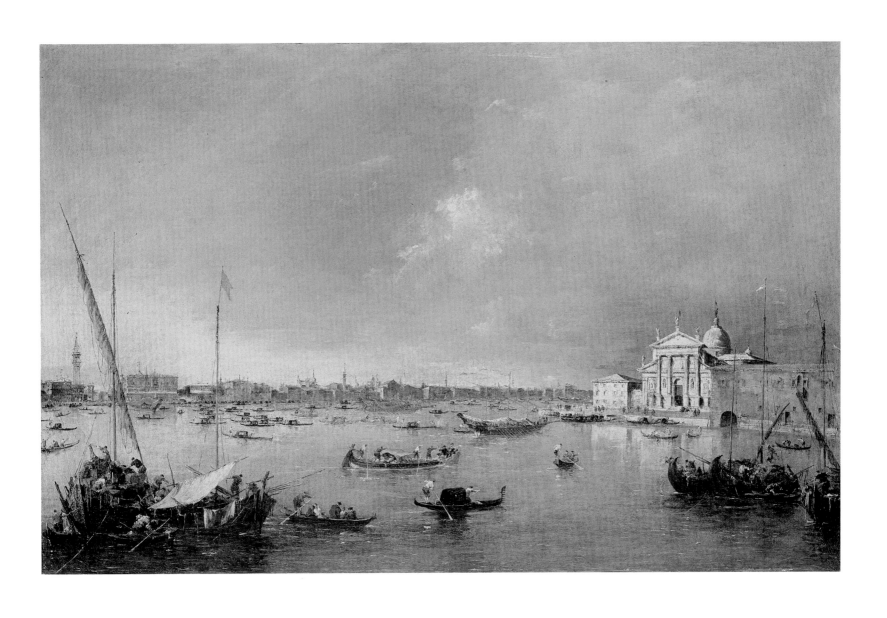

Francesco Guardi, *The Bacino di San Marco with the Bucintoro*, 1780/90
Foundation E.G. Bührle Collection, Zurich

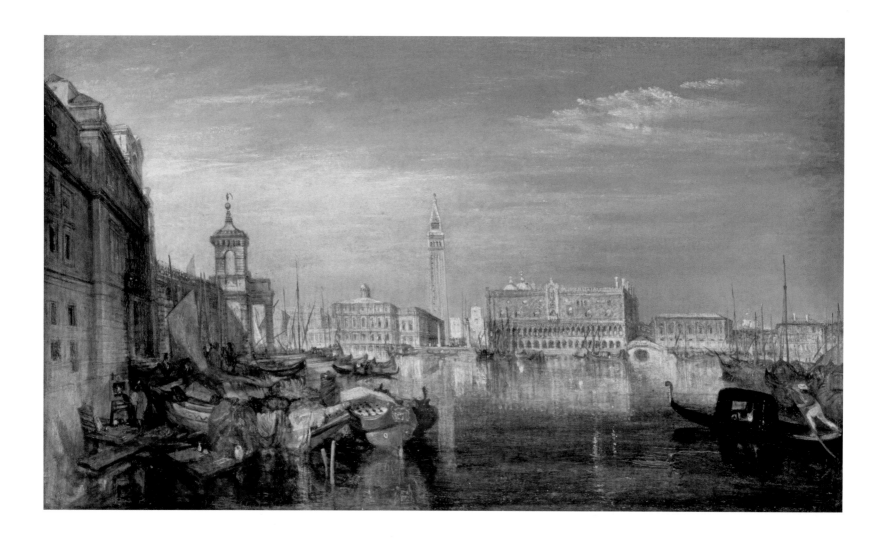

William Turner, *Bridge of Sighs, Ducal Palace and Custom-House, Venice: Canaletti painting*, 1833
Tate, accepted by the nation as part of the Turner Bequest, 1856

THE APPROACH OF NIGHT
TURNER AND LA SERENISSIMA

Ian Warrell

First impressions of an unfamiliar city frequently have a vivid potency that is not effaced by a longer acquaintance, even as the experience becomes richer and more nuanced over time through repeated and more varied contact. Such initial perceptions, though potentially superficial, sometimes manage to distil very precisely the essential characteristics of what exactly is so special about that place. For an artist like J. M. W. Turner (1775–1851), who spent so much of his working life traveling around Europe, collecting hastily-snatched impressions of hundreds of towns and cities, it was absolutely essential that he be able to depend on a finely honed intuition of what would be interesting or appealing in a topographical image.

A sense of Turner's unerring ability to capture the intrinsic qualities of any setting can be readily apprehended in the four breathtaking watercolors he created during his first stay in Venice in September 1819 (fig. 1 and p. 77 bottom).[1] He spent much of his time that year filling a couple of sketchbooks with briskly delineated pencil notations of the palaces and churches that line the city's canals, a practice he continued on subsequent visits in 1833 and 1840, when he also went on to paint dozens of color studies, as well as a series of more than twenty-five oil paintings. Yet despite the extraordinary quality and range of this body of work, the consensus of public and critical opinion has repeatedly discerned in the revelatory watercolors of 1819 an unparalleled response to the particular characteristics of Venetian light that both economically captures the specific scenes, while also being somehow transcendent. Indeed, the miracle of these watercolors is that their subject seems to be barely topographical, or is so only in as much as it focuses on the nature of Venetian light itself.

Each view is suffused with dazzling sunlight, positioned just low enough in the sky to reflect with added intensity across the surface of the lagoon, seeming to cause the artist to squint at his subjects as he attempted to discern architectural details within the silhouettes of the buildings. In the case of his view of San Giorgio Maggiore, the imposing structure of the façade of Palladio's church is effectively lost in the generalized mass of pinky-mauve shadows.

Quite reasonably, the powerful immediacy of Turner's realization of this morning light has typically been assumed to have resulted from sessions of *plein air* painting, directly from nature. But it should be noted that, when in Naples just a month or two later, Turner protested that he more usually sketched on the spot only in pencil because "it would take up too much time to color in the open air—he could make fifteen or sixteen pencil sketches to one colored."[2] In addition to this statement, there are pages in the sketchbooks Turner used in 1819 that correspond closely to the viewpoints of the watercolors, which could imply that his primary response to Venice was actually purely linear, and that he possibly recreated the enlivening atmospheric effects in the color studies subsequently from memory.[3] This was certainly something he did elsewhere. Nonetheless, even though his habitual alchemical process was an incredible feat, worth celebrating in its own right, it remains much more appealing to picture Turner, at dawn, sitting on the landing stage at the mouth of the Grand Canal, enjoying the visual feast in front of him. With time to allow his paint to dry, he would have worked up the finer parts of his compositions over the broad underlying ground washes he had previously applied to distinguish between areas of sky and water. And having completed three views from this

Fig. 1 William Turner, *Venice: San Giorgio Maggiore—Early Morning,* 1819, from the *Como and Venice* sketchbook, watercolor, 22.3 × 28.7 cm, Tate, accepted by the nation as part of the Turner Bequest, 1856

unrivaled vantage point, it is possible to imagine him, later in the morning, crossing the Bacino di San Marco to the island of San Giorgio Maggiore, from where his last color study focused on the most famous cluster of Venetian landmarks: the Campanile, the Piazzetta, the Basilica of San Marco, the Ducal Palace, and the Bridge of Sighs. The complexity of this architectonic ensemble forced him to adumbrate the basic outlines in pencil before working in color, and it is this tangible evidence of his process that tends to argue for the whole group of watercolors being created in the same way, in front of the motif.

Grand claims have inevitably been made for the 1819 Venetian series, though the precise nature of what was achieved should not be overstated: if they do constitute an artistic revolution, it was a "small" or "quiet" one.[4] In fact, during the years preceding the Italian tour, Turner had begun to fill his sketchbooks and portfolios with roughly comparable studies, generally known as "color beginnings," where form is described primarily as blocks of color. These evolved either as separate experimental ideas, or in tandem with designs that were eventually finished for the sets of engraved topographical views, which were a constant in his working life. Even so, few of these earlier works relied on the barely-painted whiteness of the paper to the same extent as the Venetian group in seeking an approximation of the brilliance of light. Perhaps the most curious thing about the Venetian watercolors is that they made so little lasting impression on Turner himself: he did not afterwards use them as the basis for finished pictures; nor did he translate his economic means of recording a setting to the works he exhibited.

It is significant that his stay in Venice in 1819 amounted to no more than a few days in

an itinerary of exactly six months, which centered on a lengthy (if hardly leisurely) sojourn in Rome and its surroundings. Aged forty-four, Turner had for years longed for the opportunity to study the landscape of the Campagna that had inspired the pictures of his most highly esteemed predecessor, Claude Gellée (known as "Le Lorrain," 1600–82). Blinkered by this goal, it seems he quickly put aside his startling first impressions of Venice and its refulgent morning light. Once further south, his work assimilated the experience, but he had, quite literally, already moved on. Thus, his studies at Naples and Tivoli later in the year reveal how he applied to these locations what he had learned from transcribing the light of Venice, even as he concentrated on his aim of surpassing Claude's achievement.

The four or five days Turner spent in Venice in 1819 almost certainly constitute his briefest stay in the city (he was there perhaps a week in 1833, but allowed himself a fortnight on his last visit in 1840).[5] Venice was then considered a dilapidated wreck, and had not quite resumed its place on the Grand Tour of Italy. In addition to this, the bureaucratic procedures imposed on the city in its politically circumscribed state may have been a factor in the length of time Turner was able to stay. For, by this date, the city had been reduced to a pawn in the international political game; captured by Napoleon's troops in 1797, it had since ping-ponged between French and Austrian control, ultimately remaining a province under the Habsburg's until the 1860s. Though it has been demonstrated that the Austrians proved to be more lenient than the French, a lingering awareness of the legendary greatness of the Venetian Empire contrived to emphasize the depths of subjugation to which its citizens had sunk during the first two decades

of the nineteenth century. At the time of Turner's visit, the city's extensive former trading connections had been suspended and its population had dwindled to barely more than 100,000.[6]

As for the potential of Venetian imagery, it is probable that for Turner, as for most of his contemporaries, the image of Venice already appeared to have been exhaustively delineated in the great urban topographical scenes of Canaletto and his school, whether painted or printed, which seemed to leave nothing new for any other artist to say. The main spur to embrace Venice as a subject, in fact, came from contemporary literature. In 1818, just a year before Turner's visit, Lord Byron had published the fourth part of his *Childe Harold's Pilgrimage*, a poetic travelogue in which the central character wandered around Italy, pondering the contrasts between its illustrious past and its present state of ignominious ruin. Setting the scene for these ruminations, at the start of the poem Byron presented Venice metaphorically, evoking a city of fairy-tale palaces doomed to be reclaimed by the lagoon in which they had been built. It was a picturesque notion that had potent appeal for his generation, and inspired others to try their hand at poetic descriptions of the city, such as Samuel Rogers in his extended work *Italy* (1822–28).

It was as an illustrator of these poems, almost a decade after his visit, that Turner began to create images of Venice for the British public.[7] However, these first images are far removed from the freshness and originality of his 1819 watercolor sketches, and instead seem to be reactions to the presentation of the city by his peers, or recollections of established pictorial formulas. In the celebrated 1830 edition of Rogers's *Italy*, for example, he created a

pastiche of one of Canaletto's views of the bustling festive vessels on the Bacino di San Marco surrounding the doge's barge, which had actually been destroyed on Napoleon's order in 1798.[8] The architectural elements of this little scene are exaggerated and not strictly accurate, perhaps resulting from the compressed vignette format (then highly fashionable) that Turner adopted for his design, and which appeared at the head of the page, above the related poem.

A somewhat more individual response can be found in the view of the Bridge of Sighs Turner produced a few years later for an illustrated edition of *The Life and Works of Lord Byron* (fig. 2), though this too is based on a sketch by another artist, rather than on Turner's first-hand observations. It does, however, mark the beginning of a novel way of presenting Venice, bestowing on the infamous prison, adjacent to the Ducal Palace, the furtive romance of moonlight.

The *Bridge of Sighs* design was barely off the press at the start of 1833 when Turner at last started to exhibit oil paintings of Venice at the Royal Academy, then the main forum for contemporary British art. That year, Turner submitted two Venetian subjects, one of which, a study of the columns of the Piazzetta, appears to have resembled the kind of picturesque subjects that had previously been treated by Richard Parkes Bonington (1802–28) or Samuel Prout (1783–1852). The other work, *Bridge of Sighs, Ducal Palace and Custom-House, Venice: Canaletti Painting*, a view from the Dogana (or Customs House, p. 56), was considered by many an attempt to rival another young artist, Clarkson Stanfield (1793–1867), whose Venetian pictures had already found favor with Lord Lansdowne. This aristocratic collector had commissioned a set of ten to dec-

Fig. 2 Edward Finden, after a watercolor by William Turner, based on a sketch by T. Little, *The Bridge of Sighs*, 1832 (from *The Life and Works of Lord Byron*, vol. XI), line engraving, 9.4 × 7.9 cm, Tate, purchased 1992

orate his home at Bowood. As an ensemble, this group was clearly conceived to be on a par with the famous Canaletto room at Woburn. Rightly or wrongly, Turner's peers attributed to him a sense of grievance that he had not won this commission, identifying his picture as a rebuke to both patron and potential rival. Though Turner was not averse to spirited confrontations of this kind with his colleagues, he more regularly positioned himself in direct competition with the great landscape artists of the past. In this case, it is clear that the chief point of his painting was to invoke the imagery of Canaletto (or "Canaletti," as the British sometimes called him in the early nineteenth century).[9] To underline his point, Turner actually included the figure of the eighteenth-century view-painter in the left-hand foreground, showing him, inappropriately, in the act of completing work on a heavily framed canvas. This detail is given further emphasis by the reference to it in the title, where Turner indulges his delight in word play: "Canaletti Painting" could allude simply to the artist at work, or indicate that we should consider Turner's picture as a trope, essentially comparable with a painting by Canaletto. But whereas Canaletto's images of the Bacino tend to foreground the pomp and glittering splendor of Venetian pageantry, Turner presents the commercial hub of the city as a mirage, its waters unnaturally becalmed and reflective. The sense of stillness is heightened by Turner's decision to frame artificially the left side of his view with the southern flanks of the Dogana, which in reality cannot be seen in conjunction with the rest of the scene; the building acts exactly like a piece of stage scenery, leading the eye to the distance. Though not completely deserted, the limited activity Turner depicts beside the Dogana contrasts sharply with the idea of

Venice as a great trading city. Just as the china pots (which also appear in several of Turner's other Venetian pictures) and the sumptuous fabrics draped over the boats suggest the extent of the city's former global reach. One could also assume that, by association, Canaletto and his art are also to be considered similar "scraps" of Venice's past.[10]

By the 1830s, Turner's pictures were increasingly denounced as willfully eccentric, particularly for his use of vibrant color. But the "Canaletto" picture won over most of the critics, as well as finding a buyer in Robert Vernon, one of the new mercantile class that supported the later part of Turner's career. Another anecdote claims that the strength of Turner's blue sky here was the result of a rivalry with yet another artist, George Jones (1786–1869), whose view of *Ghent*, hanging nearby, was dominated by the same tone. Jones's picture is now untraced, but perhaps it, like the views of Turner and Stanfield, may have made use of the striking brilliance of a synthetic ultramarine pigment, which had been introduced only a few years before. Turner's sky, with the lofty cirrus and thickening cloud to the northwest, skillfully intimates the sense of a specific time of day, and is the first of his paintings to evoke the late afternoon light of Venice, the time of day that he invariably chose for his pictures of the city. Indeed, about three quarters of his views feature this type of lighting, something that will be explored more fully later in this essay.[11]

The critical and financial success Turner achieved with his first paintings of Venice in 1833 was no doubt a factor in his decision to visit the city again later that year, though perhaps more significant was the fact that the considerable expense of his journey was underwritten by his friend and patron Hugh Andrew

Johnstone Munro of Novar (1797–1864). This wealthy Scot had already begun to acquire Turner's pictures, and offered the artist this chance to travel south once more, assuming that he would subsequently be able to select one of the resulting Venice subjects (He was the first owner of the canvas produced in 1835, *Venice from the Porch of Madonna della Salute*, now in The Metropolitan Museum of Art, New York).

Turner arrived in Venice on September 9, and remained there about a week. His sketches indicate that he very probably stayed at the Hotel Europa in the Palazzo Giustinian, near the mouth of the Grand Canal, from where, had his room been at the front of the palace, he would have enjoyed views similar to those he had transcribed so effectively in watercolor fourteen years earlier. A note of chimneys and church steeples visible from the rear of the building, however, suggests that Turner's outlook was not so well favored, but that it introduced him to a private Venice that had rarely been explored by other artists.[12] Another guest at the Europa at this time was François René, Vicomte de Chateaubriand (1768–1848), though there is no indication that the two men met. As on all his other journeys, Turner kept no diary, so we have only his sketches as a record of where he went, what he saw, and of anything else that snagged his interest. In addition to the dozens of sketches he made in a thick book, bought in Vienna earlier on his journey, Turner seems to have made some studies in muted color on separate sheets of gray paper (i.e. pp. 78 bottom, 82). A couple of these have roughly the same compositions as the paintings he exhibited in London over the next few years, but as he also used the same gray paper on his third and final visit to Venice in 1840, it is difficult for the moment to rule out the pos-

sibility that they could be recollections of the pictures created at that time.[13]

The first of the four larger-format Venetian subjects to appear between 1834 and 1837 was titled simply *Venice* in the Royal Academy catalogue (fig. 3). Once again, Turner anchored his viewers alongside the Dogana, utilizing its receding lines to lead the eye towards the island church of San Giorgio Maggiore, its marble façade dazzling in the late afternoon sun. The costumes of the figures and the rich contents of the boats evoke more specifically the Venice of the past. During the 1830s Turner frequently conceived his pictures as related pairs, most often contrasting past and present states of Italy, but his Venetian pictures also carried implicit warnings of the dangers of commercial complaisance to his countrymen, who considered themselves the heirs of Venice's maritime empire. Byron had warned his compatriots:

. . . in the fall
Of Venice think of thine, despite thy watery wall
(Childe Harold's Pilgrimage, Canto IV, XVII)

In the case of the 1834 picture, Turner possibly originally paired it with a shipwreck scene on the northeast coast of England. However, a year later, the first owner of *Venice* (the owner of cotton mills in Manchester) commissioned him to paint a moonlit view of the quays bordering the estuary of the River Tyne. Through its coal and iron, this area made a major contribution to Britain's industrial might, so the selection of this subject implicitly endorsed the widespread notion of a Venice-Britain parallel, and the admonitory note that this carried.[14]

Moonlight was also the subject of the most controversial of Turner's Venetian scenes—*Juliet and her Nurse*—which was exhibited in 1836 (fig. 4). In addition to the mockery he suffered for his curious and erroneous decision to

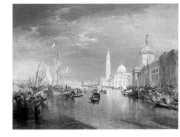

Fig. 3 William Turner, *Venice (the Dogana and San Giorgio Maggiore)*, 1834, oil on canvas, 91.5 × 122 cm, National Gallery of Art, Washington, D.C., Widener Collection

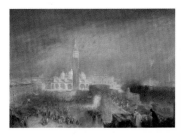

Fig. 4 William Turner, *Juliet and her Nurse*, 1836, oil on canvas, 92 × 123 cm, Sra Amalia Lacroze de Fortabat, Argentina

place Shakespeare's heroine in Venice, instead of Verona, the critics alleged that the details of Turner's representation of Venice were faulty. His idea for a nocturnal scene, looking down on the Piazza San Marco filled with carnival revelers, probably stemmed from his rooftop experiences during the 1833 visit, but the lack of precise sketches from this viewpoint forced him to fall back on other sources and his memory, resulting in distortions to his rendering of the façade of the Basilica and the placing of its Campanile. Yet, despite these shortcomings, Turner's subdued nocturne has a haunting magical romance, picking up on the mood of his earlier vignette of *The Bridge of Sighs* (fig. 2). Its deft use of a variety of punctuating light effects, erupting from the prevailing gloom, grows out of his depictions of the burning of the old Houses of Parliament a year earlier.[15]

Recalling these effects during his final visit to Venice, at the end of August 1840, Turner embarked on a series of moonlit color studies on sheets of brown or buff-toned paper. Some of these repeat the motif of the city's skyline illuminated by fireworks (p. 84 top), while others present the well-known landmarks of Venetian topography (p. 80 top and bottom), their details given an unfamiliar air of fantasy by the transforming qualities of moonlight. These private studies are bold and experimental, deploying an economy that pushes the means of representation to its limits, as if Turner was justifying what he had created imaginatively in 1836 by testing his abilities against reality. It may have seemed to Turner that moonlight provided him with a unique means of representing Venice that offered an alternative to the crisply sparkling views produced by Canaletto and his followers. But he would presumably also have been aware of the development of the literary preference for

Venice after dark in the writings of Byron, Rogers, and Thomas Moore (whose Venetian poems were set to music by Adolf Jensen, Mendelssohn and Schumann).

From 1840 onward Turner's paintings were most clearly influenced by Byron's vision of Venice, and when exhibiting them he regularly selected lines from *Childe Harold's Pilgrimage* to accompany their titles in the official catalogue. But annotations on several of his watercolors indicate that he also knew and savored the extramarital liaison humorously recounted in the poet's *Beppo* (1818). Turner's recollections of this text particularly colored the studies he made from the rooftops of the Hotel Europa, where he was able to peer down through windows, and perhaps witness romantic assignations (fig. 5 and p. 88). He lingered at the hotel for about two weeks on this final visit to the city, utilizing his bedroom as a makeshift studio, where he worked up his impressions in watercolor, infusing his scenes with his distinctive vaporous miasma. He also seems to have found time to sketch in color at several points along the Grand Canal (p. 79 top and bottom). Collectively, the Venetian watercolors of 1840 represent a refocusing of his energies, demonstrating again and again his mastery of the suggestive possibilities of the most limited means of expression. Perhaps more than the ensuing paintings of the next six years, these works offer the most forward-looking and enduring contribution to the image of Venice of any artist since Canaletto, tapping unerringly into the originality of Turner's response in the watercolors of 1819. They are, however, based on a deeper knowledge and a closer observation of the city. Instead of concentrating solely on the burst of shimmering light after daybreak, they are far more wide-ranging in their realization of dif-

ferent times of day. Even so, there is a marked preference for the slanting rays of afternoon or early evening, which cast violet shadows across the buildings, at the same time creating longer reflections on the surface of the lagoon. This prevailing twilight mood can also be traced back to Byron; Turner's favorite lines by the poet, those he quoted most often, focus on exactly this moment:

The moon is up, and yet it is not night –
Sunset divides the sky with her. . . .
(Childe Harold's Pilgrimage, Canto, IV, XXVII)

Appropriately, the only account of Turner actually at work in Venice is a charming description of him diligently sketching San Giorgio Maggiore from a gondola at sunset, the façade of the church apparently glowing magnificently before him. The impressionable young British artist who witnessed this moment was William Callow (1812–1908), who felt guilty that he had already abandoned his own labors in order to enjoy a cigar as he was rowed across the Bacino.[16] The sketches Callow observed Turner making are almost certainly those in the *Venice and Botzen* [sic] sketchbook (figs. 6, 7), where, over a series of pages, the sun can be seen gradually sinking to the west. Flicking carefully through these sheets, the nature of Turner's mark-making is always assured, if astonishingly rudimentary, especially regarding atmospheric conditions. The sun's presence, for example, is indicated merely by a circle, with no hint of the colors it produces, though Turner did suggest the way the combined bulk of the Salute and the Dogana become one silhouette with a brusque area of hatching. Despite the negligible nature of his notes of such effects, the images Turner made back in his studio were, amazingly, usually informed by a correct sense of the position of sun in relation to the site depicted.

However seductive Turner found the final hours of daylight in Venice, as a maker of images he was instinctively alert to the symbolic qualities of sunset. Indeed, he knew from his admiration of Claude's landscapes that the representation of certain times of day carried strong associations, or moral qualities, particularly if paired with contrasting states, and this was something that underpinned his own realizations of ancient Carthage, which lie at the heart of his ambitions as an artist.[17] In those works, the pure hopes and ambitions of Dido and her countrymen are epitomized by the radiant dawn in the first canvas. By contrast, the departing sun in his depiction of the final days of Carthage makes plain the city's exhausted and degenerate state. It is probable, therefore, that a similar principle is at work in the later views of Venice. Indeed, in those canvases exhibited from 1840 onwards, it is notable that he frequently elected to suggest opposing times of day, either explicitly, as in the titles of his works in 1845 and 1846 (pp. 70, 71), or more subtly, for those who knew Venice well. Where no contrast was directly intended, the majority of these late pictures depict a city burnished by the flickering rays of sunset, presumably in accordance with the notion of the place as a beautiful, but ruined shell of its former self, the images in effect acting as visual elegies for a dead empire. Even one of Turner's rare Venetian sunrise subjects carries this sense of loss, and impending doom (fig. 8). This painting of the eastern parts of Venice, nearest to the sea channel, was first exhibited in 1843, and draws the viewer's attention directly to the inextricable interplay between the actions of humanity and the sun, both through its title and the image painted on the sail of the *bragozzo* setting out to sea. Superficially this is a scene of boisterous hope, filled with flutter-

Fig. 5 William Turner, *View over the Rooftops towards the Giardini Reali and the Campanile of San Marco*, 1840, pencil, watercolor, and bodycolor, 19.3 × 28 cm, Tate, accepted by the nation as part of the Turner Bequest, 1856 (work exhibited)

Figs. 6–7 William Turner, *Sketches of San Giorgio and the Bacino di San Marco at Sunset*, 1840, from the *Venice and Botzen* sketchbook, pencil, each leaf 12.3 × 17.3 cm, Tate, accepted by the nation as part of the Turner Bequest, 1856

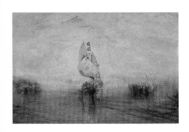

Fig. 8 William Turner, *The Sun of Venice Going to Sea*, 1843, oil on canvas, 61.6 × 92.1 cm, Tate, accepted by the nation as part of the Turner Bequest, 1856

ing sails, catching the strengthening light. But it is actually a false dawn, as is clear from the lines of poetry Turner appended to the title (from his on-going, but unpublished epic *The Fallacies of Hope*), in which he cautioned the viewer to be aware that this spirited embarkation would meet with tragedy before the day's end. Presumably embodying the fate of Venice itself, the fishing boat's inescapable future reckoning is in fact embedded in its very essence, a message that Turner pinpointed by decorating the sail, right at the center of the image, with a setting sun.

As well as pondering the demise of the most fabulous of cities, some writers have proposed that the aging Turner may have been considering his own mortality in these scenes. If this is so, there is nothing maudlin about Turner's exploration of this theme. He may well have been sixty-five when he made his final stay in Venice, but he certainly did not, at the time, believe it was his last visit, in fact expressing his hopes of returning there at least once in the following years. So it would be wrong to locate a sense of leave-taking in the images he made in the city in 1840. Of those that he created subsequently, it is notable that he focused specifically on the cemetery island of San Michele in *Campo Santo*, one of the pair of canvases he exhibited in 1842 and now in the Toledo Museum of Art. There, the long brick wall of the cemetery shimmers in a soft indeterminate light, but the viewer's attention is caught by a fishing boat, its white sails paired in form like an angel's wings. Far from being morbid, the scene is transcendent and uplifting. Indeed, Turner deliberately resists all conventional associations of mood and color, to "combine thoughts of death with light, not darkness," as has been noted recently by Sam Smiles.[18] It is yet another in-

stance of the artist challenging the over-neat equations some theorists, such as Goethe, tended to make between colors and emotional states.[19]

Judged as a complete body of work, the paintings created in the wake of the 1840 visit offer a more coherent and distinctively Turnerian vision than the earlier Venetian scenes. These pictures are smaller than those painted in the 1830s, and considerably less resolved in their attention to the specifics of place. In terms of the more pronounced physical qualities of Turner's technique, this was a development that was bemoaned by contemporary critics, who felt that the images lacked legibility. They consequently accused Turner of throwing his pigments at the canvas, and of simply making use of the patterns that resulted. But this was to misunderstand how Turner's images were built up carefully through the accumulation of layers of washes or glazes in a process more akin to his own watercolor technique than twentieth-century Action Painting. We can glean something of the very beginnings of his Venetian pictures from the handful of preliminary (or interrupted) ideas that remained in his studio, and which were only catalogued for the first time in the 1940s (pp. 72, 73, 76). In each of these there is just the intimation of underlying structures, or hints of human activity, but these features would have been steadily given more strength as Turner advanced his design towards a more conventional state of finish. He had evolved this method of working during the 1820s, and frequently only brought his canvases to their final resolution once they had been hung on the walls of the annual exhibition, so that he was assured of outshining the adjacent paintings. His Venetian subjects proved exceptionally popular, generally selling much more

readily than most of his later work, which explains why there are so many incomplete works of this kind. He presumably began work on several canvases at the same time, and having decided to exhibit a couple, kept the others in reserve to fulfill future commissions. Accordingly, appealing though these works are to the modern aesthetic, it should be recognized that neither Turner, nor his peers, would have contemplated them as exhibitable as we see them now.

In the 1840s, as Turner moved away from the particularities of Canaletto's Venice and began to fashion his own more generalized alternative, he increasingly selected viewpoints that enabled him to paint the city as a distant prospect, its spires and domes stretched out along a beckoning horizon. Instead of the civic face of the city, or its main canals, he drifted out to its peripheries. His subject became the spine-tingling anticipation of arriving in Venice, or the charged emotions felt by a visitor on departing, as transient visual pleasures are left behind. Picking up the theme of his 1836 depiction of the Piazza, several of Turner's later pictures are explicitly about the lure of carnival, and purport to depict revelers traveling on the expanses of the lagoon, to or from a ball, or some other festivity, in the city (pp. 70, 71). It is highly doubtful that any of Turner's own visits coincided with the weeks of Carnival during Lent, but he may have been aware of these celebrations, which had once been the principal attraction for earlier Grand Tourists, who timed their visits to Venice in order to witness (and often to participate in) the louche spectacle. There were also a host of other saint's days and local festivals in the various *sestieri* of Venice, the details of which may have contributed to Turner's fanciful evocation of a city perpetually *en fête*.

Undoubtedly the most visually sumptuous of this small series of journeys across the lagoon is the *Approach to Venice*, which was first exhibited in 1844 (fig. 9). As in the lines of Byron that Turner found so potent, and which he used again to accompany this painting, the sky here is a skillful blend of the fading glow of sunset and the cool, deep tones gathering around the rising moon. What Turner achieves could also serve to illustrate a word picture that appears just a few lines later in *Childe Harold's Pilgrimage*:

Fill'd with the face of heaven, which, from afar,
Comes down upon the waters; all its hues,
From the rich sunset to the rising star,
Their magical variety diffuse. . . .
(Canto IV, XXIX)

Indeed, Turner seems to revel in the splendor of twilight, fully savoring that barely and only briefly perceptible threshold between day and night. So much of the picture's beauty lies in the subtle way he builds up color with delicate touches of his brush, almost as if he were finessing a miniature. With the sole exception of an emphatically black gondola near the center of the image, most of the vessels, as well as the city itself, have an insubstantial quality, like shades that might evanesce into vapor. One might speculate that Turner is here making the fairly standard association between the blackness of the gondola and a coffin.[20] But, as in the *Campo Santo* painting discussed above, if this is indeed a metaphorical crossing of the Styx, it is one that confounds expectations of how the passage from life to death might be represented. Poised on the cusp of nightfall, Turner's image is one still captivated by what is visible, even as it hints at the mysterious beauties to follow.

The painting was one that the critic John Ruskin (1819–1900) especially admired, though

Fig. 9 William Turner, *Approach to Venice*, 1844, oil on canvas, 62 × 94 cm, National Gallery of Art, Washington, D.C., Andrew W. Mellon Collection

he felt its vibrant colors diminished soon after it was first exhibited. (He made similar allegations about many of Turner's later paintings, which sometimes featured new, untried pigments, or were finished with watercolor applied to a canvas already daubed with oil paint.) Then still only in his mid-twenties, Ruskin was already a published defender of Turner's art, having brought out (anonymously) the first volume of *Modern Painters* in the spring of 1843. Given that the aim of his book was to champion Turner's latest paintings, it is perhaps curious that Ruskin and his wealthy father did not buy *Approach to Venice*, or any of the other recent Venetian subjects. It may be that they refrained from making this sort of acquisition because these subjects were not perceived to be problematic, and were, in fact, avidly sought by new and more established collectors. In any case, it seems the Ruskins generally preferred Turner's work in watercolor, a media in which he continued to excel and innovate. It is clear, however, that they continued to have a deep appreciation of the Venetian paintings, looking back almost a decade later with regret at their decision not to acquire one of those shown in 1843.[21] It was not entirely a coincidence that Ruskin should have been in Venice itself when Turner died at the end of 1851, since his study of the artist's works had overlapped with his love of the city, leading to the intensive research that resulted in *The Stones of Venice* (1851–53). He was fortunately able to repay the inspiration he had drawn from Turner by sending him a copy of the first volume of the book with a handwritten dedication, and was continuing his writing when the news of the artist's death reached him. Though he ranged over the countless images he knew by Turner, it was those of Venice—particularly *Campo Santo* and *Approach to Venice*—that he appears to have conjured up in his mind's eye when trying to sum up all that he had found remarkable. Writing home to his father, he lamented, "every thing in the sunshine and the sky so talk of him. Their Great witness lost."[22] One cannot help but agree, for, in Venice, Turner met a subject that so perfectly suited his interests, his temperament, and his abilities that the works he produced at the end of his life combine to create one of the most harmonious aspects of his career, a palpably credible vision that continues to exert its appeal. This is especially true of the matchless watercolors, in which his lightness of touch captures something of the fleeting pleasures stirred by reflections and their shifting patterns, which color any visitor's experience of Venice. Though his impressions may be essentially those of a mere tourist, rather than being founded on the knowledge of a resident, steeped in years of careful study of the fabric of the place, there is a telling delicacy that chimes perfectly with the city's enduring fantastical qualities. And so in Venice today, if we are fortunate enough, we can still glimpse Turner's Venice, even if we cannot actually inhabit it; just as eighteenth-century visitors saw Venice with Canaletto's eyes, the corners of this most elusive city are now forever haunted by the images Turner painted.

Standard abbreviated references: Alexander Joseph Finberg, *A Complete Inventory of the Drawings of the Turner Bequest*, 2 vols. (London, 1909).

[1] See Turner's *Como and Venice* sketchbook (Tate: TB CLXXXI ff. 4–7); the other watercolors in the book were painted at Menaggio on Lake Como (ff. 1, 2), but Turner's first study in the book is likely to have been the previously unidentified view over the rooftops of Milan (f. 3). Turner's work in Venice, including the 1819 watercolors, is covered in A.J. Finberg, *In Venice with Turner* (London, 1930), Lindsay Stainton, *Turner's Venice* (London, 1985), and most recently Ian Warrell, ed., *Turner and Venice*, exh. cat. Tate Britain, London, and Kimbell Art Museum, Fort Worth (London, 2003). The 1819 watercolors, and how they were produced, are also discussed in Eric Shanes, *Turner's Watercolor Explorations, 1810–1842*, exh. cat. Tate Gallery (London, 1997), nos. 4–5.

[2] Quoted in A.J. Finberg, *The Life of J.M.W. Turner*, 2nd revised edition (Oxford, 1961), p. 262.

[3] See TB CLXXV ff. 40, 66 verso and TB CLXXVI ff. 20 verso, 21.

[4] See Michael Bockemühl, *J.M.W. Turner: 1775–1851. The World of Light and Color* (New York, 2001), p. 33.

[5] For further discussion of the dates of Turner's trip: Warrell 2003 (see note 1), pp. 15–16, 30–3. However, see *Turner and Italy*, exh. cat. (Ferrara, 2008), in which James Hamilton proposes a different range of dates for the 1819 visit, somewhat improbably identifying the artist with an individual listed twice as "Curner, William" who was there from September 1–9.

[6] See David Laven, *Venice and Venetia under the Habsburgs, 1815–1835* (Oxford, 2002), p. 36.

[7] Prior to this, possibly soon after the trip itself, he seems to have begun a large oil painting of the Rialto bridge, but abandoned it at a rudimentary stage (Warrell 2003 see note 1), p. 18, fig. 5).

[8] TB CCLXXX 193; Warrell 2003 (see note 1), pp. 76–5, figs. 64–65. See also Katharine Baetjer, "'Canaletti Painting': On Turner, Canaletto, and Venice," in *Metropolitan Museum Journal*, no. 42 (2007), pp. 163–72, which questions Turner's dependence on Canaletto in this image, though no alternative source is proposed for the conjunction of this view and the *Bucintoro*, however flawed the realization.

[9] In the same exhibition he included a painting of *Van Goyen Looking Out for a Subject* (Frick Collection, New York). There is an ambiguity to these works, which could just as easily be critiques as homage's of each artist. Since both works show painters confronting subject types that they are particularly associated with, Turner's point may be that the straightforward transcription from nature was insufficient in itself and that an imaginative response was also needed to create great works of art.

[10] According to his friend, George Jones, this was the disparaging term Turner used for the painting when he sold it in 1833 (see Martin Butlin and Evelyn Joll, *The Paintings of J.M.W. Turner* (revised edition 1984), pp. 200–01, no. 349).

[11] If, as some writers have claimed, TB CLXXXI 7 was the starting point for *Canaletti Painting*, Turner would have had to adjust the viewpoint as well as the lighting, which is bright morning in the sketch, though his ability to rework source material of this kind (or, alternatively, images by other artists) was fundamental to his imaginative creativity (see note 9).

[12] There are, for example, just a couple of drawings by Canaletto of the rooftop view from the windows of his home near San Lio (British Museum and a private collection in the USA).

[13] Further analysis of Turner's later papers may make it possible to link these sheets more effectively with others from one or other tour.

[14] See *Keelmen heaving in Coals by Moonlight*, 1835, National Gallery of Art, Washington, D.C.

[15] See the paintings of 1835 in the Cleveland Museum of Art and the Philadelphia Museum of Art.

[16] H.M.Cundall, ed., *William Callow: An Autobiography* (London, 1908), pp. 66–67. Warrell 2003 (see note 1), p. 97 for views of the Grand Canal by both Turner and Callow from this 1840 visit.

[17] See *Dido building Carthage*, 1815, National Gallery, London, and *Decline of the Carthaginian Empire*, 1817, Tate Britain. In the first draft of Turner's will, both pictures were originally intended to hang alongside works by Claude in the National Gallery.

[18] See Sam Smiles, *The Turner Book* (London, 2006), p. 132.

[19] See Gerald Finley, *Angel in the Sun. Turner's Vision of History* (Montreal/Kingston, 1999), pp. 200–08, and John Gage's entry on Goethe in Evelyn Joll, Martin Butlin, and Luke Herrmann, eds., *The Oxford Companion to J.M.W. Turner* (Oxford, 2001), pp. 127–28.

[20] See, for example, the comments of Percy Bysshe Shelley, who likened gondolas to "Moths of which coffins might have been the chrysalis" (1818).

[21] See letter from Ruskin to his father, January 1852, in John Lewis Bradley, ed., *Ruskin's Letters from Venice 1851–1852* (New Haven/London, 1955), p. 127.

[22] Ibid., p. 112.

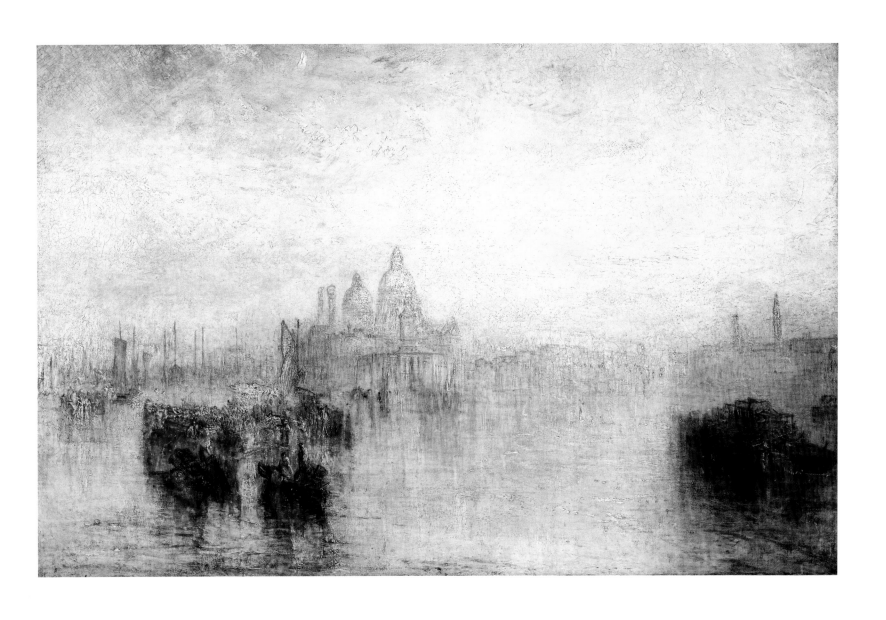

William Turner, *Venice—Maria della Salute*, 1844
Tate, accepted by the nation as part of the Turner Bequest, 1856

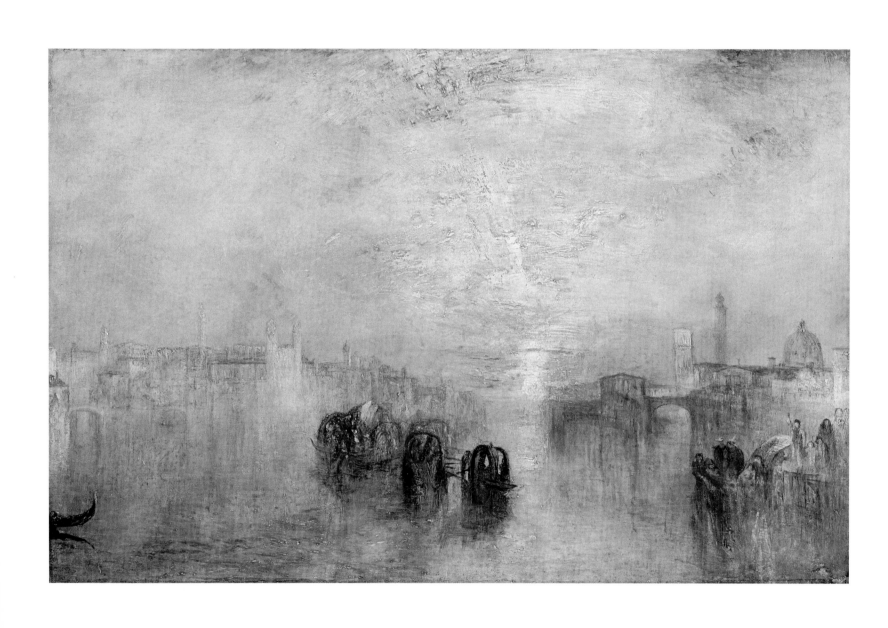

William Turner, *Going to the Ball (San Martino)*, 1846
Tate, accepted by the nation as part of the Turner Bequest, 1856

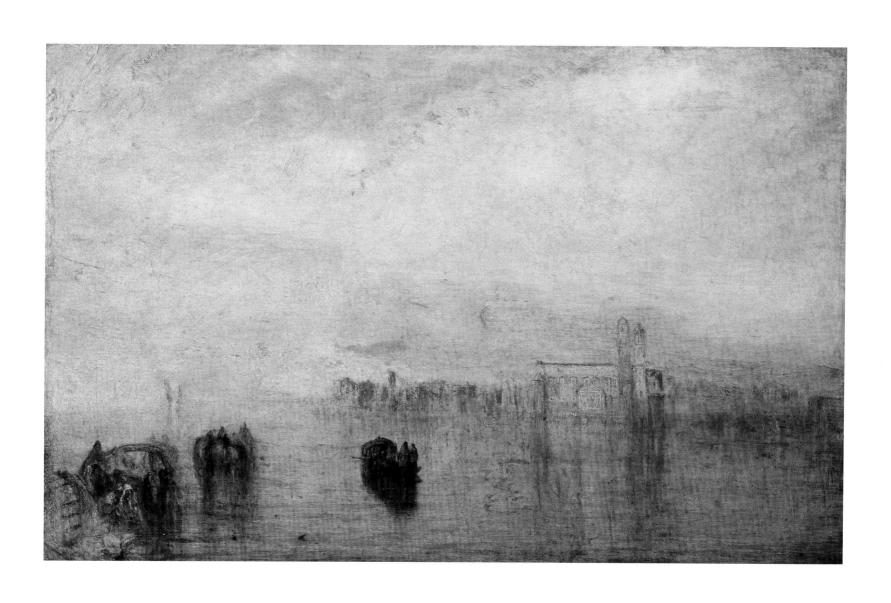

William Turner, *Returning from the Ball (St Martha)*, 1846
Tate, accepted by the nation as part of the Turner Bequest, 1856

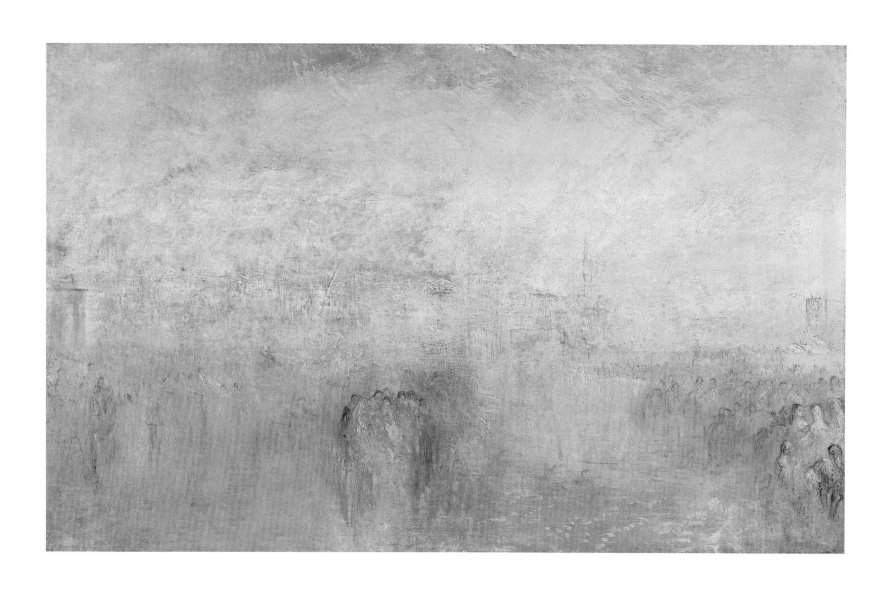

William Turner, *Venetian Festival: View over the Bacino, with the Dogana on the left, c.* 1843/45
Tate, accepted by the nation as part of the Turner Bequest, 1856

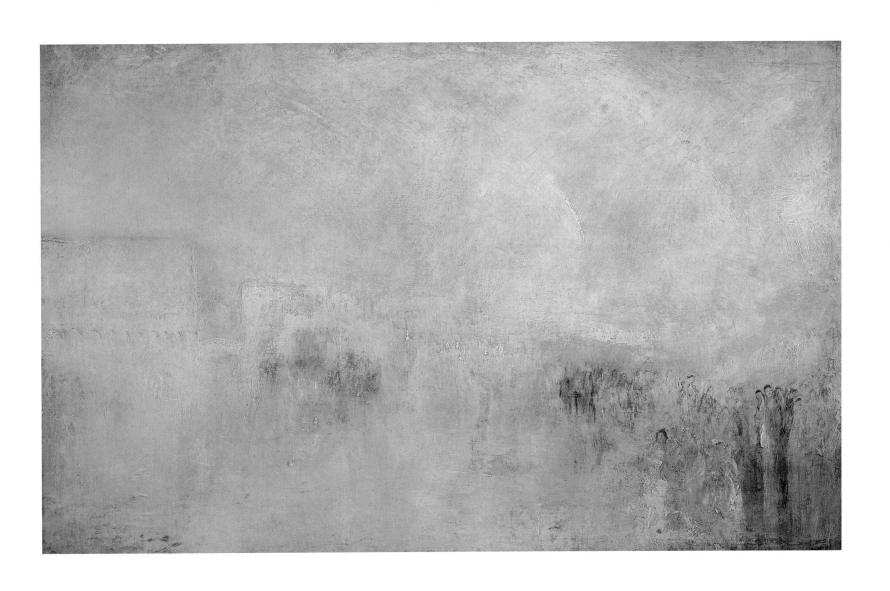

William Turner, *Riva degli Schiavoni, Venice: Water Féte, c.* 1843/45
Tate, accepted by the nation as part of the Turner Bequest, 1856

Pages 74–75:
William Turner, *The Dogana and Santa Maria della Salute, Venice,* 1843
National Gallery of Art, Washington, D.C., donated in memory of Governor Alvan T. Fuller by The Fuller Foundation

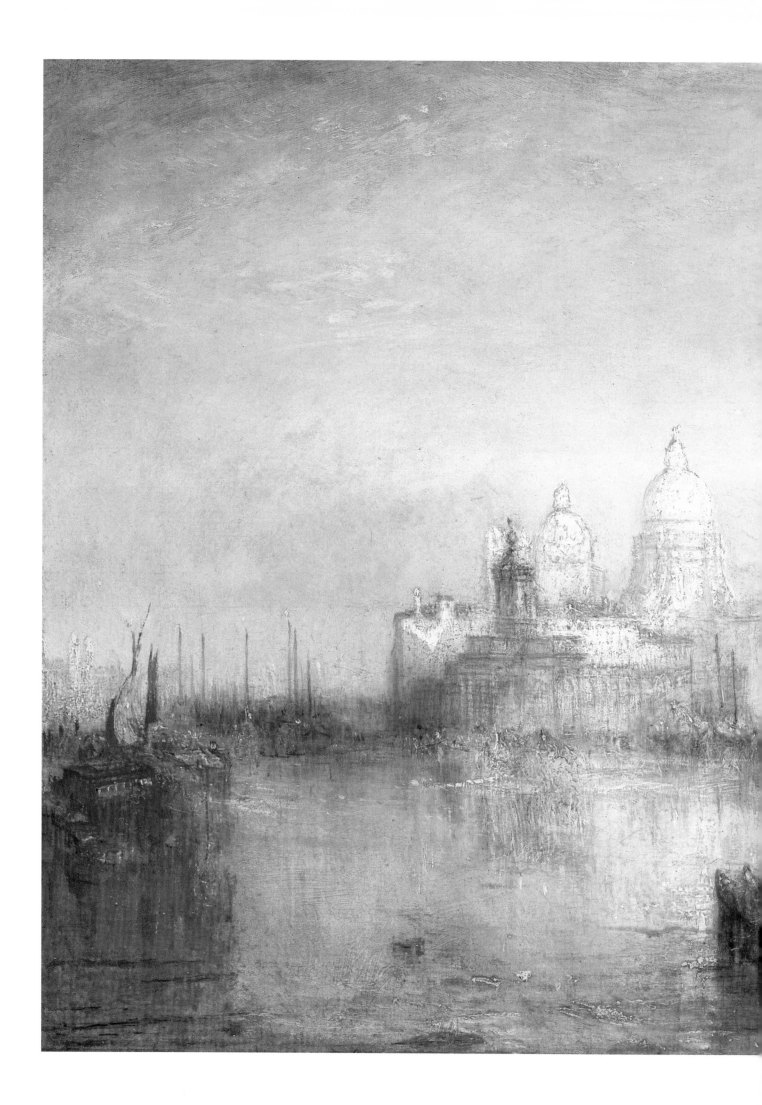

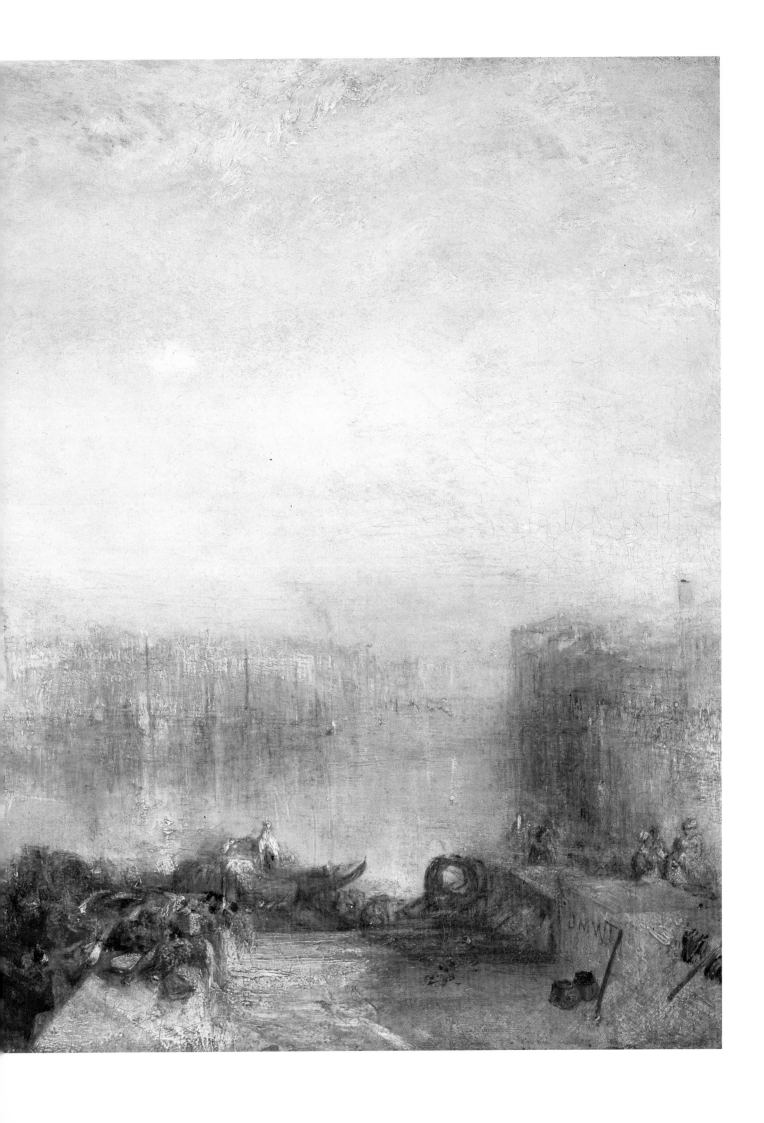

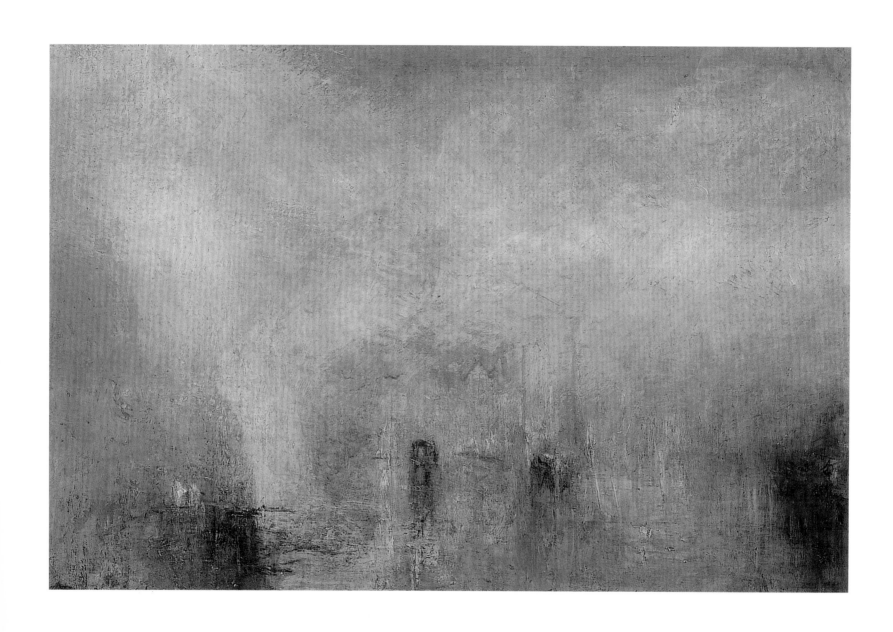

William Turner, *Scene in Venice, probably looking down the Grand Canal from alongside the Palazzo Mocenigo, c.* 1844
Tate, accepted by the nation as part of the Turner Bequest, 1856

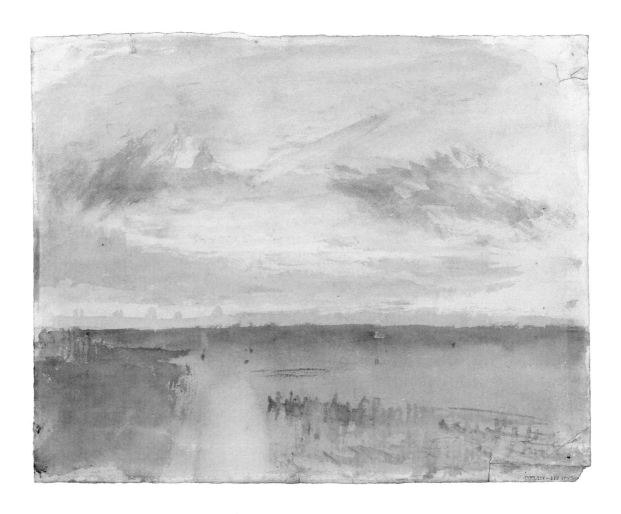

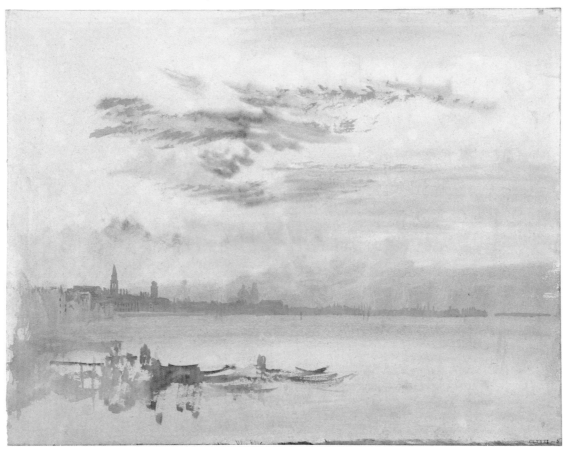

William Turner, *An Open Expanse of Water on the Lagoon, near Venice, c.* 1840
Tate, accepted by the nation as part of the Turner Bequest, 1856

William Turner, *Venice: Looking East towards San Pietro di Castello—Early Morning,* 1819
Tate, accepted by the nation as part of the Turner Bequest, 1856

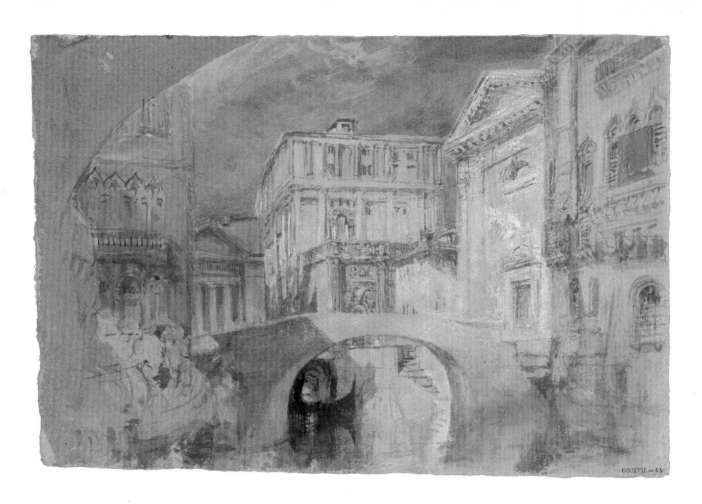

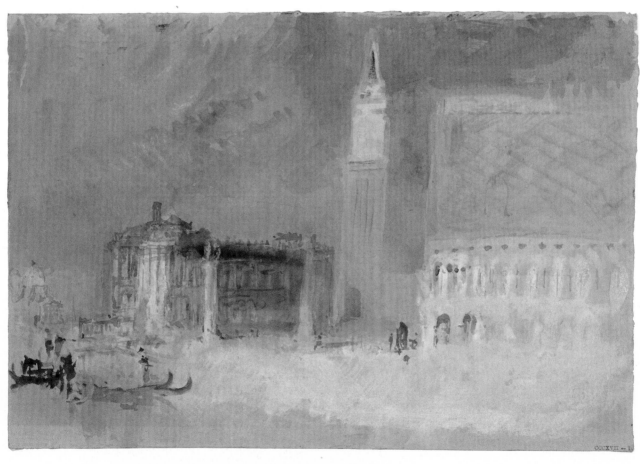

William Turner, *The Church of San Luca and the Back of the Palazzo Grimani from the Rio San Luca*, 1840
Tate, accepted by the nation as part of the Turner Bequest, 1856

William Turner, *The Piazzetta and the Doge's Palace from the Bacino, c.* 1840
Tate, accepted by the nation as part of the Turner Bequest, 1856

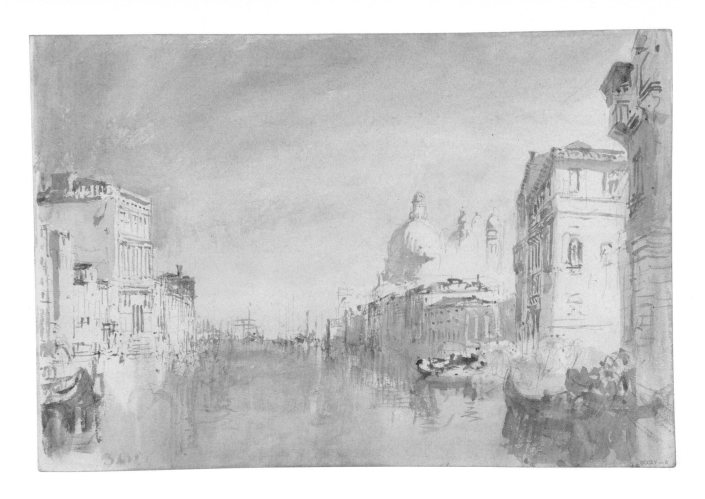

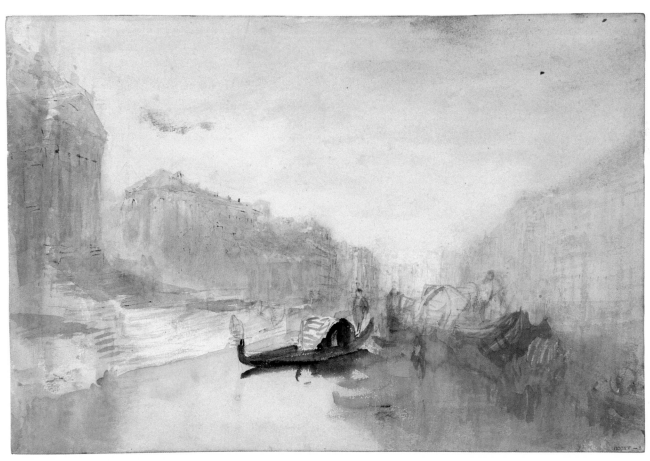

William Turner, *Looking down the Grand Canal to Palazzo Corner della Ca' Grande and Santa Maria della Salute*, 1840
Tate, accepted by the nation as part of the Turner Bequest, 1856

William Turner, *The Steps of Santa Maria della Salute, looking up the Grand Canal*, 1840
Tate, accepted by the nation as part of the Turner Bequest, 1856

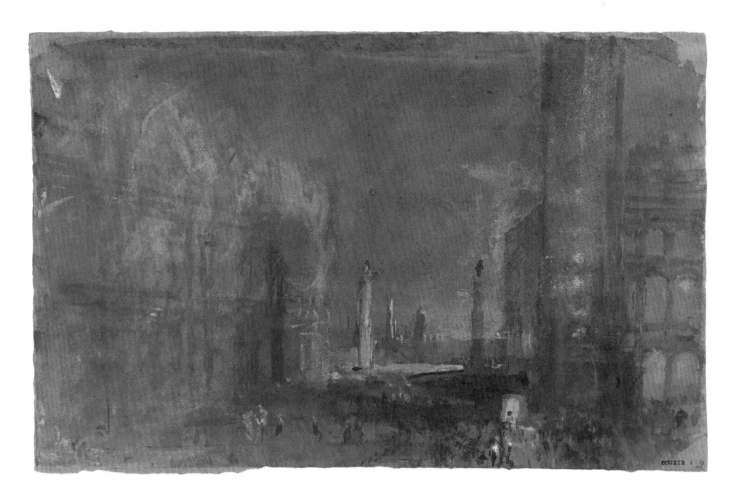

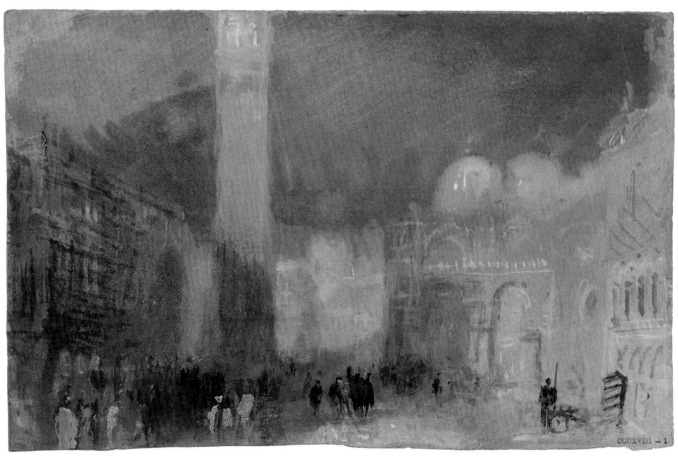

William Turner, *San Marco and the Piazzetta, with San Giorgio Maggiore; Night*, 1840
Tate, accepted by the nation as part of the Turner Bequest, 1856

William Turner, *The Piazzetta, with San Marco and its Campanile; Night*, 1840
Tate, accepted by the nation as part of the Turner Bequest, 1856

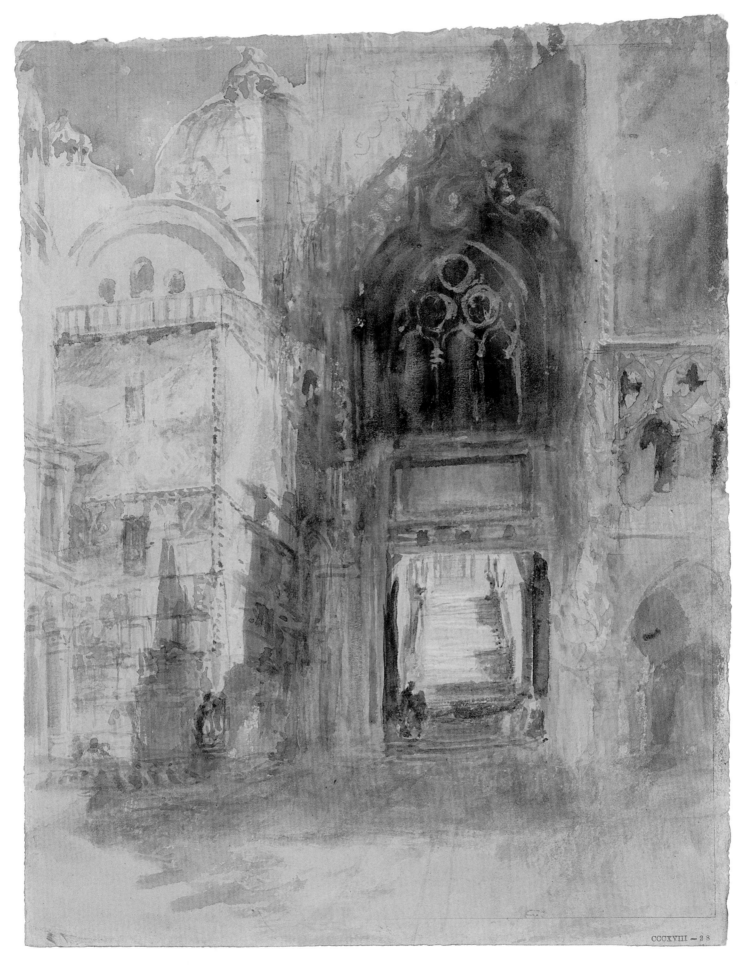

CCCXVIII – 28

William Turner, *The Porta della Carta, Doge's Palace, c.* 1840
Tate, accepted by the nation as part of the Turner Bequest, 1856

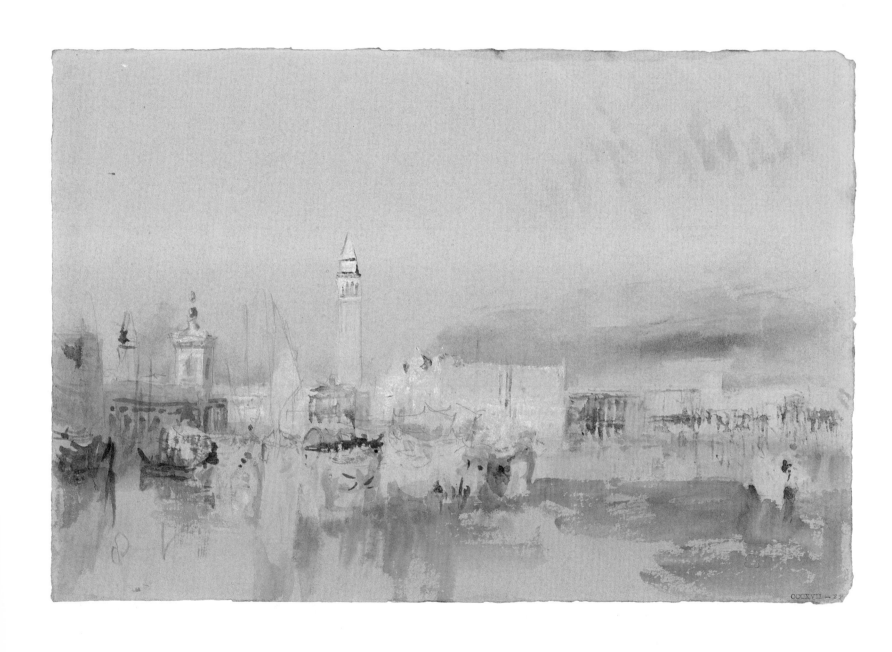

William Turner, *The Dogana, Campanile of San Marco and the Doge's Palace, c.* 1833 or 1840
Tate, accepted by the nation as part of the Turner Bequest, 1856

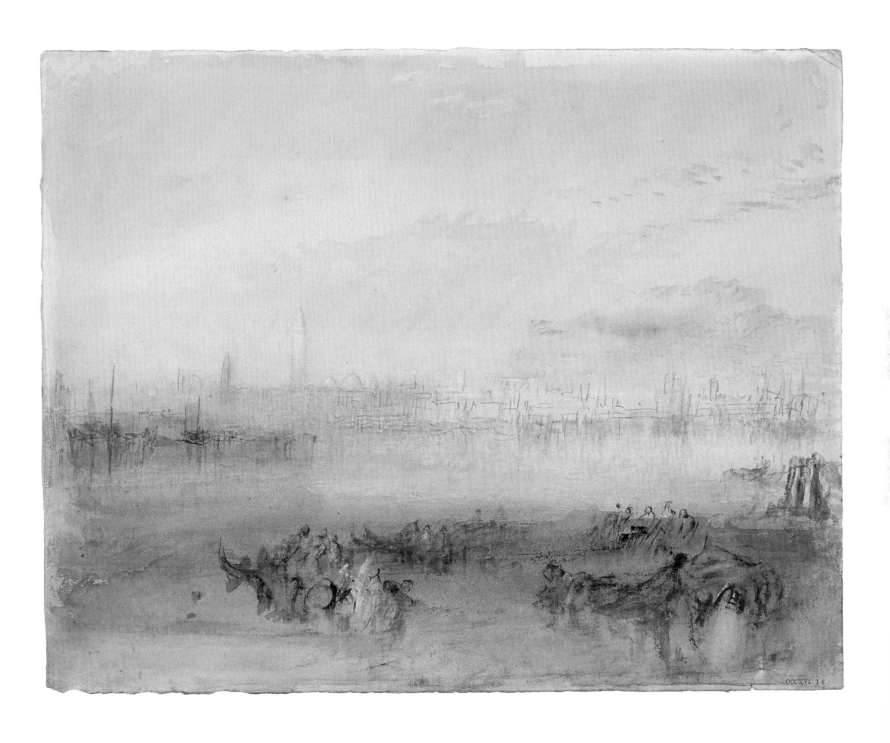

William Turner, *Looking back on Venice from the Canale di San Marco to the East*, 1840
Tate, accepted by the nation as part of the Turner Bequest, 1856

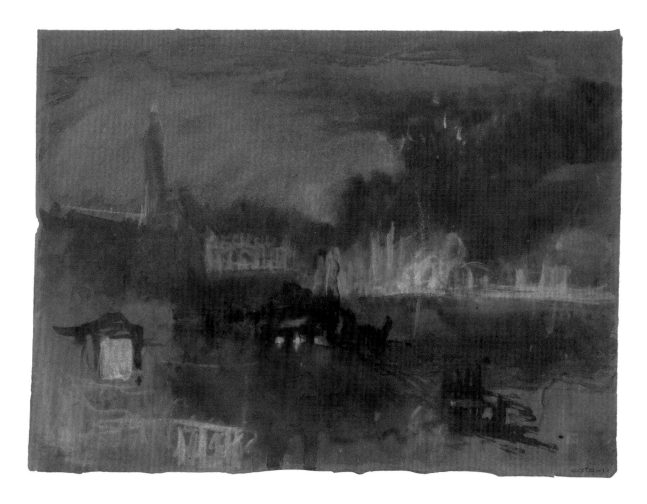

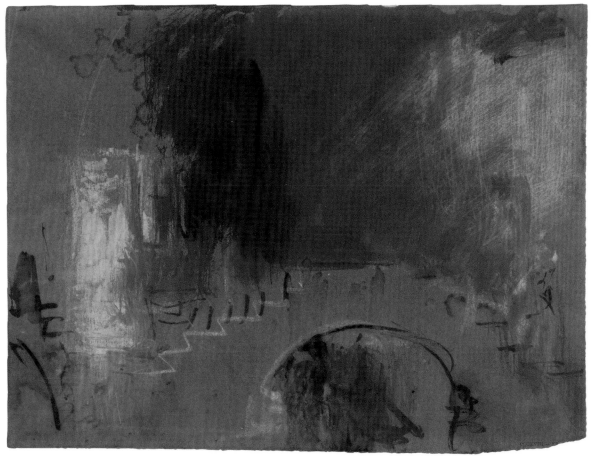

William Turner, *Venice: Fireworks on the Molo*, 1840
Tate, accepted by the nation as part of the Turner Bequest, 1856

William Turner, *A Bridge, c.* 1833 or 1840
Tate, accepted by the nation as part of the Turner Bequest, 1856

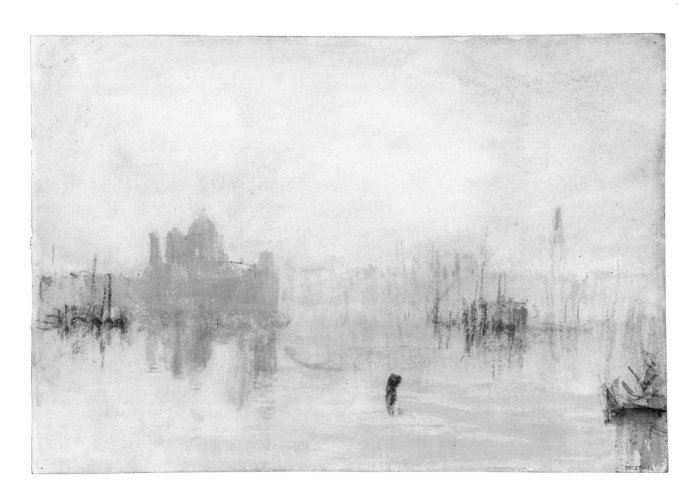

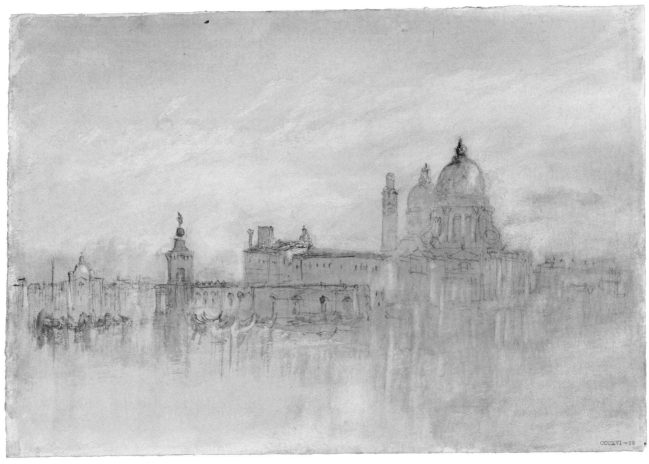

William Turner, *Sunset over Santa Maria della Salute and the Dogana*, 1840
Tate, accepted by the nation as part of the Turner Bequest, 1856

William Turner, *The Punta della Dogana, and Santa Maria della Salute at Twilight, from the Hotel Europa,* 1840
Tate, accepted by the nation as part of the Turner Bequest, 1856

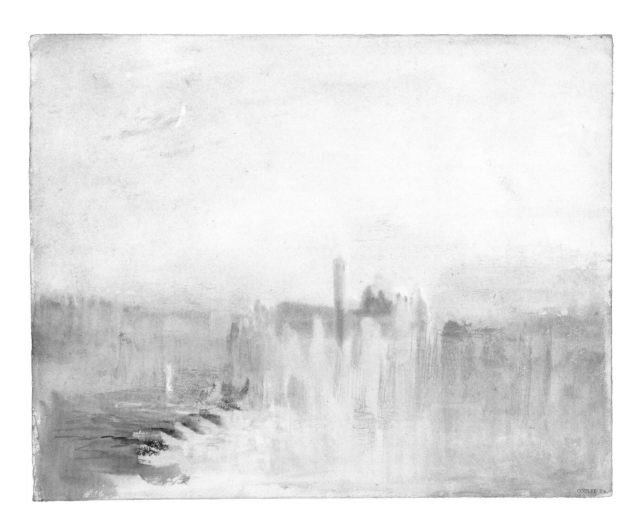

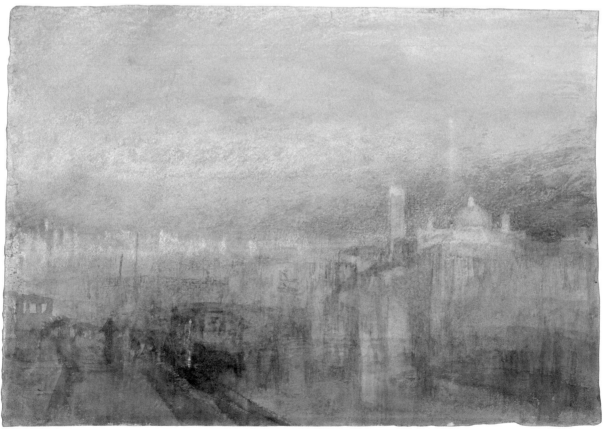

William Turner, *San Giorgio Maggiore at Sunset, from the Riva degli Schiavoni*, 1840
Tate, accepted by the nation as part of the Turner Bequest, 1856

William Turner, *San Giorgio Maggiore from the Hotel Europa, at the Entrance to the Grand Canal*, 1840
The Whitworth Art Gallery, University of Manchester

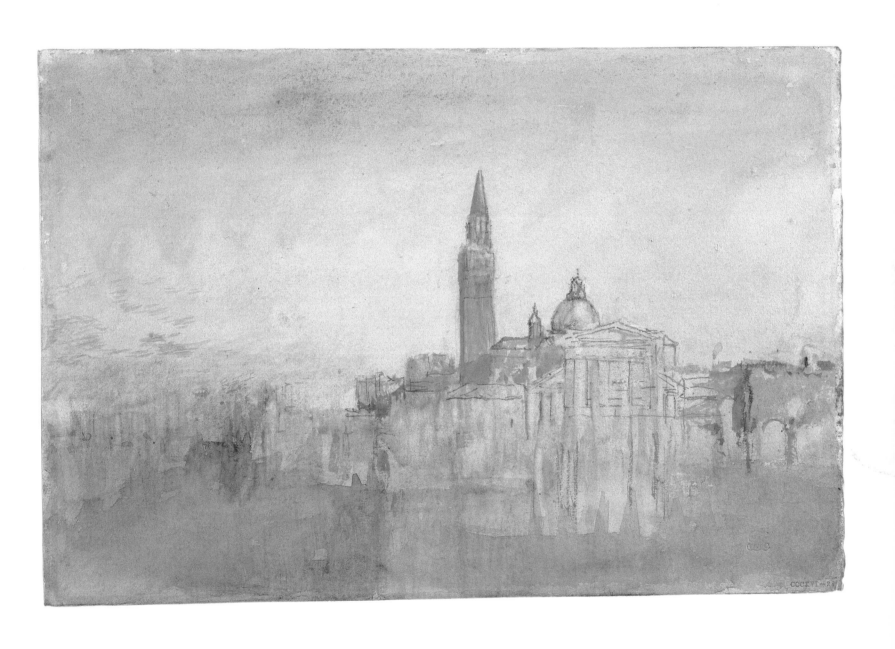

William Turner, *San Giorgio Maggiore at Sunset, from the Hotel Europa*, 1840
Tate, accepted by the nation as part of the Turner Bequest, 1856

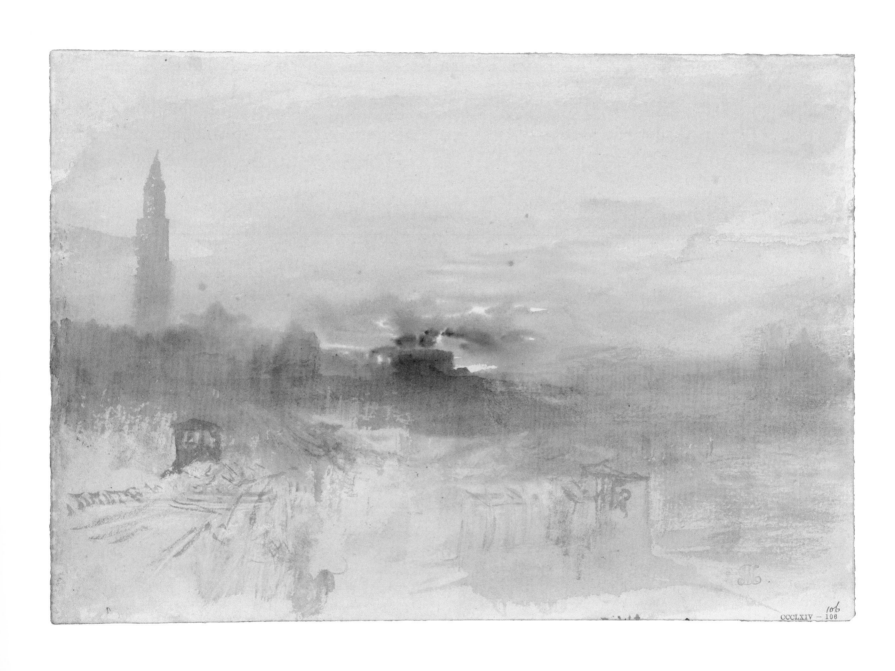

William Turner, *Venice at Sunrise from the Hotel Europa, with the Campanile of San Marco*, 1840
Tate, accepted by the nation as part of the Turner Bequest, 1856

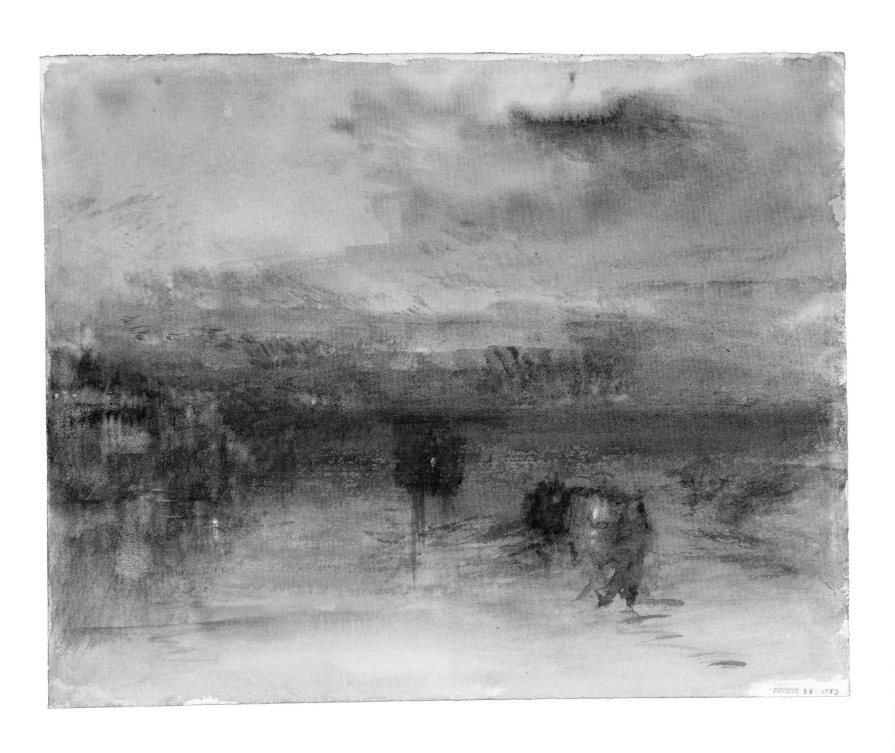

William Turner, *Venice: Moonlight on the Lagoon*, 1840
Tate, accepted by the nation as part of the Turner Bequest, 1856

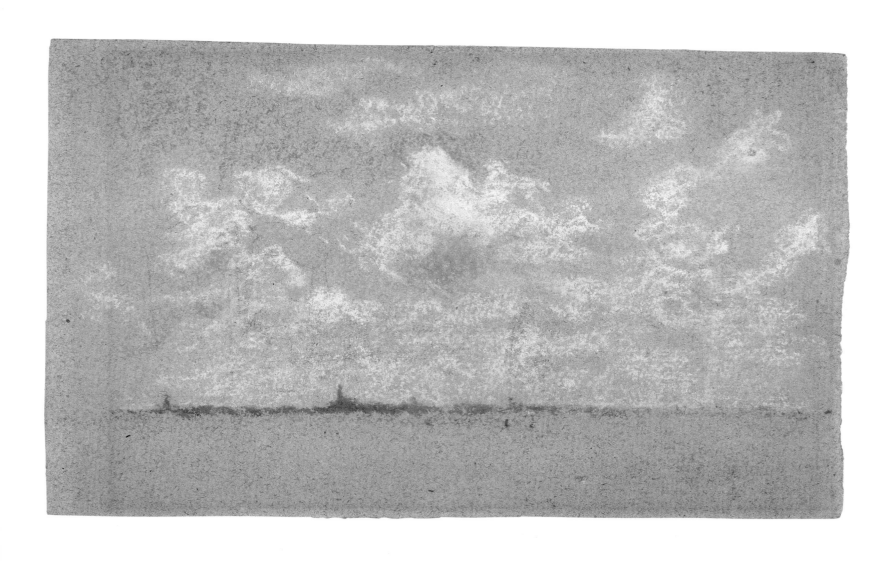

James McNeill Whistler, *Clouds and Sky, Venice,* possibly 1880
Saint Louis Art Museum, gift of J. Lionberger Davis

PALACES IN THE NIGHT
WHISTLER IN VENICE

Margaret F. MacDonald

The American painter and etcher James McNeill Whistler (1834–1903) was born in Lowell, Massachusetts—a small industrial town of canals and mills west of Boston. After a varied training as an artist in St Petersburg (Russia), West Point (USA), and Paris, he settled in London, where he worked as a painter and print-maker.

As a student in Paris he enjoyed the bohemian life of the artist's quarter; he was sociable and something of a dandy, optimistic and witty, ambitious, intense and (at times) hard working. He made lasting friendships with such artists as Edgar Degas and Henri Fantin-Latour. A great admirer of Gustave Courbet and Edouard Manet, he studied in the studio of Charles Gleyre, read the works of Baudelaire and Murger, revered the art of Raphael and Rembrandt, Van Dyck and Velázquez, Titian and Tintoretto. He excelled in French (which he first learnt in Russia) and maintained contact with the French artists long after he had settled in London. In later years he became particularly close to Claude Monet, and there are aspects of their portraiture and cityscapes, as well as their use of pastel in drawings, that show a mutual interest in each other's work.

His first series of etchings, the "French Set," was published in 1858, and formed the basis of his future work and reputation. By the early 1870s, Whistler had made tremendous breakthroughs in his art with the publication of his second series of etchings, the "Thames Set," and with his oil paintings of that river, the *Nocturnes*, as well as with the famous portraits of his mother, and of the Scottish historian Thomas Carlyle now in the Glasgow Museums. These were exhibited widely in Europe; indeed in 1892, the Musée du Luxembourg acquired the *Portrait of the Artist's Mother*, after a vigorous campaign supported by Monet and the Symbolist poets Mallarmé and Montesquiou.

Unfortunately, during the 1870s, Whistler also had problems both in completing and selling his work. In attempting to attract wealthy patrons he embraced a lifestyle well beyond his means. Even major undertakings, like the *Peacock Room* in the Freer Gallery of Art, an aesthetic decorative scheme entitled a *Harmony in Blue and Gold*, painted for the London home of Frederick R. Leyland, a Liverpool ship owner, proved financially a disaster. Disputes over payment meant he lost the support of Leyland, once his most generous patron.

Then in 1877 the influential English art critic John Ruskin attacked Whistler's atmospheric painting of the pleasure gardens at Cremorne—*Nocturne in Black and Gold: The Falling Rocket*. Ruskin publicly accused Whistler of "flinging a pot of paint in the public's face."[1] The artist sued him for libel and won the case, but he was left with huge legal costs, and in May 1879 he was declared bankrupt. His house, his art, and his collections—everything was sold. He was forty-four years old and in his prime as man and artist—and yet facing complete disaster in his career.

Whistler was rescued by a firm of London dealers, The Fine Art Society. They gave him a modest commission, advancing £150 towards a set of twelve etchings of Venice. They reserved the option of buying the etching plates on his return for £700.[2] The F.A.S. regularly held exhibitions of picturesque or dramatic views of foreign parts. They hoped that views of Italy by Whistler—a newsworthy foreigner and controversial artist at that time, famed for the quality of his earlier etchings—would appeal to connoisseurs and collectors. Their cultured clientele desired artistic "souvenirs" and were excited by glimpses of such exotic scenes.

For several years Whistler had planned to visit Venice, that most beautiful of cities, still a great port, with its gracious palaces opening onto a labyrinth of canals. He meant to produce a set of etchings comparable to the French and Thames sets, confirming his reputation as a master-printmaker. However, now his reduced circumstances meant he did not travel as an established artist—a leading figure in the aesthetic movement and the London art world—but as a bankrupt refugee, desperate to reestablish his fortunes and his career.

On September 18, 1879 he caught the night train from Paris to Venice. His mistress, Maud Franklin, joined him a month later. At twenty-two, she was still very young—a beautiful and sympathetic model, and mother of Whistler's two daughters, who were living with foster parents in England. She loved Venice, where she enjoyed much more freedom than in the class-ridden society of London. Whistler, as an artist and an American, was accustomed to moving freely in cultured society, in London, Paris, and Venice. He enjoyed the hospitality of the American consul, of expatriate Americans like the Bronsons, and also got on perfectly well with gondoliers, bead stringers, and fellow artists.

At first, Maud and James enjoyed being tourists, swimming at the Lido, and exploring the famous sites. The vivid colors of the city and the lagoon inspired a strong response—a glorious sky, for instance, in the pastel *Venice at Sunset* in the former Whitney Payson Collection (p. 108 top) was drawn with extraordinarily vivid colors, in red, yellow, orange, purple, grays, and blue, recalling Monet's impressionistic skies.

At Christmas, Whistler went to High Mass at San Marco, "and very swell it all was," he wrote home, "but do you know I couldn't help feeling that the Peacock Room is more beautiful in its effect!... That was a pleasant frame of mind to be in you will acknowledge—and I am sure you are not surprised at it!"[3]

Artists and aristocrats had been visiting Italy for centuries, and bringing back views of well-known sites. Whistler was familiar with the work of famous artists from Canaletto to Turner, and also contemporary sets of prints showing realistic and rather boring views of Venice. However, as he told a fellow artist:

... it is not merely the "Views of Venice"... or the "Canals of Venice" such as you have seen brought back by the foolish sketcher—but great pictures that stare you in the face—complete arrangements and harmonies in color and form that are ready and waiting for the one who can perceive....[4]

He was probably slow in coming to terms with the wealth of subjects. Indeed, he tackled work in a city of such stunning beauty that the mere act of choosing became a bar to progress. *I can't tell you how intoxicating this place is —.... There is work for more than a lifetime in it and a delight in it all. I shall bring you back lots but I am greedy for so much more. I do so wish you were here that I might show you the marvels that wait for me at every turn. Indeed that is the danger of the place. You are perfectly bewildered with the entanglement of beautiful things!*[5]

Perhaps that was why, at first, he chose compositions similar to those he had explored in London—bridges, old buildings, boats, and water. In particular, he painted and etched and drew the city by night—perhaps to prove that what he was doing was right, and critics like Ruskin were wrong. As he said: "The whole thing with me will be just a continuation of my own art work, some portions of which complete themselves in Venice...."[6]

Pastels like *Nocturne: Ships and Gondolas, Venice*, etchings such as *Nocturne* (p. 111), or

the oil *Nocturne in Blue and Silver: The Lagoon, Venice*, show the ephemeral effect of moonlight and mist on the lagoon, suggesting shifts of focus, the quivering reflections of faint lights, with touches of the thinnest paint, pastel, or ink. The lagoon, dominated by the tall tower of San Giorgio Maggiore, was a view painted by generations of artists before and since, from Turner to Monet.

Whistler's atmospheric oil *Nocturne in Blue and Silver: The Lagoon, Venice*, was thinly painted on coarse canvas, smoothed and rubbed to create an unfocussed effect, with the church of San Giorgio Maggiore, figures, and gondolas barely emerging from the blue, enveloping semi-darkness. In a pastel of the same subject, the paper forms the substance of the tower, and color is rubbed around it to suggest the softening of shapes by darkness.

In his earlier sets of etchings Whistler combined character studies with cityscapes. In Venice he likewise undertook a selection of views, a variety of subjects and formats. He explored the maze of back-canals as well as well-known sites, seen from fresh viewpoints. In *The Piazzetta* (p. 113 right) he represented one of the best known of Venetian sites, the cathedral of San Marco, seen from the Riva and partly hidden by the great column of St Mark's. He also etched the famous bridge, *The Rialto*, which he drew first in pencil from the far side, before etching the view from the San Marco side. That is, he selected a recognizable view of the steep steps of the bridge, rather than the more famous view from the Grand Canal, where it actually looks like a bridge.[7]

Whistler had publicly stated only the previous year, that a "picture should have its own merit, and never depend upon dramatic or legendary or local interest."[8] Yet many of his works contradict this statement: *The Rialto*

and *The Piazzetta* obviously had local interest—they were precise and accurate views of well-known sites. Furthermore, an etching, *The Beggars* (p. 115), and a pastel of the same subject now in the Freer Gallery of Art, *The Beggars—Winter*, involve both dramatic and sentimental associations.

The subject of beggars may reflect Whistler's own poverty, and it was also a prominent aspect of city life. That winter was exceptionally bitter, causing widespread suffering in Venice. However, these were not, at that moment, real beggars, since they were modeling for Whistler in a quiet courtyard where there were no passers-by at all, off a busy market square, the Campo Santa Margherita. Presumably Whistler paid them for modelling, and since the etching was generally admired the artist did rather well out of it, which was an economic necessity. The mere name of this etching, *The Beggars*, might suggest sentimentality, using emotion to loosen the purse strings—and that Whistler was in fact begging with his etching for money. The subject is a social commentary, but one that would bring in more money for Whistler than for the needy.

Whistler reworked the composition over several years and, interestingly, made the figures less attractive and more serious, changing a pretty young beggar-woman into an old bearded man and then to a haggard old woman, who looks dispassionately at the viewer. The view included other figures—water-carriers who were quintessentially Venetian—who embody that element of "local interest" to which Whistler had objected. The sinister cloaked man in the shadows was redrawn when back in London. Whistler asked a friend to pose for him, since he preferred to work from life and, if possible, on site; the setting is

pure Venice, and still looks exactly the same today. The result is a mixture of real and constructed life, intended to have an appearance of authenticity.

Meanwhile the weather that drove the beggars into the city was a grave problem to the artist, as he explained to his sister-in-law:

The etchings are of course very swell—but one is frozen out and so I am still behind hand with them! It is of a cold you have no idea—. . . ice and snow all over the place—lovely though—but upon the whole I think it is more beautiful in the rain![9]

He battled with dire weather, poor health, and depression, as he admitted in another letter:

As to the etchings they are far away beyond the old ones—only I am barely able to touch a plate—literally—it is like ice. . . . No winter like this known for at least thirty years, and at last I am getting very much depressed.[10]

This depression was a real and ongoing problem, and only to be resolved through working. For a while he abandoned etching, and turned to working in pastel. He was well prepared, having brought boxes of pastels and sheets of brown, fine-grained, fibrous paper with him. It was rather like wrapping paper, providing a base color and texture for the soft pastels.

Much of his work was done in the area around the Campo Santa Margherita, where he etched *The Beggars*. A colorful pastel drawn in the square itself shows the *Campanile Santa Margherita* (p. 103). Expressive, black chalk lines summarize the old bell tower and the corner at the north end of the square. Between the outlines, a wide range of subtle shades of pastels from soft creamy ivory through dusky pinks to browns and grays were applied sparingly on the brown paper. An impression of light and air is conveyed in the flickering colors that are used again and again across the surface, like the threads of an embroidery.

San Rocco and the famous church, the Frari, are reached along the street below the tower. At first, Whistler and Maud Franklin had rooms in the Rio di San Barnaba, and later, a house near the Frari. This is to the west of the Grand Canal—the opposite side from San Marco and the Piazzetta. Nearby, he drew one of the few interiors he completed in Venice, which was exhibited under the title *The Palace in Rags* (p. 105). Bold, broad chalk lines frame the scene, leading the eye into the exquisite detail of the figures and tiled roofs seen through the window. By contrast, the pastel *Venetian Canal* (p. 102 right) shows a site that was an important thoroughfare, the meeting of three bridges (*Tre ponti*), en route to the Piazzale Roma. Drawn in sparing black chalk, it was illuminated with touches of cool blues and pale turquoise. As clear and sparkling as sapphire, the colors sit like jewels on the brown paper.

Whistler roamed far and wide in search of new subjects: *The Tobacco Warehouse* (p. 104 right) was a tenement on the Fondamenta dei Cereri, west of the Campo Santa Margherita, and away from normal tourist routes. From the island of San Giorgio Maggiore he looked back to the city to draw a *View in Venice, looking towards the Molo* (p. 109), with the tower of San Marco in the distance against the last rays of a golden wintry sun. The brown paper provides a mid-tone, a color in its own right, and space around each stroke allows every color to breathe, so that the lines vibrate and contrast with smoothed areas in the distance, creating a sense of space and atmosphere. Across the city, north of the Grand Canal, he drew *A Venetian Canal* (p. 104 left) beside the Rio della Sensa near the Ponte dei Mori. He defined the

buildings with sharp and precise curving, black, chalk lines, highlighting the main architectural details with light touches of color, pinks and blues, white and green.[11]

By spring, Whistler's output was quite considerable, but in the medium of pastel, rather than etching. "I am working with the kind of wildness that belongs to the sportsman!" he told his friend the artist Matthew Robinson Elden, "so I am up early and off—and by the end of the day manage more or less to bring back some thing in my bag and my work is charming to me. . . ."[12]

Later, Otto Bacher, a young artist who met Whistler in Venice, described him as taking both etching plates and paper with him, moving from one scene to another, and keeping several works in progress. "He rose early, worked strenuously, and retired late." Bacher remembered:

I have known him to begin an etching as early as seven o'clock in the morning, . . . take up another until twelve—noon—get a bite of lunch, and commence on a third, sometimes an etching or perhaps a pastel, then take a fourth . . . and continue upon it until dusk, the subjects being wholly different. Whistler always had a half dozen under way, more or less complete.[13]

By day, Whistler drew views of the lagoon, back streets, and side canals, and later, sunsets from the public gardens, finishing with nocturnes from the Riva degli Schiavoni and on the Piazzetta. He aimed to produce an accurate but selective record of a site under a particular light and at a narrowly defined time, and was, in his way, treating Venice in a manner akin to the approach adopted by Claude Monet and the Impressionists.

The Church of San Giorgio Maggiore in the Corcoran Gallery of Art, for instance, shows signs of having been drawn over several days.

The edges and corners of the sheet are pockmarked with pinholes that suggest the drawing took at least a dozen sessions to complete. The orangey-brown paper contrasts with the scumbled turquoise of the sky and the bands of deeper turquoise in the sea, and complements the warm reds of the buildings, which are picked out delicately with white, gray, and cream.

Whistler wrote to his mother about the richness of the colors in Venice—a huge contrast to the murky grayness of London:

After the wet, the colors upon the walls and their reflections in the canals are more gorgeous than ever—and with sun shining upon the polished marble, mingled with rich toned bricks and plaster, this amazing city of palaces becomes really a fairyland—created one would think especially for the painter. The people with their gay gowns and handkerchiefs and the many tinted buildings for them to lounge against or pose before, seem to exist especially for one's pictures—and to have no other reason for being![14]

Many of his pastel drawings, as well as the etchings, show women in "gay gowns" going about their work. In *Courtyard on Canal* (*Gray and Red*) (p. 106 right), exquisite touches of turquoise and bright blue are placed precisely on the shutters and mooring post and skirts of the girls at a well. In *Bead Stringers* in the Freer Gallery of Art and an etching of the same name, he tried to convey the character and occupations of the people as well as the appearance of their surroundings. And in *Venetian Courtyard* (p. 106 left), the figures of women at a well stand against the rich orangey-red plastered walls so typical of Venice, in a courtyard still hardly changed to this day, the Corte Bollani in Castello.

Whistler was supposed to complete his work in two months but ultimately he stayed

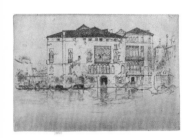

Fig. 1 James McNeill Whistler,
The Palaces, 1879/80, etching,
25.4 × 36.3 cm, Hamburger Kunsthalle,
Kupferstichkabinett (work exhibited)

for fourteen, from September 1879 to November 1880. The Fine Art Society feared for their investment, and Whistler eventually wrote to M.B. Huish, Director of the F.A.S., justifying his delay:

... had there been nothing but ordinary weather to deal with, your twelve plates would have been finished and I should have been back in London before I had at all known the mine of wealth for both you and me in this place ... and now I have learned to know a "Venice in Venice" that the others never seem to have perceived. ... The etchings themselves are more delicate in execution, more beautiful in subject and more important in interest than any of the old set. [15]

When Whistler did get down to etching he found the copperplates he had bought from the copper merchants Hughes and Kimber did not necessarily fit his requirements so he had more made locally: long and thin or broad to suit the subjects. *Long Venice* (p. 110 bottom), for instance, is a lean horizontal image on a startlingly narrow plate. A palace on the Grand Canal was simply too big for the copperplates he had bought. *The Palaces* (fig. 1) shows the Palazzo Sagredo and the smaller Palazzo Pesaro on the Grand Canal, etched from the Ponte della Pescaria on the Riva dell'Ogio in San Polo. That is, he stood on the southwest side of the canal, looking northeast, probably balancing the heavy plate on the coping of the bridge. This was his largest plate, and it had to be made especially in Venice.

The problems of getting the right paper and a printing press were acute. However, in the summer of 1880 the American artist Frank Duveneck arrived in Venice with a group of students. One of them, Otto Bacher, brought a press and Whistler soon moved in with Bacher and his companions, who were at first rather over-awed by their distinguished compatriot.

They stayed at the Casa Jankowitz, at the far end of the Riva degli Schiavoni from San Marco. Throughout the summer, Whistler found quiet corners in which to work nearby, in the working-class area around the Via Garibaldi. *San Biagio* (p. 112 bottom) and *Turkeys*, for instance, were etched within a stone's throw of his lodgings. Again and again he drew the sunset from his room in the Casa Jankowitz in increasingly bold pastels, using broken lines on the brown paper to indicate the vivid evanescent colors. Examples include *Salute—Sundown* and *Sunset, Red and Gold—Salute* in the Hunterian Museum & Art Gallery, University of Glasgow. In these works his pastels come closest to the work of Eugène Boudin and Monet in their sea and sunset subjects.

Whistler's use of line was different from others, just as everyone's handwriting is different. He consciously developed his style to suit the subjects and medium that he was using. In Venice, he worked hard, practising and experimenting continually. He must have worked in a boat out on the lagoon (and it is known he hired a full-time gondolier) to etch a simple view of a *Fishing Boat*, which shows a very straightforward and descriptive use of line. Irregular dots and dashes, spaces between lines, and areas of shading or cross-hatching create an illusion of sparkling light.

He enjoyed the whole process of etching, from preparing the plate with an acid-resistant surface, drawing on it with a sharpened needle like a dentist's tool, to biting it with acid (spreading the acid around with a feather, and occasionally dropping it and burning holes in the carpet), inking the etched lines carefully, and pulling the inked plate through the press to create the reverse image of the view he had recorded with such skill. Corrections were made by hammering, burnishing, and reetch-

ing the surface. Some etchings went through a dozen states before Whistler was satisfied. In this way he created a series of prints, each one being slightly different from the original copperplate. Although etchings, if on steel, can be printed in high numbers, this is not what Whistler envisaged. A small edition, with each impression individually printed or supervised by the artist, would sell for higher prices to connoisseurs and collectors—at least that was the market assessment at that time.

He also worked with drypoint (a much more direct method of drawing with a needle directly on the copperplate, throwing up a metal burr that, in printing, caught the ink). *Nocturne: Salute* was drawn with needle-thin lines that were extremely delicate and difficult to print, and also wore down quickly. Thus only a few impressions could be pulled from the plate, and again, rarity forced the price up. Many of the etchings incorporated fine drypoint lines to augment the deeper, etched lines. In *Islands* and *The Little Venice* (p. 110 top), the drypoint lines create atmospheric panoramas of extreme simplicity—though *The Little Venice*, if examined closely, is precise and full of detail, like a miniature.

The most important and innovative of Whistler's etchings was *Nocturne* (p. 111), a view of San Giorgio Maggiore, where he used drypoint to indicate the lanterns and gondolas flitting like moths over the still lagoon. In addition, he wiped a thin film of ink over the surface to augment the etched lines, creating an effect of color and atmosphere that was different in each impression. Some appear as misty *crepuscules*, some as dramatic velvety night. The early impressions are printed in black ink, but as the work evolved, sometimes over several years, he used dark brown ink, which gave additional color and warmth to the scene.

One of the sites that fascinated Whistler, Pietro Lombardo's Renaissance Palazzo Gussoni of 1500, on the Rio della Fava near San Marco, was photographed by Otto Bacher.[16] Whistler's etching of the *palazzo*, entitled *The Doorway*, went through some dozen stages: etching, printing, correcting, and reetching, to create the finished work. The doorway was drawn from a gondola, and is realistic and accurate in detail. The door still exists, albeit battered but beautiful. Whistler was delighted when Bacher recognized the grid-like shadows as chairs hanging from the roof—the site was a carpenter's shop. Whistler was committed to working on site in the city, and delighted in his skill and accuracy (having originally trained as a topographical draughtsman at West Point). However, the scene is not exactly "authentic," because there was a degree of manipulation in Whistler's choice of subject and composition. Apparently, the artist persuaded the owner to replace an ornate iron grill over the door before he started drawing. Furthermore, when he returned to London he continued to revise the figures, intent on their work or lost in reverie.

By the time Whistler finally agreed to return to London, in November 1880, he had produced a hundred pastels and fifty etchings, but that was not the end of the matter. There were exhibitions to be planned, works to be mounted and framed, and above all, many impressions of the etchings to be printed.

He had agreed to print fifty of the twelve etchings of the first "Venice Set" for the Fine Art Society—600 impressions in all. In the end he printed nearly twice that number. He continued printing impressions of *The Doorway* for the rest of his life—indeed the F.A.S. had to hire a professional printer, Frederick Goulding, to complete some sets after Whistler's death. He worked with the occasional help of a

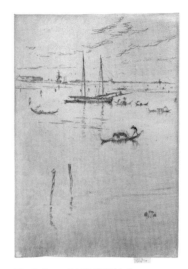

Fig. 2 James McNeill Whistler, *The Little Lagoon*, 1879/80, etching, 22.8 × 15.2 cm, Hamburger Kunsthalle, Kupferstichkabinett (work exhibited)

Fig. 3 James McNeill Whistler,
The Fish Shop, 1879/80, etching,
13.1 × 22.5 cm, Hunterian Museum &
Art Gallery, University of Glasgow
(work exhibited)

Fig. 4 James McNeill Whistler,
Nocturne: Furnace, 1879/80, etching,
16.8 × 23.2 cm, Hamburger Kunsthalle,
Kupferstichkabinett (work exhibited)

professional printer, friends, and fellow artists, printing working proofs, changing and perfecting the compositions. He sometimes wrote in a private code in the margins of successful impressions, recording the sequence of proofs, and selected particular impressions for exhibition or for favored patrons. For instance, a fine impression of *The Piazzetta* (third state) in the Baltimore Museum of Art is marked "9. x" in pencil in the right margin, and another impression of the third state marked "7. x" was sold by the dealer A.W. Thibaudeau to the Kupferstichkabinett, Berlin, in 1882.[17]

The first "Venice Set" of twelve etchings included meticulous views of well-known sites, records of people, distinctive Venetian characters, and bold experimental plates. There was variety and something to appeal to the discerning connoisseur and armchair traveler alike. Whistler's first exhibition of Venice etchings was held at the Fine Art Society in New Bond Street, London, in December 1880, and was followed by one of pastels in 1881, and in 1883 by a second exhibition of Venice etchings, which formed the basis for the second "Venice Set."

The pastels were displayed in frames in three shades of gold to complement the colors of the drawing—yellow or green or pinkish gold. The etchings were first displayed in plain white frames, but by 1883 he had designed a narrow white frame inlaid with thin black stripes, and the rooms were specially decorated in white and yellow. The catalogue was also designed by Whistler, in a brown paper cover, decorated with distinctive butterflies, and included negative reviews of his work written some time earlier that made the critics appear ridiculous.

The etching *Bead Stringers*, for instance, was accompanied by a delightfully confused press notice: "*Impressionnistes*, and of these

the various schools are represented by Mr Whistler, Mr Spencer Stanhope, Mr Walter Crane, and Mr Strudwick" and Whistler's comment in the margin: "Et voilà comme on écrit l'histoire." This might suggest that Whistler considered *Bead Stringers* as the antithesis of any form of Impressionism, or that he was amused to be linked with such a disparate group of artists as the Impressionists.

Culling from his extensive collection of press cuttings, Whistler chose the phrase "subjects unimportant in themselves" from a review by the art critic P.G. Hamerton for *Fishing Boat*. For *Upright Venice*, he quoted the comment. "Little to recommend them save the eccentricity of their titles." He had been criticized for emphasizing color and harmony in titles, but his etchings—except perhaps for the *Nocturnes*—actually have unusually straightforward titles. And for one nocturne, *Nocturne: Palaces* (p. 119), he chose an immortal line from the *Literary World*: "Pictures in darkness are contradictions in terms."

These three etchings were later included in the twenty-six etchings selected for the second "Venice Set," which was purchased by the dealers Messrs. Dowdeswell and Thibaudeau for £600 in 1886. Whistler felt a new enthusiasm for this second set. It consisted mainly of Venetian scenes plus some recent London etchings. The set comprised many of his most beautiful etchings, such as *Doorway and Vine* and *Long Venice*. It was to be a limited edition of thirty sets, and at first it was intended that a French artist, Emile-Frédéric Salmon, would print the plates. The results were good: clear prints, sharply detailed, but lacking the atmospheric effect that Whistler gained by manipulating the surface ink and by the careful choice of paper colors and texture (including Japanese, laid, and woven paper).

Whistler did not approve of Salmon's work; instead he gathered around him a group of assistants, including the young artists Walter Sickert and Mortimer Menpes, his mistress Maud Franklin, and others, who helped in the arduous job of printing the edition. Surprising even himself, he managed to complete the job within a year, receiving a further £238.17.6 for printing the plates.

The second "Venice Set" included works done late in his Venetian sojourn. *San Biagio* (p. 112 bottom), for instance, is a view of the great arches of the Sottoportego Secondo delle Colonne that opened onto the water south of the Riva degli Schiavoni. This was where the American art students kept their boats, and was certainly etched in the late summer or autumn of 1880. However, the set also included some of his earliest Venetian etchings, as well as his most innovative and progressive works, like *Nocturne: Palaces* (p. 119). *Nocturne: Palaces* was a bare, unarticulated skeleton of lines; it was the carefully manipulated surface tone that held it together. It was printed with patient care, the work of a true perfectionist. The surface ink gave it a wonderfully mysterious and atmospheric quality.

For once, Whistler kept a record of the printing. Sometimes he would print only one impression in a day, or two or three prints of several etchings, and occasionally go all out to complete a set, printing up to ten or even twelve in a day. It was hard and concentrated work, involving the careful preparation and inking of each plate, the choice and preparation of paper (he liked old watermarked, laid paper, and sometimes, for a change, the golden luster of thin Japanese paper), the physical effort of pulling a plate through the press, the drying, flattening, trimming, and signing of each impression. He trimmed the etchings to the platemark and signed them with his butterfly on a small tab left for the purpose, again, emphasizing the uniqueness of each impression. As each etching was completed, the plate was canceled.

Fruit-Stall is a typical example of the labor involved in printing the edition. A deceptively simple plate, it was frequently altered by Whistler, changing individual figures as well as the overall composition and lighting. Whistler kept one or two proofs of each new state, and was free to sell these proofs at a later date, providing a useful additional income. His changes may have been based on London models and scenes, and obviously were not done on site in Venice. At first, he printed *Fruit-Stall* at relatively long intervals, sending solitary impressions to Dowdeswell & Dowdeswell on April 2, July 31, August 20, September 21, and October 2, 1886.[18] The edition was completed by February 8, 1887, when he sent Dowdeswell & Dowdeswell twenty-eight impressions and one of the canceled state.

The second "Venice Set" was completed in 1887 with unusual efficiency, and therefore overlapped with Whistler's continuing struggle to complete the F.A.S. set. Printing these etchings punctuated Whistler's studio work for more than a twenty-year period. Later impressions of the first Venice set, in new states, and printed with many variations of surface tone, continued to inspire and challenge the artist. "I believe they will come out far more beautifully than ever," he wrote to Ernest Brown of the F.A.S. in 1889. "I am making of them wonderful new states!!"[19] He encouraged patrons like C.L. Freer of Detroit and Howard Mansfield of New York to buy rare drypoints and select proofs of different states, to round off their collections, and thus ensured himself an immediate income and a

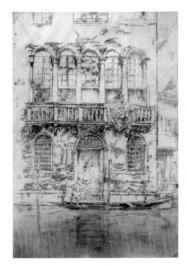

Fig. 5 James McNeill Whistler, *The Balcony*, 1879/80, etching, 29.7 × 20.2 cm, Hunterian Museum & Art Gallery, University of Glasgow (work exhibited)

lasting reputation, for Freer later left his collection to the nation.

A few years on, in his famous *Ten o'clock Lecture* of 1885, Whistler spoke of the transforming effect of light and the vision of the artist on the ordinary cityscape of London:

When the evening mist clothes the riverside with poetry, as with a veil, and the poor buildings lose themselves in the dim sky, and the tall chimneys become campanili, *and the warehouses are palaces in the night . . . the whole city hangs in the heavens, and fairyland is before us. . . .*[20]

Despite the frustrations of loss and poverty, of bitter weather and ill health, Whistler came to love the city of Venice and its people, and by hard work and controlled vision, created some of his finest works, forming the foundation for his later career.

[1] See Linda Merrill, *A Pot of Paint: Aesthetics on Trial in Whistler v. Ruskin* (Washington, D.C., 1992).

[2] Margaret F. MacDonald, *Palaces in the Night: Whistler in Venice* (Berkeley/Los Angeles, 2001), p. 16.

[3] James McNeill Whistler to H.E. Whistler, in January/February 1880, in *The Correspondence of James McNeill Whistler, 1855–1903*, edited by Margaret F. MacDonald, Patricia de Montfort, and Nigel Thorp; including *The Correspondence of Anna McNeill Whistler, 1855–1880*, edited by Georgia Toutziari. On-line edition, University of Glasgow. http://www.whistler. arts.gla.ac.uk/correspondence (hereafter cited as GUW); GUW 06687. I am grateful to the Court of the University of Glasgow for permission to quote from Whistler's letters.

[4] To M.R. Elden, April 15/30, 1880, GUW 12816.

[5] Ibid.

[6] To C.A. Howell, January 26, 1880, GUW 02860.

[7] *The Rialto*, pencil, Hunterian Museum & Art Gallery, University of Glasgow, M.733.

[8] "The Red Rag," in *The World*, May 22, 1878.

[9] To H.E. Whistler, in October/November, 1879, GUW 06686.

[10] To H.E. Whistler, in January/February 1880, GUW 06687.

[11] Alastair Grieve, *Whistler's Venice* (New Haven and London, 2000), pp. 103–04.

[12] To M.R. Elden, April 15/30, 1880, GUW 12816.

[13] Otto Bacher, *With Whistler in Venice* (New York, 1908), pp. 23, 98.

[14] To A.M. Whistler, in March/May 1880, GUW 13502.

[15] To M.B. Huish, January 21/26, 1880, GUW 02992.

[16] Bacher 1908 (see note 13).

[17] Research by Dr Grischka Petri and the author, for *The Whistler Etching Project*, University of Glasgow, on-line catalogue raisonné, to be published in 2011.

[18] Letters and accounts between Whistler and Dowdeswell, 1886, GUW 00863, 00871, 00872, 00874, 00877.

[19] April 1889, GUW 03662.

[20] James McNeill Whistler, *The Gentle Art of Making Enemies* (London, 1892), pp. 144–45.

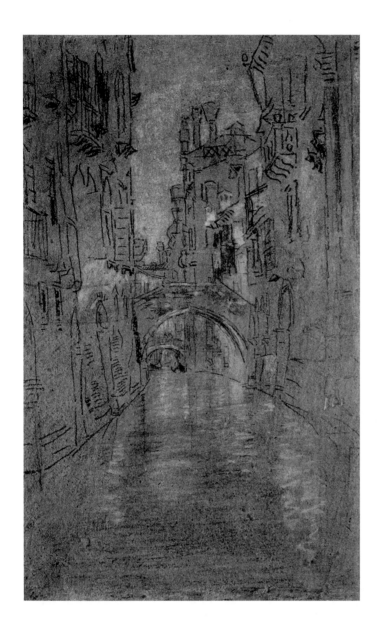

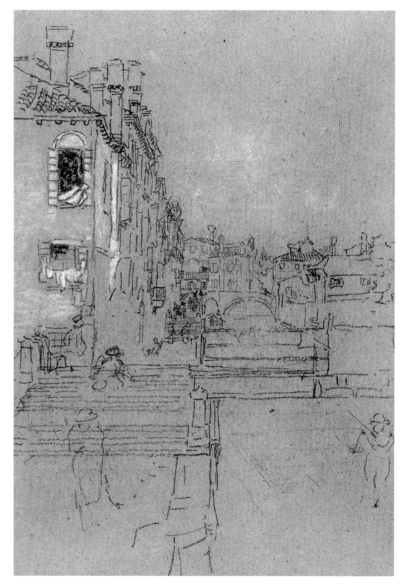

James McNeill Whistler, *A Venetian Canal*, 1879/80
Private collection, United Kingdom

James McNeill Whistler, *Venetian Canal*, 1879/80
Private collection, United Kingdom

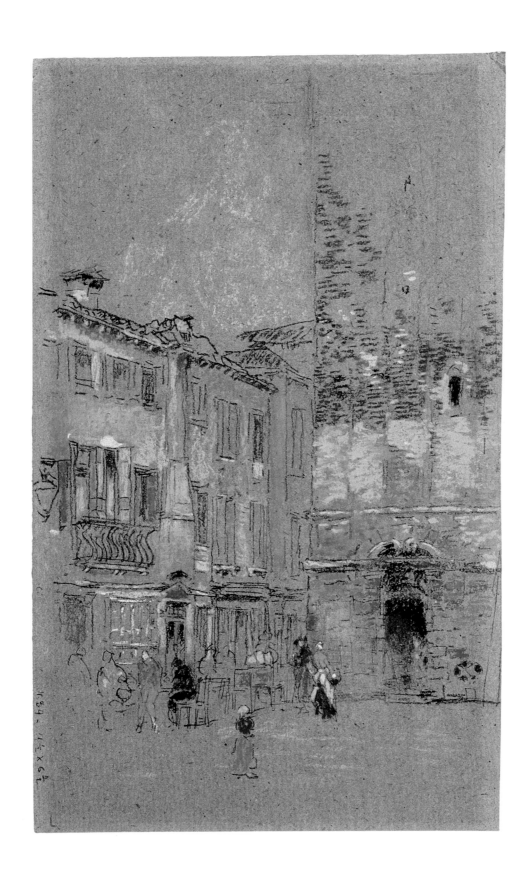

James McNeill Whistler, *Campanile Santa Margherita*, 1879/80
Addison Gallery of American Art, Phillips Academy, Andover, Massachusetts, anonymous donation

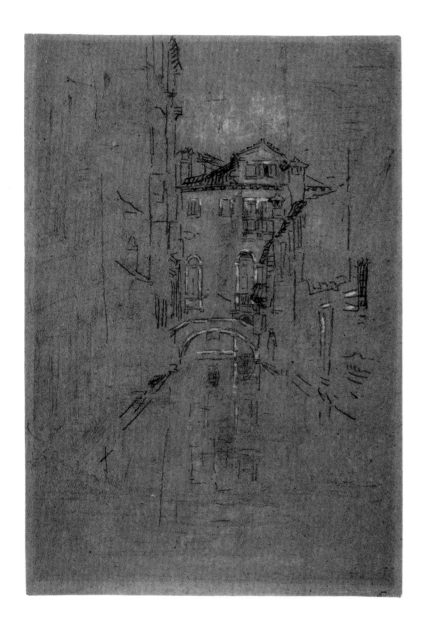

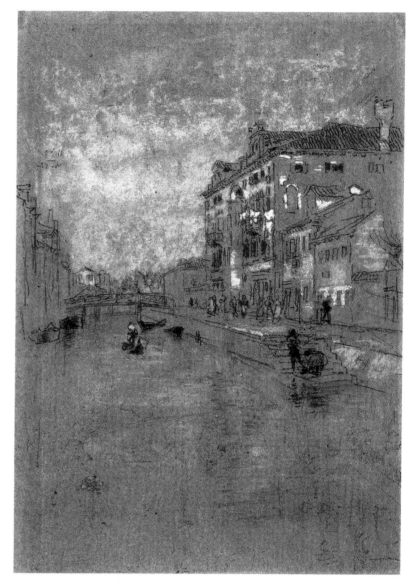

James McNeill Whistler, *A Venetian Canal*, 1879/80
Hirshhorn Museum and Sculpture Garden, Smithsonian Institution, Washington, D.C., gift of Joseph H. Hirshhorn, 1966

James McNeill Whistler, *The Tobacco Warehouse*, 1879/80
Hirshhorn Museum and Sculpture Garden, Smithsonian Institution, Washington, D.C., gift of Joseph H. Hirshhorn, 1966

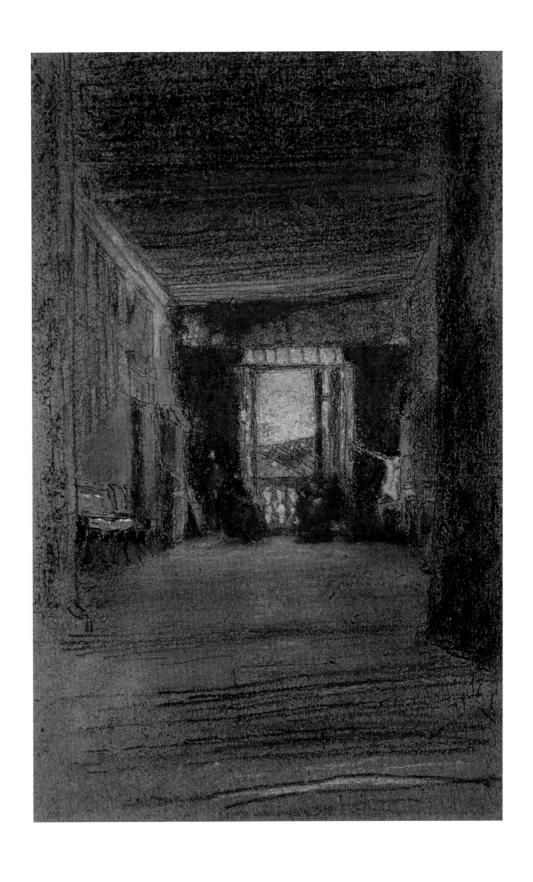

James McNeill Whistler, *The Palace in Rags*, 1879/80
Private collection, United Kingdom

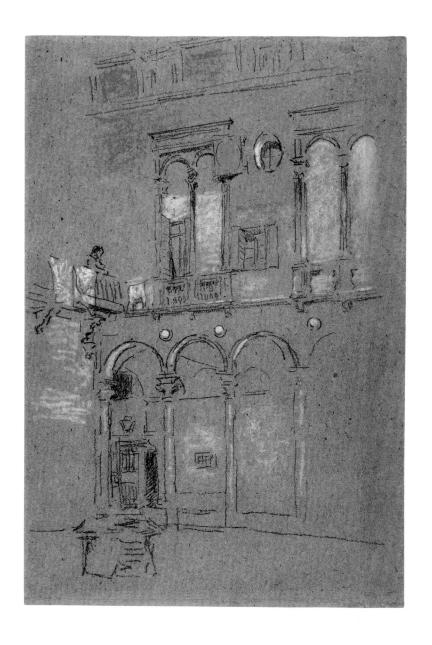

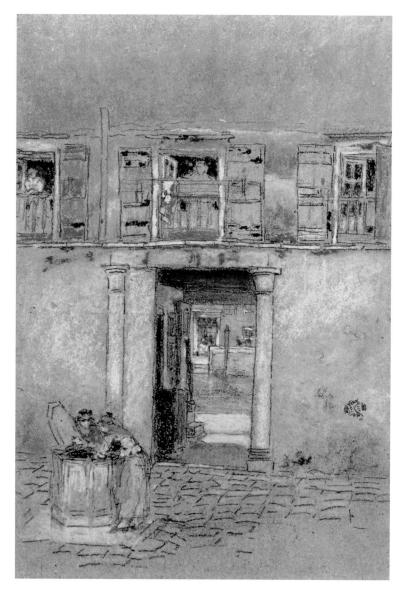

James McNeill Whistler, *Venetian Courtyard*, 1880
Dr. John E. and Colles B. Larkin

James McNeill Whistler, *Courtyard on Canal (Gray and Red)*, 1880
Saint Louis Art Museum, gift of J. Lionberger Davis

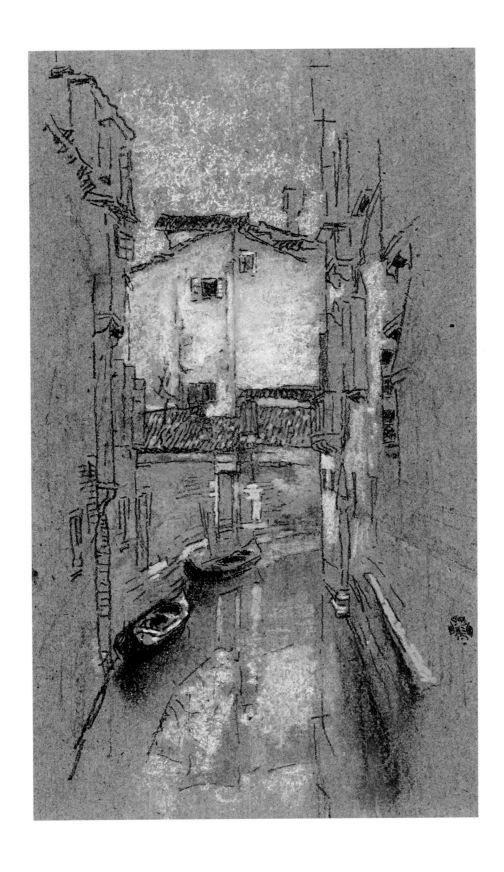

James McNeill Whistler, *Canal, San Cassiano, Venice*, 1880
Collection Westmoreland Museum of American Art, Greensburg, Pennsylvania, gift of the William A. Coulter Fund

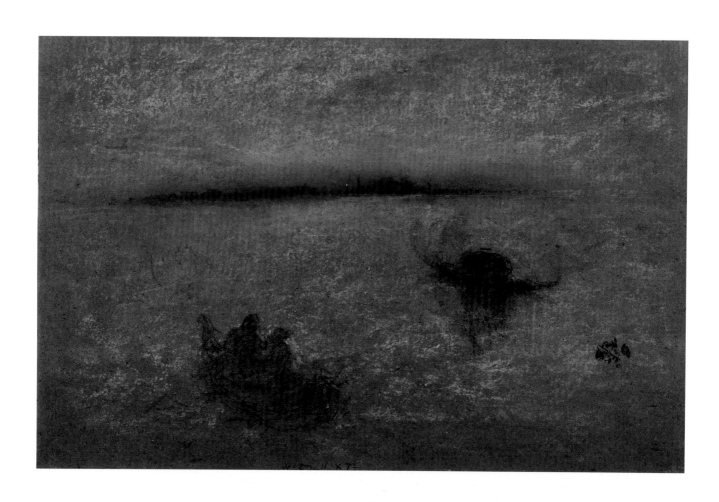

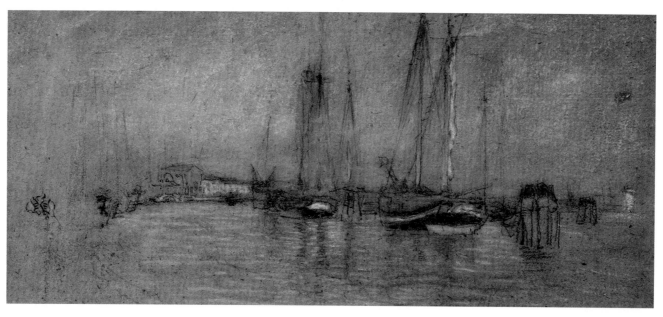

James McNeill Whistler, *Venice at Sunset*, 1879
Private collection (from the former Joan Whitney Payson Collection)

James McNeill Whistler, *The Little Riva, in Opal*, 1879/80
Collection of the Lauren Rogers Museum of Art, Laurel, Mississippi

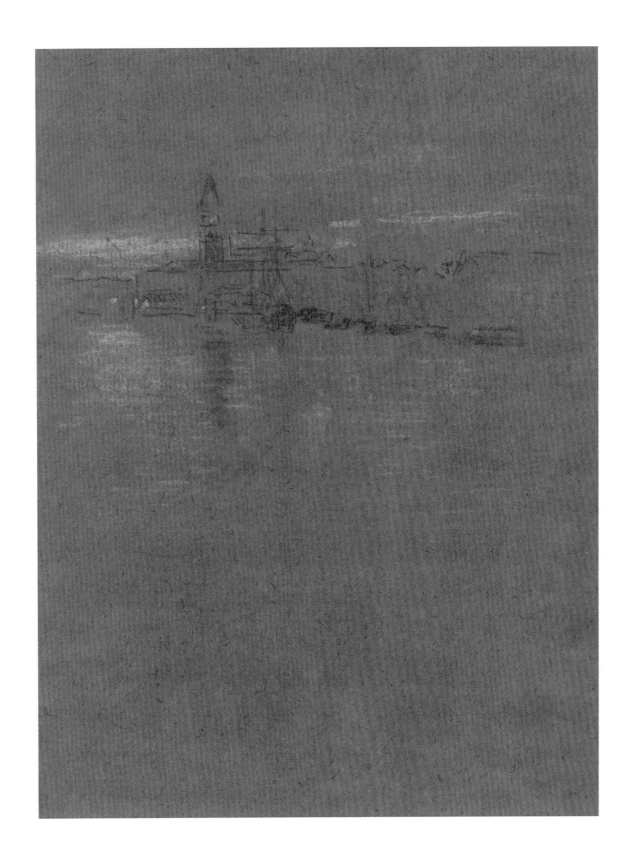

James McNeill Whistler, *View in Venice, looking towards the Molo*, 1879/80
Private collection, courtesy of Adelson Galleries, New York

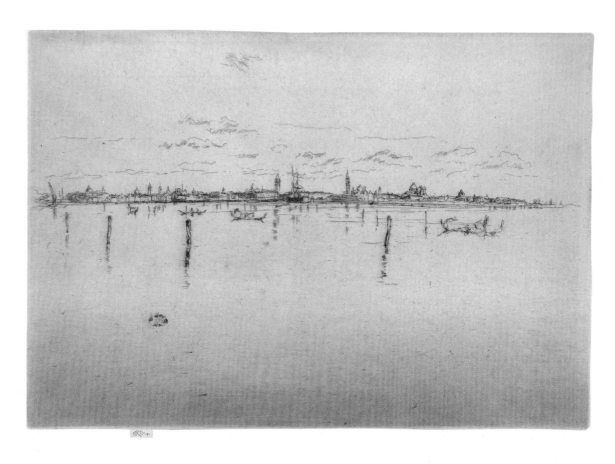

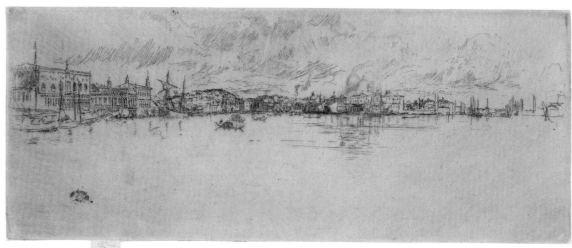

James McNeill Whistler, *The Little Venice*, 1879/80
Hamburger Kunsthalle, Kupferstichkabinett, Hamburg

James McNeill Whistler, *Long Venice*, 1879/80
Hamburger Kunsthalle, Kupferstichkabinett, Hamburg

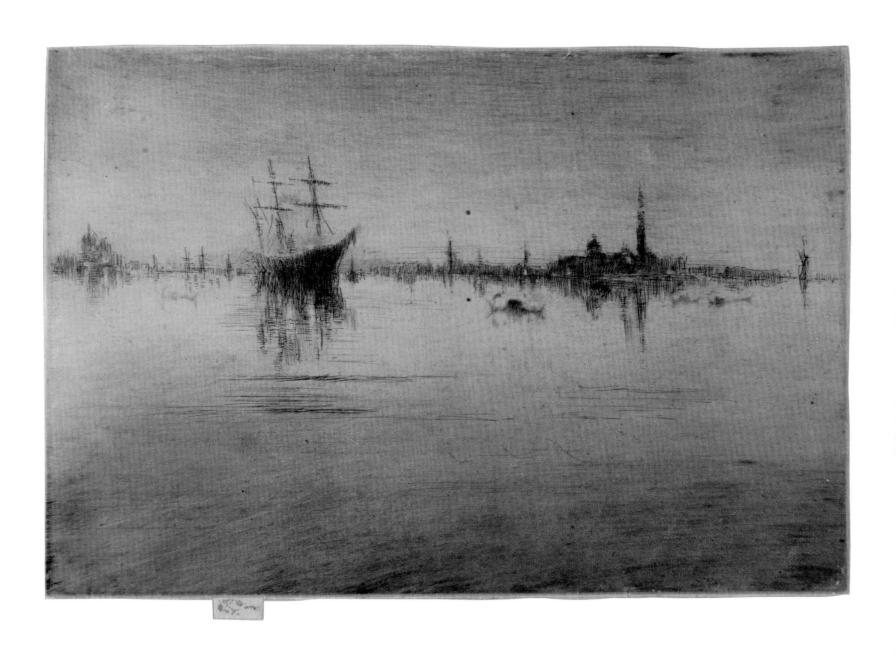

James McNeill Whistler, *Nocturne*, 1879/80
Hunterian Museum & Art Gallery, University of Glasgow

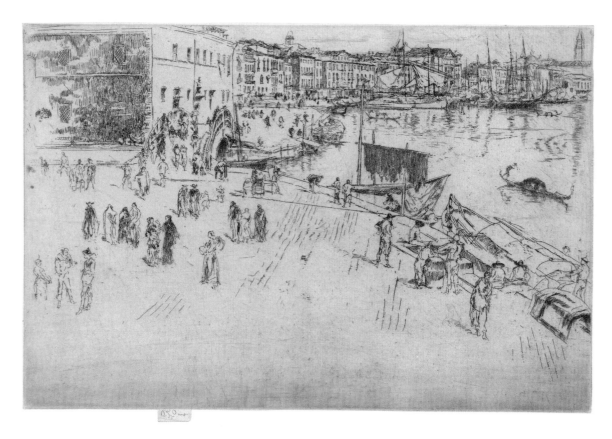

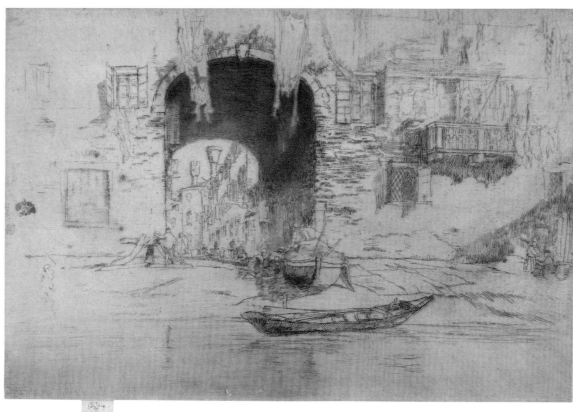

James McNeill Whistler, *The Riva, No. 1*, 1879/80
Hamburger Kunsthalle, Kupferstichkabinett, Hamburg

James McNeill Whistler, *San Biagio*, 1880
Hamburger Kunsthalle, Kupferstichkabinett, Hamburg

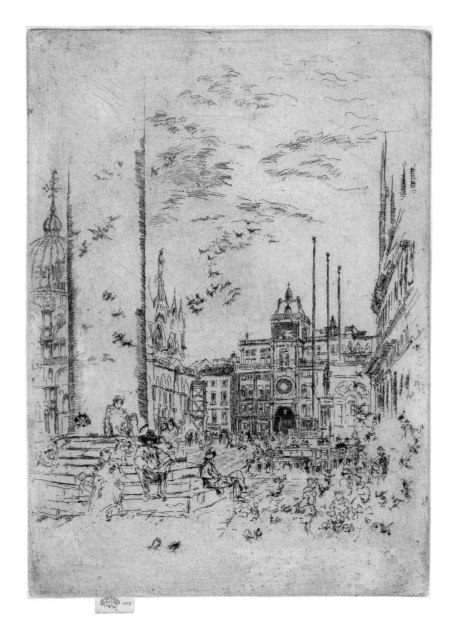

James McNeill Whistler, *The Venetian Mast*, 1879/80
Private collection, Courtesy of The Fine Art Society, London

James McNeill Whistler, *The Piazzetta*, 1879/80
Hamburger Kunsthalle, Kupferstichkabinett, Hamburg

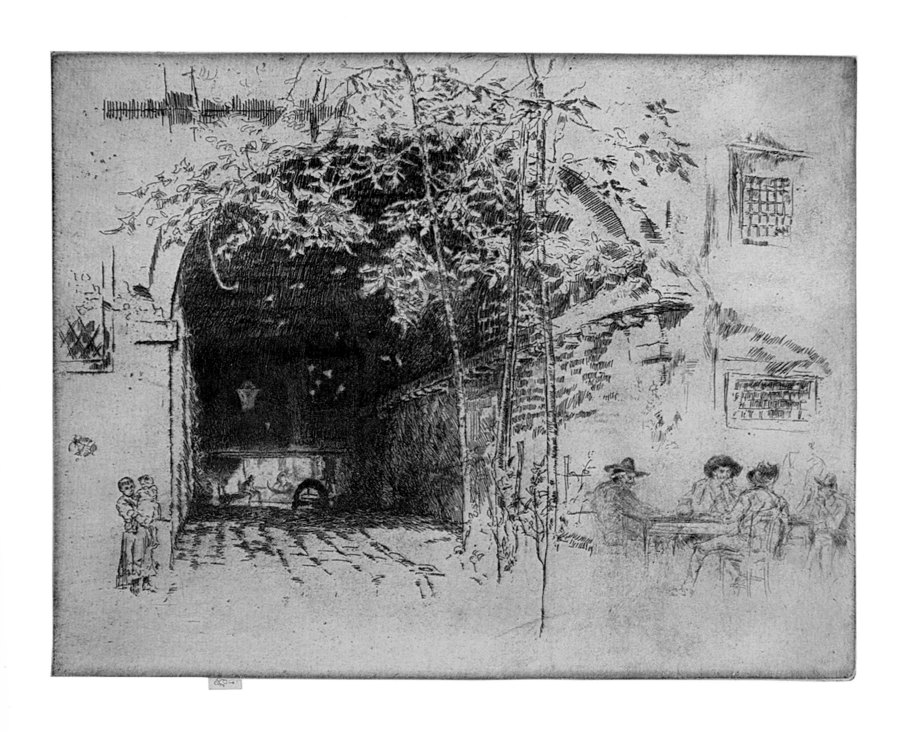

James McNeill Whistler, *The Traghetto, No. 2*, 1879/80
Hunterian Museum & Art Gallery, University of Glasgow

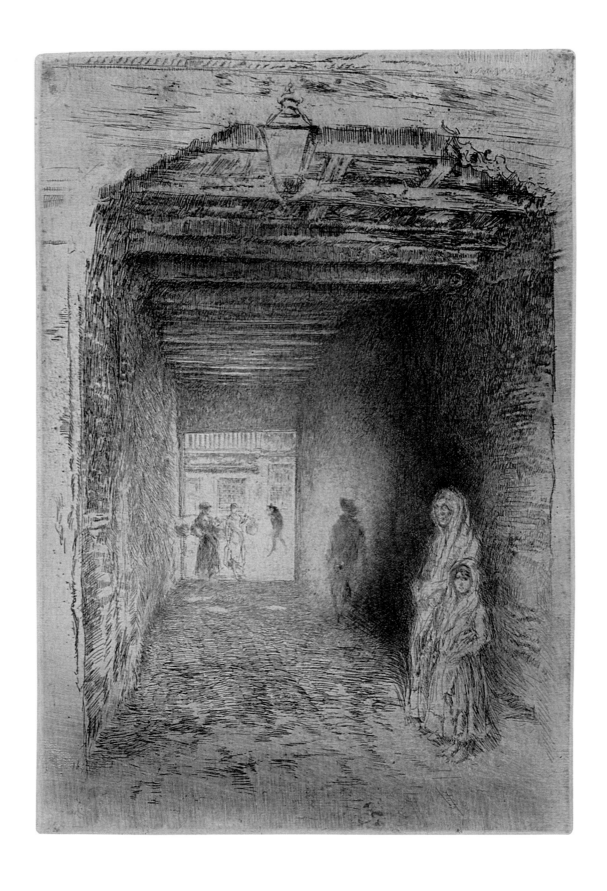

James McNeill Whistler, *The Beggars*, 1879/80
Hunterian Museum & Art Gallery, University of Glasgow

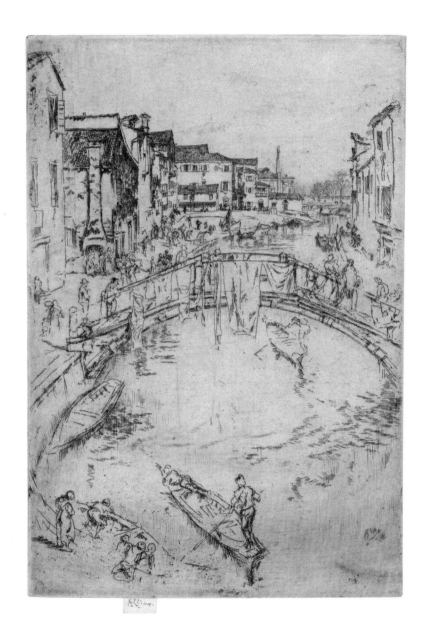

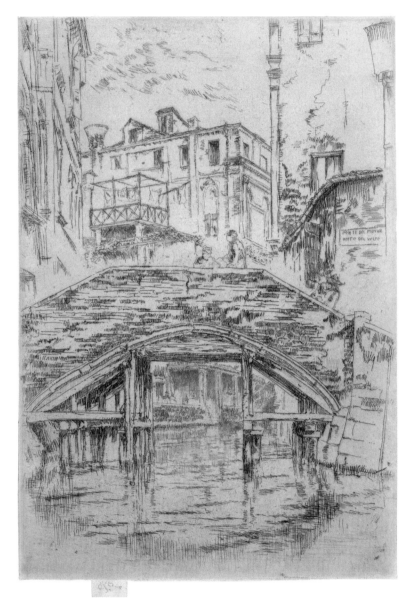

James McNeill Whistler, *The Bridge*, 1879/80
Hamburger Kunsthalle, Kupferstichkabinett, Hamburg

James McNeill Whistler, *Ponte del Piovan*, 1879/80
Hamburger Kunsthalle, Kupferstichkabinett, Hamburg

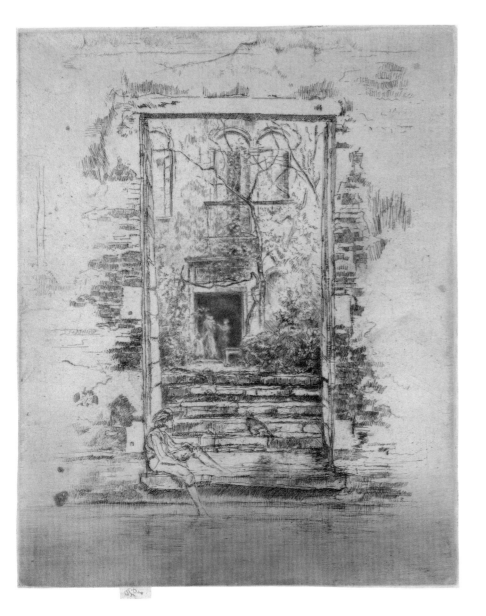

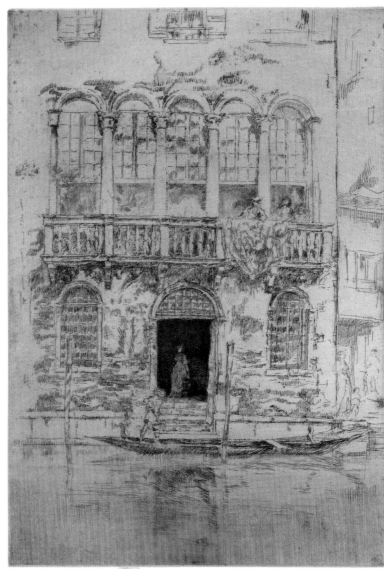

James McNeill Whistler, *The Garden*, 1879/80
Hamburger Kunsthalle, Kupferstichkabinett, Hamburg

James McNeill Whistler, *The Balcony*, 1879/80
Hamburger Kunsthalle, Kupferstichkabinett, Hamburg

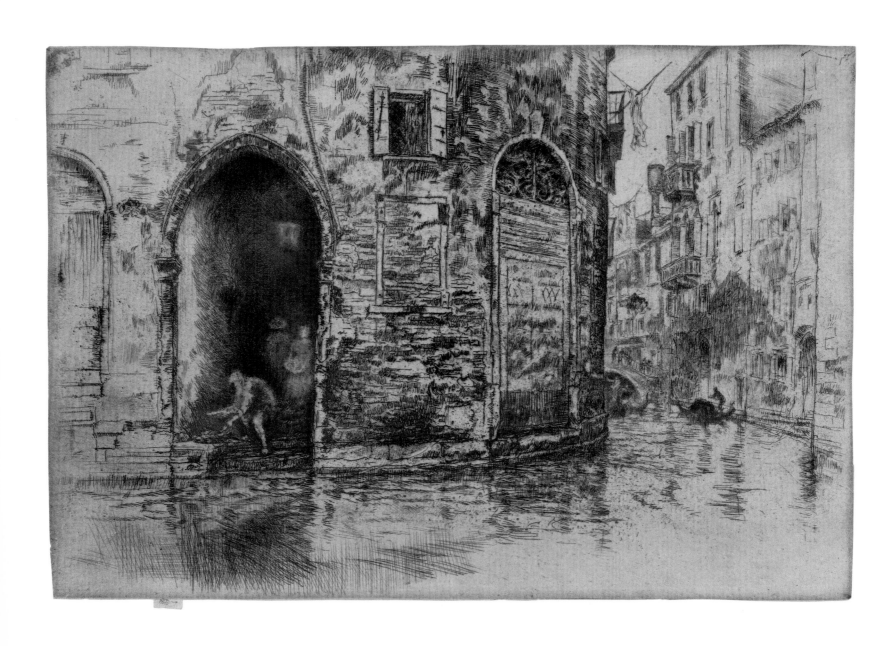

James McNeill Whistler, *The Two Doorways*, 1879/80
Hamburger Kunsthalle, Kupferstichkabinett, Hamburg

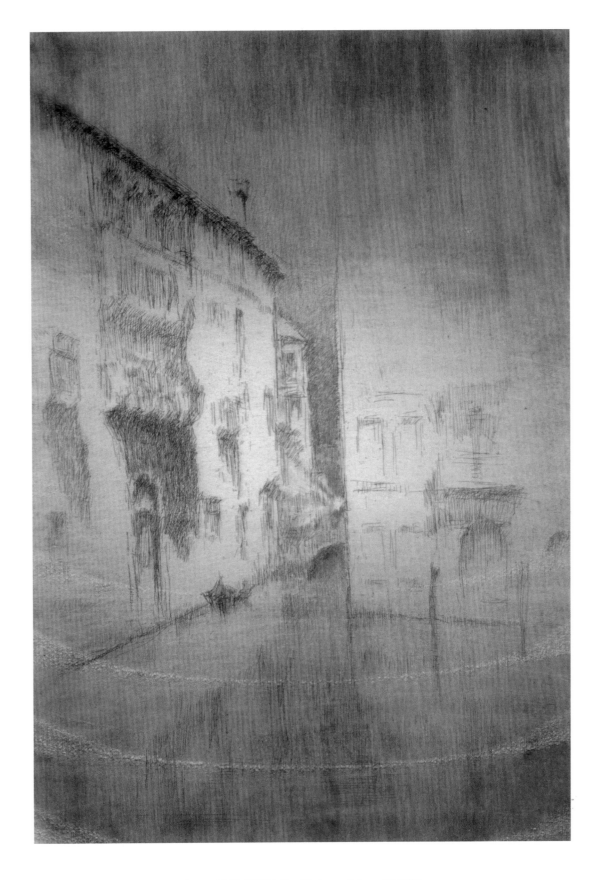

James McNeill Whistler, *Nocturne: Palaces*, 1879/80
Hunterian Museum & Art Gallery, University of Glasgow

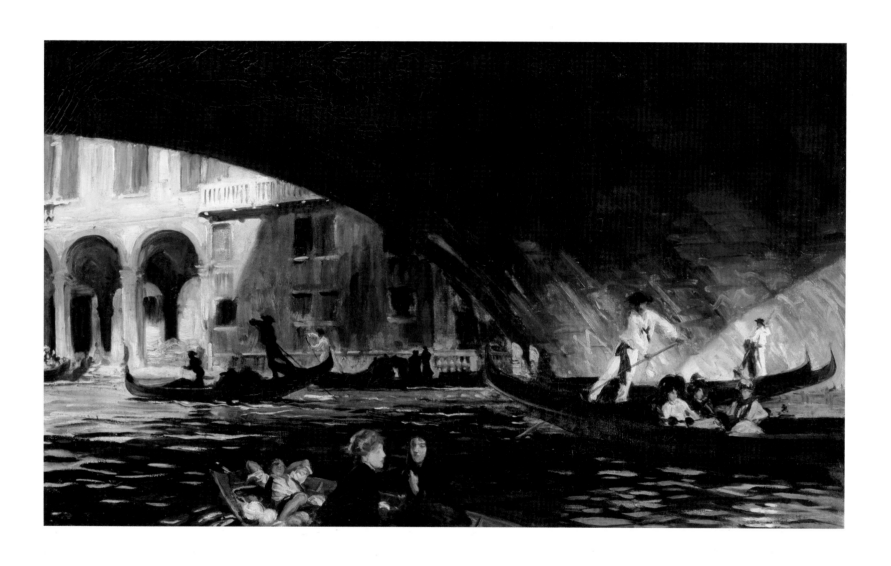

John Singer Sargent, *The Rialto, Venice*, 1911
Philadelphia Museum of Art, The George W. Elkins Collection, 1924

THE LIGHT OF VENICE
JOHN SINGER SARGENT

Elaine Kilmurray

A glance through John Singer Sargent's biography—born in Florence (in 1856, *d.* 1925), studied art in Paris, established a portrait practice in London, decorated the walls of public buildings in Boston—shows that several cities mark important points of reference in his career. Venice, however, satisfied his tastes and stirred his pictorial imagination in a unique way—and it was the city with which he had his most fertile and sustained artistic relationship. Her physical environment, the beauty and high style of her architecture, her strange romance, layered histories and oriental echoes and her resistance to the accelerating changes of modern life spoke to his temperament and answered his aesthetic preoccupations. He represented her obsessively, traveling there in 1880–01 and 1882, and returning almost year after year from 1898 to 1913, sojourns which together produced more than 180 works in oil and watercolor.

Sargent was better acquainted with Venice than most non-Italian artists. He spent much of his youth in Italy, made two extended visits to Venice with his family in the 1870s and, as he spoke fluent Italian, approached the city as something more than a tourist. From the beginning, he equated Venice with painting. In 1874, when he was studying art in Paris, he wrote to his friend Vernon Lee, whose expatriate childhood had also inculcated in her a love of Italian art and culture:

Well, we [his family] have decided to spend the winter here [Paris]. I am sorry to leave Italy—that is to say, Venice, but on the other hand I am persuaded that Paris is the place to learn painting in. When I can paint, then *away for Venice!*[1]

Sargent kept his word, making the journey to Venice in 1880, a couple of years after he had completed his formal training and embarked on his career as an artist. Still a young man who was forging his own style, he was highly receptive to a range of influences and stimuli, and his early Venetian studies are shaped by his experience of Paris and Spain. In his early Venetian works, Sargent does not concentrate on the city's celebrated beauties, choosing instead the backstage view of dilapidated palaces, empty *campi* and narrow alleyways as his subject. The theatrical imagery is apposite because the distinctive physical milieu of Venice acts as a fictive stage for Sargent's models, young working-class women walking in small groups or sitting in darkened hallways engaged in the traditional Venetian craft of glass bead-stringing, and young men and women caught in ambiguous, somewhat furtive exchanges (pp. 128–30). In psychological terms, it is an intimate world glimpsed obliquely, expressed in spare, elliptical compositions and rendered in a subdued and limited palette of cool grays, sober browns, and saturated blacks, with a few notes of bright color. In formal terms, the picture space, whether it describes the interior of a *palazzo* or a narrow passage, is contained, almost claustrophobically, with a strong sense of geometric design. Public and private arenas are fused, interior and exterior space conflated, the sky cropped to make outside areas seem enclosed, while inner corridors are rendered in such sharp perspective that they seem like public thoroughfares. An early watercolor of an anonymous *calle* develops the box-like structure—architecture compressed, receding space accentuated, sky suppressed—which becomes an arena for the Venetian life that Sargent describes and which may be a prototype for them (p. 135). His modern life scenes, with their implicit, enigmatic narratives, are permeated by a sophisticated, urban sensibility, which situates them at the confluence of local subject matter and Parisian style. They demonstrate Sargent's re-

Fig. 1 John Singer Sargent, *El Jaleo, c.* 1880/82, oil on canvas, 239.4 × 348 cm, Isabella Stewart Gardner Museum, Boston

Fig. 2 Diego Velázquez, *Las Meninas,* 1656, oil on canvas, 318 × 276 cm, Museo del Prado, Madrid

sponsiveness to esoteric, largely literary ideas developed by contemporary French aesthetes and decadents, who embraced and exalted Venice's eccentric beauties, penumbras and depredations and promoted her as a locus of self-realization and expression.[2] They are also close to Whistler in their pictorial mood and subject matter, and the work of both artists strikes a chord with contemporary descriptions of Venice written by Vernon Lee:

There, in those tall dark houses, with their dingy look-out on to narrow canals floating wisps of straw, or on to dreary little treeless, grassless squares, in those houses is the real wealth, the real honor, the real good of Venice: there, and not in the palaces of the Grand Canal.[3]

In *The Sulphur Match* (p. 128) there is something risqué, an erotic charge, in the pose of the woman, the cast-aside wine bottle and glass with their established iconographical meanings of virtue lost, and the gesture of the man lighting his cigarette. It is not a literal narrative, but it has a palpable *frisson* which is decidedly modern in its ambiguities.

Sargent's models inhabit their spaces with an aloof air, an insouciant grace, but this sense of Parisian chic has its counterpoint in the dark energies of Spain and Velázquez. Sargent had been to Spain in 1879, going, as so many artists of his generation did, to pay homage to Velázquez, a number of whose works he copied in the Prado. Attentiveness to the elegance of pose, tonal sobriety, psychological ambiguity, and mysterious space in the canvases of the seventeenth-century master is apparent in his own Venetian compositions. The figures in *The Sulphur Match*, for example, seem to derive their raw sensuality from the line of singers and musicians in the background of *El Jaleo*, Sargent's electrifying celebration of Spanish flamenco (fig. 1). In more general terms, the complex design and oblique light sources of *Las Meninas* (fig. 2) inform the ways in which Sargent manipulates the intrinsic geometry of the city's internal and external environment, its negative spaces and shadowy luminosities, for pictorial effect. In these works, Venice is a dark city, its light diffuse and indirect, or experienced as a chink or patch piercing the general obscurity. A special opalescence characterizes Sargent's only panoramic cityscape, *Venise par temps gris* (fig. 3), which is Whistlerian in its quiet radiance and restrained tonalities. It describes a wide stretch of the Riva degli Schiavoni seen from a high position and looking westward towards the Palazzo Ducale, the Campanile, and the domes of Santa Maria della Salute. Wittily drawn figures are dispersed on the quayside and the pale light of a misty winter morning touches a market stall and the gondolas and boats moored in the Bacino. Sargent's early Venetian work forms a discrete group in his oeuvre and it is evident that he considered them experimental and personal. He spoke of painting a Venetian subject for the Salon, but he does not seem to have brought anything to completion, and the Venetian pictures he did choose to exhibit were sent to smaller, more avant-garde exhibition venues, such as Georges Petit's gallery on the rue de Sèze in Paris, the Cercle des Arts libéraux, and the Cercle de l'Union artistique, also in Paris, or the Grosvenor Gallery in London, and many were presented as gifts to his artist friends.[4]

Sargent was more at home in Venice than most non-native artists in that he had a base in the city, the Palazzo Barbaro on the Grand Canal, near the Accademia bridge. The Barbaro, a beautiful Venetian Gothic building, was rented in 1881 and the upper floors bought four years later by Daniel Sargent Curtis of Boston and his English-born wife, Ariana. The Curtises

were civilized, cultured, and hospitable and, as a distant cousin, a friend of their artist son Ralph, and a painter with an exciting reputation, Sargent was a welcome guest. He was in illustrious company: Robert Browning read his poetry in the salon, Henry James used it as his imaginary setting for *The Wings of the Dove* (1902), Monet stayed there in 1908 and painted from the water steps, it would be the inspiration for Fenway Court, Isabella Stewart Gardner's Gothic palace in the Back Bay, Boston, and the Barbaro circle—thinly disguised—would feature in essays by both Edith Wharton and Vernon Lee. Sargent immortalized the Curtis family in a small conversation piece, *An Interior in Venice* (p. 131), painted in 1898. In rendering the darkened interior in fluid, abbreviated strokes, Sargent describes a fabulous rococo room by means of suggestion, focusing on the highlights of its gilded frames, the curves and swags of its mouldings, its ornate furnishings. The evocative space also give him scope to play on dissonance, between the old and young (the older Curtises seated on the right and young Ralph and his wife, Lisa, on the left), between dusky shadows and golden light flooding in from the Grand Canal, between history and modernity, opulence and informality.[5] It was probably around the same time that Sargent painted an oil study of the Hall of the Grand Council in the Palazzo Ducale, *The Interior of the Doge's Palace* (fig. 4), in which the lower area of the room is summarily rendered, while the splendid ceiling decorations by Tintoretto, Veronese, Francesco Bassano, and Jacopo Palma il Giovane with their elaborate gilt moldings dominate the composition.

There is a small group of scenes depicting life in a local *trattoria,* or wine shop, but, in general, in his later works, Sargent is out-of-doors, traversing the canals and painting from the unstable position of a gondola. As an artist inspired by the tenets of Impressionism, he was concerned to express the fleeting effects of light, an imperative made more urgent by the rarefied ambience of Venice and the subtle, shifting lights and reflections of the lagoon. It is unsurprising that the majority of his later Venetian studies should have been painted in watercolor, a medium with a special potential to capture the translucent, the evanescent, and the transitory (and one more accommodating to the practical rigors of painting from a swaying gondola). His gondola vantage point, however, enables him to simulate the way in which Venice is typically experienced—from the water. He imitates the reality of seeing in Venice, the experience of glancing, changing views, of partial vision, which is disorienting and exciting. As the prow of his gondola features in the foreground of a number of his compositions, it also serves to draw the spectator into the picture space and to declare that this is art rather than reality, which would be regarded as a modern artistic statement (pp. 132 bottom, 136 top, 138 bottom). During his sole visit to Venice in 1908, Monet used the diagonal of the platform of the Campo San Giorgio in the foreground of several paintings of the Palazzo Ducale as seen from San Giorgio Maggiore in a similar way (pp. 195, 210, 211), allowing it to secure the composition, to provide an everyday foil to the ethereal beauty of the city, drawing attention to the presence of the painter and alerting the spectator to the fact that the painted surface is an artifice, a created illusion.[6]

Sargent's approach to composition was oblique and idiosyncratic, involving the manipulation of space and scale and a play on asymmetry and spatial incongruity. This stance had a special resonance in Venice, where there is a dovetailing between the physical reality of the

Fig. 3 John Singer Sargent, *Venise par temps gris, c.* 1882, oil on canvas, 52.5 × 70.5 cm, Private collection

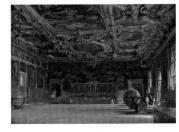

Fig. 4 John Singer Sargent, *The Interior of the Doge's Palace,* 1898, oil on canvas, 50.2 × 69.2 cm, The Earl and Countess of Harewood and the Harewood House Trust

city and Sargent's personal artistic personality, an aesthetic "fit" between the two. In depicting the city, he calls on an array of compositional strategies—compression, foreshortening, tight framings, unexpected angles, and receding perspectives—to challenge the viewer and throw him off balance, but there is a sense in which this is not pure artistic invention. Strange angles and slanting perspectives are built into the architectural fabric of the city, and Sargent brings out things that are inherent or latent within it. It is clear then that Sargent does not view Venice's churches, palaces, and public buildings with the detached eye of the topographical tradition. He paints the city in fragments, as it would be experienced from water level, often detaching particular architectural sections and examining them through his own artistic lens. The Palazzo Balbi is an imposing early Baroque edifice in a prominent position on the left side of the Grand Canal, on the *volta*, or bend, as it turns up towards the Rialto, but Sargent elects to paint it from his gondola vantage point and to give us a close-up, oblique, and truncated segment of its lower façade and water steps. He is moored close to the central water gate (the Balbi is a tripartite construction with three gates) and the first mooring post almost bisects the composition, emphasizing its verticality so that the structure seems to rise out of the water like a natural creation (p. 137). He delineates the stone steps, the rustication of the ground story, the pronounced water gate, a slice of its broken pediment and the windows at either side and, using a palette of brown, blue, green, and orange, he mimics the reflections of the sky and posts on the moving waters. He also leaves patches of reserve paper to suggest a light falling on the façade so intense that the stone is blanched and the spiral foliate motif on the decorative band around the base partially dissolved. He has colluded with the architectural form of the building, exploiting the effects of *chiaroscuro* made possible by the plastic, sculptural qualities of the Baroque (Alessandro Vittoria, the probable architect of the Balbi, was a sculptor), and creating a dazzling, painterly interplay between form and light. Sargent's architectural fragments can be remarkable for their pictorial eloquence. When he paints the church of San Stae, an exuberant Baroque construction which seems to have been hewn from white rock, he uses abrupt cropping and theatrical lighting, and by including a portion of the red rococo façade of the neighboring and more modest Scuola dei Tiraoro e Battiori (guild of goldbeaters) in his composition, creates a picture of vivid contrasts and dynamic tension (p. 133). Nowhere is Sargent's desire to avoid the pictorially banal and obvious more manifest than in his three studies (one in watercolor and two in oil) of the underside of the Rialto bridge, one of Venice's most iconic structures (p. 120). In what seems like an artistically perverse gesture, he paints the bridge from the underside, describing its immense sweep and exquisite grace of line and contrasting its dark cavernous void with arcs of golden light on the Fondaco dei Tedeschi beyond. There is an abundance of local incident in the scene, but the inventiveness of the painting lies in its formal boldness, the great nothingness at its heart, and the rich and resonant patterning of light and dark.

Venice is a city of extraordinary surfaces and its architecture can seem like stage scenery—it is difficult to escape the cliché that the façades of Venetian palaces are like theatrical stage-flats. In a number of works, Sargent embraces and points up the surface quality of Venetian architecture because its emphasis on visual effect suits his artistic purpose. Some-

times the palaces seem like a backdrop to activity on the water. In *View of Venice* (p. 134 top), Sargent represents the grandiose Palazzo Grimani and a slice of the Palazzo Corner Contarini dei Cavalli (he executed several individual studies of both palaces, paying painterly attention to their architectural form) from the far side of the Grand Canal. The morning sun illuminates the side façade of the Grimani facing the Rio di San Luca, leaving the main façade on the Grand Canal a subtle, shadowed blur. In the foreground, two gondolas are being propelled through the waters apparently at speed. The combination of the softly indistinct background architecture and the sense that the two parallel gondolas might be sequential images or frames of the same vessel like a series of still photographs by Eadweard Muybridge intent on capturing motion lends the image a cinematic quality.

It would be misleading to suggest that Venice, for Sargent, was all about spectacle. The architectural integrity of buildings was of real importance to him. From 1890, when he was commissioned to paint a mural cycle on the history of religion for the Boston Public Library, the grand civic edifice designed by the New York architects McKim, Mead, and White, he was preoccupied by architectural spaces. His response to the challenge of decorating the walls of a building conceived in the spirit of Beaux-Arts classicism was to work in the tradition of the Italian Renaissance, integrating his mural scheme with the architectural detail of the building. This was not a new field of interest. Sargent had made architectural drawings as part of his academic studies at the École des Beaux-Arts in Paris and painted the architecture of Capri and North Africa on his visits as a young artist, but it seems to have become more pressing later in the 1890s. Sargent

traveled extensively in Europe and in the Near and Middle East in the 1890s and in the pre-war years of the twentieth century, and much of his travel was planned with research for his murals in mind. The Venetian buildings he painted were important to him as artistic motifs and they are pictorial evidence that his decorative schemes were never far from his mind. There were imaginative links between the ceiling vaults, niches, friezes, and lunettes of his library decorations and the recesses of Santa Maria della Salute, the tiered stories of the Libreria, the arcade of the Scuola Grande di San Rocco or the water gates, balconies, and windows of the great merchant palaces. An understanding of Sargent's interest in architecture also goes some way to counterbalancing the description of his vision of Venice as that of the ordinary tourist, a label bestowed on him by the English art critic Roger Fry, which went on to gain considerable currency.[7]

Sargent's personal taste in architecture was for the Renaissance and Baroque (other than sections of the Palazzo Ducale, which feature in several of his views of the Piazzetta area, he paints no Venetian Gothic). He was transfixed by certain buildings, notably Baldassare Longhena's Santa Maria della Salute and Jacopo Sansovino's Libreria, but his interpretations of them are extremely selective and distinctive. He is drawn to the cool elegance of the Libreria, its dignified façade organized by classical orders, articulated in high relief, and richly decorated; but he manipulates the structure in experimental ways, isolating fragments of the upper story in contravention of orthodox perspective, slicing off the sculptures which stand on top of the balustrade, and juxtaposing the building with the column of St Theodore and the open space of the Piazzetta. Santa Maria della Salute is his signature Venetian building,

but it is only in watercolors painted from the Giudecca that we are given a sense of the whole church and its prominence, the great domes, the soaring cupolas and campaniles, a complicated skyline glimpsed through an elaborate network of masts and rigging of sailing ships moored in the canal (p. 138 top). With a single exception and with minor variations, he focused on a particular segment of the church—the angled hinge between the entrance portico and the first side chapel on the lower façade (it is built on an eight-sided plan), cropped below the pediment.[8] He uses the broad flight of steps leading up to the church to provide a preface and a linear relief to the ornate three-dimensional Baroque structure above it, and his interpretations become—in formal terms—virtuoso studies of horizontal and vertical, mass and void, light and shade. In *Santa Maria della Salute* (p. 132 top), for example, he uses an austere, almost monochromatic, palette of white, cream, and gray, with hints of blue and brown, to express light playing on the richly carved Istrian stone of column, arch, and statuary, creating deep shadowy contrasts and slow rhythmic surface patterns.

Sargent loved the stones of Venice and he dwelled on their special qualities for half a lifetime, appropriating their peculiar forms, angles, and points of view, imbibing their classical echoes and exploiting the pictorial potential of their responsiveness to light.[9] No artist from the mid-nineteenth century onwards who wanted to describe Venice could escape the long shadow cast by Ruskin and Turner, and it is unsurprising that Vernon Lee should have placed Sargent in the context of Venice's most assiduous chronicler, noting

[Sargent's] Ruskinian rendering of the planes and angles of architecture, why, every exquisite sharp, yet tender corner shows the four-square shape of the building, records the certainty that cornice or capital or archway would have revealed definite loveliness of shape if seen from another or nearer point of view.[10]

Venice is, of course, much more than a physical site. As an artistic entity, she represents the dissolution of boundaries between dream and reality, past and present, art and life, and Sargent's successive Venetian sojourns and the oeuvre that they produced are testament to her transporting and enduring allure.

[1] Letter from Sargent to Vernon Lee, September 4, 1874, private collection.

[2] For Venice in literature, see Tony Tanner, *Venice Desired*: Writing the City (Cambridge, Massachusetts, 1992), and for the development of the myth of Venice in the nineteenth century, see John Pemble, *Venice Rediscovered* (Oxford, 1995).

[3] Vernon Lee, *Studies of the Eighteenth Century in Italy* (London, 1880), p. 265.

[4] For the exhibition history of Sargent's early Venetian works and for details of those works given by him to his artist friends, see Richard Ormond and Elaine Kilmurray, *John Singer Sargent: Figures and Landscapes, 1874–1882* (New Haven/London, 2006), and Marc Simpson, *Uncanny Spectacle: The Public Career of the Young John Singer Sargent*, exh. cat. Sterling and Francine Clark Art Institute, Williamstown (Massachusetts/New Haven, 1997).

[5] For the Palazzo Barbaro circle, see Elizabeth Anne McCauley, Alan Chong, Rosella Mamoli Zorzi, and Richard Lingner, *Gondola Days: Isabella Stewart Gardner and the Palazzo Barbaro Circle*, exh. cat. Isabella Stewart Gardner Museum (Boston, 2004).

[6] Monet uses this device in a series of six studies of the Palazzo Ducale painted from San Giorgio Maggiore, see Joachim Pissarro, *Monet and the Mediterranean*, exh. cat. Kimbell Art Museum, Fort Worth, and Brooklyn Museum of Art (New York, 1997), pp. 152–57, cat. nos. 79–84.

[7] "His [Sargent's] watercolors, with their crude oppositions of positive yellow and hard purple shadows, show the city under the same aspect that we know so well in those ricordi di Venezia which the plain man brings home and frames in German gilt moldings. Mr. Sargent records this aspect with greater skill, with a more cunning shorthand notation, but the inspiration is of no finer quality." "Mr. Sargent at the Carfax Gallery" in *The Athenæum*, 3943 (May 23, 1903), p. 665.

[8] The only study of the upper structure of the Salute, a watercolor of a segment of the north-eastern side chapel of the church describing its complex Baroque statuary, volutes, and the base of the dome, is in the collection of the Yale University Art Gallery.

[9] John Ruskin's *The Stones of Venice* was published in three volumes, the first in 1851 and the second and third in 1853.

[10] Vernon Lee, "J.S.S.: In Memoriam," in Evan Charteris, *John Sargent* (London, 1927), p. 253.

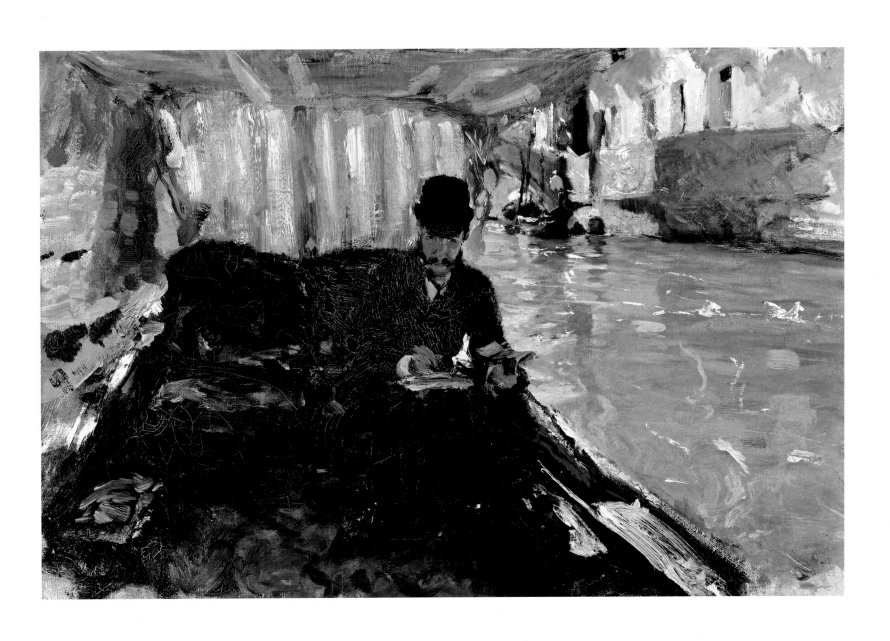

John Singer Sargent, *Ramón Subercaseaux in a Gondola, c.* 1880
Collection of The Dixon Gallery and Gardens, Memphis, Tennessee, gift of Cornelia Ritchie

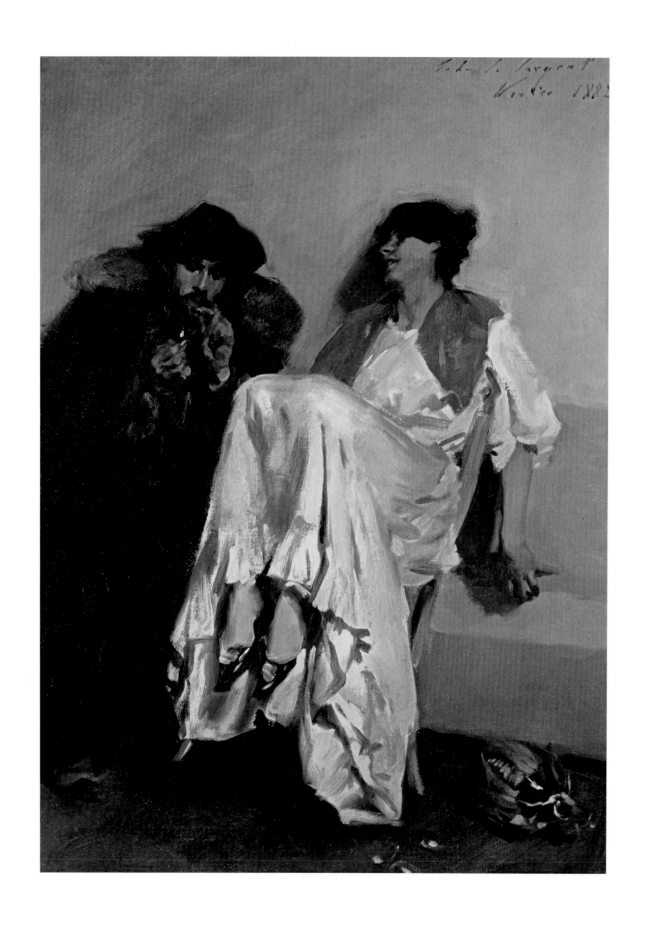

John Singer Sargent, *The Sulphur Match*, 1882
Marie and Hugh Halff

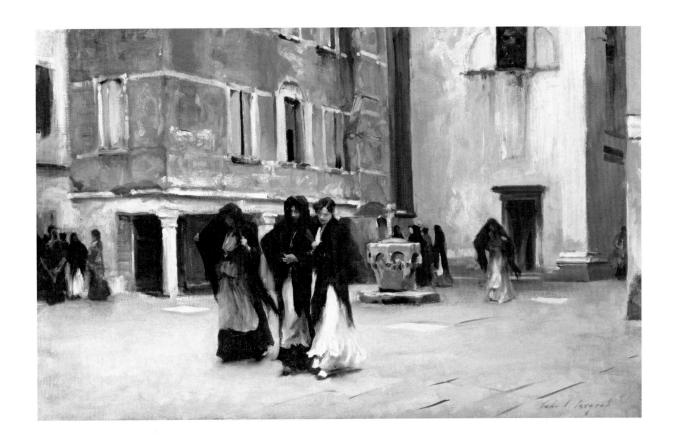

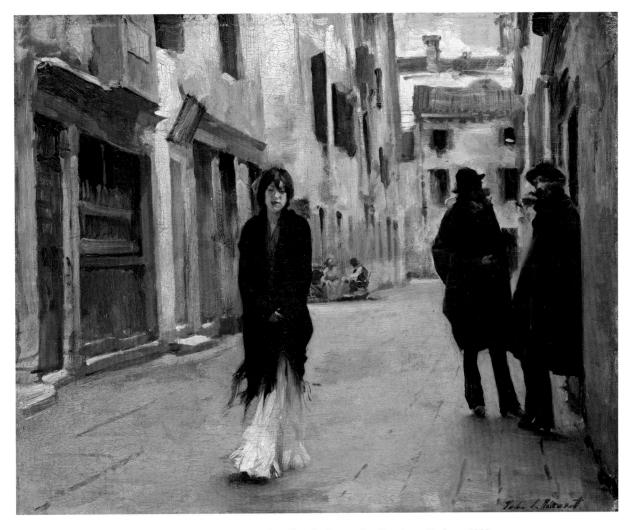

John Singer Sargent, *Leaving Church, Campo San Canciano, Venice, c.* 1882
Marie and Hugh Halff

John Singer Sargent, *Street in Venice, c.* 1882
National Gallery of Art, Washington, D.C., gift of the Avalon Foundation

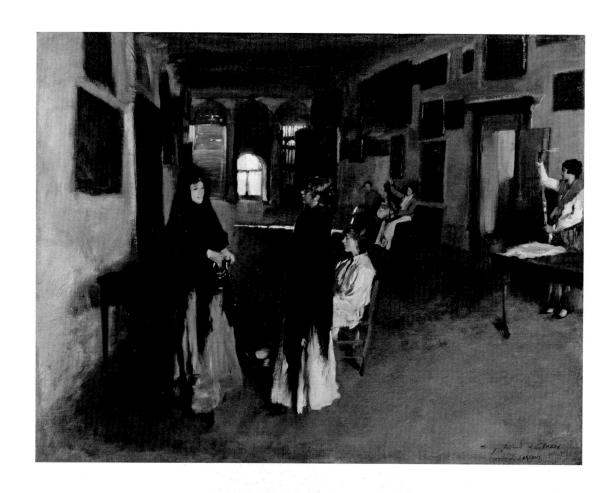

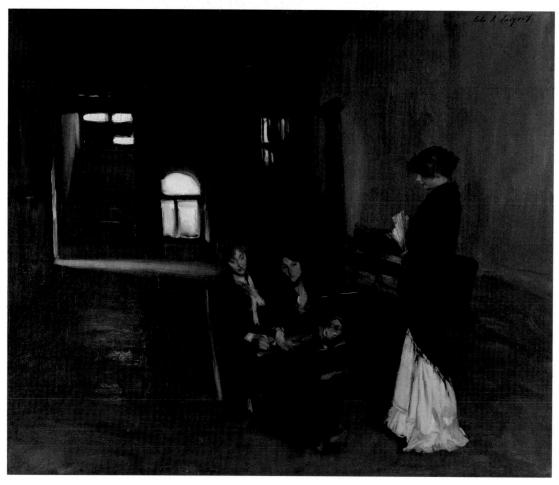

John Singer Sargent, *A Venetian Interior*, c. 1880/81
Sterling and Francine Clark Art Institute, Williamstown, Massachusetts

John Singer Sargent, *Venetian Bead Stringers*, c. 1880/82
Collection Albright-Knox Art Gallery, Buffalo, Friends of the A.A.G. Fund, 1916

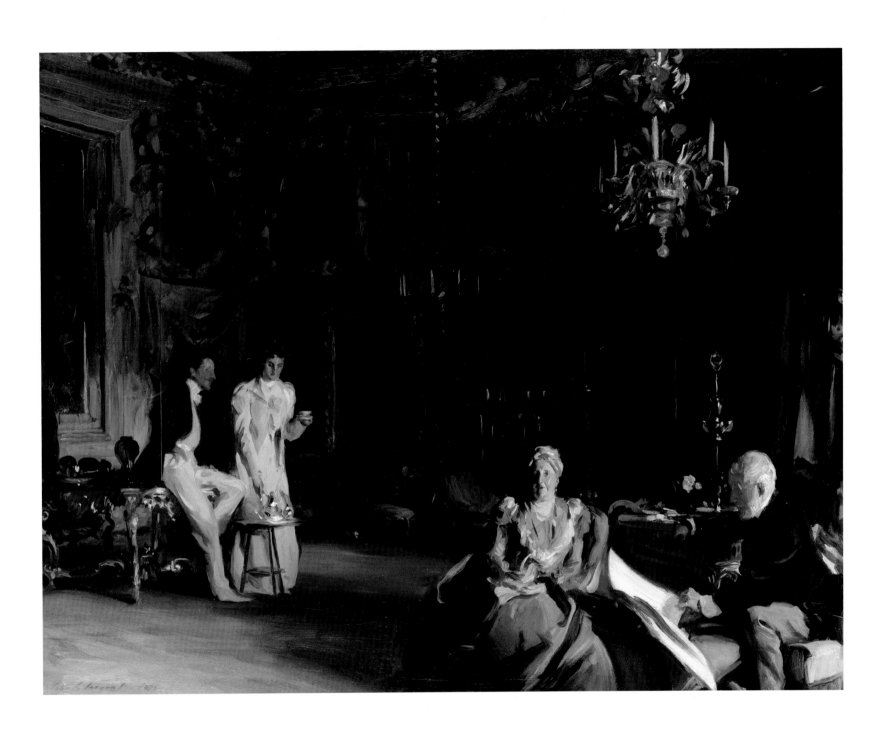

John Singer Sargent, *An Interior in Venice*, 1898
Royal Academy of Arts, London

John Singer Sargent, *Santa Maria della Salute, Venice, c.* 1906
The Syndics of the Fitzwilliam Museum, Cambridge

John Singer Sargent, *The Libreria, c.* 1906/09
Private collection

John Singer Sargent, *Corner of the Church of St Stae, Venice, c.* 1913
Private collection

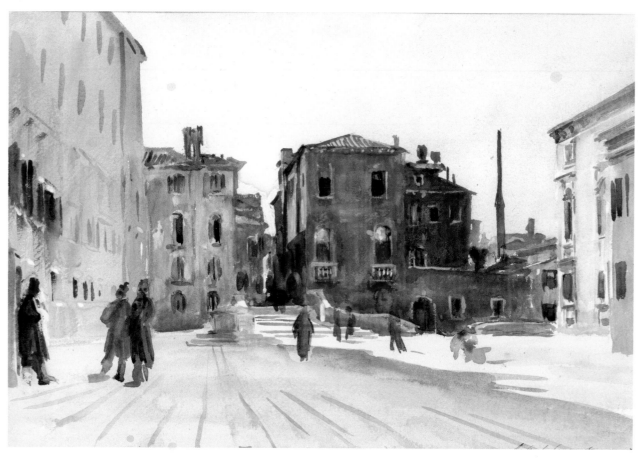

John Singer Sargent, *View of Venice (On the Canal)*, c. 1902/04
Petit Palais, Musée des Beaux-Arts de la Ville de Paris

John Singer Sargent, *Campo dei Gesuiti*, c. 1902/04
Private collection

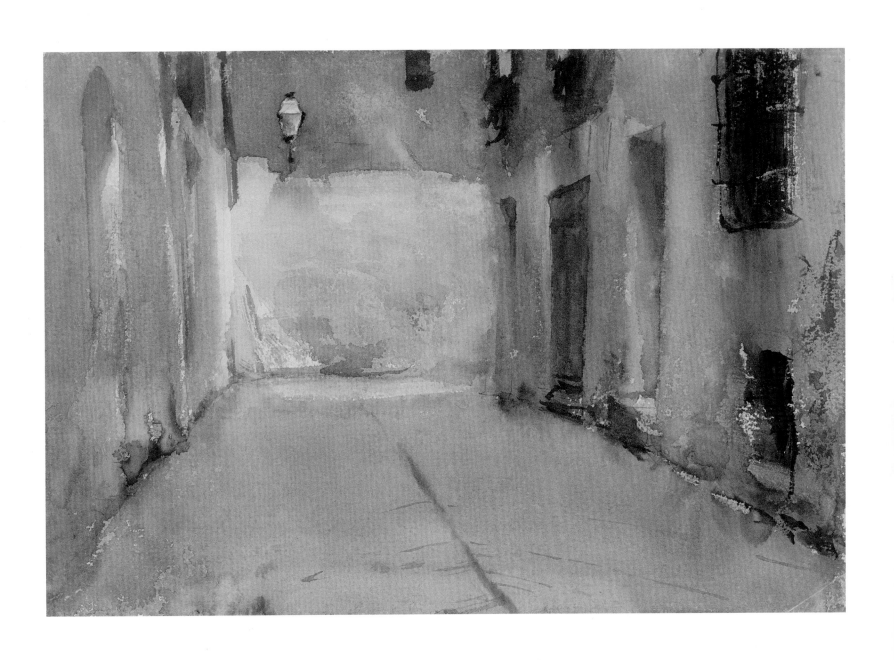

John Singer Sargent, *Venice, c.* 1880/81
The Metropolitan Museum of Art, gift of Mrs. Francis Ormond, 1950

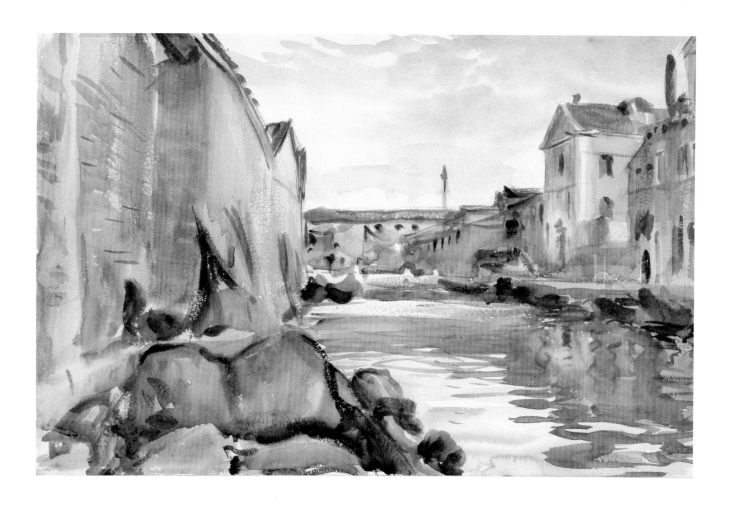

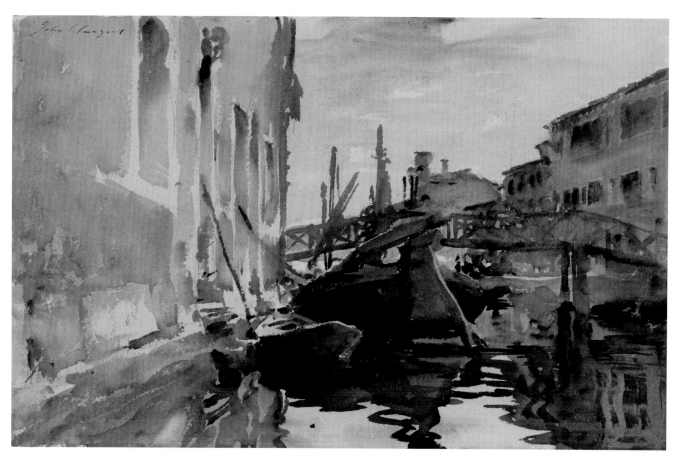

John Singer Sargent, *Giudecca, c.* 1913
The Syndics of the Fitzwilliam Museum, Cambridge

John Singer Sargent, *Giudecca, c.* 1913
The Metropolitan Museum of Art, purchase, Joseph Pulitzer Bequest, 1915

136

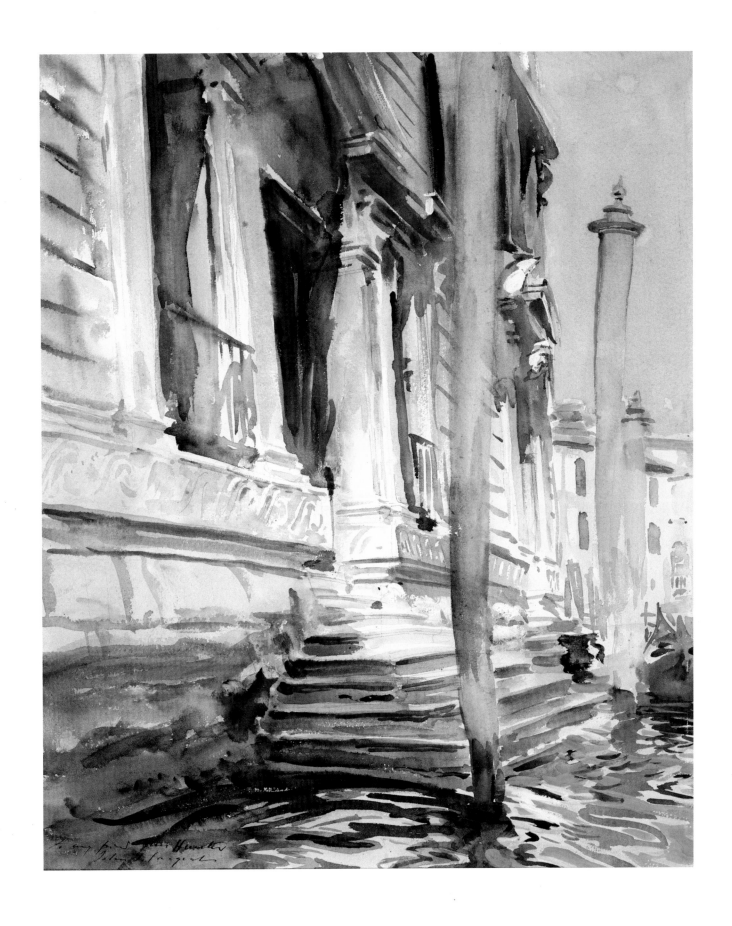

John Singer Sargent, *Doorway of a Venetian Palace*, c. 1904/09
Collection Westmoreland Museum of American Art, Greensburg, Pennsylvania, anonymous donation

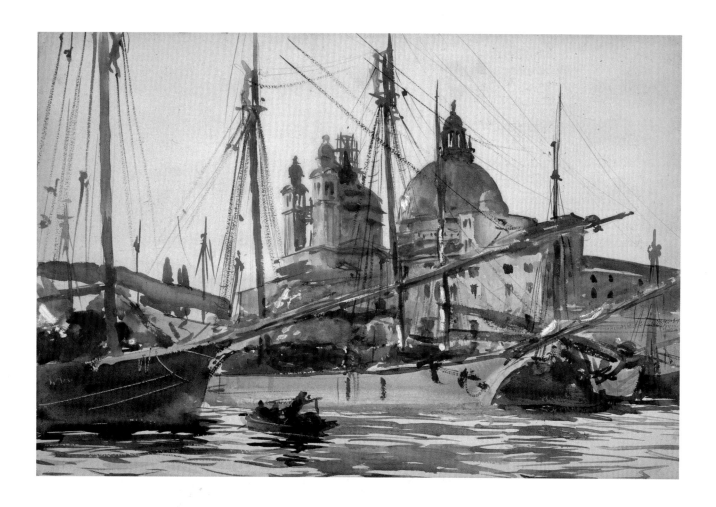

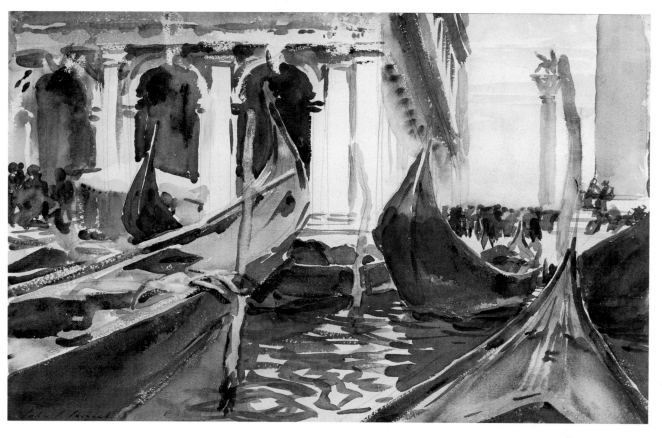

John Singer Sargent, *The Church of Santa Maria della Salute from Giudecca, c.* 1904/09
Calouste Gulbenkian Museum, Lisbon

John Singer Sargent, *The Piazzetta, Venice, c.* 1904
Tate, presented by Lord Duveen, 1919

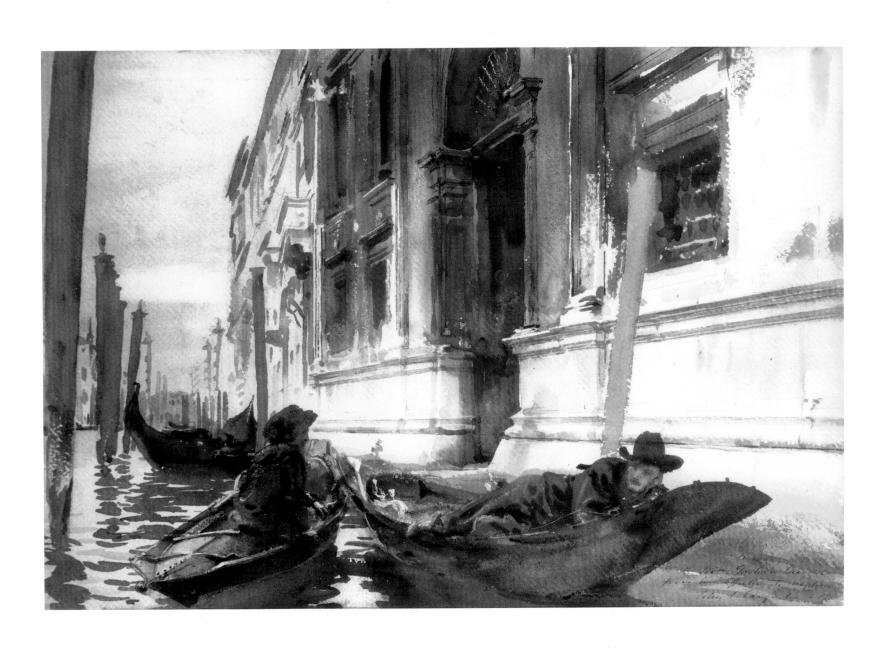

John Singer Sargent, *Gondoliers' Siesta, c.* 1904
Private collection, courtesy of Adelson Galleries, New York

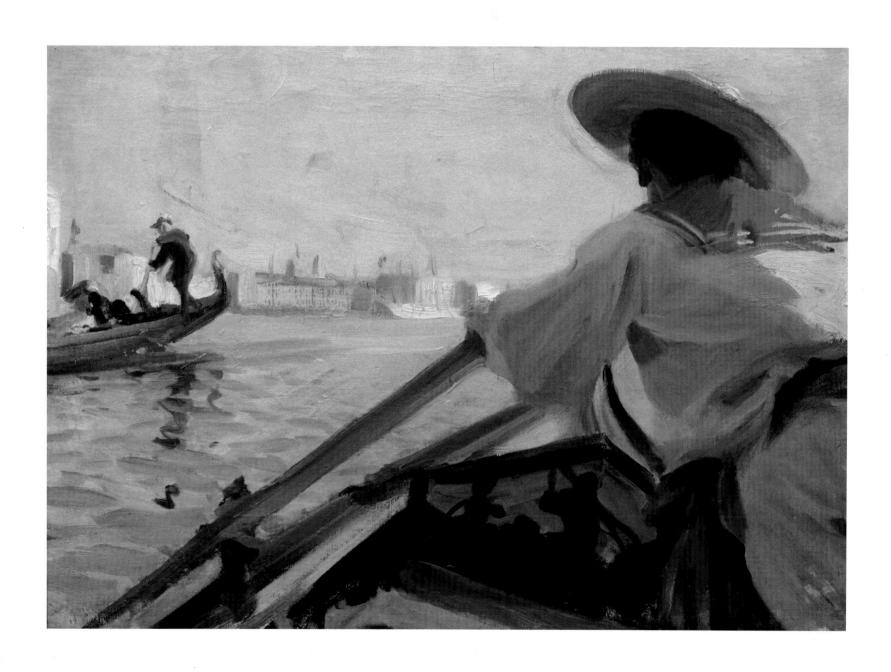

Anders Zorn, *In my Gondola*, 1894
Zornsamlingarna, Mora, Sweden

ANDERS ZORN AND THE PALAZZO BARBARO

Alan Chong

The Swedish painter Anders Zorn (1860–1920) was perhaps less profoundly effected by Venice than his contemporaries James McNeill Whistler and John Singer Sargent, who sought to capture the shifting moods and mysteries of the city with greater intensity and over a longer period. Rather, Zorn's visit to Venice in the autumn of 1894 deepened his already established fascination with certain subjects: portrait figures set in dramatically lit interiors, rowers, and women at work. Because his stay in the city was brief, and he was circulated in an elite circle, Zorn's vision of Venice was rather different from artists of his time.

The immediate cause for Zorn's Venetian sojourn was Isabella Stewart Gardner (1840–1924), the Boston collector who had met the artist at the Chicago World's Fair of 1893. Gardner recalled that she first met the artist while admiring his painting *The Omnibus,* which she immediately purchased (Isabella Stewart Gardner Museum, Boston).[1] Gardner invited Zorn and his wife, Emma, to visit Boston, where Zorn made a portrait etching of Isabella. This was judged a failure: Isabella looked shriveled and old, not to mention eccentrically dressed. Zorn's familiar compositional devices had failed to capture any of Gardner's exuberance. Gardner locked away her copies of the etching, which she originally wanted to give to friends. Undeterred, in 1894, she invited the Zorns to spend a month with her at the Palazzo Barbaro in Venice. She had rented the *piano nobile* of the *palazzo* every other year since 1890 from its owners Daniel and Ariana Curtis, formerly of Boston. These long stays inspired Gardner's collecting and the eventual formation of her own personal museum in Boston.

Anders and Emma Zorn arrived in Venice on October 6, 1894, and stayed with Jack and Isabella Gardner until November 4. This was the artist's first visit to the city, and he thrived in the lively social setting of the Palazzo Barbaro. His experience portraying wealthy sitters prepared him for a hectic schedule of excursions, parties, concerts, and an almost constant stream of visitors who wanted to watch him paint. Gardner enjoyed the company of painters, writers, and musicians; one observer remarked that her husband alone was not entertaining enough. Henry James had been a house guest at the Palazzo Barbaro in 1892, when he wrote *The Aspern Papers,* and the American artist Joseph Lindon Smith had been staying just before the Zorns arrived. Zorn recalled the whirlwind Isabella Gardner had arranged for him:

Parties were held with Don Carlos, . . . the two princesses, and Don Jaime, among other guests. Excursions inland after dinner to hear new operas. Trips through the canals in the night. Music, song, and reverie the whole time.[2]

This constant activity cannot have been conducive to serious artistic work, but Zorn (like other artist-guests) knew how to handle these situations by tossing off little sketches as party favors. Mrs. Gardner preserved several of these drawings in her albums. One celebrates her role as a patron of music and painting by depicting her as a haloed Madonna of Charity embracing two naked infants, one holding a painter's palette, the other playing a violin.[3] The role of an artist in Venice was as much performance for an audience as actual painting.

Isabella Gardner treated Zorn as an honored guest, an important international painter. She even hired a photographer to record the two couples in gondolas in front of the Palazzo Barbaro, a honor accorded no other guest, not even Henry James. The first images were not to Isabella's liking, and the photographer was called back the following week. One of the

Fig. 1 Emma Zorn and Jack Gardner and Isabella Gardner and Anders Zorn in two gondolas in front of the Palazzo Barbaro, Venice, 1894, photograph, Isabella Stewart Gardner Museum, Boston

photographs (fig. 1) shows Emma Zorn and Jack Gardner in the left vessel, with, at right, Isabella typically veiled and Zorn typically slouched.

Zorn faced a particularly daunting challenge in Venice—to produce a new portrait of Isabella Gardner. We do not know whether this was an explicit commission, but it was certainly understood that the etched portrait had been a failure. Isabella had longed for a portrait of herself. Sargent had painted a highly praised portrait of her in 1888, but the provocative *décolletage* (intentionally reminiscent of the painter's *Madame X*) led her husband to request that it not be shown, leaving Mrs. Gardner without a public effigy. A planned commission from Whistler resulted in nothing more than a quick little pastel. Ludwig Passini's portraits of the couple, made in Venice in 1892, were also not well regarded; and this was followed by Zorn's disappointing etching. The incident with the photographer shows just how fussy Isabella could be.

Zorn described the creation of his portrait of Gardner (fig. 2):

I painted many canvases. But first and last, Mrs. Gardner as she came into the large salon of the palace from the balcony over the Grand Canal—fully expressing her character. Grand, more noble than most, and with a charm to her voice that made us all her slaves.[4]

Isabella too recalled the painting of the portrait:

The other is a portrait of me—astounding! A night scene..., I am on the balcony, stepping down into the salone *pushing both sides of the window back with my arms raised up and spread wide! Exactly like me.*[5]

The seeming spontaneity of her gesture opening the windows is perfectly matched by Zorn's very free brushwork. The fabrics of the curtain and the dress, the reflections on the windows, and the flickering moonlight on the Grand Canal are all rendered with energy. The effect is heightened by the scale of the portrait, which is considerably smaller than Zorn's commissioned portraits and closer to an oil sketch. The work has the feeling of being quickly painted—an immediate record of a special moment in time. Movement is further suggested by Isabella Gardner's position on the threshold between the exterior and interior, as well as between the effects of moonlight and candlelight. Isabella said that Zorn had seen her at the balcony door and exclaimed: "Stay just as you are! That is the way I want to paint you," and immediately began to paint the portrait.[6] Jack Gardner also recorded that Zorn painted in front of guests and finished the portrait quickly: "After dinner Zorn painted, then Mrs. G. and Zorns went out in gondola"; and the following day recorded: "Zorn finished picture of Mrs. G. in the window."[7]

At this time, Zorn was greatly interested in the strange effects created by the interplay of different kinds of light, and by figures standing in thresholds. For example, in 1888 he had painted a watercolor, at the request of Antonin Proust, showing the dancer Rosita Mauri in a doorway, turning as if by surprise.[8] After his visit to Venice, Zorn returned to Paris and began work on a painting closely related to Isabella Gardner's portrait. He described *Night Effect* now in Göteborgs Konstmuseum as an exploration of a "difficult illumination problem" because it mixed candle and electric light.[9] Zorn asked a prostitute to pose leaving a café. Her red dress and unsteady gait is underlined by the peculiar light, which distorts and flattens the spaces of the interior. The colors of gaslight and electric light—a new feature of cities in the 1890s—form a queasy mixture, as

unsteady as the woman herself. At the Paris Salon of 1895, Zorn exhibited the portrait of Isabella Gardner as a *pendant* to *Night Effect.* Isabella and Jack Gardner came to Paris specifically to see her portrait. She does not seem to have complained about the juxtaposition of her portrait with the depiction of a plump, unstable prostitute. Indeed, she seems to have enjoyed comparing herself to sensual images of women.

Without doubt, Gardner considered Zorn's portrait a tremendous success. When the Isabella Stewart Gardner Museum first opened to the public in 1903, the painting was placed in the first gallery (the Chinese Room) of the *piano nobile*, where the image of Mrs. Gardner welcomed visitors. When the museum was re-installed in 1914, the portrait was placed in a Venetian-themed alcove, next to a portrait of her husband, Jack Gardner, which Antonio Mancini had painted in Venice in 1895.

The third painting that Zorn exhibited at the 1895 Salon was another Venetian composition—a depiction of lacemakers at work. The subject matter closely echoes Zorn's earlier paintings of women working, for example, *The Large Brewery* of 1890 in Göteborgs Konstmuseum or *Sunday Morning* of 1891. Zorn sought out lace workshops, in particular the lacemaking firm of Jesurum where he made sketches, including an oil sketch now in the Zornsamlingarna in Mora. The welfare of poor lacemakers was a prominent concern for Isabella and other English and American residents in Venice; her friend Katharine Bronson supported the revival of local lace manufacturing. Zorn's *Lacemakers* makes a strong contrast with several paintings by Sargent of bead stringers from around 1882. Although ostensibly about women working at a typical Venetian craft, Sargent depicted a few solitary women

standing and sitting quietly in various configurations in some dark Venetian palace. In contrast, Zorn's painting is a bustle of activity, and is truly concerned with capturing physical labor, as long rows of women bend over their work.

Zorn's other major painting produced in Venice represents a gondolier rowing, the viewer apparently in the gondola itself. The artist wrote of the Palazzo Barbaro's gondoliers: "One of whom was the handsomest in Venice, and perhaps also the stupidest. My wife asked to sit beside me in the gondola just in order to see his back and neck when I painted him. I painted him, it is embarrassing to say, just from the back as I saw him when he rowed."[10] *In My Gondola* (p. 140) captures the breezy openness of the Venetian lagoon, the gondolier seen straining at his task.

At first glance, the painting seems about as Venetian as possible, especially since gondoliers were such a common, picturesque sight, and a favorite subject for artists. Zorn was an enthusiastic sailor, and had often painted pictures of small boats, executed in the vessel; he sought out this theme wherever he traveled. For example, a watercolor painted in England in 1883 shows an elegantly dressed young woman seated in a row boat, and in 1886 and 1887, Zorn had depicted rowers in the harbors of Istanbul and Algiers. In 1891, he repeated the subject in his native Sweden in a painting entitled *Midnight* in the Zornsamlingarna in Mora, which shows a robust young woman rowing. Turned away from us, she gazes towards a bank eerily illuminated by the midnight sun. These examples are all compositionally similar to *In My Gondola*, although the mood and atmosphere are distinct.

Zorn seems to have been attracted by the energy and the specific characteristics of the

Fig. 2 Anders Zorn, *Isabella Stewart Gardner in Venice*, 1894, oil on canvas, 91.1 × 66 cm, Isabella Stewart Gardner Museum, Boston

rower, whether in Venice, Istanbul, or Sweden. The artist studies and examines the gondolier as much as the setting. Indeed, in the process of finishing *In My Gondola,* Zorn made significant alterations in the composition to emphasize the grace of the figure perched on the gondola's prow. Besides adjustments to reduce the size of the gondolier's hat, Zorn also painted over much of the cityscape on the left. Clearly visible in pentimenti is the Campanile of St. Mark's Square. Zorn must have felt that the famed landmark was too touristy and predictable—too much of a distraction for the depiction of a gondola skipping over the waves in the exhilarating air.

But the mysterious moods that many artists discovered in Venice's quiet canals and courtyards entirely eluded Zorn. His oil sketches of Venetian canals are curiously compressed and airless—marvelous layerings of shapes and colors, but curiously unevocative of Venice. Zorn's principal paintings made in Venice have excitement and movement, but frankly could have been made almost anywhere in the world. It is perhaps not a coincidence that when Zorn exhibited works at the first Venice Biennale in 1895, he submitted Swedish rather than Venetian subjects.

Zorn remained close friends with Isabella Gardner, although he did not paint any further pictures for her after the trip to Venice, and despite traveling to America several times after 1894. The artist participated with enthusiasm at the early Venice Biennali; thirty works were shown in 1905 and a retrospective of seventy-six works in 1909, when the artist returned to Venice.[11] Venice connected painter and collector on one further occasion. Gentile Bellini's drawing of a seated scribe at the court of Mehmed II was discovered in Istanbul by a friend of Zorn's, Frederick Martin. In 1907, Zorn suggested that Isabella Gardner purchase the work, a delicate colored sheet by a Venetian artist working in Istanbul in 1480.

1 Morris Carter, *Isabella Stewart Gardner and Fenway Court* (Boston, 1925), p. 137.

2 Elizabeth Anne McCauley, Alan Chong, Rosella Mamoli Zorzi and Richard Lingner, *Gondola Days: Isabella Stewart Gardner and the Palazzo Barbaro Circle*, exh. cat. Isabella Stewart Gardner Museum (Boston, 2004), p. 105. Zorn recalled the episode in autobiographical notes written in 1911: Anders Zorn, *Självbiografiska anteckningar,* Hans Henrik Brummer, ed. (Stockholm, 1982), p. 89.

3 Boston 2004 (see note 2), p. 107, fig. 78.

4 Ibid., p. 105.

5 Ibid., p. 105, Isabella Gardner to Joseph Lindon Smith, November 4, 1894.

6 Carter 1925 (see note 1), p. 147.

7 Boston 2004 (see note 2), pp. 106–07; Jack Gardner diary (Gardner Museum), October 21 and 22, 1894.

8 Private collection; see Hans Henrik Brummer, *ZORNMCMLXXXIX*, exh. cat. Zornsamlingarna (Mora, 1989), no. 55. Zorn also made an etching of the composition, which Isabella Gardner acquired in 1894.

9 Zorn 1982 (see note 2), p. 89, also p, 202. See also Boston 2004 (note 2), p. 125, notes 79, 80.

10 Zorn 1982 (see note 2), pp. 87, 89; Boston 2004 (see note 2), p. 110.

11 Jan Andreas May, *La Biennale di Venezia: Kontinuität und Wandel in der venezianischen Ausstellungspolitik, 1895–1948* (Berlin, 2008).

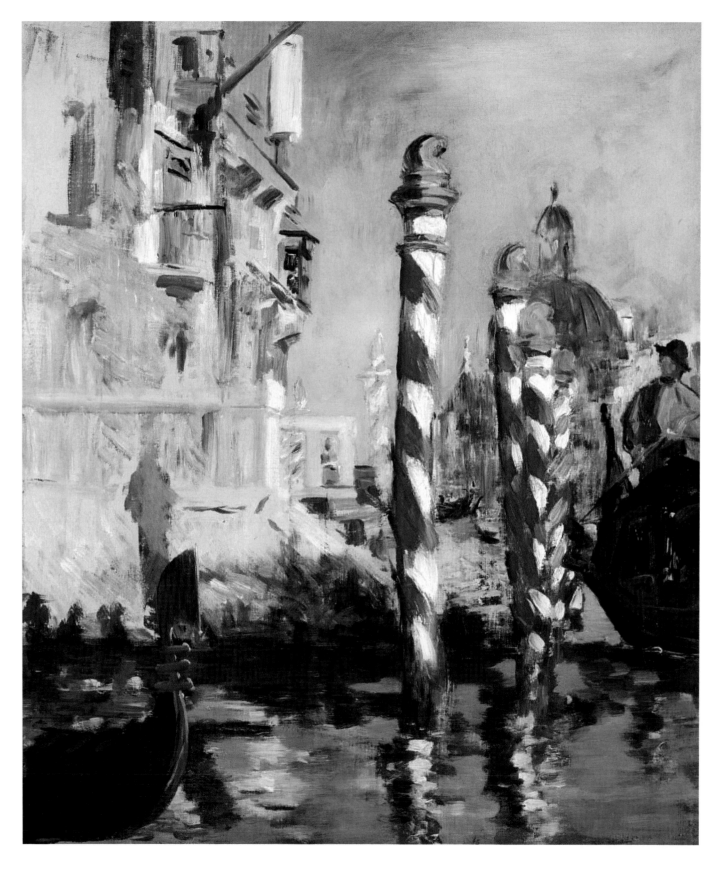

Edouard Manet, *The Grand Canal* (*View of Venice*), 1874
Paul G. Allen Family Collection

Pages 152–53:
Edouard Manet, *The Grand Canal, Venice* (*Blue Venice*), 1874
Shelburne Museum, Shelburne, Vermont

TWO PAINTINGS OF THE GRAND CANAL
EDOUARD MANET IN VENICE

Juliet Wilson-Bareau

Thanks to Charles Toché (1851–1916), who spent several years as a young artist in Venice, and to the insatiable curiosity of the celebrated dealer, collector, publisher, and memorialist Ambroise Vollard (1866–1939), much illuminating information is available concerning the brief visit to Venice towards the end of 1874 made by Edouard Manet (1832–1883). Conversations between his two admirers took place years after the event, when Manet's *Olympia* had finally entered the Louvre in 1907, and Vollard recognized Toché standing in front of the controversial painting. Questioned by the dealer, Toché described his chance encounter with Manet and his wife at the Caffè Florian on the Piazza San Marco. He knew Manet by sight, and was impressed by the majestic bearing of Madame Manet. When Toché politely retrieved the parasol she had dropped, he was rewarded with a word from Manet, delighted to find a compatriot in whom he could confide: "*Mon Dieu*, how this place bores me."[1]

Manet's boredom was no doubt confined to such occasions as sitting with his placid, good-natured Dutch wife in fashionable Venetian cafés. When Vollard suggested that the artist's stay in Venice must have provided him with rest and relaxation after the agitation of life in Paris, Toché responded that Manet's one concern was to paint:

In Venice I used to go and join him almost every day. The lagoons, the palaces, the old houses, scaled and mellowed by time, offered him an inexhaustible variety of subjects. But his preference was for out-of-the-way corners. I asked him if I might follow him in my gondola. "As much as you like," he told me. "When I am working, I pay no attention to anything but my subject."[2]

However, this assiduous search for motifs and Manet's almost daily painting expeditions over a period of a month or more resulted in only two works on canvas being brought back to Paris (pp. 146, 152–53). All the other projects to which Toché refers are "word pictures" that have survived thanks to the attention paid to them by a young French artist who happened to be present, and to Vollard who recorded and published them in his memoirs.

Until the publication of a new document in 1989, the date of Manet's visit to Venice had remained unclear and was generally believed to have taken place in 1875.[3] Although it is now known to have occurred during the later months of 1874, its exact date is still problematic. Etienne Moreau-Nélaton suggested that Manet left for Venice very soon after the summer months spent on the family property at Gennevilliers, to the north of Paris and not far from Argenteuil, the small town to which Claude Monet had moved with his family in the winter of 1871. From Gennevilliers in the summer of 1874, Manet took to crossing the Seine to paint alongside Monet in his garden and on the banks of the river. In May, he had exhibited his painting *The Railway* at the Salon, which opened just two weeks after the Société Anonyme des Artistes inaugurated the first of what would become known as the series of eight "Impressionist" exhibitions (1874–86). Manet always refused to contribute to these shows, but remained in close contact with the artists who were involved, including Edgar Degas, Monet, Pierre-Auguste Renoir, and Berthe Morisot, who in December 1874 married Manet's brother Eugène, thus becoming his sister-in-law as well as a friend and colleague.

Although *The Railway* had been posed and probably partly painted out of doors in 1872,[4] it was worked up and completed in the artist's studio. The following year, we know that Manet painted in the open air, on the beach, and in

the fields at Berck-sur-Mer,[5] but it was at Argenteuil, when painting with Monet and Renoir, another visitor there, that Manet came into close contact with their newly defined pictorial responses to the natural world, and developed a painterly style that came very close to that of the so-called "Impressionists". Out of this experience came two major Salon pictures: *Argenteuil*, shown in 1875, and *Boating*, exhibited much later, at the Salon of 1879. Both these works were essentially studio pictures in their final, completed form, but several canvases were executed entirely or mainly *en plein air*, including *The Boat* that prefigures to a remarkable degree the paintings Manet was to execute very soon afterwards in Venice. It is a radiant and fascinating study of Monet painting in his studio boat, while Camille sits patiently, framed within the entrance to the little cabin on the deck.[6] In spite of its spontaneous, "impressionistic" appearance, closer examination shows that this painting was also reworked, probably in Manet's Paris studio, and quite possibly after his return from Venice, when he was revising all his recent canvases towards the end of the year. There is even something of the "gondola" in the black hull of Monet's river boat, and in both this painting and *The Grand Canal in Venice (Blue Venice)* (pp. 152–53) there is a strikingly similar treatment of water, through juxtaposed, horizontal dabs of paint in predominantly blue and blue-black hues, with suggestions of sparkling yellow sunlight.

If Manet was painting with Monet at Argenteuil in August,[7] he must have left for Venice in early September. Mary Cassatt told Louisine W. Havemeyer that Manet "had been a long time in Venice. I believe he spent the winter there," and that the painting Mrs. Havemeyer called *Blue Venice* had been done in two sessions, at the very end of his stay. In her words:

… he was thoroughly discouraged and depressed at his inability to paint anything to his satisfaction. He had just decided to give it up and return home to Paris. On his last afternoon in Venice, he took a fairly small canvas and went out on the Grand Canal just to make a sketch to recall his visit; he told me he was so pleased with the result of his afternoon's work that he decided to remain over a day and finish it.[8]

This is all very evocative, and led Louisine to indulge in a long fantasy about Manet in Venice, "wrapped in his work, forgetting how modern he is, sinking back into the centuries past as he paints the lagoons and the palaces of long ago." Her rêverie even included a dialogue between "this living French modern" and "the shade of that modern of long ago, the shade of Veronese himself."[9] However, Toché's much more vivid memories of his encounters with Manet indicate, as one would expect, that he painted in the mornings, and spent the afternoons in pleasant rambles with his wife through the city's narrow back streets or by gondola along the network of smaller, winding canals.[10]

Toché's memory is nevertheless at fault in his recollection of a visit to the fish market beneath the Rialto bridge, when Manet "bubbled over with delight at the sight of the enormous fish with their silver bellies," but also expressed his disappointment at the thought of "what I should have liked to paint if the Conseil Municipal of Paris had not refused my decorative scheme for the Hôtel de Ville."[11] Unfortunately for Toché's account, Manet did not submit his proposal until four and a half years later, in April 1879![12] There is also a possible confusion in the descriptions of the two paintings. At the beginning of his questions to

Toché, Vollard refers to "that famous picture of Manet's," *Mooring-Posts in the Grand Canal*, which one would take to refer to the larger *The Grand Canal in Venice (Blue Venice)*. But when Toché responds, recalling "Manet's enthusiasm for that motif," he evokes "the white marble staircase against the faded pink of the bricks of the façade, and the cadmium and greens of the basements."[13] The description of a pink brick façade and white marble steps can surely only apply to *The Grand Canal in Venice* (p. 146) listed by Manet as *Vue de Venise* when he sold the canvas to the celebrated singer and collector Jean-Baptiste Faure, in January 1875.[14] This work remained in Faure's collection in Paris until Durand-Ruel bought it in 1906 and immediately sold it to the Crocker family in San Francisco. The other, larger painting was sold by the artist four months later, on May 24, 1875, to James Tissot, listed simply as *Venise*.[15] It remained in Tissot's studio in London, and was lent by him to Manet's memorial exhibition held at the Ecole des Beaux-Arts in Paris in January 1884, when it was photographed by Fernand Lochard and added, as no. 406, to the works included in the inventory compiled by Léon Leenhoff in Manet's studio at his death. On the annotated photo card, the painting is titled *Vue de Venise*, and below is its title in the 1884 exhibition catalogue, *Le Grand Canal à Venise*.[16] Durand-Ruel acquired the canvas in or before 1891, and sold it to Mr. and Mrs. Havemeyer in April 1895.[17]

The genesis of Faure's painting is evoked in another passage from Toché's reminiscences: *Through the row of gigantic twisted posts, blue and white, one saw the domes of the incomparable* Salute, *dear to Guardi: "I shall put in a gondola," cried Manet, "steered by a boatman in a pink shirt, with an orange scarf—one of those fine dark chaps like a Moor of Granada."*[18]

In yet another reference to this painting, which Toché appreciated for its perfect atmospheric qualities, he cited Manet's account of his youthful voyage to Brazil and his observation of the sea, by night and by day, adding: "That taught me how to plan out a sky."[19] The larger painting, sold to Tissot, includes only a glimpse of the sky, but a far more extensive and more systematically vibrant area of water, recalling Manet's description of water disturbed by passing boats, with dancing patterns of light and shade "like Champagne bottle-ends floating."[20] This work takes a gondola and its boatman as a central motif, whereas in the smaller canvas these are squeezed in between the mooring posts and the edge of the canvas. Manet had problems with the motif, telling Toché:
It's the devil to suggest that a hat is stuck firmly on a head, or that a boat is built of planks cut and fitted according to geometrical laws.[21]

Both paintings were reworked by the artist. The smaller canvas reveals changes to the placing of the domes of Santa Maria della Salute, but otherwise remains closer to what must have been a swiftly brushed impression. The larger work is a mixture of observed and recreated reality, with recognizable Venetian palaces in the background to the right—from the fifteenth-century Palazzo Dario near the center, past a modern building, to the Palazzo Venier dei Leoni (now the home of the Peggy Guggenheim Collection) at the right edge, but with façades on the left that do not correspond with the original palaces on the canal and must have been added later, after scraping out an unsatisfactory sketch. Manet struggled to capture what he observed, in a composition that would satisfy stringent aesthetic criteria while retaining the spontaneity of his initial impression and sketch. Toché noted his difficulties:

Now and then he would make a gesture of annoyance that set his boat rocking, and I would see his palette knife scraping away with ferocity. But all at once I would hear the refrain of a song, or a few notes whistled gaily. Then Manet would call out to me, "I'm getting on, I'm getting on! When things are going well, I have to express my pleasure aloud."[22]

With only two paintings to show at the end of such an active period of work, there must have been many scraped and abandoned canvases. Toché described one of them, a view of the Redentore church, glimpsed from a restaurant table, through an arbor of vines, opposite the Giudecca. The pretty, rose-colored church contrasted with the sea-green water and the sharp black extremities of the gondolas, and Manet began by analysing the changing colors in the dying light, and describing how he would try to reproduce their dusky tonalities. But then he took his box of colors and a small canvas, ran to the water's edge, and with a few strokes of his brush, set down the distant view.[23]

Of all Toché's "word pictures," the most remarkable is his detailed description of what could have been a major Salon composition. He recalled:

There was that Sunday in September, for instance, when I accompanied him to Mestre, where regattas were being held in the lagoon.... Lying on the cushions of our boat, a rug over his knees, one hand dragging in the water, Manet, from under his wife's parasol, described to us the plan of a picture he would like to paint of this regatta.[24]

Toché noted down Manet's spoken instructions to himself for the dazzling composition and the details of its execution, adding that it was the artist's last taste of the pleasures Venice had to offer him.[25] A few days later Manet and his wife left for Paris, their arrival there documented by a letter from Manet to Eugène Montrosier, written on October 6 and asking him to "come round to the studio—I have some pictures to show you."[26] Four years later, Toché visited the couple on his return to the French capital, and he described to Vollard the studio at 4, rue de Saint-Pétersbourg and Manet's last studio on the rue d'Amsterdam.[27] To this young man and his sympathetic and intelligent concern for the artist's life and art we owe much of our knowledge and understanding of Manet's brief but unforgettable visit to Venice.

[1] Ambroise Vollard, *Recollections of a picture dealer,* translated from the original French manuscript by Violet M. MacDonald (London, 1936), p. 149. For the French edition see Ambroise Vollard, *Souvenirs d'un marchand de tableaux* (Paris, 1937).

[2] Ibid. 1936, p. 152.

[3] Juliet Wilson-Bareau, "L'année impressionniste de Manet: Argenteuil et Venise en 1874," in *Revue de l'art*, 86 (1989), pp. 28–34, figs. 7–9. As indicated in the article, Etienne Moreau-Nélaton was the only biographer to have indicated the correct date of 1874, on the basis of an early, annotated photograph of *Vue de Venise* (now known as *The Grand Canal in Venice* or *Blue Venice*) (pp. 152–53), which James Tissot acquired from Manet in May 1875. The incorrect date has continued to appear in literature (see Richard R. Brettell in *Impression: Painting Quickly in France, 1860–1890* (New Haven/London, 2000), pp. 88–89, fig. 47), but was reiterated in Wilson-Bareau and David Degener, *Manet and the Sea*, exh. cat. The Art Institute of Chicago, Philadelphia Museum of Art and the Van Gogh Museum, Amsterdam (Philadelphia, 2003), p. 99, note 141.

[4] See Juliet Wilson-Bareau, *Manet, Monet, and the Gare Saint-Lazare*, exh. cat. Musée d'Orsay, Paris, and the National Gallery of Art, Washington, D.C. (New Haven/London, 1998), pp. 44–47, 56–59.

[5] Wilson-Bareau 2003 (see note 3) pp. 81–84, plates 57–64.

[6] This painting was a study for, or connected with, a much larger, unfinished work that was probably intended for the Salon, in which both Monet and Camille face the spectator, in a close-up, foreground view. See Ina Conzen, "Eine neue Welt," in *Edouard Manet und die Impressionisten*, exh. cat. Staatsgalerie (Stuttgart, 2002), pp. 74–77, figs. 83, 84.

[7] In a letter dated August 2, Manet apologized to Théodore de Banville for failing to complete an etched frontispiece for a volume of his poems. See Juliet Wilson-Bareau, *Manet by himself/Manet par lui-même* (London/Sydney/Paris, 1991), p. 171.

[8] Louisine W. Havemeyer, *Sixteen to Sixty. Memoirs of a Collector* (New York, 1993), p. 226.

[9] Ibid., pp. 226–28.

[10] Vollard 1936 (see note 1), p. 153.

[11] Ibid., p. 153. See Wilson-Bareau 1991 (note 7), p. 185.

[12] See letter from Manet to the prefect of the Département Seine and to the president of the Conseil municipal of Paris, April 1879, in Wilson-Bareau 1991 (note 7), p. 185.

[13] Vollard 1936 (see note 1), p. 149.

[14] See Léon Leenhoff's transcription of this part of Manet's lost account book in Wilson-Bareau 1989 (note 3), p. 31, fig. 9.

[15] Ibid.

[16] These additional works belonged mainly to members of the Manet family or to friends and collectors: Antonin Proust, Pertuiset, Faure, and others who lent works to the memorial exhibition. They were also included in the four, original Lochard photograph albums, annotated by Leenhoff (one in the Bibliothèque nationale de France in Paris, and three in the Tabarant archive at The Morgan Library & Museum, New York. The photo card for Tissot's painting is in the Tabarant archive, vol. 2, p. 23, reproduced in Wilson-Bareau 1989 (see note 3), p. 30, fig. 7.

[17] See document mentioned in note 13, and the references in A.C. Frelinghuysen, G. Tinterow, et al., *Splendid Legacy: The Havemeyer Collection,* exh. cat. The Metropolitan Museum of Art (New York, 1993), p. 356, no. 359.

[18] Vollard 1936 (see note 1), p. 149; Wilson-Bareau 1991 (see note 7), p. 172.

[19] Ibid. 1936, p. 151; ibid. 1991, p. 26.

[20] Ibid. 1936, p. 149.

[21] Ibid. 1936, p. 151; ibid. 1991, p. 172.

[22] Ibid. 1936, p. 152.

[23] Ibid., p.151. Incorrectly called San Salvatore in the English edition.

[24] Ibid., p. 155; Wilson-Bareau 1991 (see note 7), p. 172 (both with the full text of Toché's notes on the composition).

[25] Ibid., p. 156.

[26] Wilson-Bareau 1991 (see note 7), p. 171.

[27] Vollard 1936 (see note 1), p. 157.

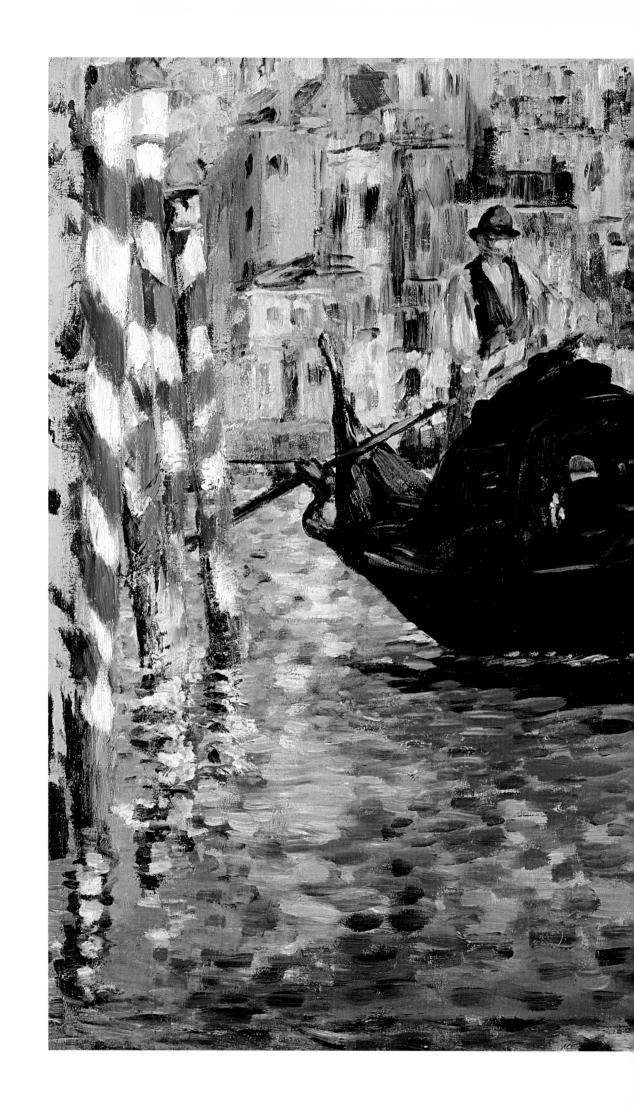

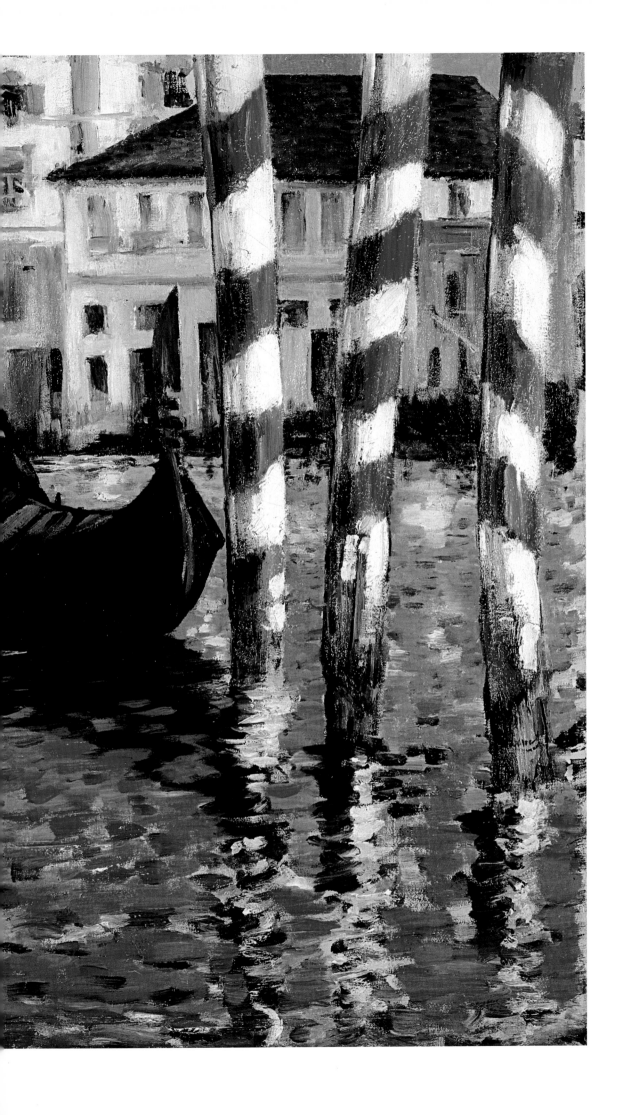

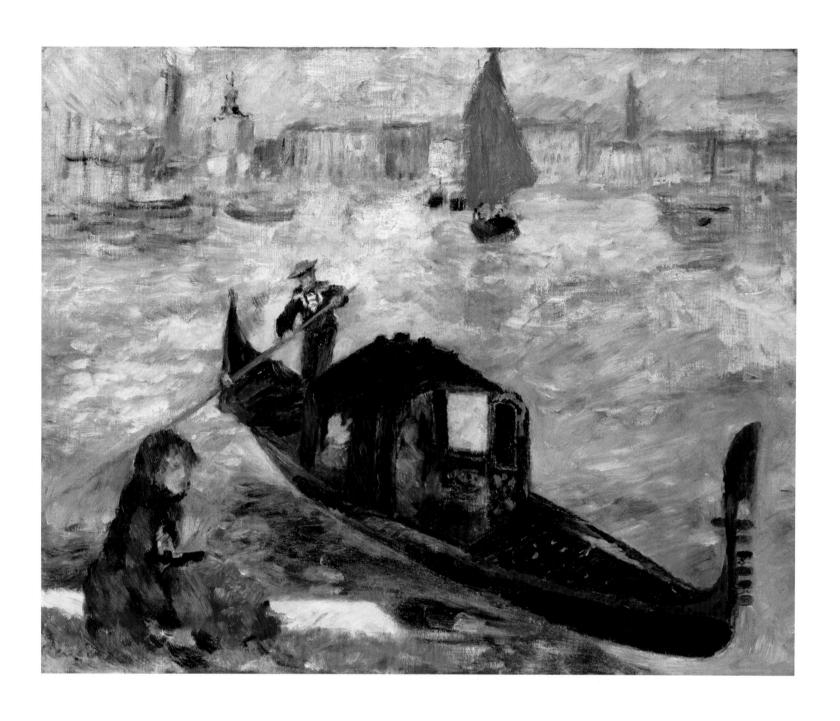

Pierre-Auguste Renoir, *The Grand Canal, Venice (Gondola)*, 1881
Nahmad Collection, Switzerland

Pages 152–53:
Edouard Manet, *The Grand Canal, Venice (Blue Venice)*, 1874
Shelburne Museum, Shelburne, Vermont

RENOIR'S AMBIVALENT RESPONSE TO LA SERENISSIMA

Christopher Riopelle

Returning to France early in April 1881 from the first journey he had ever made abroad, to Algeria, Pierre-Auguste Renoir (1841–1919) headed for Chatou, a leafy suburb along the Seine, northwest of Paris. Novel scenery and the brilliant North African sun had released new artistic energies in the forty-year-old painter, and at Chatou he continued to paint landscapes as full of animation, color, and variety as the vibrant canvases he had recently executed in Algiers.[1] He was not planning further foreign travel, however, having canceled a planned visit to London, as he intended to concentrate his new-found vigor on the depiction of local "trees in bloom, women and children."[2] Then he ran into an old acquaintance. On about April 18, Renoir had lunch at Chatou with James McNeill Whistler, whom he had known since the 1860s. Although the two had drifted apart over the years, Renoir had recently read an article in the *Gazette des Beaux-Arts* about the American-born painter written by a mutual friend, Théodore Duret.[3] From it, Renoir learned that Whistler had recently returned from Venice with a series of richly atmospheric etchings and pastels of La Serenissima executed there. Indeed, Whistler brought the etchings with him to Chatou and the artists may have pored over them together.[4] Duret had underlined the novelty of these radically abbreviated works: "Never has anyone attempted to render so much with so little apparent effort and so few means."[5] Renoir would have been intrigued by the description. Always ready to emulate his most progressive peers, he may well have taken it as a challenge to pare down his own painting style and see where that might lead. The two artists soon went their separate ways but the April meeting with Whistler may have planted a seed in Renoir's mind. By the autumn, he had deter-

mined to set out on his travels once again, this time to visit Italy. The first stop on his itinerary would be Venice.[6]

The example of a contemporary whom he admired—although only seven years older, Whistler was already in Renoir's eyes a "great artist"[7]—was not the only incentive Renoir would have had to include Venice in his plans. He would have known that Edouard Manet had visited and painted there in 1874. He also would have known that another adventurous American painter, John Singer Sargent, fifteen years his junior, was exhibiting Venetian interiors that very month at the exhibition of the Cercle des arts libéraux in Paris; he would also show Venetian scenes at the 1881 Paris Salon, that coming May.[8] Indeed, Renoir may have seen both exhibitions, further confirmation following the examples of Whistler and Manet, that progressive artists could indeed find inspiration in Venice, as admired figures from an earlier generation, Turner and Corot, also had done. On the other hand, a painter like Félix Ziem had been traveling to Venice frequently since the early 1840s and building up a wide clientele for his highly conventional views of the city, remarkable only for torrid, unnatural light effects. Ziem emerged from a long tradition of *veduta* paintings by Italians and foreigners alike which, by endlessly repeating views of the city's best-known monuments, had helped make Venice one of the most popular tourist sights of Europe. Moreover, in April, Renoir's dealer, Paul Durand-Ruel, had purchased five of his Algerian views. They did not sell for quite some time and the dealer, anxious to promote the artist's career but not particularly taken by his more experimental works, might well have reminded Renoir that views of Venice—of the right kind—had a proven track record with collectors and might find a mar-

ket. Thus, before he ever departed for Venice in October 1881, Renoir knew that both avant-garde and traditional artists chose to paint there, some in experimental and some in conventional ways. It would influence how he looked at the city once he arrived.

Renoir's primary purpose in visiting Italy was not to paint views of Venice. Rather, he was coming to feel that Impressionist painting depended too heavily on the rendering of transitory effects of light and atmosphere. His art was in need of renewal and a more solid foundation in drawing and in the art of the past. These, he strongly suspected from repeated visits to the Louvre, were to be found in the works of the masters of the Renaissance, notably Raphael. Italy was the place to study them in depth, Florence and Rome in particular. He would visit both cities after spending time in Venice and before moving on to Naples. Moreover, he was increasingly drawn away from landscape to the depiction of the human figure. To be sure, the latter had figured in his art from the beginning but now its allure was growing steadily, for figure painting stood at the top of the academic hierarchy of genres to which Renoir, at heart a traditionalist, continued to pay allegiance. Indeed, he later told the dealer Ambroise Vollard that on arrival in Venice he had painted various *figures nues*, but these have not been identified.[9] He soon gave it up as he seems to have found it difficult to work with models whose language he did not share.[10] He also studied the art of the Venetian masters as he roamed the city, its *palazzi*, *scuole*, galleries, and churches. Of these artists, he singled out Giovanni Battista Tiepolo and especially Vittore Carpaccio, both new to him. As he told Vollard of the latter, Carpaccio was "one of the first who dared to paint people walking in the streets. . . . [He was] able to find

his models at the fair."[11] Renoir must have looked at the sixteenth-century master's work with a shock of recognition. Years earlier, he too had depicted people passing by on the street and in the fair grounds when he painted Paris cityscapes like *The Champs-Elysées during the Fair of 1867* and *The Pont Neuf* in 1872. His discovery of Carpaccio in Venice revealed to Renoir a sixteenth-century precursor who, like the Impressionists, had been on the lookout for distinctive, haphazard local color and who dared to make use of it in his art.

The artistic evidence of the weeks Renoir spent in Venice in October and November is a series of limpid cityscapes.[12] The paintings fall into two broad categories. The first are traditional Venetian *vedute* showing motifs Carlevarijs, Canaletto, and Bellotto had painted long before him, but now executed in a shimmering Impressionist style. *On the Grand Canal, Venice* (p. 160) depicts one of the most heavily frequented and most often represented stretches of the principal waterway that cuts a meandering path through the city. Indeed, comparison with Canaletto's paintings suggests that, more specifically, it is the stretch running from the Ca' Foscari back towards the Rialto Bridge, a distance of some 800 meters.[13] Whereas Canaletto would have depicted it in such a way that each building could be identified—although he was not above altering details and manipulating the laws of perspective for pictorial effect[14]—Renoir was more interested in general effects and the sense of an ambient atmosphere washing over the city and uniting sea, sky, and architecture. The buildings themselves are enveloped in a golden glow, and reflected gold dances on the water on the left side of the canvas. Imperceptibly, the *palazzi* merge and become more indistinct as they recede into the distance, and the leftward turn of

the canal just beyond the Rialto Bridge is obscured.

Among the most distinctive aspects of Venetian life were (and remain) the black-hulled gondolas that ply the canals, and the red and blue-striped poles jutting out of the water where those gondolas moor. Manet had painted two pictures depicting these motifs when he visited Venice in 1874 (pp. 146, 152–53). Renoir included a gondola and mooring pole prominently in the right foreground of the Boston painting; he did not use black paint to describe it but, true to Impressionist optics, purples and blues instead, suggestive of colors reflected onto the gondola's hull from the water. A gondolier bends to his work at the rear of the craft, as does another—Renoir requires only a few deft strokes to evoke his angular posture—on a boat about to disappear out of the picture frame at left. In fact, these oarsmen, unique to Venice, would have been in the news during Renoir's stay in the city as they went on strike on November 1 or 2, while the artist was there.[15]

No less typically Venetian was Renoir's depiction of the Doge's Palace seen from the Bacino, or as Renoir described it somewhat misleadingly in a letter to Charles Deudon, "from San Giorgio across the canal"[16] (p. 161). That Renoir knew the motif to be a cliché of Venetian painting was suggested by that same letter: he jokes that no one has ever thought of painting the motif before but then allows that "we were at least six in line."[17] As in *On the Grand Canal, Venice* (p. 160), the architecture of the city, here with some of its most famous buildings, including the seat of government, the Biblioteca Marciana, and the Campanile, forms a thin strip across the centre line of the canvas, with a sky full of scudding clouds above and water full of reflection below. Sunlight dances

off every surface and boats of various kinds move back and forth in front of the monumental backdrop. An enormous tricolor Italian flag hangs almost to the ground behind the lion-topped column facing the Bacino, suggesting that the city was celebrating a civic or national holiday, although none occur in late autumn. Unlike *On the Grand Canal, Venice,* John House points out that "a remarkable amount of information is conveyed about the details of the buildings" here, including correct fenestration.[18] In that verisimilitude, it is the most Canaletto-like of Renoir's Venetian paintings. This and the previous work were soon sent to Durand-Ruel in Paris, who presented them at the seventh Impressionist group exhibition in March 1882.[19] There, they were roundly criticized, indeed compared to the work of Ziem, which in avant-garde Parisian circles was very far short of praise.

The second broad category of Venetian pictures includes more experimental works. Faced with the unique characteristics of the Venetian environment and way of life, in these, Renoir tried his hand at more daring and atypical scenes. Among the most suggestive is *Venice (Fog)* (fig. 1), an almost monochromatic image in pinks and mauves, accented by touches of acid yellow, thinly painted in washes of color, in which gondolas make their way through the haze of the Bacino, while the dome of San Giorgio Maggiore looms faintly out of the mist. All is indistinct, abbreviated, allusive rather than descriptive, as fully an impression as Monet's epochal *Impression, soleil levant* (Impression, Sunrise), which had given the art movement its name. More than that, it is an homage to Whistler's monochromatic Venetian views and river scenes, masterpieces of pictorial understatement that may well have been on Renoir's mind, having met the painter

Fig. 1 Pierre-Auguste Renoir, *Venice (Fog)*, 1881, oil on canvas, 44 × 60 cm, The Kreeger Museum, Washington, D.C.

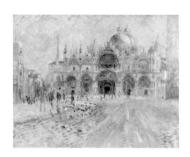

Fig. 2 Pierre-Auguste Renoir, *Piazza San Marco, Venice,* 1881, oil on canvas, 65.4 × 81.3 cm, Minneapolis Institute of Arts, The John R. Van Derlip Fund

just after his return from Venice. Here, Renoir can be seen to try his hand at that radical abbreviation of pictorial means which Duret had praised in Whistler's work.

Another painting, *The Grand Canal, Venice (Gondola)* (p. 154), is the closest Renoir came to a genre scene in Venice. His debt would seem to be to Sargent, whose Venetian scenes he had also recently seen and who avoided the obvious sites of Venice in order to depict the life of the city and its common people, often in its back streets and side canals. Here, a gondolier in a striped shirt has transported two ladies across the lagoon, foreign tourists from the French style of hat one of them is wearing. They are about to berth at the Isola di San Giorgio Maggiore and to explore the monumental sixteenth-century church by Palladio that dominates it. An Italian girl sits on the water's edge, her head turned away from the approaching visitors. Her short hair suggests that she is the Venetian model Renoir had also drawn in pencil and sketched in oils.[20] While the picture also recalls the vivid scenes of gondolas plying the Grand Canal that resulted from Manet's 1874 visit to Venice, specific to Renoir is the conjunction of large-scale figures in the foreground, including the gondola itself, and a panoramic view of the city across the water. While the background is freely sketched, we are still able to recognize the profile of the Dogana at upper left and the more distant Campanile, silhouetted against the sky, further to the right. Much of the center of the canvas is given over to the choppy waters of the lagoon rendered in quick touches of paint. The golden triangle of sail near the center of the painting, tinged with red, consolidates and intensifies the tones used to delineate the distant cityscape. Renoir painted a second gondola scene as well, even more freely executed,

as part of his exploration of this specifically Venetian mode of transport which seems to have fascinated him. Perhaps he sensed that its picturesque, age-old reign was coming to an end; the first public *vaporetto* service on the Grand Canal, less romantic than the gondola in every imaginable way, had been introduced on September 15, 1881, only a few months before the artist's arrival.[21]

Perhaps the most audacious of Renoir's Venetian paintings was his *Piazza San Marco* (fig. 2). Unfinished, sketch-like, with much primed canvas still showing, it is a quick and confident "portrait" of the façade of Venice's most famous and architecturally complex church, marked by an intensity of observation and economy of rendering that sets it apart from the artist's other views of Venetian landmarks. Renoir, who was a keen student of architecture, admired San Marco above almost any other building for its irregularity of execution and sense of age-old crafting by skilled masons.[22] As Renoir would have known, Ruskin had only recently led a massive international campaign to rescue the church from a disastrous "restoration" well underway in the late 1870s. Ultimately, Ruskin prevailed, the project was stopped, and San Marco saved. By the time Renoir arrived in Venice all scaffolding had been removed from the façade and the church had been returned to its former glory. Renoir's painting may well be a celebration of that activism in support of good architecture and of architectural preservation that, as early as 1877, Renoir had called for.[23] It was here that Venice spoke most immediately to the concerns that Renoir had brought with him from Paris, and it resulted in a masterpiece.

Renoir would soon move on, southward down the boot of Italy, never to return to Venice. The city cannot be said to have had a

profound effect on him or on his art. Rather, La Serenissima was an apparition of beauty looming out of the Adriatic; he fell under its spell for a few weeks, felt its magic, painted beguiling pictures as he experienced its allure, and then left Venice behind to consider the future direction of his art.

1 On Renoir's Algerian and Chatou landscapes of 1881, see Colin B. Bailey, Christopher Riopelle, John House, Simon Kelly, and John Zarobell, eds., *Renoir Landscapes, 1865–1883,* exh. cat. The National Gallery, London, The National Gallery of Canada, Ottawa, and Philadelphia Museum of Art (London/Ottawa/Philadelphia, 2007/08), cat. nos. 54–61.

2 Renoir's letter to Théodore Duret cited in Michel Florisoone, *Renoir* (Paris, 1938), p. 40.

3 Théodore Duret, "Artistes anglais; James Whistler," in *Gazette des Beaux-Arts* (April 1, 1881), pp. 365–69.

4 Bailey et al. 2007 (see note 1) p. 236, note 5.

5 Duret 1881 (see note 3), p. 369.

6 That Whistler may have influenced Renoir's decision to visit Venice in 1881 has been suggested previously by Lisa R. Leavitt, *Impressionism Abroad: Boston and French Painting*, exh. cat. Royal Academy of Arts (London, 2005), p. 121.

7 Letter to Duret cited in Florisoone (see note 2), p. 40.

8 On Sargent's two Paris exhibitions of Spring 1881, see Elaine Kilmurray and Richard Ormond, eds., *John Singer Sargent*, exh. cat. Tate Gallery (London, 1998), p. 273. Renoir himself showed two portraits at the Paris Salon of 1881.

9 Ambroise Vollard, *Renoir* (n.p., 1920), p. 111. A drawing and a painting of a Venetian peasant girl, the latter inscribed *Venise 81*, are illustrated in Barbara Ehrlich White, *Renoir: His Life, Art, and Letters* (New York, 1984), p. 117.

10 Renoir discusses the problem in a letter from Venice to his friend Charles Deudon, quoted in White 1984 (see note 9), p. 112.

11 Vollard 1920 (see note 9), pp. 113–14.

12 For the most complete study of Renoir's Italian sojourn, see Maria Teresa Benedetti, "Il viaggio in Italia," in Kathleen Adler, ed., *Renoir: La maturità tra classico e moderno*, exh. cat. Complesso del Vittoriano (Rome, 2008), pp. 57–75.

13 Bailey et al. 2007 (see note 1), cat. no. 63 and p. 243.

14 See David Bomford and Gabriele Finaldi, *Venice through Canaletto's Eyes*, exh. cat. The National Gallery (London, 1998).

15 Alastair Grieve, *Whistler's Venice* (New Haven/London, 2000), p. 20.

16 White 1984 (see note 9), p. 112.

17 Ibid.

18 Bailey et al. 2007 (see note 1), cat. no. 62 and p. 240.

19 Ibid., note 4, p. 242, for John House's convincing arguments for identifying these as the two paintings in the 1882 exhibition.

20 Vollard 1920 (see note 9).

21 Grieve 2000 (see note 15), p. 20.

22 The argument is laid out more fully in Bailey et al. 2007 (see note 1), cat. 64, pp. 246, 248.

23 On Renoir's architectural interests and writings, see Robert L. Herbert, *Nature's Workshop: Renoir's Writings on the Decorative Arts* (New Haven/London, 2000).

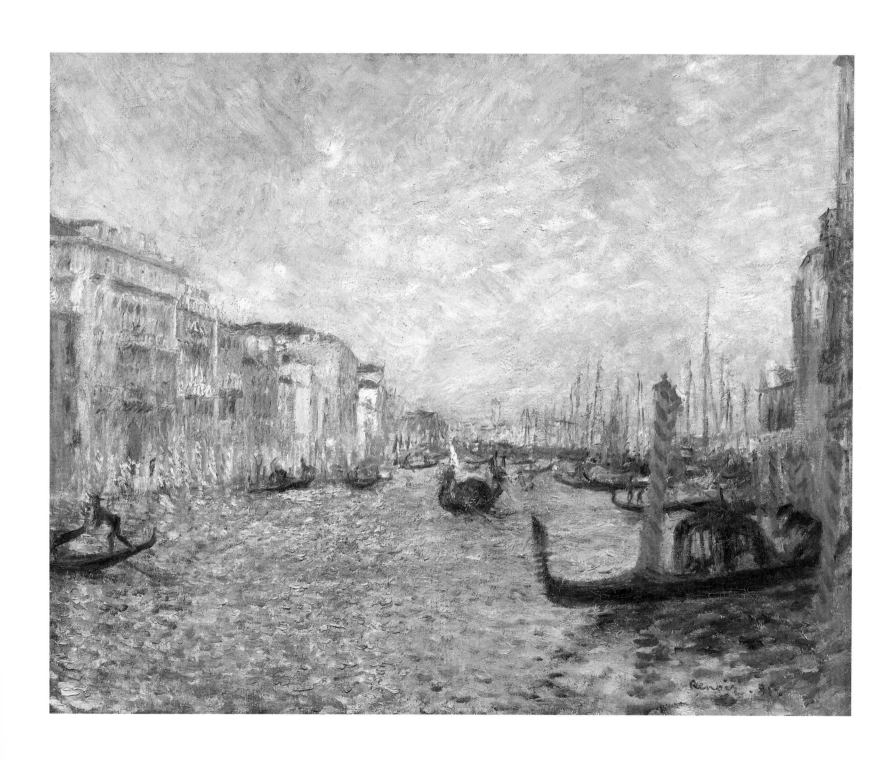

Pierre-Auguste Renoir, *On the Grand Canal, Venice*, 1881
Museum of Fine Arts, Boston, bequest of Alexander Cochrane

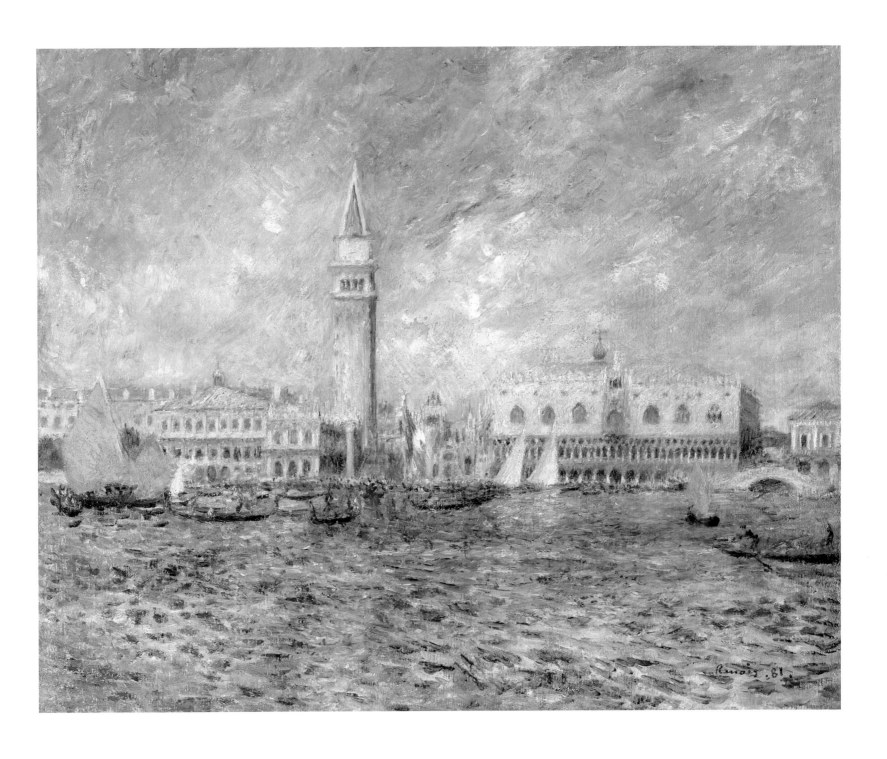

Pierre-Auguste Renoir, *Venice* (*The Doge's Palace*), 1881
Sterling and Francine Clark Art Institute, Williamstown, Massachusetts

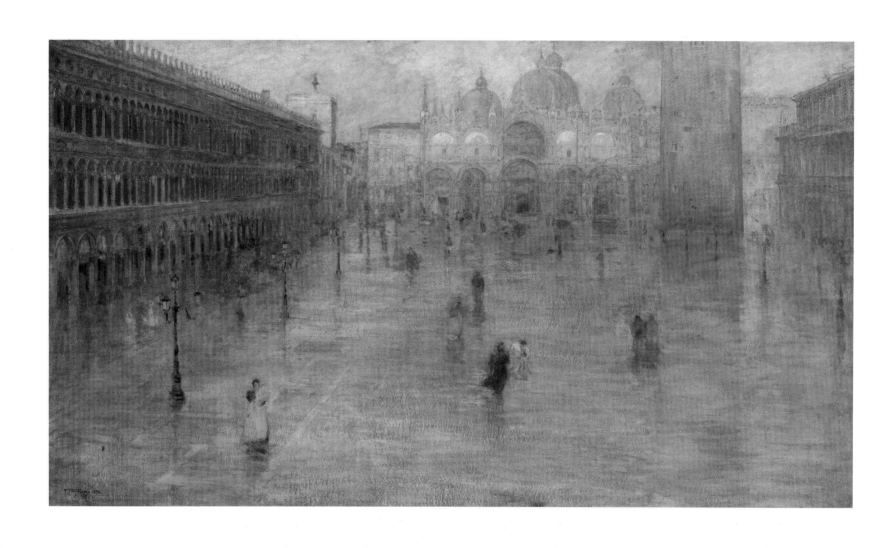

Pietro Fragiacomo, *Piazza San Marco*, 1899
Galleria Internazionale d'Arte Moderna di Ca' Pesaro, Venice

PIETRO FRAGIACOMO
AND THE SOUL OF THE LAGOON

Giandomenico Romanelli

Pietro Fragiacomo (1856–1922) was not a Venetian by birth, and yet his ties with the city were so close—in terms of his works, his sensibilities, the places he frequented, and the subjects he painted—to allow us to consider him one of the most faithful and discerning interpreters of the city, in its appearance, image, and moods. And also one of the most original, in view of the times and the expressive instruments he had at his disposal. Fragiacomo was certainly influenced and positively conditioned in his development and career by one of the most important and momentous artistic events in the history of more recent Italian culture (and, perhaps, not just Italian)—namely, the birth of the Biennale, which was launched at the initiative of the City of Venice in 1895.

The son of Domenico Fragiacomo, a cook of no great wealth who came from Pirano in Istria, and Caterina Dolce, Pietro was born in Trieste in 1856.[1] This was an area that was culturally Venetian but at the time fell politically within the confines of the Habsburg Empire. Job prospects prompted the family to move to Venice some years later, where Domenico obtained permission to run a café in the vicinity of the Piazza San Marco.

Pietro's education was erratic and initially of a technical nature. Only after a period spent working for an engineering company in Treviso did he return to Venice to spend a year at the Academy of Fine Arts, attending the courses of two humble but not ineffective teachers, landscape artist Domenico Bresolin and *prospettico* Tommaso Viola. However, of particular importance in this period (he was by then nearly twenty-two) was his friendship with two artists who would become key figures in Venetian painting in the second half of the nineteenth century—Giacomo Favretto (who died early in 1887, but was by then thoroughly established) and Ettore Tito, a ubiquitous and long-lived showman working in a more successful and shamelessly fashionable style.

From the very first works presented in art exhibitions at home and abroad, for which Fragiacomo often received awards (in Turin, Milan, Rome, Munich, and Paris, for example), the absolutely predominant subject in Fragiacomo's paintings that never failed to inspire him was the waterscape of the lagoon. Scenes of places in the city featured much more rarely. This distinguishes the poetry of Fragiacomo from that of many contemporaries both in the subject matter and its treatment. Indeed, in a purely thematic respect, it brings him closer to another outstanding figure and great landscape artist at that time, Guglielmo Ciardi.

In the last decade of the century, Fragiacomo was sufficiently at home in the coterie of major Venetian painters to form part of the original nucleus of founders and first organizers of the Biennale associated with Venice mayor Riccardo Selvatico and the general secretary of the event, Antonio Fradeletto.

Even though Fragiacomo had first participated in exhibitions in Munich and Paris, and subsequently Trieste and elsewhere, where he was able to see and catch up on contemporary art and its developments, it was the Biennale that gave the talented artist in his late thirties the most extraordinary of opportunities. From 1895 onward, the Biennale in the municipal gardens displayed a continuous panorama of the very latest that was happening in the studios and academies worldwide. A lot of it was "official" painting, of course, but there was also a large amount of work that was experimental, innovative, taboo-breaking, and inventive. Fragiacomo's sources of inspiration, the most powerful influences, and the creative "space" behind his paintings can be found in this envi-

ronment, from the veristic crossing of the horizon to Divisionism and Symbolist influences that undoubtedly make his paintings so distinctive *vis-à-vis* other contemporary works.

Beside the artist's salient thematic choices, there are typically "linguistic" reasons for this on the one hand—such as the shapes, light, and colors in his pictorial language—and others of an essentially compositional nature. But it is, above all, the atmosphere, the lyrical, twilight-like inspiration, that aching, melancholic meditation that make—from many points of view—the visual handwriting of this "sentimental landscape artist," as Vittorio Pica perceptively described Fragiacomo in 1909,[2] so unmistakable. A sophisticated and solitary style ultimately appears distinctively and clear-cut in a kind of empathetic transmission and extension of states of mind through waves, concentric circles, and echoes picked up even as they die away, through the watery light of evening gradually translated into long shadows on the remnants of shores, stationary boats, between inertia and meditation.

Pompeo Molmenti's striking describtion of Fragiacomo's lyricism was not without a certain vein of irony: Fragiacomo was, he said, capable of getting down on canvas the delectable melancholy of a misty sky, a strange sense of solitude, lonely islets, stagnant waters, and wild vegetation—the *lacrimae rerum*. Where once there was bustling life, industry, and wealth, now the desolation of the desert prevails. All that remained was *tristesse*, like the relics of love long past.[3] Molmenti's comments were anything but fortuitous. They express sensibilities that could take us back to the D'Annunzio of *Il Fuoco*; the contrast between what had been (industry and wealth) and today's "desolation of the desert" could not be more telling. But in this sentimental voyage there is no

trace of the typical signs of nostalgia for the past which infected such a large part of the art and literature of nineteenth-century Venetian art, perennially bathed in tears of regret. Even the feeling of decadence is transfigured and shown as a pictorial sensation, as a light effect, a figurative factor, and chromatic harmony.

Fragiacomo thus comes very close to Divisionism without crossing the boundary, choosing instead to apply paint thickly in the Pointillist fashion to achieve an allusive coloration of atmospheric conditions.[4] And indeed, a predominant *pathétique* is evident, played upon compositional editing in the form of low skies and vast watery surfaces, lightened or darkened colors, little figures that are motionless or in suspense, and horizons that are indefinite apart from morning mists or evening haze.

This pathos is also an innovation of Fragiacomo's. It is the eye with which he goes beyond Impressionist landscape realism to merge with decadent and perhaps literary sensibilities in an unbroken, broad, homogeneous, pliant, and almost pastose atmosphere, peopled with symbols and brought to life with allusions and psychological variations, emotional reactions, and states of mind.

In this respect, the writer and essayist Ugo Ojetti made a number of pertinent comments: *[Fragiacomo] never paints a landscape, skyscape, or seascape without giving it a precise expression or very human emotional power ...*

and again, in connection with the progressive absorption of the human figures in the landscape to an extent that is explicitly symbolic: *Figures had become for him just a comment within the landscape. ... he consciously joined forces with the great landscape painters of modern times, who, from Constable to Turner, had recognized only one "person" that expressed their passions, namely light, and with a sweeping philoso-*

*phy instinctive to them had reduced human fig-
ures to being—like plants, animals, water fea-
tures, and rocks—simple objects of color and re-
flections; like things, tiny, transient objects en-
veloped by the same sun as the rocks and
vegetation.*[5]

Fragiacomo's path took him away from
Giacomo Favretto's verism, which was often
too caricatural and anecdotal. He opted for the
plein air of a lagoon and a kind of interior land-
scape with symbolist and psychological over-
tones, together with unusual and unfamiliar—
or in the art-history professor Nico Stringa's
words "metaphorical"—light effects.

The remoteness from any documentary or
photographic intention and essentially evoca-
tive nature of his style are summed up pithily
and authentically by the writer Mario Morasso:
*These boats and canals can be placed in any situ-
ation because here it is only the special atmos-
pheric conditions and the combination of those
particular elements that amount to anything, and
perhaps that is all the artist wanted.*[6]

But in his career, the artist did not close his
eyes to the great works of European and Amer-
ican painting that appeared in Venice every
other year—from John Singer Sargent and An-
ders Zorn to the landscape artists of the Glas-
gow School and Whistler, to say nothing the
Pre-Raphaelites and other visionaries, or the
decadence inspired by Gabriele D'Annunzio
and Necromantic painters. As several critics
noted, and as highlighted by Ojetti above, Paolo
Pistellato[7] rightly reminds us how "he seemed
to many to perceive … the influence of the
Norwegians and perhaps the Scots."[8]

All this saved Fragiacomo from the com-
monplace of the nineteenth-century style of
Venice and the Veneto, which never managed
to substantiate its own, sometimes stunning
virtuosity with credible cultural choices. One

of the painter's masterpieces is the *Piazza San
Marco* shown at the 3rd Biennale in 1899 and
bought on the spot by the Province of Venice
on behalf of the International Gallery of Mod-
ern Art in the Ca' Pesaro (p. 162). "Stimulating
basic model of a new iconography of the San
Marco basilica," said Pistellato.[9] The canvas
seemed to him rich in unusual, sophisticated
qualities. "Undoubtedly one of the best paint-
ings by Fragiacomo, particularly in the ex-
quisiteness of the delicate chromatic har-
monies," said Giuseppe Pavanello.[10] Here, the
view is of the piazza looking towards the basil-
ica, seen from a rather elevated point of view,
obviously after a storm and thus with the
paving wet with rain. The upper part of the
basilica almost up to the domes is bathed in an
intense golden light, while the entire painting
is invested with an even, highly delicate, rose-
colored tonality.

Fragiacomo's rapport with his adopted city
encompasses everything from the "poor Venice"
scenes of the early days to a transfigured and
mysterious horizon—that in certain respects
brings him closer to Cesare Laurenti or Mario
de Maria (*Marius Pictor*) with his *danses
macabres*. On the other hand, there are the
more dreamlike atmospheric scenes found in
less well-known Nordic, Flemish and Walloon,
Breton and Norman paintings, or works im-
bued with a pale Scandinavian light, such as
dusks over the lakes of Finland or the foaming
sea in the fjords—all subjects that populated
the walls of the pavilions at the Biennale. Be-
tween the end of the nineteenth century and
the beginning of the new century, the charm
of these evocations had also bewitched Italian
painting with an irresistible appeal, particu-
larly in Veneto and Lombardy. In 1901, Vittorio
Pica reported ironically but perceptively on
this "Nordic obsession," writing that:

… many of our painters … look profoundly influenced by Nordic art, to the point of abandoning any traditional characteristics of Italian art so as to show themselves disguised as Scots, Scandinavians, or Germans.[11]

Later, Fragiacomo even assumed the influences of experiences more remote and "modern" that motivated the younger generation of artists at Ca' Pesaro: namely, the spirit of Munich and Vienna, and the Secessionist revolution. These include the small masterpieces of his mature years, such as *Sad Sunset* and *End of the Day*, the mysterious, enigmatic lunar visions of *Waiting*, or the moving solitude of the Villa Malcontenta in *The Survivors*.[12]

[1] For Fragiacomo's biography, see "a.b. [Andrea Baboni] ad vocem," in Giuseppe Pavanello, ed., *La Pittura nel Veneto. L'Ottocento* (Milan, 2002–03), vol. 2, pp. 729–30.

[2] Vittorio Pica, "L'arte mondiale all'VIII Esposizione di Venezia," in *Emporium* (1909).

[3] Pompeo Molmenti, "Guglielmo Ciardi e Pietro Fragiacomo," in *Natura ed Arte*, XXII (1895–96), pp. 821–26. "No-one understands better than he [Fragiacomo] does the hidden meaning of things, the effect of the sunset and evening on the lagoon, the alternatives, the contrasts, the harmonies of the various conditions of light and shadow that arouse sweet sensations dormant in the depths of our souls." Pompeo Molmenti, *La Pittura Veneziana* (Florence, 1903) p. 163.

[4] Nico Stringa, "Venezia dalla Esposizione Nazionale Artistica alle prime Biennali: contraddizioni del vero, ambiguità del simbolo," in Molmenti 1903, (see note 3), vol. I, pp. 95–126.

[5] Ugo Ojetti, *Ritratti d'Artisti Italiani. Pietro Fragiacomo* (Milan, 1911),

pp. 179–92.

[6] Mario Morasso, *La Vita Moderna nell'Arte* (Turin, 1904), p. 139.

[7] Note by Paolo Pistellato on *Piazza San Marco,* in Maria Masau Dan and Giuseppe Pavanello, eds., *Arte d'Europa tra Due Secoli: 1895–1914. Trieste, Venezia e le Biennali,* exh. cat. Civico Museo Revoltella, Triest (Milan, 1995), p. 144.

[8] Ojetti 1911, (see note 5), p. 190.

[9] Pistellato 1995 (see note 7).

[10] Giuseppe Pavanello, note on *Piazza San Marco* in Giuseppe Pavanello and Giandomenico Romanelli, *Venezia nell'Ottocento: Immagini e mito,* exh. cat. Ala Napoleonica and Museo Correr, Venice (Milan, 1983), p. 76.

[11] Vittorio Pica, "L'arte mondiale alla IV Esposizione di Venezia," in *Emporium* special issue (August 1901), pp. 5–6.

[12] See Nico Stringa, "Il paesaggio e la veduta: appunti per una storia," in Pavanello 2002–03 (see note 1), pp. 593–628.

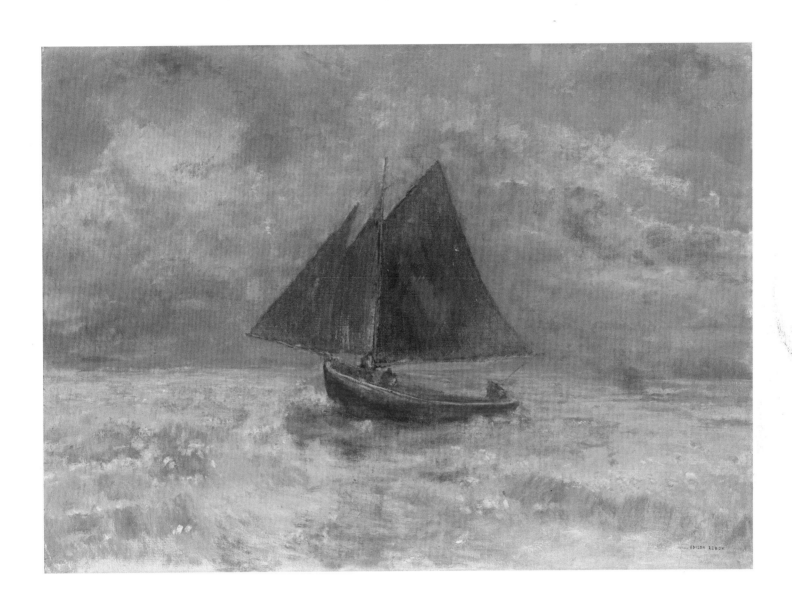

Odilon Redon, *Red Boat with Blue Sail*, 1906/07
Hahnloser/Jaeggli Stiftung, Villa Flora, Winterthur

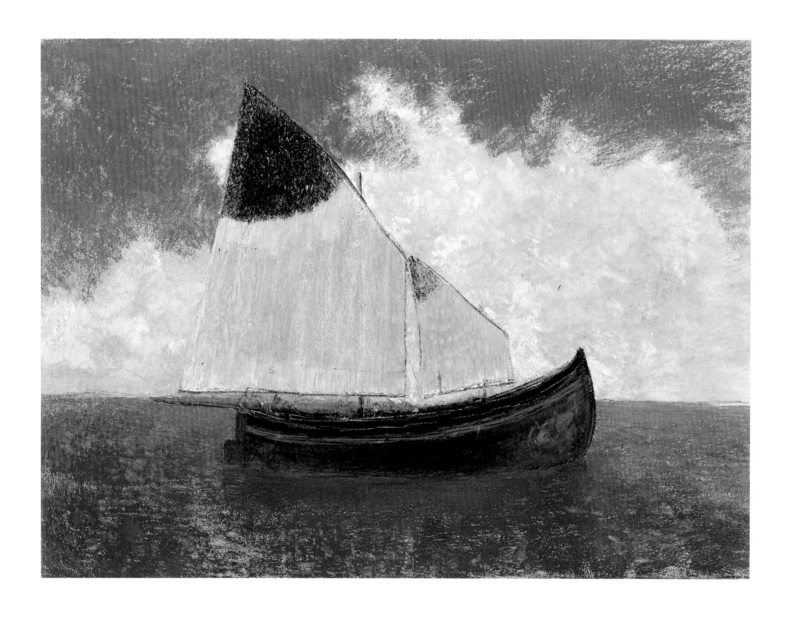

Odilon Redon, *Drifting* (*The Boat with Yellow Sails*), *c.* 1908
Private collection, Switzerland

"OLD ORIENTAL CARPET REFLECTING ITSELF IN GREEN WATERS": ODILON REDON AND VENICE

Dario Gamboni

Odilon Redon (1840–1916) went to Venice twice, first in 1900 and then in 1908, when he was sixty and sixty-eight years old respectively. It was late in his life—prior to that, his limited resources had prevented him from traveling much—but during a period of great artistic output. Moreover, color had now become his main concern, and in this respect, the timing of his visits was appropriate.

Little is known about Redon's first stay. It was part of a trip to Italy he made at the invitation and in the company of Robert de Domecy, an eccentric French aristocrat who had started buying charcoal drawings in 1893 and approved of the current shift to color in Redon's work. De Domecy even suspected that the artist, who had almost always worked in small formats, was capable of covering large surfaces, and commissioned him to decorate the dining-room of his new castle in Sermizelles (Yonne) in the Bourgogne region of France.[1] An unpublished note in Redon's manuscripts gives more details about their trip, which lasted from April 16 to 30, 1900 and led them to Pisa, Florence, Parma, Venice, and Como, and back to Paris by way of Lucerne and Basel (where Redon mentions Hans Holbein and Hans Hug Kluber).[2] They arrived in Venice on Monday night, April 23—one day after Redon's sixtieth birthday—and left the following Wednesday, in the night of the 25th. Redon's telegraphic note mentions the streets, the Grand Canal, the basilica of San Marco, Tintoretto, and the Lido. The name of the French painter Edouard Vuillard unexpectedly appears after his mention of the basilica. Vuillard had visited Venice himself one year earlier, together with Pierre Bonnard and Ker-Xavier Roussel. Had he advised Redon on what to see, or perhaps something in San Marco made Redon think of him or his work as a painter-decorator,[3] for example, which could well have been on Redon's mind on the eve of his own decorative career? Domecy's invitation was probably not wholly without interest and that by bringing Redon to Italy, a country famed for its wall paintings, he hoped to prepare the artist for a new task.

Redon's second stay in Venice is better documented. He traveled this time with his wife, Camille, their eighteen-year old son Ari, and the artist's friend and patron Arthur Fontaine, a French engineer and director of the board of governors of the Bureau International du Travail in Geneva. They stayed some ten days, which did not prevent Redon from writing to another friend and patron, Gabriel Frizeau, that he had only been "running with a suitcase in his hand."[4] They arrived in Venice on April 14, and had left by April 27, 1908. They lodged in the Jolanda Hotel on the Riva degli Schiavoni and enjoyed a direct view of the Bacino di San Marco, with the island of San Giorgio Maggiore in front, Santa Maria della Salute and the Grand Canal to the right. In a long letter to the wife of Redon's close friend and collector Andries Bonger, Camille mentions visiting the Lido, Burano, and Torcello.[5]

Redon made drawings during this stay, of which eight have survived,[6] and once back in Paris he made pastels and paintings based on them and on his memories. Already in November 1908, in a one-man show at the Galerie Druet in Paris, he presented paintings entitled "Impressions of Venice" and "Boats (Memories of Venice)" (p. 176) and a pastel named "Venetian Boats." In addition to these explicit references, there were four other paintings of small boats: two paintings and two pastels, including "Boats (Yellow Sails)" (p. 168).[7] The Venetian motifs sold well. In a letter to Frizeau, in which

he complains slightly that he is still financially dependent on producing new art and compares his activity to a singer's, he writes that he has received an "encore" for his Venetian song and is being advised to return there and "take the tone."[8]

Redon's letters contain numerous enthusiastic comments about Venice. He calls the city unique, unheard of, and dreams of painting "the only cityscape, the unique beauty of its old walls, of its waters, of its beautiful marbles."[9] To Emile Bernard, who spent eight months there in 1903, he writes that, together with the Basque country, it is the only place on earth he has left in tears.[10] A letter to Frizeau written three months after his 1908 stay is particularly revealing:

Now that my sensations reach a synthesis, I would depict Venice as an antiquated rag, as an old oriental carpet reflecting itself in green waters. But the spirit one inhales there is so sweet, so far away! And all that one's eyes meet is beautiful. A cobblestone, a chimney pipe are beautiful, with the patina given to them by a unique atmosphere. This is a place where certain states of our own life are evoked, and only there. This is why it leaves us with a certain nostalgia. It is truly unique.[11]

A recurring theme in Redon's comments on Venice is the feeling of having already lived there, which need not refer to an actual belief in metempsychosis, but certainly expresses the sense of an innate bond with the city.[12] Although Redon only mentions the desire to show Venice to his son as a goal of his second trip, he may well have been in search of new motifs. Camille writes that he immediately started working,

fascinated by the beautiful fishing boats and their sails with singing colors of yellow and black, on this blue-green water, and the sky with clouds colored so delicately in rose by the April sun.[13]

This is a good description of the paintings made by Redon from memory, but the drawings he made on the spot are documentary studies. They depict precisely a few places, details of boats, mooring posts, and chimneys. Giuseppina Dal Canton has identified two of the places represented, including a view of the Rio dei Mendicanti with the Scuola di San Marco on the right, as well as the types of boats recorded.[14] In the pastels and the paintings, however, she remarked that the Venetian types of boats are often amalgamated with other ships such as those Redon could see in St Georges-de-Didonne, near Royan and Bordeaux, where he used to spend his summers in these years. In other words, the artist used his studies from nature as a point of departure from which he could extrapolate freely—as he had always done, true to Delacroix and Baudelaire's dictum of using nature as a dictionary.

In the case of Venice, this freedom of interpretation was all the more welcome as "truthful" depictions had long been degraded into hackneyed formulas. Writing to Redon after the artist's return from Italy, Frizeau defined Venice sarcastically as the "city of the clichés of painting" in which "one puts a canvas before the sun and only needs to fix and develop [it]."[15] Redon could expect such prejudice and must have striven for originality in his choice and treatment of motifs. It is significant that Dal Canton was unable to locate the site he recorded with the most precision in one drawing which he used for the painting *Venetian Landscape* (p. 173). Rather than a *squero* (shipyard for gondolas) in Venice itself, she concludes, it may well represent San Pietro in Volta or Pellestrina, small fishing villages on the narrow islet between the Lido and Chioggia. The choice of such a marginal place, in comparison with the celebrated highlights of the

city, would not only satisfy the need for originality but also correspond to Redon's general attitude of shying away from the limelight and sympathizing with the periphery, be it geographical or social. Wherever the model of this small cityscape is, Redon brings in his notion of Venice, close to that of other places he was attracted to, such as villages in Brittany or the Basque village of St Jean-Pied-de-Port, etched as early as 1866.[16]

It seems all the more probable that Redon took an interest in the fishing villages of the lidos as his other paintings and pastels of the city only show a colorful glimpse of it in the distance, as seen from the Laguna Veneta (p. 176). This distance is clearly not only spatial but also temporal and one might say psychological or ontological: Venice appears as a dream or a vision rather than an actual place. This fits well with Redon's habit of painting from memory and imagination and with the Symbolist preference for suggestion over description. In that sense, Redon may have been content with the short time he spent in the city: the Venice he was interested in could only arise in the mist of memory, both individual and collective. He described to Frizeau the moment he could start painting it with the words "now that my sensations reach a synthesis"; it is a crystallization process that took place as soon as he had left the city, since on April 27, he wrote from Clarens on Lake Geneva to Bonger in Castagnola:

From here, Venice now appears to me with the unreal quality of a tale. A tale made of dead and beautiful things. It is the Orient of times past, in Europe. What a marvel![17]

While a few works explicitly refer in their titles to Venice, and several with similar compositions seem directly inspired by the same experience, others still may or may not be re-

lated to it. Redon had a long-standing interest in the sea and voyages on a boat carried for him associations ranging from the traditional symbolism of human life to a "metaphor for negotiating the perils of the unconscious."[18] Starting in the late 1890s, he had developed an iconographic theme combining boats and human figures, mostly female and more or less clearly defined as religious. He must have been reminded of it in Venice, since on the sheet with notations of chimneys, boats, and mooring posts, he drew a woman in a large shawl in the lower right corner, seen from the back, and placed—not very convincingly—at the helm of a boat. What Redon's stay in Venice may have contributed to this theme is the chromatic brightness, audacity, and variety of the boats. The predilection of the fishermen for yellow sails with a red quarter-circle at the tip fitted well the equivalence he sometimes suggests between sail and sun, and when the quarter-circle is dark, it can even evoke a gigantic eye (p. 168). These iconic suggestions, so crucial to Redon's art in black and white, tend, however, to lose importance in the face of the expressive power of color itself. Redon had been well acquainted with color from his youth, through his admiration for Delacroix and his assiduous visits to the Louvre, but its significance had greatly increased for him in those years and it may have been one of the reasons why he came to Venice in the first place.

In her letter to Mrs. Bonger, Camille Redon refered to their visit of San Marco: "We have seen in the upper galleries a mosaic that was surely made by Redon in a former life."[19] Dal Canton suggested she may have been refering to a mosaic depicting Apollo or Phaeton leading the chariot of the sun—and thus related iconographically to Redon's work—or, more generally, to the flatness and hieratic quality

of the figures in the mosaics. The latter hypothesis is more in tune with the context and meaning of Redon's interest for Venice. We have seen that at the time of his first visit, in 1900, the artist was entering a new field of activity as a painter-decorator. By 1908, this activity had developed and Redon had received a commission from the Manufacture des Gobelins to design fabric for chairs and a fire screen. Two years later, Redon would visit the Musée des Tissus in Lyons and express his admiration for Byzantine and Persian silks. Three canvases with abstract (or vaguely vegetal) symmetrical patterns, dated 1908–1910, have been rightly compared to carpets. But we have seen that Redon likened Venice to a carpet (or a rag) and these pictures could also be com-

pared to the marble wall facing of Byzantine churches, of which San Marco is a prime example. Byzantine art had been regarded as a model by the French Symbolists, especially by Maurice Denis, from the 1890s onward, and it was being redefined as a model in a more formalist sense by English and American Modernists such as Roger Fry and Matthew Prichard, in connection with Matisse's work.[20] As for Redon, it is striking that the elements he points out in his memories of Venice are those mutually reflecting ambiguous surfaces: old walls—with a possible allusion to Leonardo's theory of the artistic use of imaginative perception— water, and beautiful marbles. This may be the ultimate reason why he felt that he belonged there.

[1] See Roseline Bacou, "La décoration d'Odilon Redon pour le château de Domecy (1900–01)," in *Revue du Louvre,* XLII, no. 2 (June 1992), pp. 42–52, and Alec Wildenstein, *Odilon Redon, catalogue raisonné de l'œuvre peint et dessiné* (Paris, 1992–98), vol. IV, nos. 2536–50. Other works described in this essay can also be found in this catalogue: 1920, 1930, 1939, 2497, 2515, 2520–22.

[2] Odilon Redon, note (1900?), The Art Institute of Chicago, Ryerson and Burnham Libraries, Mellerio Redon Papers, C: 13.

[3] See Gloria Groom, *Edouard Vuillard Painter-Decorator: Patrons and Projects, 1892–1912* (New Haven/London, 1993).

[4] Letter of July 16, 1908 from Redon to Frizeau, repr. in Jean-François Moueix, *Un amateur d'art éclairé à Bordeaux: Gabriel Frizeau 1870–1938,* (Bordeaux, 1969), vol. II, p. 189.

[5] Undated letter of May or June 1908 from Camille Redon to Anne Marie Louise Bonger-van der Linden, Rijksprentenkabinet, Amsterdam, Bonger Archives, "Album met betrekking tot O. Redon," p. 161 in Suzy Lévy, ed., *Lettres inédites d'Odilon Redon à Bonger, Jourdain, Viñes…* (Paris, 1987), p. 149; on the problems in using this edition see Dario Gamboni, "Note de lecture," in *Revue de l'art,* 80 (1988), pp. 92–93.

[6] Wildenstein 1992–98 (see note 1), nos. 2496, 2497, 2510–15.

[7] Ibid., no. 1930; see *Peintures, pastels, dessins, lithographies par Odilon Redon exposés Galerie Druet 20, rue Royale du 9 au 21 Novembre 1908, catalogue,* exh. cat. Galerie Druet (Paris, 1908), nos. 7–10, 33, 35, 37.

[8] Letter of December 10, 1908 from Redon to Frizeau, in Moueix 1969 (see note 4), p. 192.

[9] Letter of September 25, 1902 from Redon to Paule Gobillard in *Lettres*

d'Odilon Redon 1878–1916 (Paris/Brussels, 1923), pp. 51–52.

[10] Letter of June 20, 1903 from Redon to Bernard, in *Lettres à Emile Bernard* (Brussels, 1942 [1926]), p. 160.

[11] Letter of July 16, 1908 from Redon to Frizeau in Moueix 1969 (see note 4), pp. 189–90.

[12] Redon had already expressed a similar feeling about the Basque country; see Claire Moran, *Odilon Redon: Ecrits* (London, 2005), p. 29.

[13] Lévy 1987 (see note 5).

[14] Wildenstein 1992–98 (see note 1), no. 2496; Giuseppina Dal Canton, "Odilon Redon e Venezia," in *Venezia Arti,* no. 4 (1990), pp. 107–13.

[15] Letter of May 25, 1908 from Frizeau to Redon in Moueix 1969 (see note 4), p. 189.

[16] André Mellerio, *Odilon Redon* (New York, 1968 [1913]), cat. 12.

[17] Odilon Redon, postcard of April 27, 1908, to Anne Marie Louise Bonger-van der Linden, Bonger Archives, "Album met betrekking tot O. Redon", p. 144.

[18] Fred Leeman, "Redon's Spiritualism and the Rise of Mysticism," in Douglas W. Druick et al., *Odilon Redon Prince of Dreams 1840–1916,* exh. cat. Art Institute of Chicago, Van Gogh Museum, Amsterdam, Royal Academy of Arts, London (New York, 1994), pp. 233–36; see also Gilberte Martin-Méry, ed., *Odilon Redon 1840–1916,* exh. cat. Galerie des Beaux-Arts (Bordeaux, 1985), p. 194, cat. 183.

[19] Lévy 1987 (see note 5).

[20] See J.B. Bullen, "Byzantinism and Modernism 1900–14," in *Burlington Magazine,* 141, no. 1160 (November 1999), pp. 65–75. On Redon's ideal of ambiguity and the reference to Leonardo, see Dario Gamboni, *Potential Images: Ambiguity and Indeterminacy in Modern Art* (London, 2002), pp. 68–77.

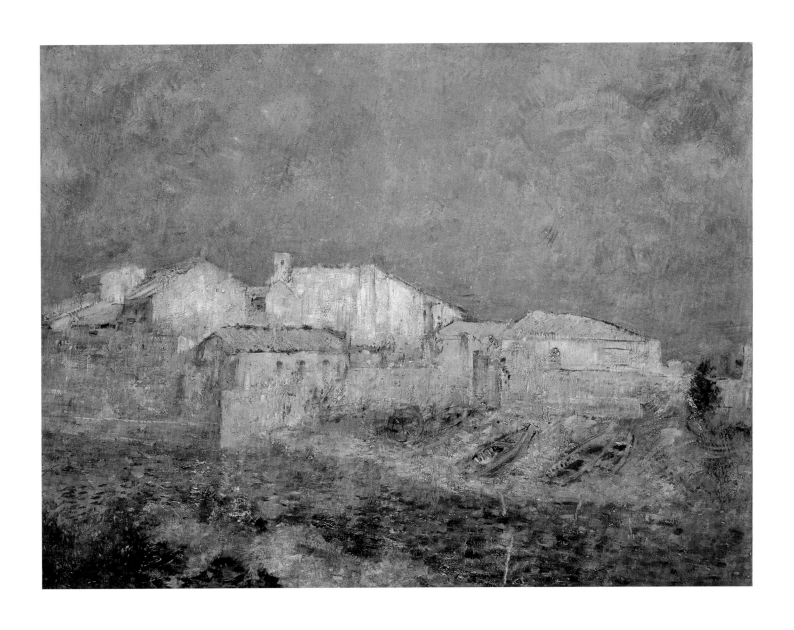

Odilon Redon, *Venetian Landscape, c.* 1908
Musée des Beaux-Arts de Bordeaux

Pages 174–75:
Odilon Redon, *View of Venice*, 1900 or 1908
Private collection, courtesy of Dickinson, London

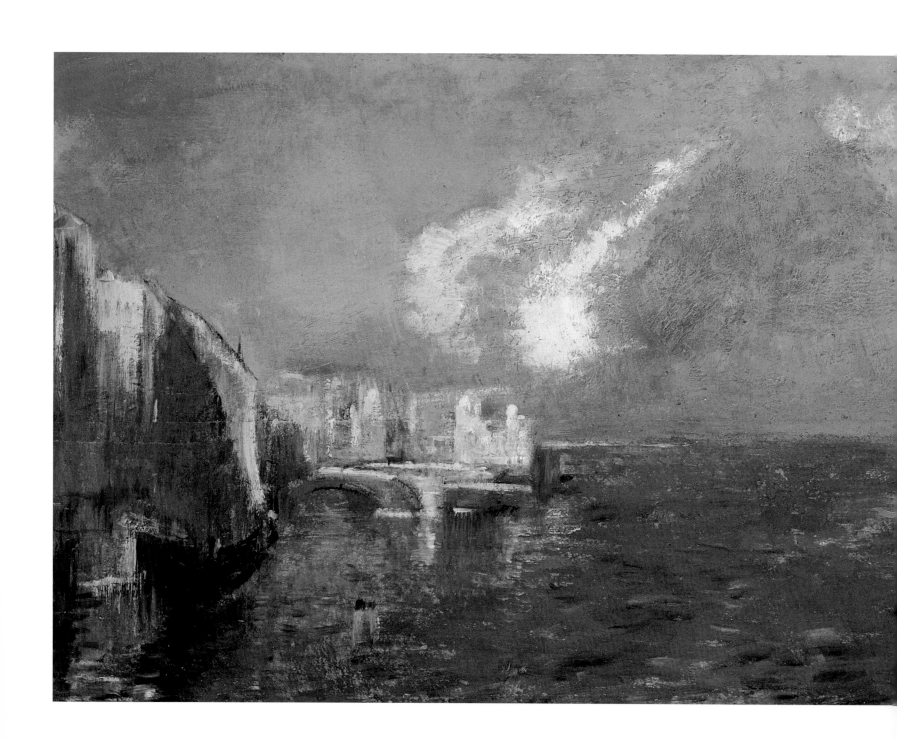

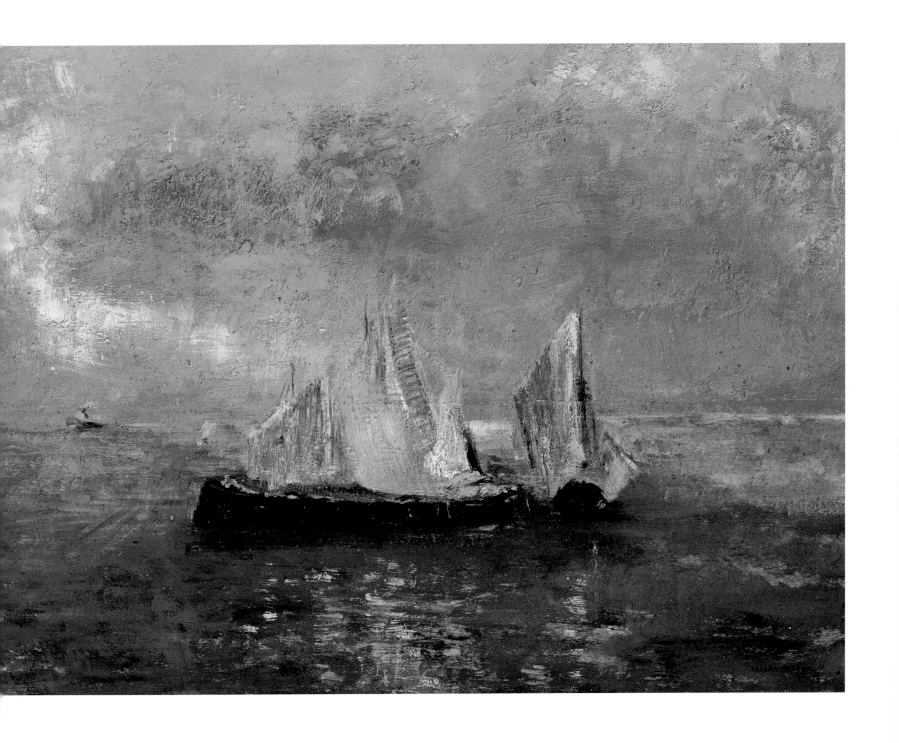

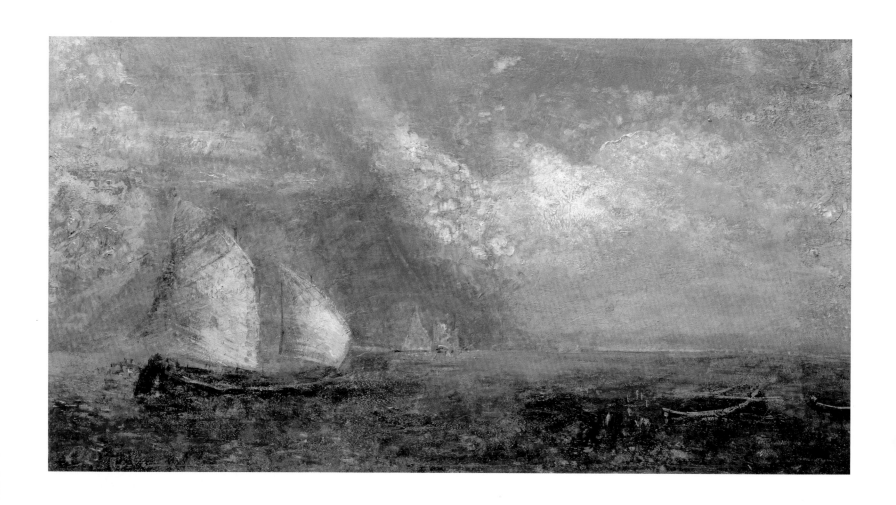

Odilon Redon, *Boats, Memories of Venice, c.* 1908
Museum Langmatt, Stiftung Langmatt Sidney und Jenny Brown, Baden, Switzerland

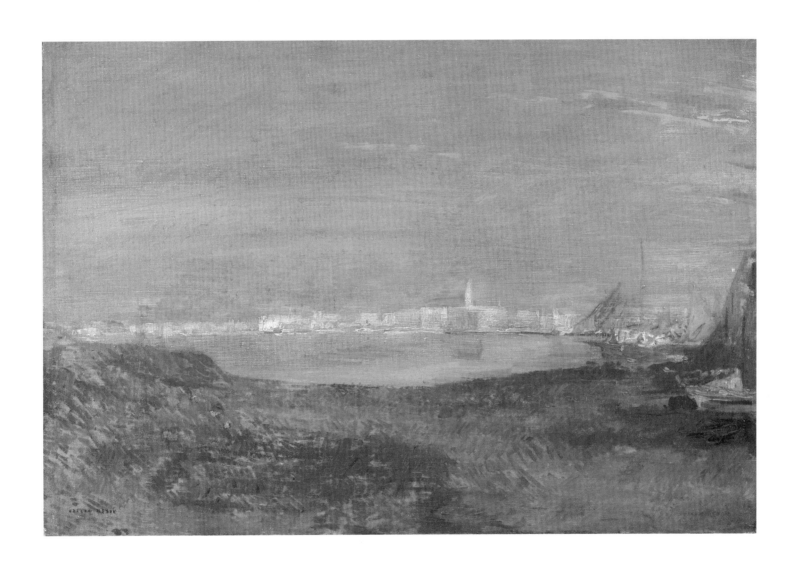

Odilon Redon, *Italian Landscape, c.* 1908
Collection of The Honorable and Mrs. Joseph P. Carroll, courtesy of Edelman Arts, Inc.

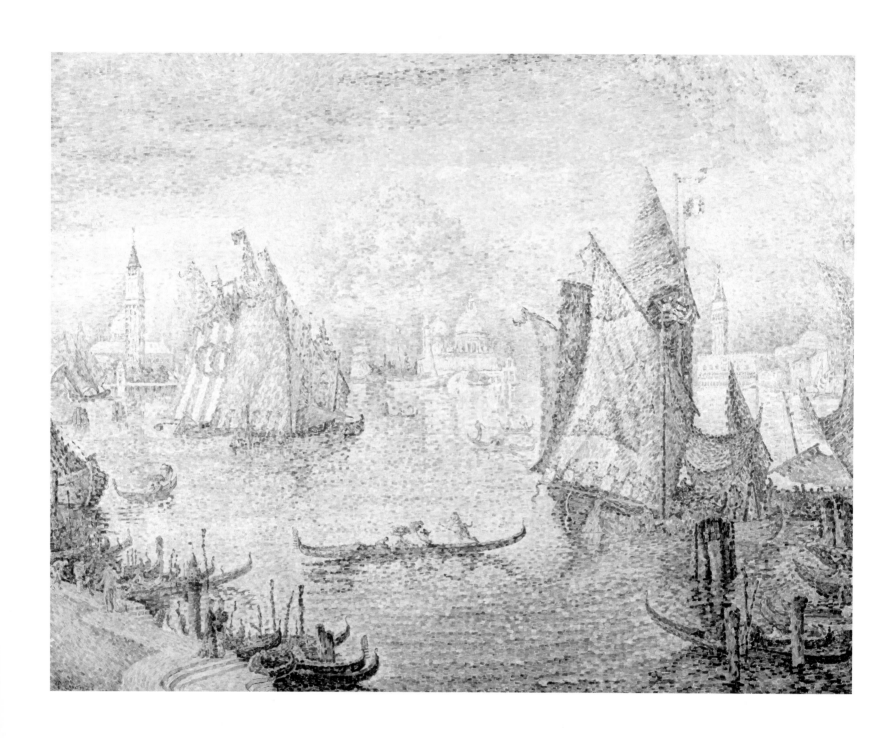

Paul Signac, *The Lagoon of Saint Mark, Venice,* 1905
Chrysler Museum of Art, Norfolk, Virginia, gift of Walter P. Chrysler, Jr.

VENICE BETWEEN TURNER AND MONET
PAUL SIGNAC'S NEO-IMPRESSIONIST VISION

Anne Distel

In spring 1904, Paul Signac (1863–1935) told his friend Henri Edmond Cross, the French neo-Impressionist painter, he hoped to bring back "200 rough watercolor *croquetons*" (little sketches) from a trip to Venice.[1] In December the same year, the cover of Signac's exhibition catalogue at the Galerie Druet, recently established on the Faubourg Saint-Honoré in Paris, featured a Venetian motif printed in green on cream paper. Hanging on the walls of the gallery besides canvases of Holland, Paris, Mont St Michel, the Alps, and Provence there were also four paintings, including *Laguna, Yellow Sail,* and *Giudecca Mooring* (pp. 184, 188), an oil *notation,* and twenty watercolor *notations* of views of Venice. In the preface to the catalogue, young critic and writer Félix Fénéon enthused:

[Signac's] colorations ripple out in broad waves, dying away, intersecting, and running together, constituting a polychromy akin to a linear arabesque.[2]

Signac happily reported:

Lots of visitors; painters who are beginning at last to notice the charms of pure colors and contrasts; kind critics—and buyers. I have already sold thirty items, including two paintings to connoisseurs who have hitherto been hostile to us.[3]

Signac's satisfaction appears like a milestone for the forty-one-year-old artist looking back on an already long career.

Born the year Eugène Delacroix died, Signac claimed Claude Monet was his sole teacher. Along with his friend Georges Seurat, it did not take him long to make his presence felt within the Parisian avant-garde, having been invited to exhibit at the last Impressionist group exhibition in 1886. The "neo-Impressionists," as Fénéon soon labeled them, or "independents," advocated optical mixing, basing their theory as much on empiricism as on re-cent scientific data about the theory of color. The juxtaposition of tiny dabs of pigments of pure colors on the canvas contrasted with the technique of mixing these same pigments on the palette.

A pigment is weak and insipid compared with a color obtained by optical mixing. The latter, mysteriously invigorated by a perpetual action of recomposition, shimmers elastic, opulent, and polished.[4]

A figure painting by Signac, *Dresser and Stuffer (Fashions), Rue du Caire,* also known as *The Milliners,* now in the Foundation E.G. Bührle Collection in Zurich, and a landscape of suburban Paris, *The Gasometers, Clichy,* in the National Gallery of Victoria in Melbourne, became, like *A Sunday on La Grande Jatte,* in The Art Institute in Chigaco, the movement's manifesto pictures. Divisionism resulting from a "conscious technique," observance of the laws of contrast, and rules of a linear process formulated by their friend, mathematician Charles Henry, would surely guide painters to harmony while preserving their individuality.

Georges Seurat's premature death in spring 1891 was a shock to Signac and the little group of neo-Impressionists. However, the movement developed under Signac's leadership, recruiting newcomers, notably Henri Edmond Cross and Théo van Rysselberghe, and through exhibiting with the Indépendants and Les XX in Brussels. The outcome and summary of Signac's ideas had been formulated in his principal theoretical work, *D'Eugène Delacroix au Néo-Impressionnisme* (From Delacroix to Neo-Impressionism), published in 1898. The painter who left for Venice in 1904 was thus taking with him more than twenty years of practice and theory about painting.

The journey seems to have been his first trip to Venice, although Signac had already been elsewhere in Italy. During summer 1894,

Fig. 1 Paul Signac, *Santa Maria della Salute and the Lagoon*, 1904, watercolor and black crayon, 19.3 × 30.7 cm, Musée du Louvre, Département des Arts Graphiques (Fonds Orsay), Paris

when he was working on his great composition *In Time of Harmony* at his house in St Tropez, Signac noted in his diary:

Am overcome by a desire to go to Italy, see Florence and Rome again, then the Giottos, the Michelangelos, and the Raphaels. Then the little towns I never saw on my first trip: Siena, Orvieto, Assisi. How good it would do me to see the decorative figures of Michelangelo again before finishing my painting.[5]

The previous voyage he mentions, which is poorly documented, had taken him and his mother, apparently in quick succession, to Genoa and then on to the Stendhalian trio of Rome, Naples, and Florence in April 1890. At the end of the trip he found his friend Théo van Rysselberghe in Florence, copying works by Masaccio.[6] However, Signac decided on finishing his great composition instead and showed it at the Salon des Indépendants in 1895, without putting his traveling plans into effect.

In April 1898, while finishing off the notes that would become his manifesto *From Delacroix to Neo-Impressionism*, the great Italian decorative artists of the fifteenth and sixteenth centuries were obviously much on his mind, since on his return from a trip to London, he reeled off the names of Pinturicchio, Ghirlandaio, Perugino, Signorelli, Mantegna, and Raphael.[7] These classical references, harking back to an ideal of saturated color within clearly defined shapes, may initially seem surprising from the pen of an *indépendant* who had always proclaimed his allegiance to the art of Monet and modern science. With the exception of Edgar Degas, in their youthful days the Impressionists had saved themselves the cost of the initiatory trip to Italy, leaving this trophy to the pundits at the Ecole des Beaux-Arts.

Later, however, Pierre-Auguste Renoir made a trip to Italy in autumn 1881, beginning at Venice and going on to Sicily. It marked a major milestone in his career. Curiously enough, it was an admiring comment by Signac with regard to Renoir's exhibition at Durand-Ruel in spring 1899 that brought him to first mention a great Venetian:

In this room, the only person you can think of is Veronese. And it is astonishing to think of what used to shock people in his [Renoir's] pictures. I get the impression of a room at the Louvre.[8]

These repeated references to the art of the past, combined with the present, went hand in hand with Signac's interest in the work of William Turner, which was the object of a trip to London in 1898.[9] At the same time that he was studying Turner and being charmed by the vision of Venice which the English painter offered, he was also delving into the writings of critic and writer John Ruskin, whom he described as "a didactic aesthetician, prescient and adept critic" of neo-Impressionist principles. It was thanks to his friend Cross, who undertook the translation, that he was able to familiarize himself with Ruskin's theoretical writings. Numerous fragments of the latter's *Elements of Drawing* (published in English in 1879) are incorporated in *From Delacroix to Neo-Impressionism*, and it is probable that Signac also knew *The Stones of Venice*, even though the French translation only appeared later.

Cross also spent part of the summer of 1903 in Venice. He painted watercolors, and on his return to Saint-Clair[10] (a place near Lavandou, not far from St Tropez, where Signac, whom he also saw in Paris, spent a large part of the year), took notes that he would use to work on a series of canvases, including those shown later at the Salons des Indépendants in 1904 and 1905. The correspondence between Cross and Signac[11] illuminates the relationship be-

tween the two friends' respective stays in Venice. Signac had probably already thought of going to Venice in 1903, but was worried about their possible rivalry. Cross reassured him, saying:

I do not think that, in the years we have been exhibiting side by side, you have ever experienced the least problem from the fact that our inspirations started out from the same object.

So, with his wife, Berthe, Signac finally set off for Venice in spring 1904, traveling via Geneva, Milan, and Verona. They arrived on April 27 and planned to stay there until mid-May.

Lodging at the Casa Petrarca,[12] a modest guesthouse which the *Guide Joanne*[13] tells us was situated near San Silvestro on the Grand Canal, not far from the Rialto bridge, he was immediately overwhelmed.

What could I tell you, dear Angrand, about Venice that you don't know! That the Scuola di San Rocco with its thirty Tintorettos is one of those marvels that make you feel, the moment you enter, the great frisson *of art that you experience four or five times in a very full career (the Museum of Montpellier, Saint-Sulpice, the Pantheon, and the* Night Watch*); that, at the Academy, Veronese's* Feast at the House of Levy *comfortably jostles shoulders with the* Miracle of St Roch *and the* Crucifixion *of "Robusto" [Tintoretto]; that when you come out of there, you are a little ashamed to do a small watercolor measuring 17 cm × 25 cm; that Tiepolo is nauseous; although I don't feel a need to abuse him publicly the way young (!) Bernard (Emile) did on the visitors' book at the Palais Labia; that gondolas have charm, especially for Mme Signac, though I am too accustomed to steering boats myself to take any pleasure in riding steerage like a suitcase.*[14]

Signac was a serious tourist, visiting churches and museums, but as he wrote to his cousin Albert Signac, he was in Venice to do watercolors.[15] He described his way of doing these watercolor *notations*, which would support his studio work and some of which he would exhibit, as follows:

Ah no! No table, not even an easel for the watercolor. If you make yourself too comfortable, you do washes or architectural drawings. I always draw standing, my sheet of paper held in place by the frame of a stirator box. . . . To do a watercolor drawing, I sit on a precarious folding stool, my bowls of water at my feet. . . . I stop the moment the effect disappears. . . . Often I finish [it] from memory when I get back . . . I have the greatest dislike of Whatman and any torchon *paper that wrecks lines and breaks up colors at the whim of the manufacturer and not of the artist. I use nice papier Hollande.*[16]

Elsewhere, Signac recommended a "smooth, thin paper on which the pencil can flow and the water of the wash sits for a few seconds in little beads where the effects of drying will distribute the color in infinitely varied amounts."[17] The watercolors of Venice dated 1904 that we know are numbered. The highest number noted being 258; this tally fits in with what the artist told Cross. Almost all of them, even the most allusive ones, have a point of reference in an architectural structure, the churches of Santa Maria della Salute (figs. 1, 2) and San Giorgio Maggiore recurring most frequently, seen from various points of view. No watercolor relates exactly to the compositions worked out in the series of canvases, dated 1904–07, that followed this 1904 campaign.[18] Signac always insisted on the documentary purpose of his direct *notations* of the subjects, his linear and chromatic compositions being worked into pictures in the studio. *The Lagoon of Saint Mark, Venice*, 1905 (p. 178), in its exceptional monumental format, is a real Venetian

Fig. 2 Paul Signac, *Venice, la Salute*, 1904, pencil and watercolor, 31.4 × 74 cm, Arkansas Arts Center Foundation Collection, gift of James T. Dyke

symphony of gondolas and *bragozzi* with colored trapezoidal sails, pushing back the profile of the famous monuments into a distant, diorama-like arrangement with San Giorgio Maggiore, the Salute, the Campanile, the domes of San Marco, and the Doge's Palace. Signac's "neo" Venice is all sky, light, reflections on the water, gleams of color, and linear rhythms, but properly anchored in their time with the parasols of tourists in their gondolas or large merchant ships at anchor. In this respect, it has similarities with contemporary themes by the painter, such as views of the ports in Marseilles or Rotterdam, or the Golden Horn.

Signac's work on his Venetian canvases in summer 1904 coincides with the moment when Henri Matisse, who also lived in St Tropez, painted the study for *Luxe, Calme et Volupté* at Signac's suggestion—a work which Signac subsequently bought from him. Like Raoul Dufy, Matisse was very struck by Signac's show at Druet in December. Without going into details about the birth of Fauvism, it should be stressed that it was precisely Signac's canvases and his watercolors of Venice that acted as a counterpoint to Matisse's investigations and those of his young fellow artists.

The success of this first Venetian series was confirmed at the Salons des Indépendants in 1905 and 1906, followed by a solo exhibition at Bernheim-Jeune in January and February 1907,[19] obviously prompting Signac to make a second trip to Venice in 1908.

His itinerary in 1908, after Florence, Siena, Rome, and Perugia, brought him to Venice at the end of March. Parts of this journey are particularly well documented thanks to the painter's notes, but unfortunately these do not cover Venice.[20] This time, the Signacs opted for the Casa Fontana, a guesthouse on the Riva degli Schiavoni.[21] Their stay continued throughout the whole of April, and they did not embark on their return journey by way of Verona until mid-May. A spate of watercolors, somewhat frustrated by bad weather,[22] nevertheless generated eleven canvases in 1908 and two repetitions in 1909 and 1923.[23] New compositions thus completed the previous series. Although exhibited and sold in Paris and throughout Europe, they did not form the subject of a special exhibition. This ensemble was incidentally the last on a single theme, since Signac painted much less after 1910.

As a symbolic coincidence, this final Venetian "series" by Signac was conceived just before Monet's visit to the city from October to December, 1908. The careers of master and disciple thus crossed again at the end of a long period of development, as a letter from Signac to Monet reveals, when he had just seen the works exhibited at Bernheim-Jeune in 1912:

My dear maestro, on looking at your Venice pictures, at the admirable interpretation of these subjects that I know so well, I experienced as full and powerful an emotion as I felt in 1879 in La Vie moderne *exhibition room, looking at your* Stations *and* Festive Streets, *etc., which decided my career. Any Monet always moved me. I always drew a lesson from it, and in days of discouragement and doubt, a Monet was for me a friend and guide. And these* Venices, *even more powerful, where everything accords with the expression of your will, when no detail, runs counter to the emotion, where you have attained that inspired sacrifice that Delacroix always urges on us—I admire them as the highest manifestation of your art.*[24]

1 Undated letter from Signac to Cross, Signac Archives, cited by Marina Ferretti-Bocquillon in the chronology in Françoise Cachin, *Paul Signac, Catalogue Raisonné de l'Œuvre Peint* (Paris, 2000), p. 374.

2 Félix Fénéon, introduction to *Exposition Paul Signac, Venise, Hollande, Paris, Provence,* exh. cat. Galerie Druet (Paris, 1904).

3 Letter from Signac to Angrand, cited in Cachin 2000 (see note 1), p. 376.

4 Félix Fénéon, "Signac," in *Les Hommes d'Aujourd'hui,* 8, no. 373 (June 1890).

5 Signac's note dated September 6, 1894, in John Rewald, ed., "Extraits du journal inédit de Paul Signac, I, 1894–1895" (extracts from Signac's unpublished diary), *Gazette des Beaux-Arts,* 6th issue, XXXVI/ 1–3, July–Sept. 1949, p. 102.

6 Cachin 2000 (see note 1), p. 358.

7 Signac's note dated April, 1898, in Rewald 1949 (see note 5), *Gazette des Beaux-Arts,* 6th issue, XXXIX/4 (April 1952), p. 279 and in a letter from Signac to Angrand cited in Cachin 2000 (see note 1), p. 369. A reference to another Italian Renaissance master appears unexpectedly in Fénéon's article in *Les Hommes d'Aujourd'hui* in 1890, which draws attention to the hardback volume of a "silver blue Leonardo da Vinci" in the painter's chosen library.

8 Signac's note dated April 22, 1899, in Rewald 1949 (see note 5), in *Gazette des Beaux-Arts,* 6th issue, XLII/1 (July 1953), p. 52.

9 Cachin 2000 (see note 1), p. 369.
A sketchbook with watercolored sketches after compositions by Turner, including Venetian subjects (Département des Arts Graphiques, Musée du Louvre, Paris, Musée d'Orsay fund, RF 50856) is generally dated to the 1898 trip. However, since it came from a Florentine supplier, Giuseppe Giannini, it may possibly date from Signac's second trip to London in April 1909, closer to his stay in Florence in February 1908. It seems less likely that Signac waited eight years to use a notebook bought during his first stay in Florence in 1890.

10 Isabelle Compin, *H.E. Cross* (Paris, 1964), pp. 58, 59, 72, 208.

11 Letter from Henri Edmond Cross to Signac dated August 14, 1903, in Marina Ferretti-Bocquillon, *Signac, 1863–1935,* exh. cat. Galeries Nationales du Grand Palais, Paris, Van Gogh Museum, Amsterdam, The Metropolitan Museum of Art (New York, 2001), no. 111, p. 290.

12 Cachin 2000 (see note 1), p. 374.

13 This was probably the guide Signac used, because pages torn from it, giving lists of works to see, featured in a package of correspondence with Charles Thorndike (sale of documents, Hôtel Drouot, Paris, May 22–23, 2001, no. 362).

14 Letter from Signac to Charles Angrand dated May 10, 1904, in Cachin 2000 (see note 1), p. 374.

15 Letter from Signac to his cousin Albert Signac in 1904 (sale of documents, Hôtel Drouot, Paris, April 19, 1991, no. 514).

16 Letter from Signac to his cousin Albert Signac in 1933 (sale of documents, Hôtel Drouot, Paris, April 19, 1991, no. 514).

17 Paul Signac, *Jongkind* (Paris, 1927), p. 102.

18 The catalogue raisonné (see Cachin 2000, note 1) lists, besides two *notations à l'huile* (406–07), sixteen canvases dated 1904–07 (409–21, 424–25, 447).

19 The catalogue is illustrated with linear vignettes reproducing the pictures exhibited. Several original pen-and-ink sketches for these vignettes were given to the Musée d'Orsay by Françoise Cachin.

20 Françoise Cachin, "Paul Signac, notes de voyage en Italie, février–mars 1908," in *Hommage à Michel Laclotte* (Paris/Milan, 1994), pp. 607–15. The comments on Venetian painters seen at the Uffizi confirm his taste, being appreciative of Tintoretto, the "Rebel," "a rose morning mist Canaletto with just the right atmosphere and without his usual arid bits, two very Jongkind Guardis." He castigates the "black-guardliness of Tiepolo."

21 Cachin 2000 (see note 1), p. 378.

22 Letter from Signac to Théo van Rysselberghe, "Easter Monday," Librairie Les Argonautes, sales cat. (1987), no. 146.

23 Cachin 2000 (see note 1), nos. 465–75, 482, 558.

24 Letter from Signac to Monet, May 31, 1912, cited by Gustave Geffroy, *Claude Monet, Sa Vie, Son Temps, Son Œuvre* (repr. Paris, 1924), vol. 2, p. 164–65.

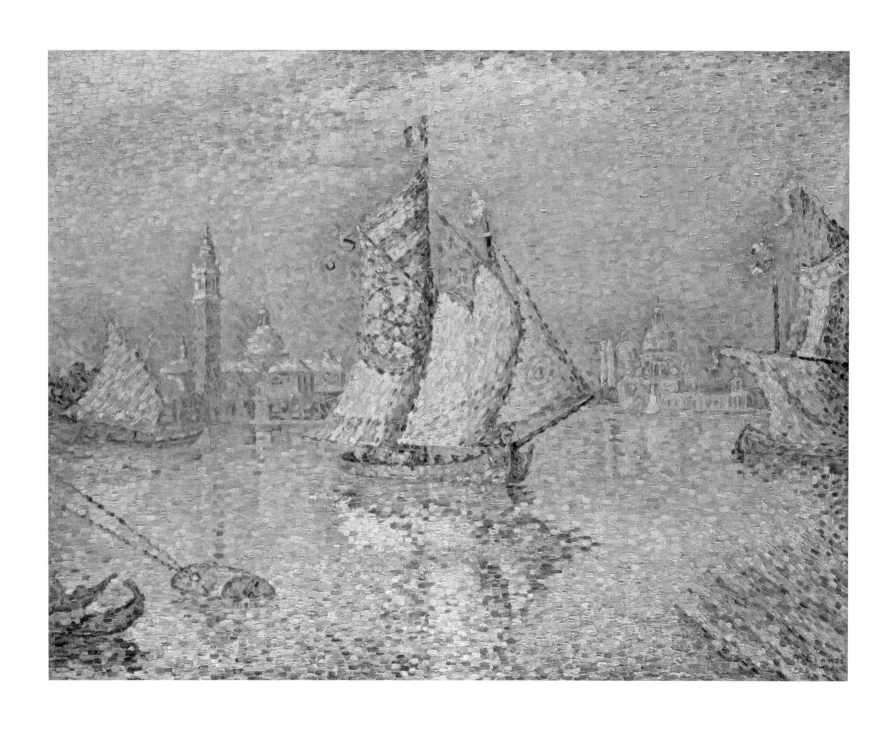

Paul Signac, *Laguna, Yellow Sail*, 1904
Musée des Beaux-Arts et d'Archéologie, Besançon, on permanent loan from the Centre Georges Pompidou,
Musée national d'art moderne, Paris, gift of Adèle and Georges Besson, 1963

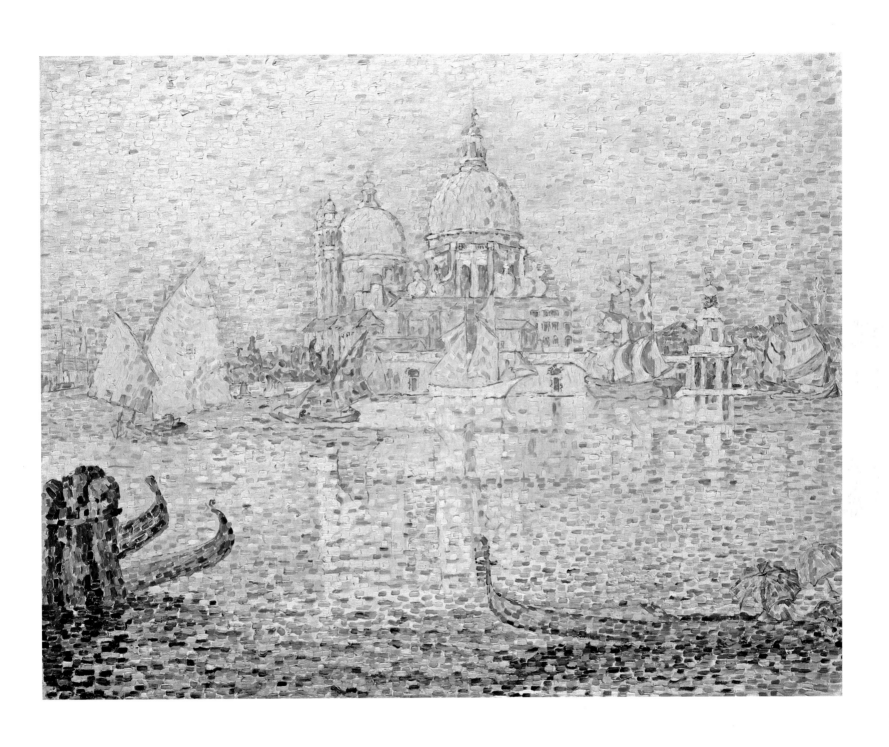

Paul Signac, *The Giudecca Canal in the Morning (Venice)*, 1905
Foundation E.G. Bührle Collection, Zurich

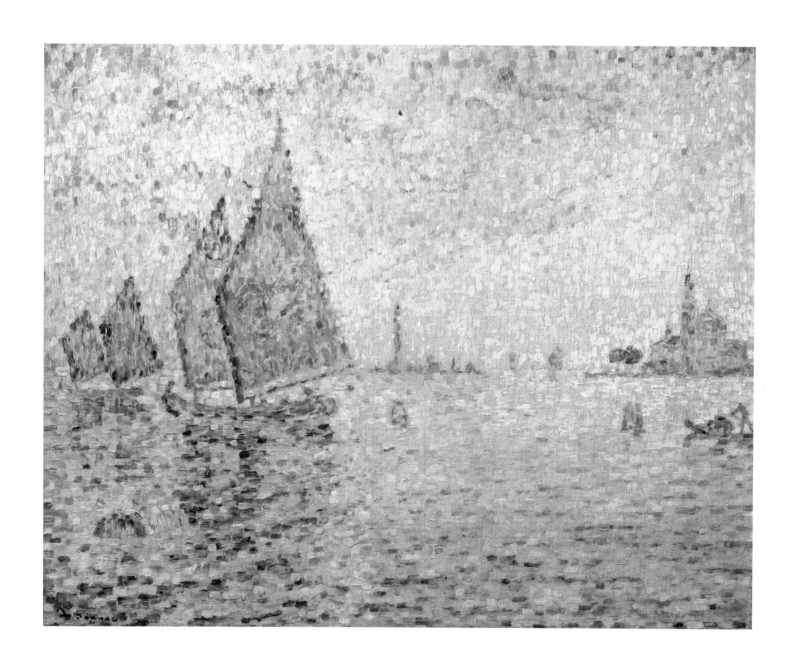

Paul Signac, *The Islands in the Lagoon (Venice)*, 1905
Collection Fondation Pierre Gianadda, Martigny, Switzerland

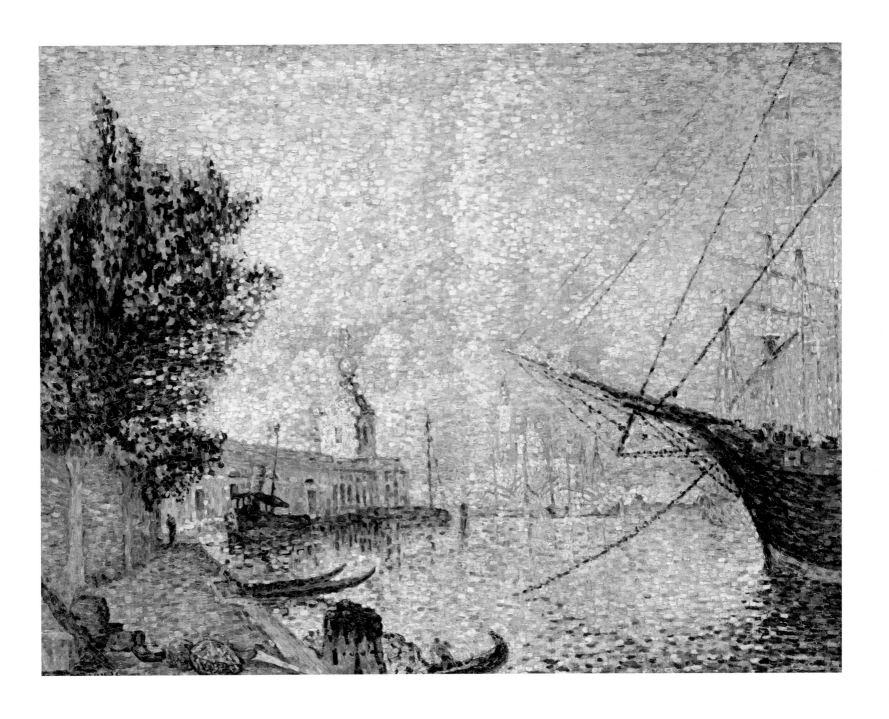

Paul Signac, *The Dogana (Venice)*, 1904
Private collection, United Kingdom

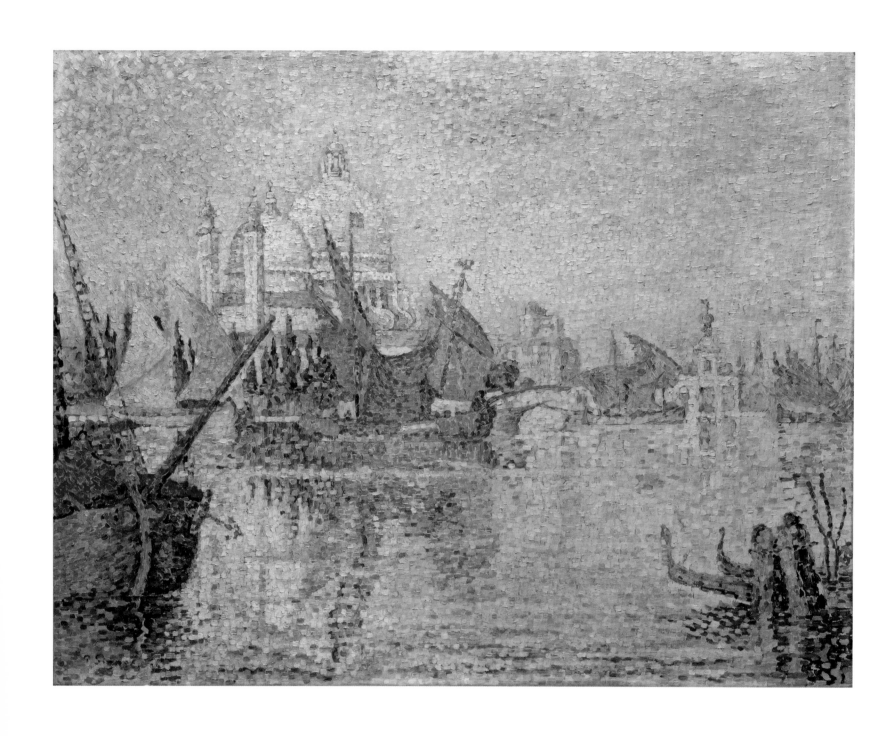

Paul Signac, *Giudecca Mooring (Venice)*, 1904
Bayerische Staatsgemäldesammlungen, Neue Pinakothek, Munich

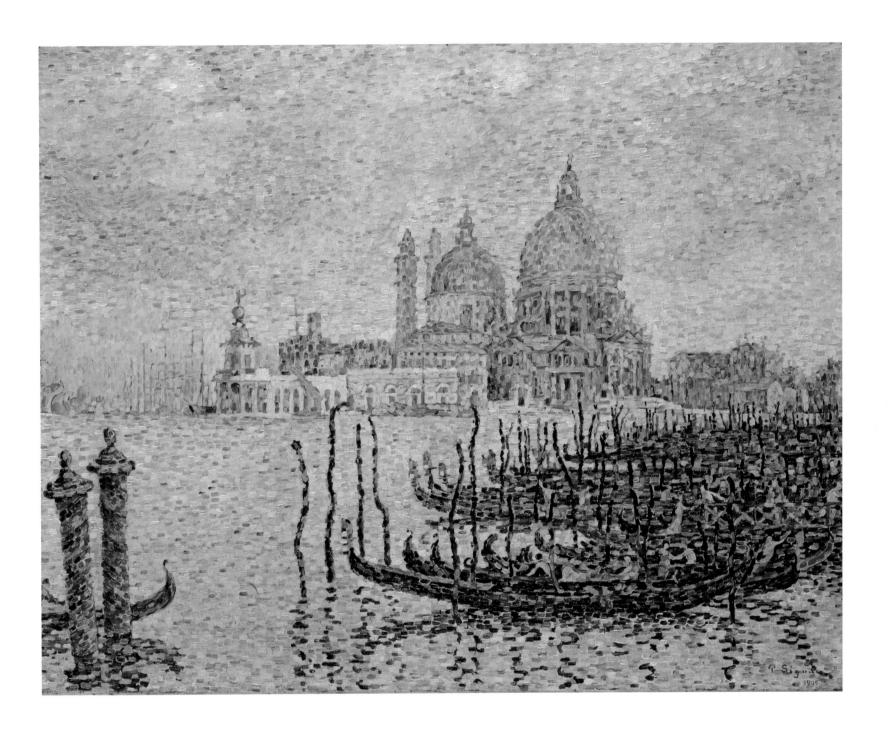

Paul Signac, *The Grand Canal (Venice)*, 1905
Toledo Museum of Art, purchased with funds from the Libbey Endowment, gift of Edward Drummond Libbey

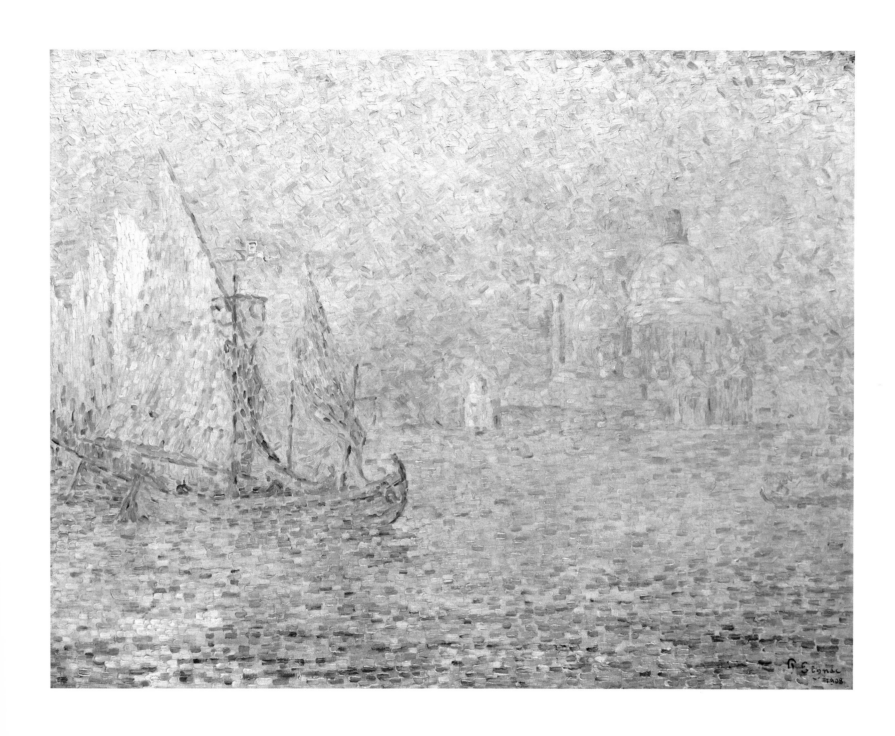

Paul Signac, *Venice in the Mist, Santa Maria della Salute*, 1908
Niedersächsisches Landesmuseum Hannover, Hanover

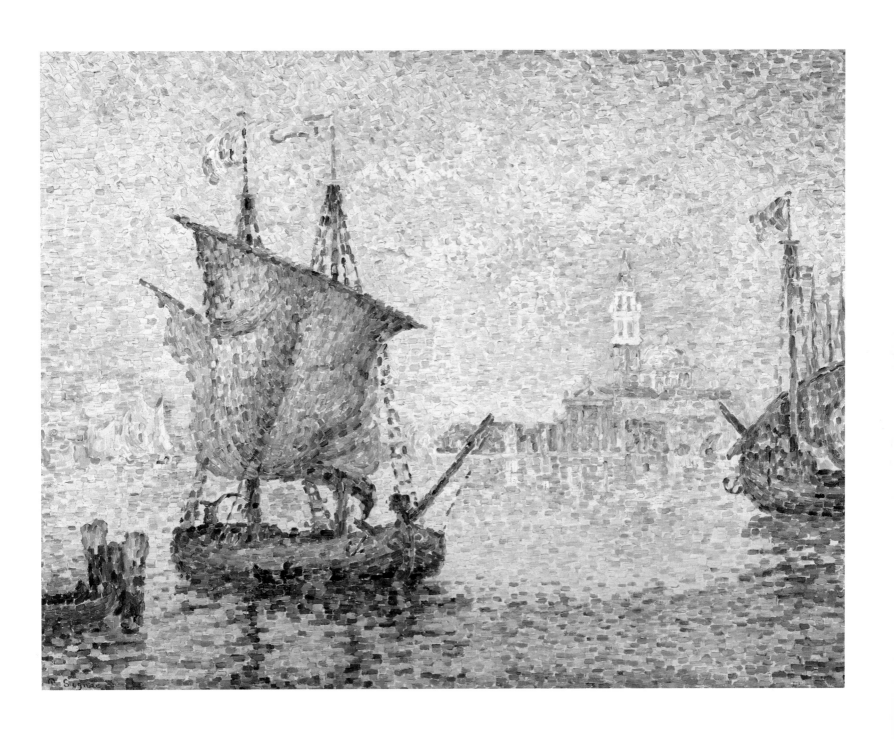

Paul Signac, *Venice, Giudecca Mooring* (*Venice, the Pink Cloud*), 1909
Albertina, Vienna, on permanent loan from the Batliner Collection

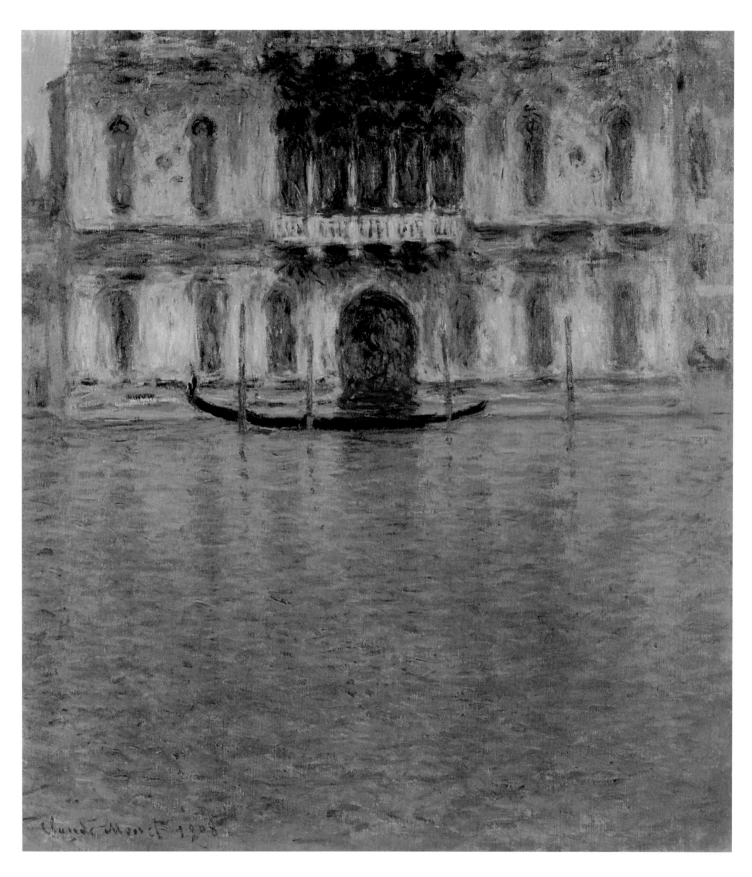

Claude Monet, *The Palazzo Contarini*, 1908
Kunstmuseum St. Gallen, acquired from the Ernst Schürpf Foundation, 1950

MOMENTS: MONET'S TRANSFORMATION
OF THE VENETIAN VEDUTA

Gottfried Boehm

The motif's final journey

In the evening of October 1, 1908, Claude Monet (1840–1926) reached Venice, accompanied by his wife, Alice, where they were to stay until December 7, first at the Palazzo Barbaro, then in the Grand Hôtel Britannia (now the Westin Europa & Regina)—both located on the Canal Grande. This was to be the last of his lengthy trips which had taken him to destinations such as Norway, the Côte d'Azur, and London in a quest to assimilate—through painting—places beyond the Ile-de-France region. On this occasion, it was an invitation from his wealthy art acquaintance, Mary Hunter, that lured the artist away from Giverny and his garden, where for some time Monet had been cultivating his rural retreat into a studio. It was not without hesitation that he set out on the journey since he was unsure whether he would be able to plumb the depths of the city on his painterly expedition. Even in the course of his stay, during which he was to paint thirty-seven pictures altogether, his mood swayed between exaltation and dejection. This we know, in astonishing detail, from the almost daily letters that Alice wrote, above all to her daughter Germaine in Nice.[1] Descriptions of the artist's moods, the obstacles he faced, and the way he grew to know the city, are interspersed with details of the food, family and social intercourse, the most suitable weather for painting and general impressions as a tourist. What in rare moments also shines through is Alice's arduous task as a wife, who in all respects was anxious about the well-being of her difficult and at times cantankerous husband. All in all, the work Monet accomplished in Venice gave rise to plans for their return the following year, but which ultimately came to nothing as a result of Alice's illness and, in 1911, her subsequent death.

In retrospect, one can only marvel at Monet's artistic courage in attempting paintings of his own in a place like Venice, whose "views"—even by this time—had become so hackneyed due to the countless reproductions and to photographs in particular. The 1908 edition of Baedeker leaves no doubts as to the swelling hordes brought about by international mass tourism which had already reached Venice. Should one imagine Monet as a street painter being gaped at by passers-by? Since its progressive political decline at the end of the sixteenth century, Venice had long become the European capital for sightseers—a veritable display case, a city for the eye. Evidence of this is visible in the sequence of major cityscapes presented here. But, with the nascent age of mass tourism, hadn't this city's picturesque substance—and thereby also its mystery—already been rendered banal and usurped by reproductions? Monet's paintings of Venice do indeed mark the preliminary end to a superb history of portrayals of this city, bringing it to a triumphant climax not only through his works. How did he do it? Was it possible to unshackle the image of Venice from the visual clichés and stereotypes that blossomed in the age of printed reproductions? Monet considered this an oppressive burden and gave vent to his feelings in the exclamation, often quoted by Alice: "Too beautiful to be painted."[2] Initially, there had been concern that the artist might depart before he had painted even a single picture. The remedy Monet found for this dilemma is the subject of this essay, with attention being focused on the artist's transformation of the cityscape, his ingenious idea of taking up the pictorial form of the *veduta*, and through painting, endowing this form with a completely new appearance and adding the dimension of experience.

An ambiguous place

Around 1900 and in the years to follow, Venice once again served as a magnet for the imaginative output of productive European minds—such as, to name but a few, Hugo von Hofmannsthal and Rainer Maria Rilke, Thomas Mann, whose *Death in Venice* revived the topos of the "realm of nemesis," and Georg Trakl with his Venetian poem.[3] This is worth mentioning if only because the viewer of the Venice paintings is confronted with a wealth of interpretations that have perceived the same face of the city in a huge variety of ways. From the very outset, Venice's amphibian reality made it a site of significant "ambiguities" with changing polarities: between Eros and death, fathomless superficiality and unfathomable depths, between dream and reality, exuberant *joie de vivre* and melancholy, between a removal from reality in adventure and the political settings for one of Europe's oldest republics.

Shortly before Monet's arrival, the German sociologist and essayist Georg Simmel, a keen and highly perceptive observer, had just completed a short essay on Venice, published in June 1907, outlining once more the ambiguous image this city had engraved in Europe's collective memory. In comparison with Florence, the capital of the rational *disegno*, Simmel too discerned Venice as a place of superficial and colorful brilliance, of structural falsehood, of façade from which reality had withdrawn, and described its "protean mantel," the lights dancing on its surface, behind which he perceived a lack of wholeness and substance.[4] But it was precisely such visual delights, the profusion of light and its capacity for richly colored refractions at a moment's glance that attracted a painter like Monet and offered him such promising potential.

But where was he to start? Where to begin in this indecipherable, tangled warren of houses, alleyways, and water channels? Which of the many stereotyped motifs, which had already been repeated time and again, should he choose and which ones opened up suitable avenues to his experience? In terms of radicality, the Impressionist concentration on the eye was certainly new, but in the *veduta* this focus gained a neglected correlation which very much suited Monet's purposes. Since the seventeenth century, the genre of the *veduta* had established itself as a singular form of landscape and was restricted to the depiction of towns and cities. As a term, it initially described the interplay of aspects shared by a view and a topographical record: everything that can be construed by means of seeing—*vedere*.[5] It is about the city as a visual entity. The ensuing eschewal of *idea* and *concetto*—the guiding concerns of early modern art—not infrequently gave rise to rebuke. Similar to portraiture, the *veduta* was belittled for being satisfied with given reality and thus curtailing the freedom of *invenzione*, the power of invention and creative imagination.

The development of the *veduta* had then begun to branch out into different directions and variants, with Canaletto and Francesco Guardi in particular standing for those evolved in Venice. But this range of divergence can also be observed elsewhere, as shown here. One type of *veduta* consists of an architectural prospect or perspective, which also explains its other, more common terms: *prospetto* or *prospettiva*. The architecture of the buildings and squares is lent a three-dimensional character as if its main purpose were to produce the most accurate possible survey of buildings and their surroundings. Indeed, *vedute* of this kind quite frequently served as a record of

what historical inner cities once looked like, before—as so often happened—they were erased or radically transformed. Thus, Canaletto and Bernardo Bellotto's work, for instance, proved invaluable in the reconstruction of Dresden after 1945 and in 1989. The other kind of *veduta* was concerned with different issues, and treated existing architecture more as an opportunity for reinventing it or concocting similar versions of the same on canvas. The purpose of devising such caprices and variations was to enhance the viewer's experience of the picturesque, of atmospheric settings and their aura.

How did Monet respond to this alternative? In a nutshell, by withdrawing from it. On the one hand, even if his paintings address the famous vistas of the city, they pay little heed to their architectural form; by the same token, however, Monet cannot be accused of indulging in mere *capricci* or the aesthetic charms of decay. He had a different purpose in mind.

Examining the routes he took through the city, one is struck by their brevity: in terms of the two places in which he stayed—the Palazzo Barbaro (close to the Accademia Bridge) and the Grand Hôtel Britannia (located where the Canal Grande widens, close to St. Mark's Square)—they were just a few steps away.[6] There were also simple painterly reasons for limiting himself to selected views within an area which, in essence, encompasses the final stretch of the Canal Grande, the open square in front of the Palazzo Ducale, and San Giorgio Maggiore on the opposite bank. The accommodation he chose afforded him views of the end of the Canal Grande from the Palazzo Barbaro, with the soaring dome of Santa Maria della Salute (pp. 206, 207), or of San Giorgio Maggiore from the terrace of the Grand Hôtel Britannia (pp. 212, 213). His paintings of the

Palazzo da Mula and of the Palazzo Contarini, each viewed face-on from the other side of the canal, came about because he managed to find matching positions opposite his motifs (pp. 200, 192, 201)—Palazzo Corner for the one, Palazzo Barbaro for the other. This makes it possible to pinpoint his painting sites and vantage points with great accuracy, as Philippe Piguet has done with admirable clarity. For Monet it was, as ever, a matter of principle that the painting be based on the evidence of an empirically verifiable view of a motif and not to make anything up. Despite this, however slender the range of motifs Monet chose to paint during his stay, it nonetheless sufficed to create a picture of the city as a whole. As has been rightly observed, the Venice paintings do not so much form a series as they do a "suite," whose individual parts evoke memories of the *città bellissima*.

The motif transformed

Monet's direct commitment to visual impressions gained in the presence of the motif did not mean, of course, that he was interested in a true-to-scale or even constructional transfer onto canvas, in portraying townscapes in perspective—if for no other reason because such depictions inevitably would have struck him as impossible. For as soon as the painter relied simply on what he saw, the bewildering logic of the eye and oscillating color hues sufficed to transform all visible phenomena, the buildings and squares of Venice, into something utterly new. Characteristic for this is the method Monet applied to the views he encountered. He endeavored to construct the painting in such a way that the upper and lower halves were arranged around a horizontal axis of symmetry which, in general, was identical to the zone where buildings and waterline met.

Fig. 1 Claude Monet, *The Palazzo Ducale Seen from San Giorgio Maggiore*, 1908, oil on canvas, 65 × 100 cm, Nahmad Collection, Switzerland (work exhibited)

Only the paintings showing the Palazzo Ducale with the Molo and the two columns, for which Monet took up a working position in the vicinity of the bank in front of San Giorgio Maggiore, mark the spot where he set up his easel (pp. 195, 210, 211). Otherwise the location of the painter *vis-à-vis* his subject is excluded from the painting: the motif appears to be unmoored and floating adrift at an immeasurable distance. It is borne by the liquid reality of the water, which then merges into the vaporous reality of the air, both joined together by the same light. This alignment to an axis of symmetry as the painting's dominant feature engages top and bottom—in other words, what can be seen above the line of the horizon and what below, the sky and the land—in a relationship of profound and intense exchange. In some of his paintings the sky seems almost immersed in the water, which has been transformed into a scintillating fabric of color and light. If anywhere, surely it is here that the Heraclitian notion of flux and flow holds as a valid and appropriate description. The intense blend of such extremely different elements— water, light, earth, air—none of which is attributable to another, assimilates them and erases their disparities. Mass loses its weight: the immense architecture of the Salute church is sufficiently borne aloft by water, light, and air that it seems almost to be afloat (pp. 206, 207). The island of San Giorgio Maggiore, on the other hand, appears to be drifting, albeit somewhat more slowly than the gondolas gliding along in front of it (pp. 212, 213). The evaporation of weight, but also of the hardness of walls and buildings, matches the indeterminacy of depth on the surface. The rational certainty of mass and distance gives way to a mounting irreality which permeates the entire depiction. The wooden beacons visible in the paintings of the Canal Grande, slightly inclined poles used for mooring boats, can be viewed as scales for measuring the varying degrees of reality any one thing has assumed.

It is already evident by this point, however, that not only have the diverse qualities of empirical reality become diffused in the chalky, milky waters and skies, but also historical memory has begun to pale. For instance, although Monet turns his attention to the façades—that is to say, to the faces—of individual palaces, as far as the relative differences between their Gothic, Moorish or neo-classical styles, the specific historic features, and legible architectural definition they manifest are concerned (pp. 192, 200–05), these distinctive traits recede and lose substance. The façades resemble the elusive natural phenomenon of a mirage, especially when the power of twilight takes hold of these human artifacts and the light begins to glow, igniting a fiery blaze. Monet heightens the quality of light as it begins to consume all that is made by human hand, the indescribable preeminence but also fragility of a city that had been floating for centuries; but in a painting, of course, in a work fashioned by hand that claims a lasting presence.

In the early 1890s, while he was working on his Rouen Cathedral series, Monet had already reached a position best described as scepticism towards the seeming permanence of monuments such as age-old churches. Although their façades had accumulated the patina of historical experience, under the painter's gaze they were above all like a stage offering Nature's play of light the chance to deliver a *tour-de-force* performance. This thread is taken up again in the Venice suite and given greater momentum. The cathedral was not right on the water's edge. But now it became possible

for Monet to combine the topographical elements of churches and buildings with the structure of an aquatic landscape. He had already devoted himself to the waterscape, especially in his Seine paintings around Vétheuil and Argenteuil. The particular character of Venice enabled him to combine both aspects in a single, audacious step.

Accordingly, then, Monet's passionate work was not concerned with conveying the factual details of his motifs. More important to him by far was to register the varying coherence of the luminous situations that manifested themselves differently in morning light than in afternoon light, and differently again in afternoon light than in evening light. From Alice's letters we learn, for instance, how he was caught on the wrong foot by morning mist, how changes in the weather hampered him, that he took a keen interest in the progress of the seasons and the transition to frost and winter light.[7] The Venice paintings are a very accurate record of how the various times of day take possession of the same motif and change its aspect by immersing it in a different light. Furthermore, Monet kept to a strict daily routine, about which we learn from letters written on October 12 and 16, 1908. They describe how his working day began early:

From 8–10 at the first motif (at San Giorgio Maggiore) opposite St. Mark's Square; from 10 a.m. in St. Mark's Square, opposite San Giorgio Maggiore. After breakfast Monet worked on the steps of the Palazzo Barbaro, then at 3 p.m. near the gondolas; we take a walk to admire the sunset and return at 7 p.m.[8]

The impression made by the motif, its appearance, breaks free and determines what it is that is visible *vis-à-vis*. And it bears a name: Palazzo da Mula, Contarini, Ducale. . . .

How long does a moment last?

The liquefaction of motifs, the mixture and approximation of different realities by means of small dashes of paint applied by the brush to cover an entire canvas do not account for everything that is new about his cityscapes. Irrespective of what Monet depicts, be it stones, ramparts, windows, doors, walls, domes, or towers, the painting is built from the same colorful substratum. "Water equals time," as Joseph Brodsky noted in his Venice diary.[9] Indeed, this calls to mind the experience of phenomena like the murmur of the sea, the clarity of a starry sky or the texture of smooth surfaces brushing against the tips of our fingers. What these all have in common is that—as isolated elements—they elude direct identification. With his patches of color Monet operates on (or just below) the boundary of our attention. Here and there we manage to distinguish single areas, but they derive their overall effect from a lack of form and contour: from the blurredness of their appearance. Monet's painting technique aims to achieve the effects of an oscillation which sparks an intensely animated fusion of the pulsating patches of color with the depicted motif.

But what do these color pulses we see stand for? They are the indivisible bond between the activity of seeing and the occurrence of something. Both coalesce in the colored data on the canvas.[10] We encounter a mysterious state in which the artist endeavors to fuse parts of the motif with parts of the visible object to forge a new and shared reality. Concepts such as oscillation, pulse or diffusion seem appropriate for our description here because they also point to the temporal qualities that have infused the paintings. These assume the place of what had previously been a spatially defined variant of the *veduta* based on the laws of per-

spective, which generated a metrical and visually legible sequence of pictorial planes between close-to and far-away that converge on the vanishing point. Views of the city in such *vedute* often resemble a stage set, where occasionally genre scenes are acted out, but whose major theme is to give visual expression to the very urban space in which they are staged. With its perspective views, diagonals, vanishing lines, its façades and floor patterns, the spatial *veduta* creates suggestive impressions which are evident and beautiful. By contrast, Monet was in search of something quite different. He no longer assembled his picture from distinguishable planes of previously conceived space. On the chromatic surface, the various aspects intermingle to become an all-encompassing, out-of-focus haze. The viewer's eye is unleashed from the factuality of things and constructed space and surveys the painting's surface in a constant *va-et-vient*. Any attempt to bring the oscillation of the gaze to a standstill founders on the painting itself. One aspect thereby gains importance to which we are perhaps reluctant to attach much value: the perfection of uncertainty. Perfection in the sense that it would never occur to the viewer to wish that Monet's paintings were more precise or more sharply focused. Here, certainty is no longer the superior opposite of uncertainty.

The pulse of oscillation underlies the experience of time which spreads out in small particles over the entire surface of the painting. From the history of older *vedute* we are familiar with the way space hardens into a static construct with the aid of trajectories, which guide the eye's movement, and with niches, for example, where figures can open up subsidiary scenarios. Our sense of time in these conditions is gauged from individual movements; they do not take possession of the

paintings as a whole. Monet is different. Composed of tiny elements, contrasts shape the overall impression of these works. The entire picture is bound up in a single state of movement and time which is derived from the painting structure rather than from the implied movements of people, clouds, paths or vanishing lines. Everything that is visible in the painting has been melted into a pulsating appearance.

But Monet's intention was certainly not to render his painting as flat as possible, no more than he could be considered indifferent to content or space. Had this been the case, he would not have needed to put himself through all the effort of traveling to Venice with the laborious working conditions this incurred. Nonetheless, the space he created is not a measurable or primary quantity, but a product of the color structure. Rather than being built or constructed, it glides and seems to breathe with the gaze. More than anything else, Monet's Venetian *vedute* are fluctuating spaces of color with varying climates, depending on the time of day and season. Cool temperatures prevail when blue or violet hues predominate in the morning light. They become warmer as the sun rises in the sky and red, yellow, and orange come to the fore. Monet's *vedute* open up a *temps-espace*, whereby the emphasis here lies on the first term: time.[11] This represents a clear inversion of the subordination imposed by the perspectival *veduta*. Temporal impulses now open up spaces which exhibit the qualities from which they are constructed: liquidity and fluidity. Nowhere do these qualities turn into solid form, even though altogether different aggregate states can be observed in the Venetian paintings, as, for instance, in the contrasts between the soft edges of buildings and sharply defined demarcations. Emerging be-

tween such depictions is a range of temporal rhythms worthy of the viewer's attention—if only because they make us aware of the paradox that characterizes Monet's painting. Along with other Impressionists, he had followed the principle of "instantaneousness" (*instantanéité*) since the 1870s. In his Venice paintings too, over thirty years later, the fleeting, lapsed moment is not tempered but radicalized. The entire surface appears as an ensemble of connected and competing forms of fleetingness. But, surprisingly, the sum of all this momentary transience is manifested as a condition. The picture is brought to a standstill by this aggregate as a condition and given duration.

How long does a moment last? We generally tend to define it as a miniscule quantity squeezed between the past and the future, as some point along a time axis. Monet's moments are of a different order. Scattered over the canvas's surface, they collectively denote a condition. It is the condition of momentari-ness, which has neither a beginning nor an end and for this very reason endures.[12] Duration is not the absence of time and change, but is the product of minimal contrasts that Monet organizes in his paintings. The duration of this moment cannot be measured by a clock, it is: *now*. The lapsing of each single moment is transformed into the inexhaustible abundance of everything the viewer encounters in the painting.

So if the initial question was how Monet managed to evade the stereotypes of reproduction and the deterioration of beautiful and all too frequently reiterated motifs, the answer now seems apparent. In his interpretation of the *veduta*, he denied any spatial stability, not even that of a stage set; instead, he renewed its visual order by means of a multitude of moments which then transpose everything into a state of mobility. He created a presence which the archaic cityscape was no longer capable of generating: space became time.

[1] Philippe Piguet, *Monet et Venise*, with a preface by Pierre Schneider (Paris, 1986), pp. 25–56.

[2] Ibid., p. 11.

[3] Hellmuth Petriconi, "*La Mort de Venise* und *Der Tod in Venedig*," in *Das Reich des Untergangs. Bemerkungen über ein mythologisches Thema* (Hamburg, 1958); Paul Requadt, *Die Bildersprache der deutschen Italiendichtung. Von Goethe bis Benn* (Bern/Munich), 1962, pp. 187–251.

[4] Georg Simmel, "Venedig," in *Der Kunstwart, Halbmonatsschau über Dichtung, Theater, Musik, bildende und angewandte Kunst* (June 1907); also Georg Simmel, *Zur Philosophie der Kunst* (Potsdam, 1922), pp. 71, 72.

[5] Jannette Stoschek, "Die Vedute. Bemerkungen zu Entstehung und Geschichte eines Genres," in Corinna Höper, ed., *Giovanni Battista Piranesi, Die poetische Wahrheit. Radierungen*, exh. cat. Staatsgalerie Stuttgart (Ostfildern-Ruit, 1999), pp. 31–60.

[6] Piguet 1986 (see note 1), pp. 63–66.

[7] Ibid., pp. 25–56.

[8] Ibid., p. 30.

[9] Joseph Brodsky, *Watermark* (New York, 1992), p. 134.

[10] Pierre Schneider, in Piguet 1986 (see note 1), p. 9. Schneider characterizes this position with recourse to Kant, who Monet also quoted according to the recollections of Georges Clemenceau in *Claude Monet, Betrachtungen und Erinnerungen eines Freundes*, 1st ed., (Freiburg/Br., n.d.), pp. 145–46.

[11] Gottfried Boehm, "Die Wiedergewinnung der ikonischen Zeit," in Walter Schweidler, ed., *Weltbild-Bildwelt* (St. Augustin, 2007), pp. 97–123.

[12] Pierre Schneider in Piguet 1986 (see note 1), p. 12: "The moment is the crossroads between space and time."

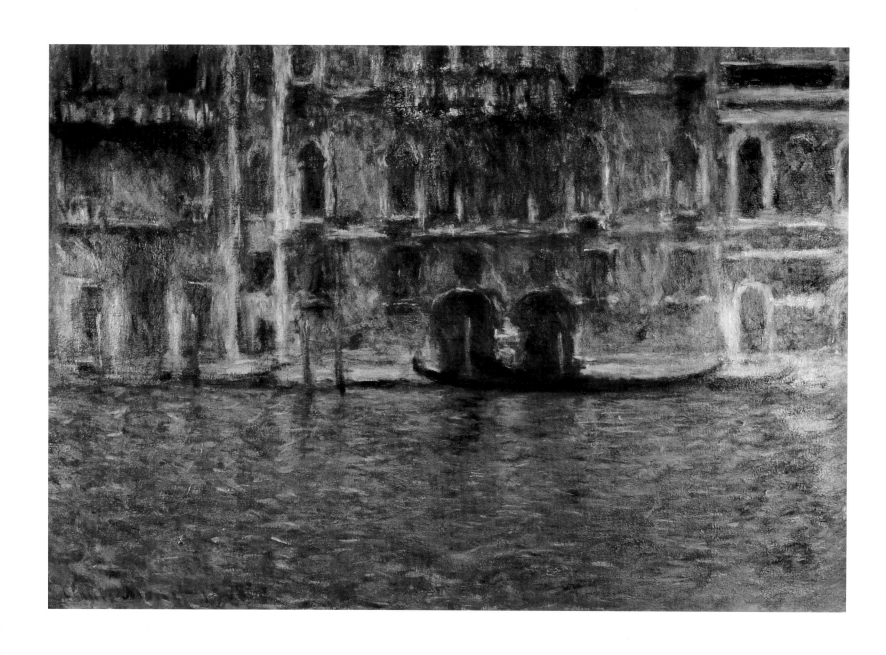

Claude Monet, *The Palazzo da Mula*, 1908
Paul G. Allen Family Collection

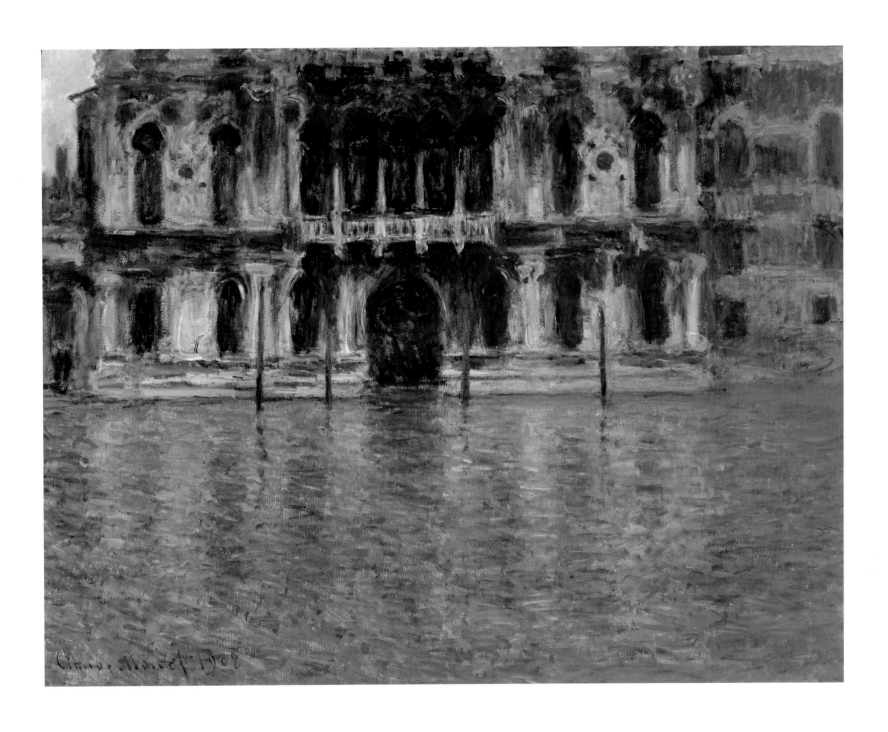

Claude Monet, *The Palazzo Contarini*, 1908
Nahmad Collection, Switzerland

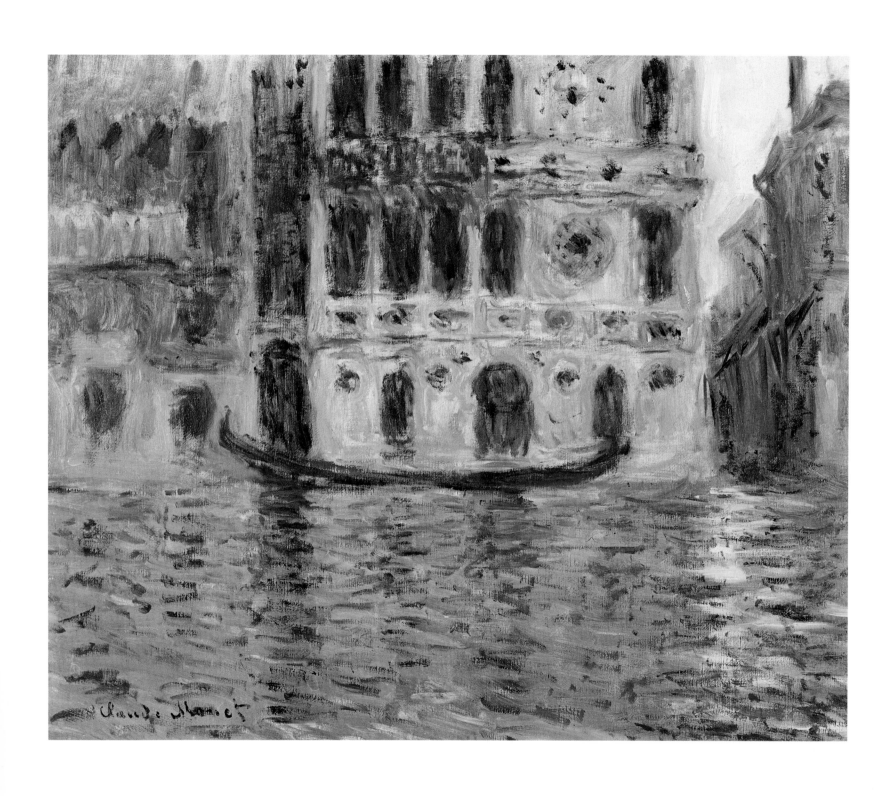

Claude Monet, *The Palazzo Dario*, 1908
Mrs. Henry J. Heinz II

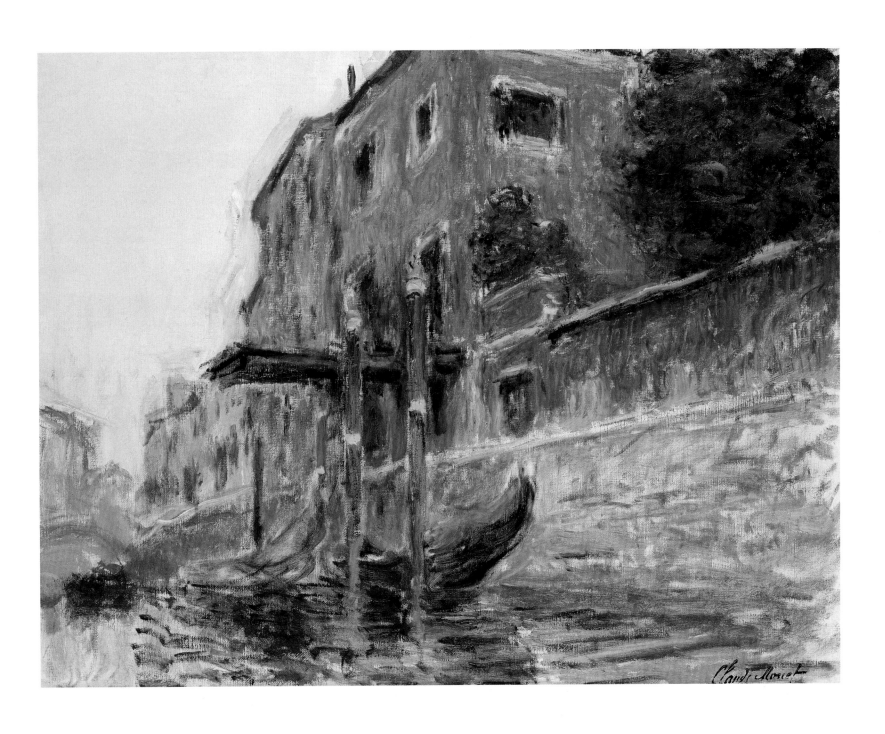

Claude Monet, *The Red House, sketch*, 1908
Collection Galerie Larock-Granoff

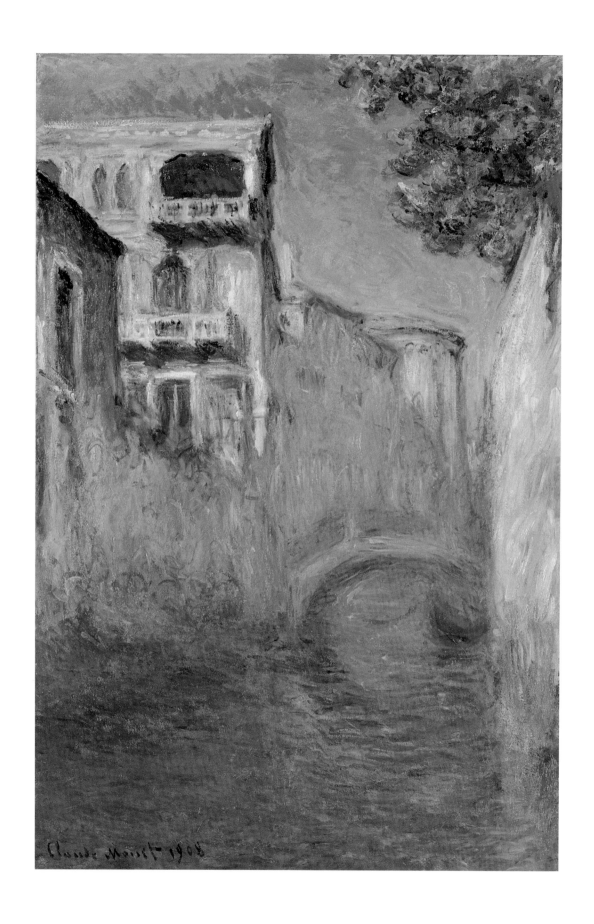

Claude Monet, *The Rio della Salute*, 1908
Pola Museum of Art, Pola Art Foundation, Japan

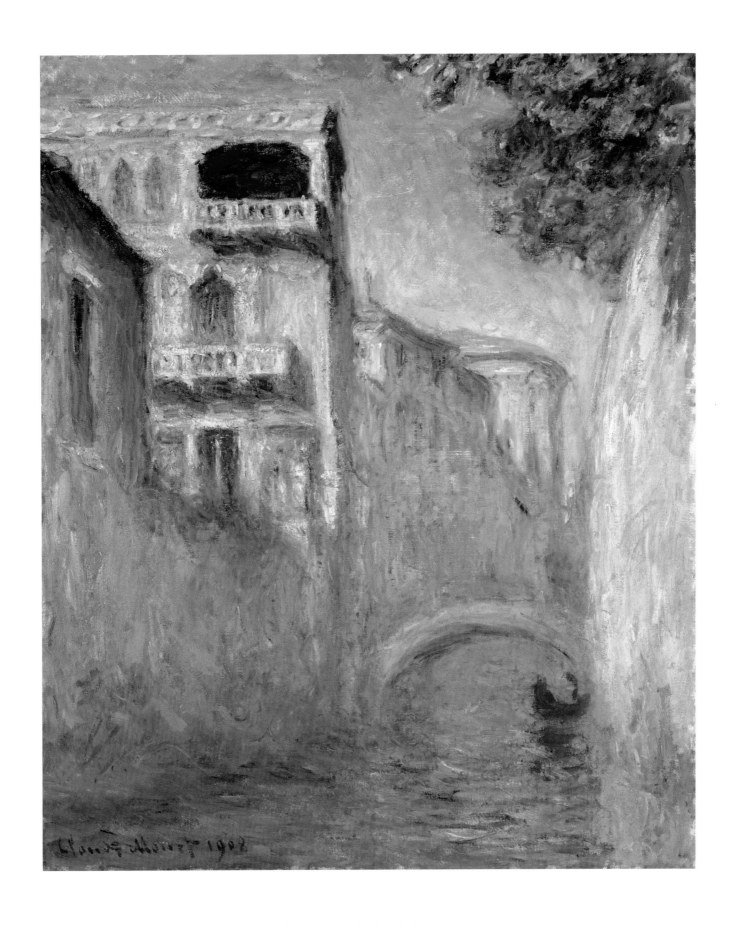

Claude Monet, *The Rio della Salute*, 1908
Nahmad Collection, Switzerland

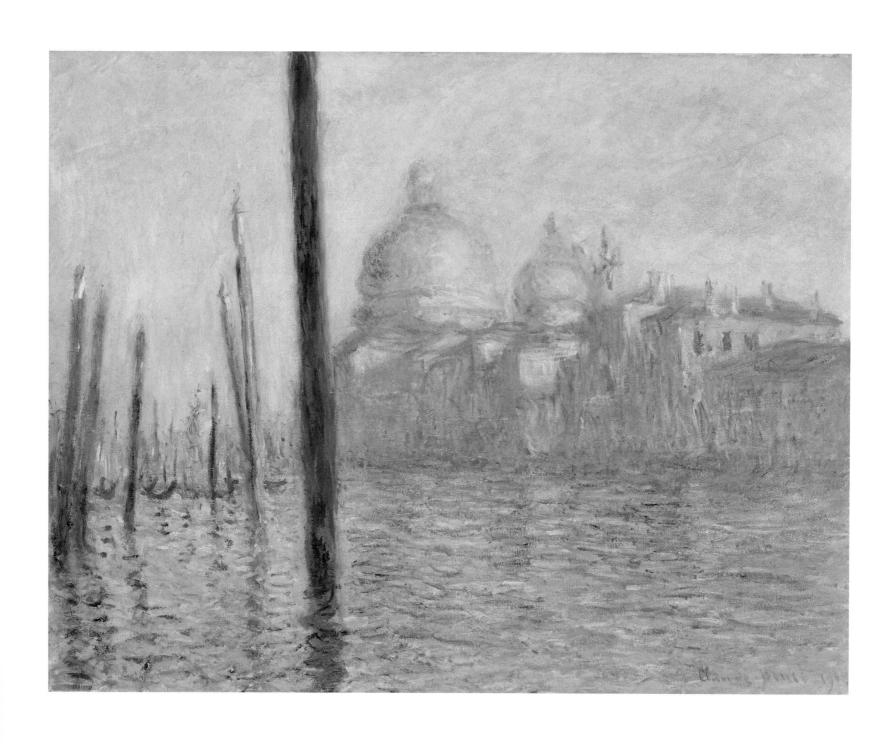

Claude Monet, *The Grand Canal*, 1908
Museum of Fine Arts, Boston, bequest of Alexander Cochrane

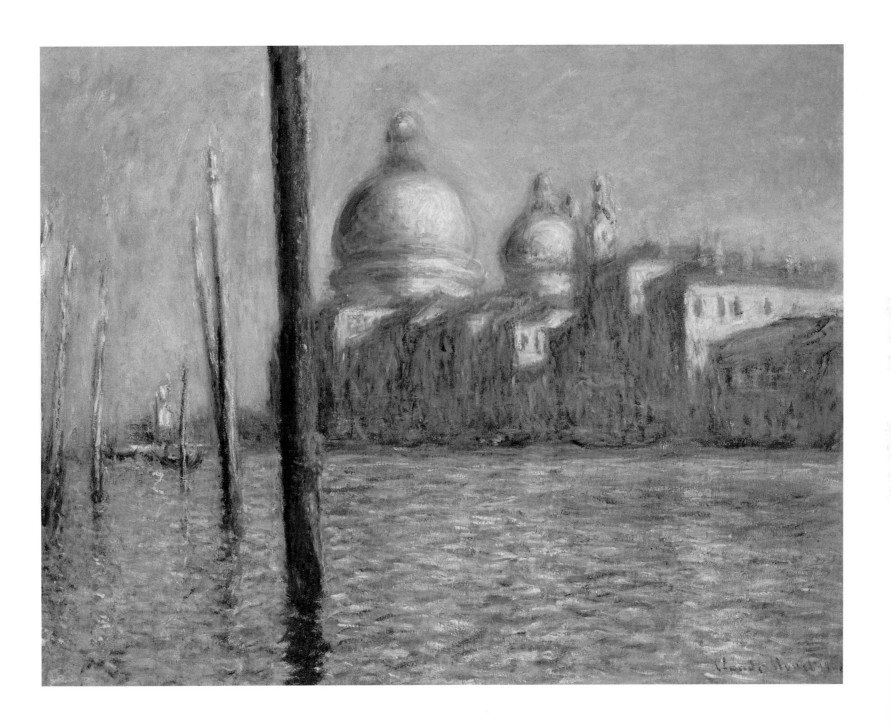

Claude Monet, *The Grand Canal*, 1908
Private collection

Pages 208–09:
Claude Monet, *Palazzo Ducale*, 1908
Brooklyn Museum of Art, gift of A. Augustus Healy

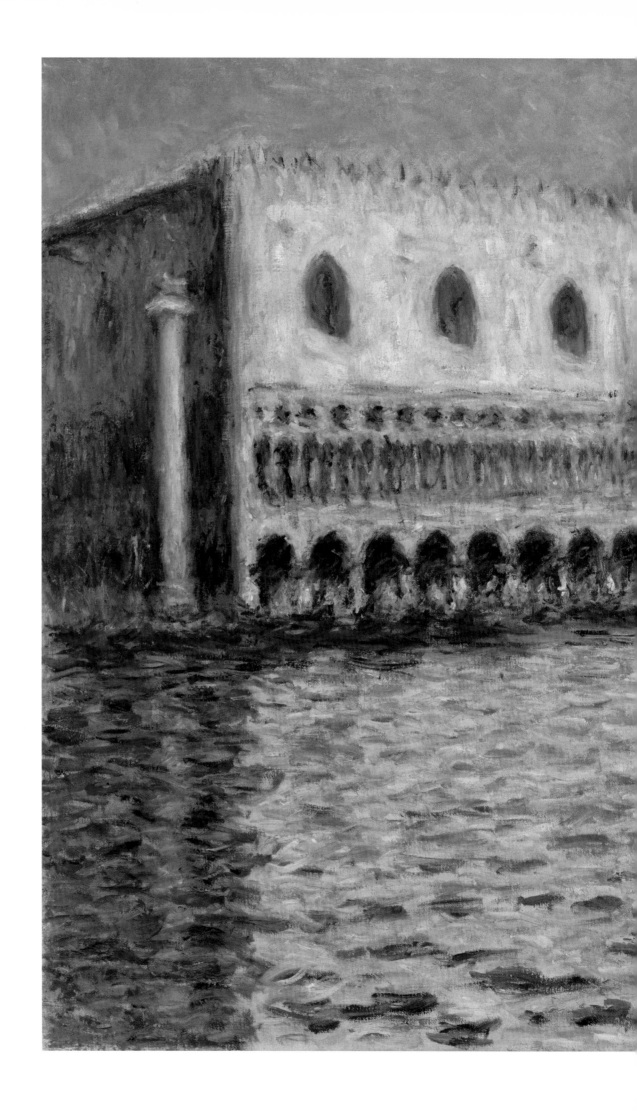

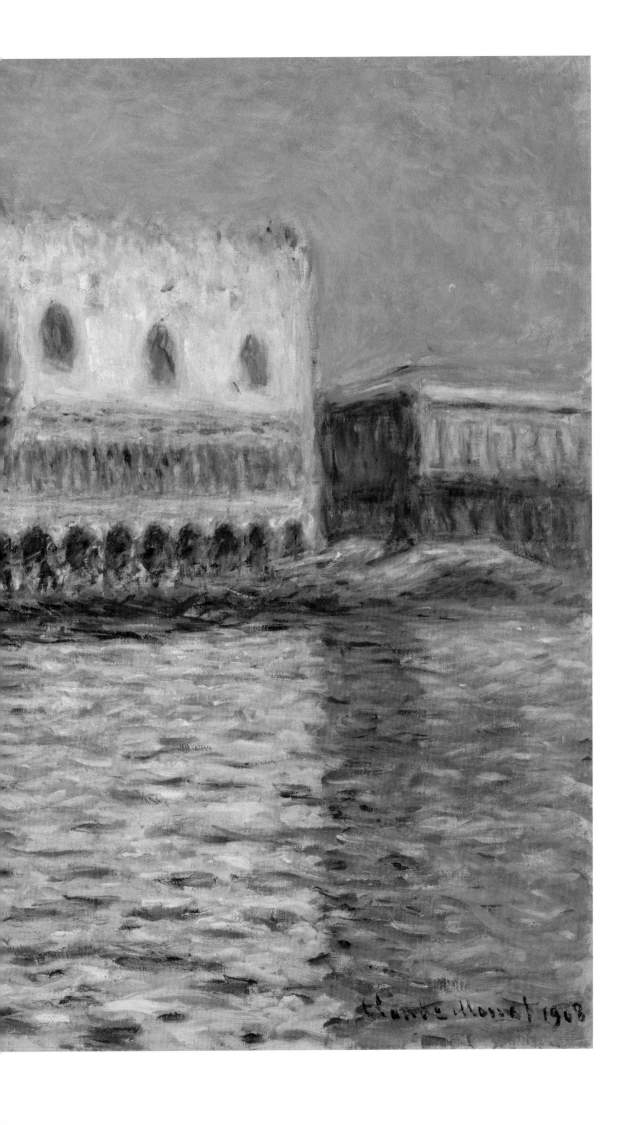

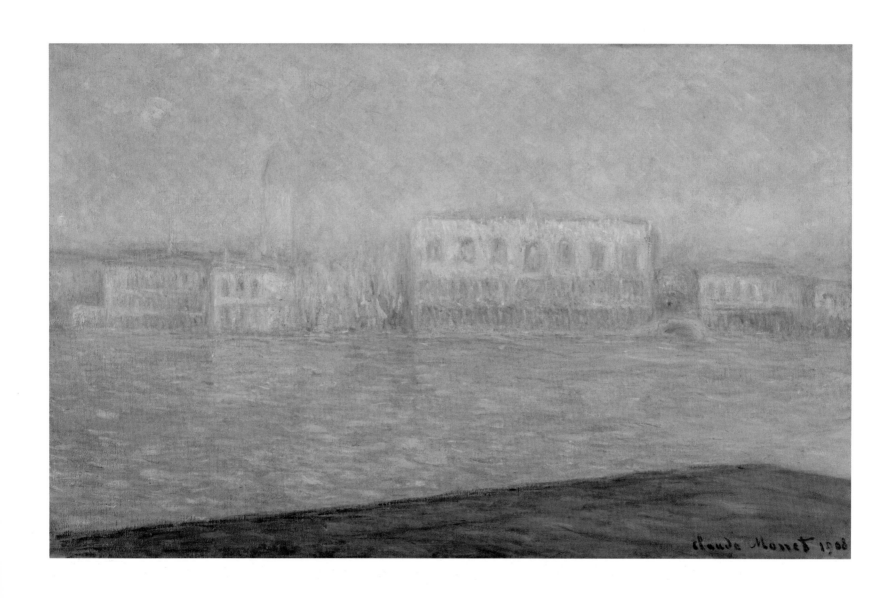

Claude Monet, *The Palazzo Ducale seen from San Giorgio Maggiore*, 1908
Solomon R. Guggenheim Museum, New York, Thannhauser Collection, bequest of Hilde Thannhauser, 1991

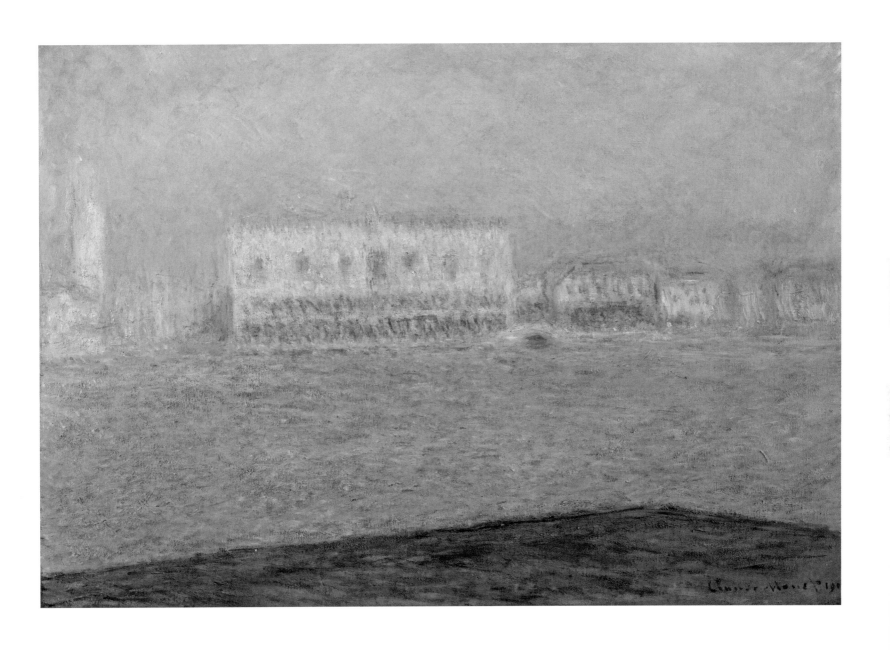

Claude Monet, *The Palazzo Ducale seen from San Giorgio Maggiore*, 1908
The Metropolitan Museum of Art, New York, gift of Mr. and Mrs. Charles S. McVeigh, 1959

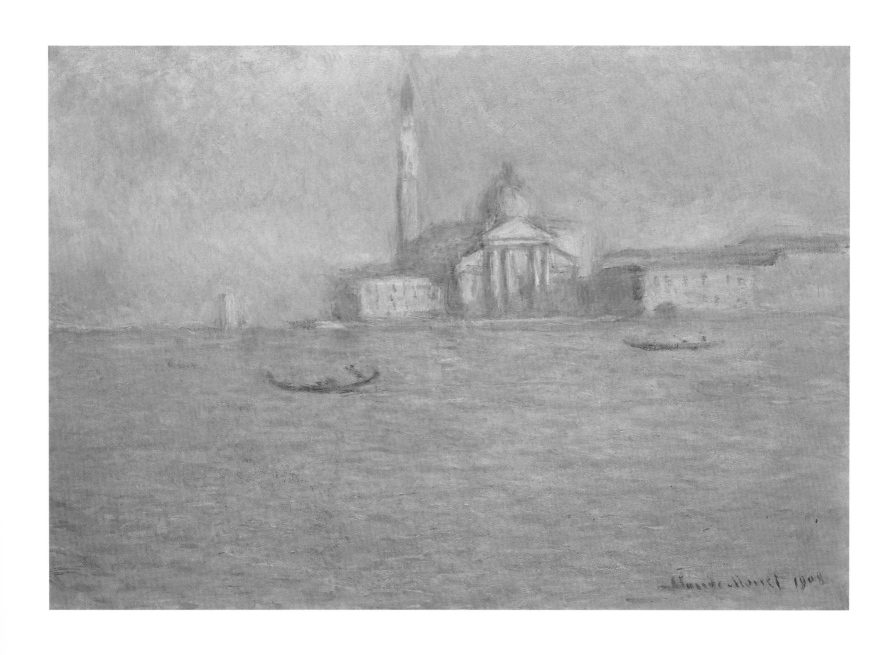

Claude Monet, *San Giorgio Maggiore*, 1908
Indianapolis Museum of Art, The Lockton Collection

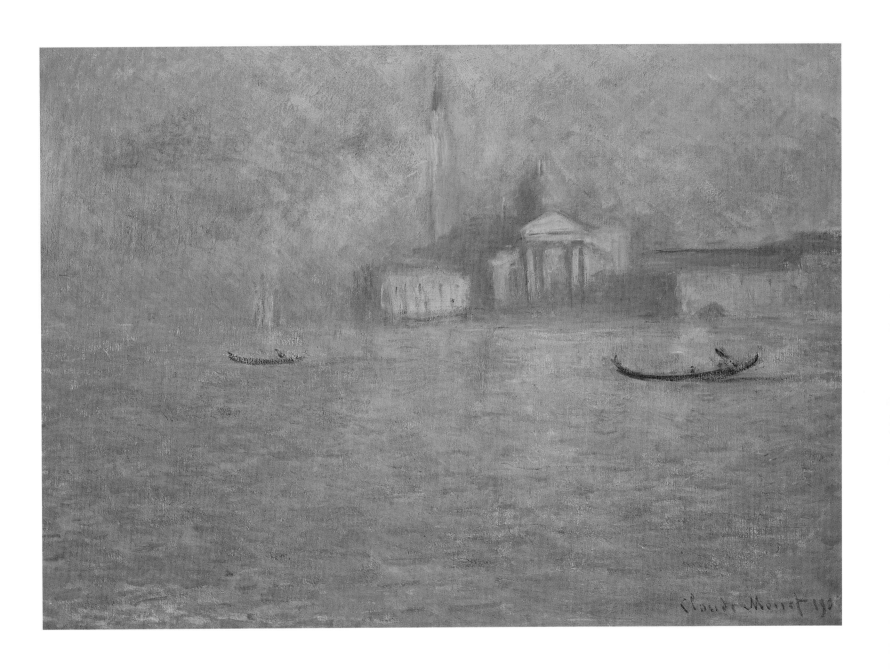

Claude Monet, *San Giorgio Maggiore*, 1908
Amgueddfa Cymru—National Museum Wales, Cardiff, bequeathed by Gwendoline Davies, 1951

Pages 214–15:
Claude Monet, *San Giorgio Maggiore at Dusk*, 1908
Amgueddfa Cymru—National Museum Wales, Cardiff, bequeathed by Gwendoline Davies, 1951

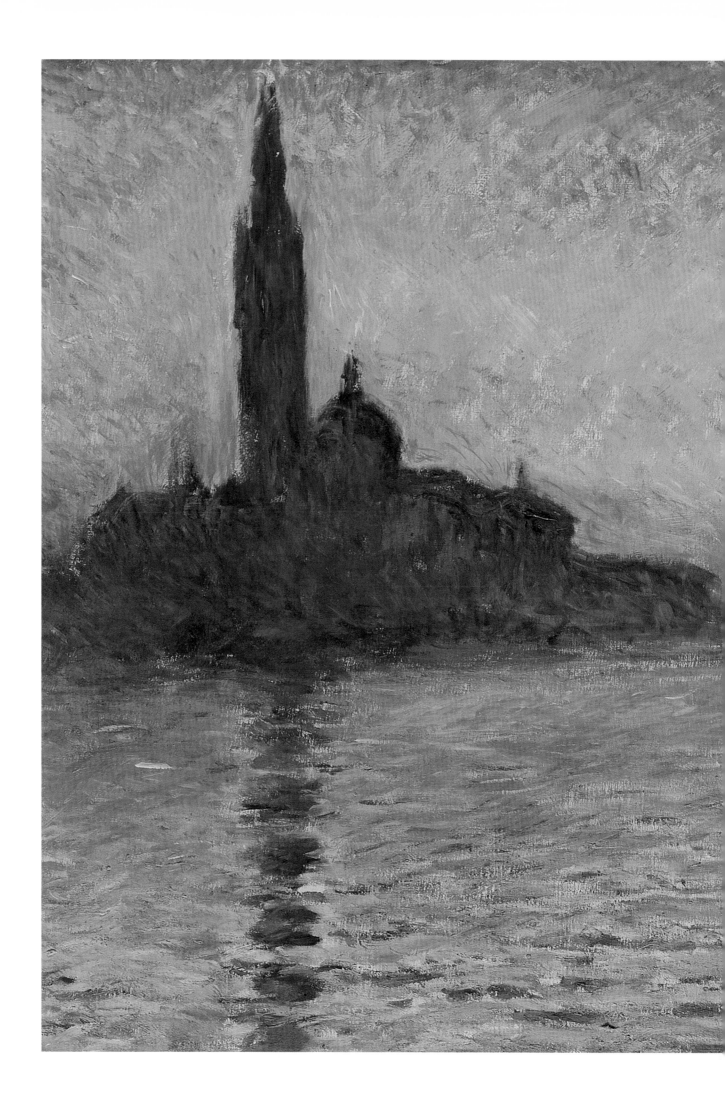

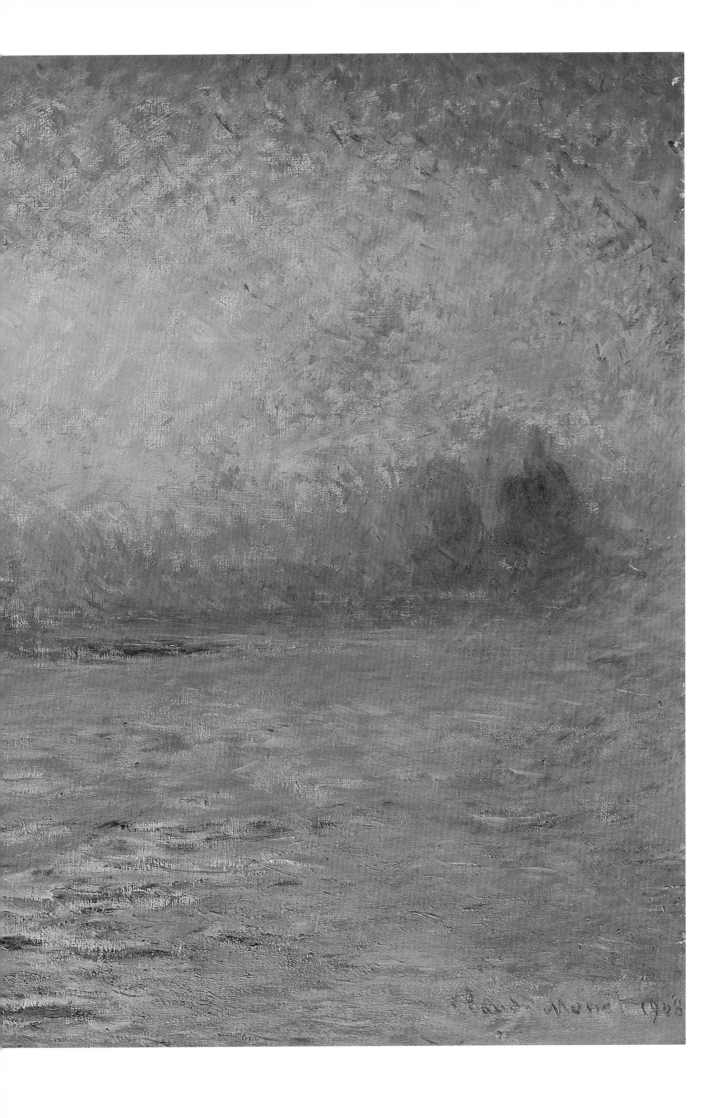

CATALOGUE OF WORKS EXHIBITED

GIOVANNI ANTONIO CANAL
(KNOWN AS CANALETTO)
1697–1768

Piazza San Marco, 1723/24
Oil on canvas, 141.5 × 204.5 cm
Constable/Links 1
Museo Thyssen-Bornemisza, Madrid
Page 28

*Il Canal Grande dal Palazzo Balbi al Ponte
di Rialto*, 1724/25
*The Grand Canal from the Palazzo Balbi
to the Rialto Bridge*
Oil on canvas, 66.7 × 97.7 cm
Constable/Links 214
Hull Museums, Ferens Art Gallery,
United Kingdom
Page 38

*Il Canal Grande da Santa Maria della Carità,
verso il Bacino di San Marco*, 1726
*The Grand Canal from Santa Maria della Carità,
towards the Bacino di San Marco*
Oil on canvas, 91.6 × 135.3 cm
Constable/Links 194
Pinacoteca Giovanni e Marella Agnelli,
Turin
Pages 40–41

Il Molo dal Bacino di San Marco, 1733/34
The Molo from the Bacino di San Marco
Oil on canvas, 48.5 × 80.5 cm
Constable/Links 105
Collection Juan Abelló, Madrid
Page 42

*Il Canal Grande dal Campo San Vio,
verso il Bacino di San Marco*, 1733/34
*The Grand Canal from the Campo di San Vio,
towards the Bacino di San Marco*
Oil on canvas, 48.5 × 80.5 cm
Constable/Links 189
Collection Juan Abelló, Madrid
Page 43

Festa notturna a San Pietro di Castello,
1758/63
Night Festival at San Pietro di Castello
Oil on canvas, 97 × 131 cm
Constable/Links 359
Collection Dr. Gert-Rudolf Flick, London
Page 39

PIETRO FRAGIACOMO
1856–1922

Piazza San Marco, 1899
Oil on panel, 84 × 145 cm
Galleria Internazionale d'Arte Moderna
di Ca' Pesaro, Venice
Page 162

FRANCESCO GUARDI
1712–1793

Il Canale della Giudecca con le Zattere,
1757/1758
The Giudecca Canal with the Zattere
Oil on canvas, 72.2 × 119.3 cm
Morassi 622
Colección Carmen Thyssen-Bornemisza
on loan to the Museo Thyssen-Bornemisza,
Madrid
Page 44

*Il Canal Grande con l'ingresso a Cannaregio
e San Geremia*, 1764/65
*The Grand Canal with the Entrance to
Cannaregio and the Church of San Geremia*
Oil on canvas, 71.5 × 120 cm
Morassi 573
Bayerische Staatsgemäldesammlungen,
Alte Pinakothek, Munich,
on loan from the HVB Group
Page 46

*Il Canal Grande con il Ponte di Rialto e il Palazzo
dei Camerlenghi*, 1764/65
*The Grand Canal with the Rialto Bridge and
the Palazzo dei Camerlenghi*
Oil on canvas, 72.5 × 120 cm
Morassi 551
Bayerische Staatsgemäldesammlungen,
Alte Pinakothek, Munich,
on loan from the HVB Group
Page 47

La Piazzetta con la Libreria, 1770/75
The Piazzetta with the Libreria
Oil on canvas, 62.7 × 89.5 cm
Morassi 387
Gemäldegalerie der Akademie der bildenden
Künste Wien, Vienna
Page 49

*La Partenza del Bucintoro dal Molo il giorno
dell'Ascensione*, 1770/75
*The Bucintoro Preparing to Leave the Molo
on Ascension Day*
Oil on canvas, 61 × 92 cm
Morassi 403
Calouste Gulbenkian Museum, Lisbon
Pages 52–53

La Torre dell'Orologio in Piazza San Marco,
c. 1775
The Torre dell'Orologio in Piazza San Marco
Oil on canvas, 44 × 70.5 cm
Morassi 355
Bayerische Staatsgemäldesammlungen,
Alte Pinakothek, Munich,
on loan from the HVB Group
Page 48

La Veduta attraverso un arco, 1775/80
The Veduta through an Arch
Oil on canvas, 60 × 43 cm
Morassi 812
Bayerische Staatsgemäldesammlungen,
Alte Pinakothek, Munich,
on loan from HVB Group
Page 50

*Il Canal Grande con le chiese Santa Lucia
e degli Scalzi*, c. 1780
*The Grand Canal with the Churches of Santa
Lucia and the Scalzi*
Oil on canvas, 63 × 89 cm
Morassi 584
Gemäldegalerie der Akademie der bildenden
Künste Wien, Vienna
Page 45

La Giudecca con la chiesa delle Zitelle, 1780/85
The Giudecca with the Church of the Zitelle
Oil on canvas, 26 × 33.5 cm
Morassi 633
Kunsthaus Zürich, Stiftung Betty
und David M. Koetser, Zurich, 1986
Page 54

Piazza San Marco, c. 1785
Oil on canvas, 35 × 45 cm
Morassi 332
Musée Granet, Aix-en-Provence,
anonymous donation, 2000
Page 51

Il Bacino di San Marco con il Bucintoro,
1780/90
The Bacino di San Marco with the Bucintoro
Oil on canvas, 62 × 93.5 cm
Morassi 288
Foundation E.G. Bührle Collection, Zurich
Page 55

EDOUARD MANET
1832–1883

Le Grand Canal à Venise (*Vue de Venise*),
1874
The Grand Canal (*View of Venice*)
Oil on canvas, 56 × 45.7 cm
Rouart/Wildenstein 230
Paul G. Allen Family Collection
Page 146

Le Grand Canal à Venise (*Venise*), 1874
The Grand Canal, Venice (*Blue Venice*)
Oil on canvas, 58.7 × 71.4 cm
Rouart/Wildenstein 231
Shelburne Museum, Shelburne, Vermont
Pages 152–53

PIERRE-AUGUSTE RENOIR
1841–1919

Le Grand Canal, Venise (Gondole), 1881
The Grand Canal, Venice (Gondola)
Oil on canvas, 54.6 × 66 cm
Dauberville 160
Nahmad Collection, Switzerland
Page 154

Sur le Grand Canal, Venise, 1881
On the Grand Canal, Venice
Oil on canvas, 54 × 65.1 cm
Dauberville 162
Museum of Fine Arts, Boston,
bequest of Alexander Cochrane
Page 160

Vue de Venise (Le Palais des Doges), 1881
Venice (The Doge's Palace)
Oil on canvas, 54 × 65 cm
Dauberville 161
Sterling and Francine Clark Art Institute,
Williamstown, Massachusetts
Page 161

JOHN SINGER SARGENT
1856–1925

Paintings

Ramón Subercaseaux in a Gondola, c. 1880
Oil on canvas, 47 × 63.5 cm
Ormond/Kilmurray 41
Collection of The Dixon Gallery and Gardens,
Memphis, Tennessee, gift of Cornelia Ritchie
Page 127

A Venetian Interior, c. 1880/81
Oil on canvas, 48.4 × 60.8 cm
Ormond/Kilmurray 795
Sterling and Francine Clark Art Institute,
Williamstown, Massachusetts
Page 130 top

Venetian Bead Stringers, c. 1880/82
Oil on canvas, 67 × 78.1 cm
Ormond/Kilmurray 794
Collection Albright-Knox Art Gallery, Buffalo,
Friends of the A.A.G. Fund, 1916
Page 130 bottom

The Sulphur Match, 1882
Oil on canvas, 58.4 × 41.3 cm
Ormond/Kilmurray 803
Marie and Hugh Halff
Page 128

Sortie de l'église, Campo San Canciano, Venise,
c. 1882
Leaving Church, Campo San Canciano, Venice
Oil on canvas, 55.9 × 85.1 cm
Ormond/Kilmurray 806
Marie and Hugh Halff
Page 129 top

Street in Venice, c. 1882
Oil on panel, 45.1 × 54 cm
Ormond/Kilmurray 808
National Gallery of Art, Washington, D.C.,
gift of the Avalon Foundation
Page 129 bottom

An Interior in Venice, 1898
Oil on canvas, 66 × 83.5 cm
Royal Academy of Arts, London
Page 131

Santa Maria della Salute, Venice, c. 1906
Oil on canvas, 63.5 × 91.4 cm
The Syndics of the Fitzwilliam Museum,
Cambridge
Page 132 top

The Libreria, c. 1906/09
Oil on canvas, 54.6 × 69.9 cm
Private collection
Page 132 bottom

The Rialto, Venice, 1911
Oil on canvas, 55.9 × 92.1 cm
Philadelphia Museum of Art,
The George W. Elkins Collection, 1924
Page 120

Corner of the Church of St Stae, Venice, c. 1913
Oil on canvas, 72.4 × 55.9 cm
Private collection
Page 133

Watercolors

Venice, c. 1880/81
Pencil and watercolor, 25.1 × 35.6 cm
Ormond/Kilmurray 811
The Metropolitan Museum of Art,
gift of Mrs. Francis Ormond, 1950
Page 135

Vue de Venise (sur le canal), c. 1902/04
View of Venice (On the Canal)
Watercolor, 34.3 × 49.5 cm
Petit Palais, Musée des Beaux-Arts de la Ville
de Paris
Page 134 top

Campo dei Gesuiti, c. 1902/04
Watercolor, 34.9 × 50.2 cm
Private collection
Page 134 bottom

The Piazzetta, Venice, c. 1904
Pencil, watercolor, and gouache,
34.3 × 53.7 cm
Tate, presented by Lord Duveen, 1919
Page 138 bottom

Gondoliers' Siesta, c. 1904
Watercolor, 35.6 × 50.8 cm
Private collection, courtesy of Adelson
Galleries, New York
Page 139

Doorway of a Venetian Palace, c. 1904/09
Pencil and watercolor, 58.4 × 45.7 cm
Collection Westmoreland Museum
of American Art, Greensburg, Pennsylvania,
anonymous donation
Page 137

*The Church of Santa Maria della Salute
from Giudecca*, c. 1904/09
Pencil and watercolor, 35.6 × 52.7 cm
Calouste Gulbenkian Museum, Lisbon
Page 138 top

Giudecca, c. 1913
Pencil and watercolor, 30.5 × 45.7 cm
The Syndics of the Fitzwilliam Museum,
Cambridge
Page 136 top

Giudecca, c. 1913
Pencil and watercolor, 33.2 × 53.2 cm
The Metropolitan Museum of Art, purchase,
Joseph Pulitzer Bequest, 1915
Page 136 bottom

PAUL SIGNAC
1863–1935

Laguna, Voile jaune, 1904
Laguna, Yellow Sail
Oil on canvas, 72 × 91 cm
Cachin 413
Musée des Beaux-Arts et d'Archéologie,
Besançon, on permanent loan from the Centre
Georges Pompidou,
Musée national d'art moderne, Paris,
gift of Adèle and Georges Besson, 1963
Page 184

La Dogana (Venise), 1904
The Dogana (Venice)
Oil on canvas, 71 × 90 cm
Cachin 412
Private collection, United Kingdom
Page 187

*The Piazzetta and the Doge's Palace
from the Bacino*, c. 1840
Watercolor and bodycolor on gray paper,
19.3 × 27.9 cm
Finberg TB CCCXVII 1
Tate, accepted by the nation as part
of the Turner Bequest, 1856
Page 78 bottom

*Looking down the Grand Canal to Palazzo Corner
della Ca' Grande and Santa Maria della Salute*,
1840
From the *Grand Canal and Giudecca*
sketchbook
Pencil and watercolor, 22.1 × 32.5 cm
Finberg TB CCCXV 6
Tate, accepted by the nation as part
of the Turner Bequest, 1856
Page 79 top

*The Steps of Santa Maria della Salute,
looking up the Grand Canal*, 1840
From the *Grand Canal and Giudecca*
sketchbook
Pencil and watercolor, 22.1 × 32.3 cm
Finberg TB CCCXV 5
Tate, accepted by the nation as part
of the Turner Bequest, 1856
Page 79 bottom

*San Marco and the Piazzetta, with San Giorgio
Maggiore; Night*, 1840
Watercolor and bodycolor on gray-brown
paper, 14.8 × 22.8 cm
Finberg TB CCCXIX 2
Tate, accepted by the nation as part
of the Turner Bequest, 1856
Page 80 top

*The Piazzetta, with San Marco and
its Campanile; Night*, 1840
Watercolor and bodycolor on gray-brown
paper, 15 × 22.8 cm
Finberg TB CCCXVIII 1
Tate, accepted by the nation as part
of the Turner Bequest, 1856
Page 80 bottom

The Porta della Carta, Doge's Palace, c. 1840
Pencil, watercolor and bodycolor on pale buff
paper, 30.5 × 23.4 cm
Finberg TB CCCXVIII 28
Tate, accepted by the nation as part
of the Turner Bequest, 1856
Page 81

*Looking back on Venice from the Canale
di San Marco to the East*, 1840
Watercolor, 24.5 × 30.6 cm
Finberg TB CCCXVI 18
Tate, accepted by the nation as part
of the Turner Bequest, 1856
Page 83

Venice: Fireworks on the Molo, 1840
Watercolor, bodycolor, and chalk, 22.8 × 30 cm
Finberg TB CCCXVIII c 10
Tate, accepted by the nation as part
of the Turner Bequest, 1856
Page 84 top

*Sunset over Santa Maria della Salute
and the Dogana*, 1840
From the *Grand Canal and Giudecca*
sketchbook
Watercolor, 22.1 × 32.1 cm
Finberg TB CCCXV 14
Tate, accepted by the nation as part
of the Turner Bequest, 1856
Page 85 top

*The Punta della Dogana, and Santa Maria
della Salute at Twilight, from the Hotel Europa*,
1840
Pencil, watercolor and ink, 19.4 × 28 cm
Finberg TB CCCXVI 29
Tate, accepted by the nation as part
of the Turner Bequest, 1856
Page 85 bottom

*San Giorgio Maggiore at Sunset, from the Riva
degli Schiavoni*, 1840
Watercolor, 24.4 × 30.6 cm
Finberg TB CCCXVI 24
Tate, accepted by the nation as part
of the Turner Bequest, 1856
Page 86 top

*San Giorgio Maggiore from the Hotel Europa,
at the Entrance to the Grand Canal*, 1840
Watercolor, 19.5 × 27.6 cm
The Whitworth Art Gallery, University of
Manchester
Page 86 bottom

*San Giorgio Maggiore at Sunset, from the Hotel
Europa*, 1840
Pencil, watercolor, and bodycolor, 19.3 × 28.1 cm
Finberg TB CCCXVI 28
Tate, accepted by the nation as part
of the Turner Bequest, 1856
Page 87

*Venice at Sunrise from the Hotel Europa,
with the Campanile of San Marco*, 1840
Watercolor, 19.8 × 28 cm
Finberg TB CCCLXIV 106
Tate, accepted by the nation as part
of the Turner Bequest, 1856
Page 88

Venice: Moonlight on the Lagoon, 1840
Watercolor and bodycolor, 24.5 × 30.4 cm
Finberg TB CCCXVI 39
Tate, accepted by the nation as part
of the Turner Bequest, 1856
Page 89

JAMES McNEILL WHISTLER
1834–1903

Pastel drawings

Venice at Sunset, 1879
Chalk and pastel on brown paper,
19.4 × 29.3 cm
MacDonald 741
Private collection (from the former Joan
Whitney Payson Collection)
Page 108 top

A Venetian Canal, 1879/80
Chalk and pastel on brown paper, 30.7 × 18.7 cm
MacDonald 754
Private collection, United Kingdom
Page 102 left

Venetian Canal [recto], *Bridge over Canal*
[verso], 1879/80
Chalk and pastel on brown paper,
29.9 × 20.3 cm
MacDonald 766
Private collection, United Kingdom
Page 102 right

Campanile Santa Margherita, 1879/80
Chalk and pastel on brown paper, 30.2 × 18.7 cm
MacDonald 773
Addison Gallery of American Art,
Phillips Academy, Andover, Massachusetts,
anonymous donation
Page 103

A Venetian Canal, 1879/80
Chalk and pastel on brown paper, 31 × 21.3 cm
MacDonald 765
Hirshhorn Museum and Sculpture Garden,
Smithsonian Institution, Washington, D.C.,
gift of Joseph H. Hirshhorn, 1966
Page 104 left

The Tobacco Warehouse, 1879/80
Chalk and pastel on brown paper, 30.7 × 21.4 cm
MacDonald 762
Hirshhorn Museum and Sculpture Garden,
Smithsonian Institution, Washington, D.C.,
gift of Joseph H. Hirshhorn, 1966
Page 104 right

The Palace in Rags [recto], *Houses by a Canal,
with Bridges* [verso], 1879/80
Chalk and pastel on brown paper, 28 × 16.5 cm
MacDonald 770
Private collection, United Kingdom
Page 105

The Little Riva, in Opal, 1879/80
Chalk and pastel on brown paper, 15.2 × 30.1 cm
MacDonald 749
Collection of the Lauren Rogers Museum
of Art, Laurel, Mississippi
Page 108 bottom

View in Venice, looking towards the Molo,
1879/80
Pencil, chalk and pastel on brown paper,
23.4 × 17.1 cm
MacDonald 742
Private collection, courtesy of Adelson
Galleries, New York
Page 109

Venetian Scene, c. 1880
Chalk and pastel on brown paper,
29.6 × 20.2 cm
MacDonald 744
New Britain Museum of American Art,
Connecticut, Harriet Russell Stanley Fund
Page 10

Clouds and Sky, Venice [recto], *Buildings* [verso],
possibly 1880
Pastel [recto] and pencil [verso], on gray wove
paper, 12.7 × 21.6 cm
MacDonald 820
Saint Louis Art Museum, gift of J. Lionberger
Davis
Page 90

Venetian Courtyard, 1880
Chalk and pastel on brown paper,
30.9 × 20.3 cm
MacDonald 792
Dr. John E. and Colles B. Larkin
Page 106 left

Courtyard on Canal (Gray and Red), 1880
Chalk and pastel on brown paper,
30.1 × 20.2 cm
MacDonald 790
Saint Louis Art Museum, gift of J. Lionberger
Davis
Page 106 right

Canal, San Cassiano, Venice, 1880
Chalk and pastel on brown paper, 29.2 × 17.1 cm
MacDonald 778
Collection Westmoreland Museum of
American Art, Greensburg, Pennsylvania,
gift of the William A. Coulter Fund
Page 107

Etchings

The Palaces, 1879/80
Etching, 25.4 × 36.3 cm
Kennedy 187
Hamburger Kunsthalle, Kupferstichkabinett,
Hamburg
Page 96

The Little Lagoon, 1879/80
Etching, 22.8 × 15.2 cm
Kennedy 186
Hamburger Kunsthalle, Kupferstichkabinett,
Hamburg
Page 97

The Fish Shop, 1879/80
Etching, 13.1 × 22.5 cm
Kennedy 218
Hunterian Museum & Art Gallery,
University of Glasgow
Page 98 top

Nocturne: Furnace, 1879/80
Etching, 16.8 × 23.2 cm
Kennedy 213
Hamburger Kunsthalle, Kupferstichkabinett,
Hamburg
Page 98 bottom

The Balcony, 1879/80
Etching, 29.7 × 20.2 cm
Kennedy 207
Hunterian Museum & Art Gallery,
University of Glasgow
Page 99

The Little Venice, 1879/80
Etching, 18.4 × 26.3 cm
Kennedy 183
Hamburger Kunsthalle, Kupferstichkabinett,
Hamburg
Page 110 top

Long Venice, 1879/80
Etching, 12.7 × 30.8 cm
Kennedy 212
Hamburger Kunsthalle, Kupferstichkabinett,
Hamburg
Page 110 bottom

Nocturne, 1879/80
Etching, 20 × 29.5 cm
Kennedy 184
Hunterian Museum & Art Gallery,
University of Glasgow
Page 111

The Riva, No. 1, 1879/80
Etching, 20 × 29.2 cm
Kennedy 192
Hamburger Kunsthalle, Kupferstichkabinett,
Hamburg
Page 112 top

The Venetian Mast, 1879/80
Etching, 34 × 16.3 cm
Kennedy 195
In an original frame designed by Whistler
Private collection, courtesy of The Fine Art
Society, London
Page 113 left

The Piazzetta, 1879/80
Etching, 25.4 × 18.1 cm
Kennedy 189
Hamburger Kunsthalle, Kupferstichkabinett,
Hamburg
Page 113 right

The Traghetto, No. 2, 1879/80
Etching, 23.5 × 30.5 cm
Kennedy 191
Hunterian Museum & Art Gallery,
University of Glasgow
Page 114

The Beggars, 1879/80
Etching, 30.6 × 21 cm
Kennedy 194
Hunterian Museum & Art Gallery,
University of Glasgow
Page 115

The Bridge, 1879/80
Etching, 29.8 × 20 cm
Kennedy 204
Hamburger Kunsthalle, Kupferstichkabinett,
Hamburg
Page 116 left

Ponte del Piovan, 1879/80
Etching, 22.8 × 15.2 cm
Kennedy 209
Hamburger Kunsthalle, Kupferstichkabinett,
Hamburg
Page 116 right

The Garden, 1879/80
Etching, 30.5 × 23.8 cm
Kennedy 210
Hamburger Kunsthalle, Kupferstichkabinett,
Hamburg
Page 117 left

The Balcony, 1879/80
Etching, 29.7 × 20 cm
Kennedy 207
Hamburger Kunsthalle, Kupferstichkabinett,
Hamburg
Page 117 right

The Two Doorways, 1879/80
Etching, 20.3 × 29.2 cm
Kennedy 193
Hamburger Kunsthalle, Kupferstichkabinett,
Hamburg
Page 118

Nocturne: Palaces, 1879/80
Etching, 29.4 × 19.9 cm
Kennedy 202
Hunterian Museum & Art Gallery,
University of Glasgow
Page 119

San Biagio, 1880
Etching, 20.9 × 30.5 cm
Kennedy 197
Hamburger Kunsthalle, Kupferstichkabinett,
Hamburg
Page 112 bottom

ANDERS ZORN
1860–1920

In my Gondola, 1894
Oil on canvas, 67 × 91 cm
Zornsamlingarna, Mora, Sweden
Page 140

PHOTOGRAPHS

The exhibition also includes a selection of
historical photographs of Venetian motifs from
the Herzog Collection, Basel.

EXHIBITION

Venice
From Canaletto and Turner to Monet
Fondation Beyeler, Riehen/Basel
September 28, 2008 – January 25, 2009

Conception and realization
Martin Schwander, guest curator

Assistant
Michiko Kono

Beyeler Museum AG
Director: Samuel Keller
Managing Director: Fausto De Lorenzo
Curators: Philippe Büttner and Ulf Küster
Registrars: Nicole Rüegsegger and Tanja Narr
Conservator: Markus Gross
Public relations: Catherine Schott and Ricarda Dobler
Corporate communication: Claudia Carrara
Exhibition services: Ben Ludwig
Administrative office: Claudia Santomauro

CATALOGUE

Venice
From Canaletto and Turner to Monet

Editor
Martin Schwander and Beyeler Museum AG
(Fondation Beyeler)

Editorial direction
Delia Ciuha with Raphaël Bouvier

Translations from the German
John W. Gabriel, Worpswede
(Preface, Schwander);
Matthew Partridge, Berlin (Boehm)

Translations from the Italian
Paul Aston, Rome (Distel, Kowalczyk, Romanelli)

Copyeditor
Christopher Wynne, Bad Tölz
Danko Szabó, Gräfelfing

Design
Heinz Hiltbrunner, Munich

Typesetting
Jürgen Geiger, Stuttgart, and collaborator:
Günter Heimbach, Stuttgart

Typeface
Bodoni Berthold
ITC Veljovic

Production coordination
Stefanie Langner, Hatje Cantz

Printing
Dr. Cantz'sche Druckerei, Ostfildern

Paper
LuxoSamtoffset, 150 g/m²

Binding
Conzella Verlagsbuchbinderei,
Urban Meister GmbH, Aschheim-Dornach

Copyright
© 2008 Beyeler Museum AG, Riehen/Basel;
Hatje Cantz Verlag, Ostfildern;
authors and translators

A publication of the Beyeler Museum AG
(Fondation Beyeler)
Baselstrasse 101
4125 Riehen/Basel
Switzerland
Tel. 0041 61 64597 00
Fax 0041 61 64597 19
www.beyeler.com
fondation@beyeler.com

Museum edition (softcover):
ISBN 978-3-905632-71-2 (English)
ISBN 978-3-905632-70-5 (German)

The trade edition is published
by Hatje Cantz Verlag
Zeppelinstrasse 32
73760 Ostfildern
Germany
Tel. + 49 711 44 05 200
Fax + 711 44 05 220
www.hatjecantz.com

Trade edition (hardcover with dust jacket):
ISBN 978-3-7757-2241-4 (English)
ISBN 978-3-7757-2240-7 (German)

Printed in Germany

Cover: Claude Monet, *The Palazzo Contarini*, 1908 (page 201)
Frontispiece: Claude Monet, *Gondola in Venice*, 1908 (page 2)

759.5